SEXY BODIES

ƒ
10

SEXY BODIES

The strange carnalities
of feminism

Edited by
Elizabeth Grosz
and Elspeth Probyn

London and New York

First published 1995
by Routledge
11 New Fetter Lane, London EC4P 4EE

Simultaneously published in the USA and Canada
by Routledge
29 West 35th Street, New York, NY 10001

© 1995 Elizabeth Grosz and Elspeth Probyn
Individual contributions © individual contributors

Typeset in Times by
Ponting–Green Publishing Services, Chesham, Bucks
Printed and bound in Great Britain by
Biddles Ltd, Guildford and Kings Lynn

British Library Cataloguing in Publication Data
A catalogue record for this book is available from
the British Library

Library of Congress Cataloguing in Publication Data
Sexy Bodies: the strange carnalities of feminism / edited by
Elizabeth Grosz and Elspeth Probyn
p. cm.
Includes bibliographical references and index.
1. Sex 2. Homosexuality. 3. Lesbianism.
4. Lesbian feminists. I. Grosz, E. A. (Elizabeth A.)
II. Probyn, Elspeth, 1958– .
HQ16.S49 1995
306.76'63–dc20 94–36929

ISBN 0–415–09802–5
ISBN 0–415–09803–3 (pbk)

CONTENTS

NOTES ON CONTRIBUTORS

Sue Best teaches in the Department of Art History, University of Western Sydney, Nepean.

Nicole Brossard is a poet, novelist and essay writer. More than thirty titles of her work are internationally renowned for the originality of their feminist intervention and include such books as *Mauve Desert*, *The Aerial Letter* and *Picture Theory*.

Dianne Chisholm is Associate Professor of English at the University of Alberta. She is author of *H.D.'s Freudian Poetics: Psychoanalysis in Translation* (Cornell University Press, 1992) and consultant editor to *Feminism and Psychoanalysis: A Critical Dictionary* (Blackwell, 1992), edited by Elizabeth Wright. She is currently at work on three book projects: *Queer Avant-Gardes, Pornopoeia: The Last/Lost Art of Modernism* and *Violent Femmes: Violence in Contemporary Writing by Canadian Women*.

Barbara Creed lectures in Cinema Studies at La Trobe University, Melbourne. She has published widely in the areas of film, feminist theory and cultural studies. Her most recent book is *The Monstrous-Feminine: Film, Feminism, Psychoanalysis* (Routledge, 1993).

Angela Y. Davis is a Professor of History of Consciousness at the University of California, Santa Cruz. Her articles and essays have been published in numerous journals and anthologies, both scholarly and popular. She is the author of five books, including *Angela Davis: An Autobiography, Women, Race, and Class* and the forthcoming *Ma Rainey, Bessie Smith and Billie Holiday: Black Women's Music and Social Consciousness*. She is currently conducting research on incarcerated women and alternatives to imprisonment, which will be the subject of her next book.

Mary Fallon is currently writing a two-act play *Angels Bellowing* on motherhood, faster motherhood and interracial relations in Australia, and *Con/struction Site*, an 'opera' for eight women performers about the construction of female subjectivity, sexuality and language. Her novel-in-progress *The Staff of Life* (about that which sustains us) is in progress and sustains her.

Anna Gibbs teaches creative writing and textual theory at the University of Western Sydney, Nepean. Her most recent theoretical work has been on writing and death, and on Gertrude Stein as a ghost-writer. She also publishes fiction, and is currently writing for collaborative projects with visual artists.

Sue Golding is a writer and director of avant-garde work. She is also a Senior Lecturer in Political Philosophy at Greenwich University, London. Her fiction and non-fiction work centres on radical democratic theory, sexualities/techne, and nomadic curiosities. Her first book (*Gramsci's Democratic Theory*, 1992) is being followed by a new work which steps into the virtual realities of a Nietzschean/Wittgensteinian/Foucauldian blend to explore, as it is entitled, *The Cunning of Democracy* (forthcoming from Verso).

Elizabeth Grosz is the Director of the Institute of Critical and Cultural Studies at Monash University, Australia. Her most recent book is *Volatile Bodies: Toward a Corporeal Feminism* (Indiana University Press).

Melissa Jane Hardie is a Lecturer in Cultural Studies and English at the University of Wollongong. She wrote her Ph.D. on Djuna Barnes and Modernism. Her recent work for a book about camp and femininity includes studies of Dolly Parton, country music and the novels of Jacqueline Susann.

Lisa Moore is Assistant Professor of English at the University of Texas at Austin. She is currently completing a manuscript entitled *Dangerous Intimacies*, which examines the representation of love between women in the eighteenth-century English novel. Her articles on feminist theory and early modern constructions of gender and sexuality have appeared in *Textual Practice*, *Diacritics* and *Feminist Studies*.

Chantal Nadeau is Assistant Professor in the Department of Communication Studies, Concordia University. Until recently, she was Visiting Scholar in the Department of English, University of Pittsburgh, pursuing her research on the representations of lesbians in cinema and the politicization of the sexual other in the social. She has published and given talks and lectures on women's cinema, popular culture, feminist epistemology and lesbian and gay representations in the context of national identities. She is currently working on lesbian sexual practices and the regulation of subversion in Canada.

Elspeth Probyn is Associate Professor of Sociology at the Université de Montréal. Her work includes *Sexing the Self. Gendered Positions in Cultural Studies* (Routledge, 1993), *By Choice. Feminism, Desire and Subjectification* (University of Minnesota Press, forthcoming 1996) and *Outside Belonging(s), The Singularities of Sex* (forthcoming).

Sabina Sawhney teaches English at Daemen College and has published articles on feminism and post-colonial literature. She is currently working on *The Other Colonialists: Imperial Margins of Victorian Literature*, which deals with the impact of colonialism on the narrative structure of nineteenth-century British novels.

Catherine Waldby has worked in various areas of feminist research since 1984. She has published in a number of journals and anthologies on questions of sexuality, biomedical representations of HIV/AIDS and feminist and social theory. She is currently completing a Ph.D. thesis on AIDS and the idea of the body politic in the Women's Studies programme at Murdoch University.

INTRODUCTION

It is by now commonplace to introduce an anthology by announcing the aims of the collection, describing its contents, presenting the collection as a more or less unified, coherent entity and marketing it as a desirable commodity which promises multiple perspectives or viewpoints on a limited number of 'objects'. It is thus not surprising that there are many, many collections on the body, although in the past they tended to converge on an unmarked, unsexed and a definitely unsexy body, a neutered and supposedly neutral object that was to explain the workings of another unmarked entity: society. More recently, critical attention has turned to sexuality, and especially women's sexualities, producing a small avalanche of books which claim to explore pleasure, desire, lust, love, from a variety of angles, seeking to elucidate the intricacies, details, indeed the 'secrets' that compose this apparently ever-fascinating topic, to probe the tiniest details of sexuality, the intimate passions of desire so as to provide a better understanding of sexuality as a glistening, evasive yet circumscribable object.

This collection is different. For a start, it does not assume that there is a clear-cut and predefined thing called sexuality which we need to carefully describe and explain. Nor are the authors interested in pinning down the body or in tracking it in order to arrive at the threshold of sexuality, a threshold that would miraculously open upon the inner workings of subjectivity, power and knowledge, finally appearing translucent before the researcher's detached vision. Rather, the writers take a risk and renounce any claims that their texts, bodies and sexualities may want to have on identity, they do not need to know in advance, to contain sexual desire, pleasure or any associated terms. Rather, the project that unites the disparate subjects of these essays is the *production* of sexualities, not their description; the wager is to constitute activities as sexual – the sexualization of activities – rather than merely to reflect on a pre-established and already valorized notion of sexuality and its attendant support, the body.

This book was conceived and produced in the spirit of conceptual and political exploration and experimentation: its brief was to rethink, to reconceptualize, explore, disentangle or recomplicate sexual bodies, considered in

their broadest and loosest terms, and to analyse sexualities in transition, in movement. Its goal is to ask rather than presume what sex, sexuality or sexiness are. And significantly, if this was the brief to the contributors, the result of their various labours has led to a quite wild and disconcerting idea: that perhaps sex, and for that matter queer, could function as *verbs* rather than as *nouns* or adjectives. Conjugated, they could be fully conceived as activities and processes, rather than objects or impulses, as movements rather than identities, as lines more than locations, as motions of making rather than as forms of expression. If, as the Chinese artist Li Shan says, 'if we make "rouge" a verb, to wish "to rouge" something away, this is not so much a matter of will and method as a question of attitude',[1] then *to sex, to queer* can never obey the dictates of previously defined methods and disciplinary wills to know. To think sex, sexiness, otherwise – alongside, beyond the received understandings of the master discourses of sexuality (psychoanalysis, Foucault, Deleuze and their various landings within feminist theory); but also beyond heterosexism and phallocentricism (even – especially – in those essays which deal explicitly with heterosexuality); and even, in some cases, beyond the great unities posed and promised by the concepts of subjectivity and signification (as articulated within the discourses of ideology, social construction and representation correlative with psychoanalysis). What these essays seem to do is to think the sexiness of bodies in movement, the encounters of one surface with another, one body, body-part or body-activity with another (person or thing), seeing the relations between the human and the non-human, between one sex and another, one element and another, in terms of movements, productions, transitions, modes of transportation or metamorphosis. Simply put, to think in terms of becoming. However, if this phrase is commonly bandied about of late, it is less evident to write of pleasures pleasurably, to write not just of sex but *as* sex. In writing, to become, to bump (and sometimes grind) against surfaces, to realize the sensations of elements finding (un)common elements. These emerged as unexpected possibilities from the essays that follow.

Our title, *Sexy Bodies*, may beg questions, but these are questions requiring careful and continuous re-posing. These essays proceed without an a priori sexy body as they challenge established notions, producing bodies as sexy in ways that were never considered before (as in Melissa Jane Hardie's telling of Elizabeth Taylor's celebrated body). Moreover, it turned out that many of the contributors discuss forms of sex and sexuality which do not usually count as sex (even if like the praying mantis they have functioned as titillatingly sexy): counter-sexes, sub-sexes, anti-sexes, a-sexes, component sexes, which can and do work as autonomous obsessions and pleasures. The pleasures or the sexualization of memory, of departures and dislocations, of writing and collaboration, of urban movement, of skin and surfaces, of silken ties, of mouthing words, of singing, of eating, obsessively collecting, of conquering and imaging. Petty sexualities somehow considered below or outside the

threshold of 'proper' or 'real' sex, the threshold that designates certain forms of sex as the proper, the property of certain bodies, knowledges and things. Consequently, this is not simply a book *on* lesbian or queer sexualities, celebrating what is marginalized, reversing moral values, as is the wont of several recent lesbian and queer anthologies. Instead, it explores what runs underneath and within *all* sexualities, the inherent production of all sexualities as perverse, whether they conform to the norms and ideals of culturally valorized models or not (and concomitantly, the possibility that what is now heralded as culturally perverse may instead be in the midst of becoming normative). This is not just a book on queer sexualities, it is about making queer all sexualities, about what is fundamentally weird and strange about all bodies, all carnalities.

This collection is 'about' establishing new alliances, new connections between and among bodies, desires, pleasures, powers, cruising the borders of the obscene, the pleasurable, the desirable, the mundane and the hitherto unspoken. In one way or another, every essay presented here, at some level, acknowledges the disquieting effect of sexuality as it spills the boundaries of its proper containment, the unease of bodies breaking and flowing over their limits. For instance, Sue Golding discusses the 'unquantifiable strangeness' of queer desire as it refuses to be bowed in the face of death, refuses to be ranged in the face of disciplinary dressage; Melissa Jane Hardie finds a celebrity body that is carried along within the 'travelling sideshow of sexuality'; Barbara Creed talks of a 'body that's going places'; Elspeth Probyn of an unpossessable, dispossessed body transported by 'the singularities of desire'; Mary Fallon of the 'ludicrous overexposure' of sexual desire. While desire is figured as the carnal lesbian centre of the green night for Nicole Brossard, for Sue Best, the female body lies in the 'precariousness of its boundedness'; and while Chantal Nadeau rehearses the binding of bodies and desires in Cavani's scenes of s/m, Angela Davis discusses the movement of desire in the blues, that music which functioned to represent sexuality, sexual pleasure and social and individual freedom for Black Americans.

Bound up though they are in thinking about cultural practices, be they cinematic, literary or the so-called paraliterary, concerned with the everyday practices that strive to fix bodies into gendered and sexed categories, be they colonial, therapeutic, historical or contemporary, the essays gathered in this book nonetheless transgress normative analyses of bodies as either resistant or compliant. Working over disciplinary modes of fixating on certain bodies, the intellectual project that moves the bodies in this text is situated at the interstices of many disciplines. They work within and across the conventional disciplinary frameworks of literature, cinema studies, cultural studies, critical theory, post-colonial and anti-racist studies, history, ficto-criticism, queer theory and feminist theory (to name but a few). Each essay contests, in its own way, the boundaries dividing disciplines, refusing to be contained within existing disciplinary territories. While attempting to think sexuality as a truly

interdisciplinary production, the authors nonetheless manage to avoid the historical, geographical, material and intellectual *nowhereness* that tends to pervade much contemporary writing on sexuality; writing that produces sexuality as either unlived, abstract and decidedly stolid, or as unliveable, as caught up in the autobiographical minuteness of a particular practice. As a kind of a dare, we asked the contributors to have some fun with the topic of 'Sexy Bodies' and while many responded that the actual writing was at times hellish, the results are indeed fun (as long as you have a slightly strange sense of humour). As important as fun, is the sensibility that emerges across these essays: that sensuality does not undermine seriousness and rigour – indeed, it obliges a certain exactitude; that it is possible to engage a delight in thinking, writing, theorizing, punning; that a delight in sexuality can engage others, other modes of engaging, touching and connecting. In short, a politics of tangibility, or at the very least the necessity of putting tangibility, touch and lucidity back into politics and critical theory.

A variety of approaches to sexuality, broadly conceived, are brought together here, approaches and tangents that explore the (strange) subjects of pleasures, the (at times bizarre) objects of pleasure and the particular connections and conjunctions between them as they entice and produce each other. These include approaches that take up and off from psychoanalysis, Foucault and Deleuze, but in each case and in contradistinction to disciplinarian readings, when these master discourses are evoked it is an oblique, refractory and wanton line that emerges. Where, for example, psychoanalysis provides a framework for understanding sexuality (as in Anna Gibbs' essay), it is not the Oedipalized discourses of lack and castration that form the basis of the argument, and it is not simply genital (hetero- or homo-) sexuality that is the presumed outcome. Instead, the sexuality under discussion is the eros of writing (both theory and fiction), the 'pleasure of the text', the slide of 'the grain of the voice' (as in Barthes' charming phrases) where the explanatory framework relies on the affective and not simply the verbal relations between analyst and analysand. And while several writers invoke a Deleuzian and/or Foucauldian framework, it is again more in the spirit of seeing where, how far, how fast one can run with their insights rather than a detailed pinning down of the Author, the painful mimicry of the disciple. Be it in regard to lesbian fiction (Dianne Chisholm), Cavani's use of s/m within a policed *ménage à trois* (Chantal Nadeau), the manifestation and movement of the desire to belong within geo-sexual locations (Elspeth Probyn), it is a mode of undermining or stretching these frameworks, forcing them beyond themselves, taking bits, leaving others, in order to push the ideas to places that Foucault and Deleuze would never visit, using them in the service of that which they could never contain: perverse desire speaking (as) itself. Desire bubbling up hot in between the lines as in Grosz' seemingly proper philosophical exposition of Alphonso Lingis and Roger Callois. A rangy, curvaceous mode of thinking that takes models that may have been developed elsewhere, as does

Angela Davis when she studies the ideologies and emancipatory self-representations in the music of the legendary blueswomen, Bessie Smith and Ma Rainey; or as Catherine Waldby does in her analysis of the subversive possibilities inherent in rethinking male and female body-imagos in non-binarized heterosexual relations, dressing them in new tasks for alternative projects.

Although very present in tone, several of the essays are solidly grounded in rethinking the legacies of colonialist modes of yoking women's sexualities to imperial projects, be it in the forced marriage that England tried to perform on India (which Sabina Sawhney analyses) or the ways in which western philosophy historically used women's bodies in order to figure space and equally to evacuate actual women from it (as Sue Best argues). But again the tenor of these arguments, as exemplified in the historical reworking that Barbara Creed performs on the tribade, refuses a stance on the sideline of history with its comforting position of purity away from the messy, brutal, sometimes pleasurable, often dirty and deadly processes in which bodies, sexualities, knowledges and powers come into being, battle, commingle and collude. As in Lisa Moore's essay, this is the virtual space of sexualities now, the criss-crossing of practices and activities that for the moment refuse to be named.

These are not self-congratulatory essays, they are not defensive justifications of one's own sexual pleasures and desires in politically validated terms, nor are they self-enclosed writings produced as forms of defence against hostile criticism, reactive in form. Refusing to be fenced in, refusing the security of a marginal space, refusing to reify difference, these are nevertheless celebratory essays, celebrating the very movement of essaying out against the known and the reassuring and into the unknown – the unknown of pleasures and desires yet to be known, of transformations yet to be considered.

Yet while there is a theoretical bent to stray, all of the essays in one way or another carry with them a clear sense of their individual points of departure, of where they are writing from and why. While quite located, they refuse the enticements of humanism that haunt much writing on sexuality. For instance, many of the contributors write about and out of lesbian and queer sexualities (Probyn, Creed, Chisholm, Fallon, Golding, Moore, Brossard), but it is not to eulogize but to problematize. Then, a number of essays also focus on the excess latent, but usually unexplored, in heterosexuality (Hardie, Waldby, Davis), while others project sexuality out beyond the human altogether, either into megahuman-constituting cities (Best), continents and empires (Sawhney), language (Gibbs) or into the subhuman (Grosz). While we hope that the essays gathered together here contribute to ongoing discussions, debates and analyses in the arena(s) of lesbian, gay and queer studies, we also hope to encourage by example exchange between feminism and queer studies (instead of simple merger in which feminism

tends to disappear). We are also pleased that one of the major domains of discomfort (indeed, one of the remaining unspoken topics) within feminist politics, that of the relations between feminism and heterosexuality and more precisely, the implications of feminism in hetero-culture, is also opened up for discussion. In the theoretical spirit, and in the political and personal necessity, of refusing the marginalized status of 'other' outside of the heterosexual norm (be it as dyke, bi, transgender, transracial sex, as well as any number of other compositions), it is also crucial that heterosexuality be explored and interrogated from within, revealing the insecurities, anxieties, uncertainties and possibilities for transformation.

While as editors we must assume responsibilities for the numerous lacunae inevitable in any anthology, we were first and foremost committed to making this project as accessible, as readable and as free in range, scope and attitude as possible. We did not proceed from a shopping list of subjects, rather we started with a vague but deeply held desire to produce a volume that moved away from an overly scholarly mode where naive empiricism meets with theoretical polemic in a supposed gesture of covering the politically correct catalogue that motivates much writing on identity-politics. Instead of covering a 'correct' sexuality (be it in celebrating being a bad-girl for bad-girl's sake or in conversely condemning whatever sexual practice you don't like), instead of obeying the 'oughts' and 'shoulds' demanded by the insecure, we wanted to explore sexualities not as neatly categorized objects but as that passion which fires the imagination, that defies moral imperatives and regulatory decrees. This is not simply to invoke a wild and free space, a deterritorialized flow, a sexuality that would be free of restraint; rather, beyond such atopic musings we want to encourage a sexuality that may disrupt what is expected, that is fully within the social, that functions hence as political (if not correct).

Rather than outline and summarize the essays that follow, we prefer for them to be read for themselves, on their own terms, for what each says in its own specificity and of its own sexual intensities. The order in which they are presented here is of course arbitrary; it is clear that they could and will be read in quite other ways with equally powerful, though perhaps different, effects. What, if anything, integrates them are kaleidoscopic, shifting sets of images and speculations which produce strange angles and unexpected configurations, unaccustomed patterns refocusing sexuality, producing images of its own rather than reflecting reproductive forms of heterosexuality or moralizing lesbian and gay identities. Hopefully, what we have produced here is a text that shamelessly and guiltlessly enjoys, takes pleasure in thinking, writing, problematizing sexuality, that produces bodies that unabashedly revel in being sexy as they explode normative notions, provoking other considerations about the sexiness of sexuality.

E.G. and E.P.

NOTE

1 From the 'Mao goes Pop: China Post-1989' exhibition, Museum of Contemporary Art, Sydney, 2 June–15 August 1993.

EDITORS'
ACKNOWLEDGEMENTS

We wish to acknowledge the support of our institutions which provided the resources and funds to render possible such a collaboration between two hemispheres and covering many countries and much territory in between. Our thanks to the Département de sociologie, at the Université de Montréal, Québec and to the Critical Theory program at Monash University, Victoria. We also thank Valerie Hazel for her wonderful job of indexing and Katarina Soukup for the dreary job of standardizing the references of the texts. Elizabeth Grosz would like to thank the staff of Critical Theory and the Philosophy Department, Monash University, and especially Gail Ward, whose clarity and firm common sense have been an ongoing inspiration. Elspeth Probyn gratefully acknowledges funding from the Social Science and Humanities Research Council of Canada, and from FCAR-Subvention aux Nouveaux Chercheurs (Québec) which provided a course release, and thanks Professor Val Hartouni and the Women's Studies Program at the University of California, San Diego, for inviting her as a visiting professor during the winter of 1994, thus providing a warmer climate in which to consider the questions raised by this book.

1

QUEER BELONGINGS

The politics of departure

Elspeth Probyn

> When we are sitting on the bank of a river, the flowing of water, the gliding of a boat or the flight of a bird, the uninterrupted murmur of our deep life, are for us three different things or a single one, at will.
>
> (Henri Bergson; cited in Deleuze 1991: 80)

UP ON THE ROOF

It is the winter of 1994 when all of the east of North America froze and here I am in San Diego with strains of T.S. Eliot going through my brain: 'A cold coming we had of it. . . . The very dead of winter' (1963: 109).[1] The very dead of winter and I'm up on the roof with the harbour in front of me and the airport to the side. Still not totally sure where I am, I sit on the roof and watch the planes slope by. They angle by the two weird trees on the close horizon, then from mere specks they emerge in all their awesome materiality over me; bellies swaggering, lights flashing, they descend and are gone. This happens over and over and over again; the frisson of slight excitement each time smoothed away. From where I am, all is descending, arriving, returning. The only hints of leaving are the invisible roars from the space-off.

This seems like a very apt place in which to think about belonging. This most southern of Californian cities is a strange place of movements. Across the flight path lies the port, dotted with yachts, criss-crossed with ocean cruisers, the site of cargo ships coming and going. I navigate San Diego on bike, my trips constantly interrupted by canyons, by signs declaring 'Danger', 'Peligro', 'Naval Property'. I ride along paths enjoying the feeling of self-locomotion, ignoring the refrains of friends who said 'you're crazy, you can't exist in southern California without a driver's licence'. Frequently I am stopped, caught in a net of highways, halted before concrete channels of movement, fascinated and appalled by a place that constructs highways as lethal barriers to aliens crossing borders. In short, this is an appropriately strange place in which to consider belonging, a space that cackles with

1

movement as people continually arrive, depart, are thrown out; some try to belong, some take their belonging for granted.

In turn, this reminds me that in common usages, the term belonging moves from 'being the property of someone, something' to the sense of 'fitting in socially', 'being a member', and that 'belongings' designates 'possessions' and 'baggage'. Belonging for me conjures up a deep insecurity about the possibility of really belonging, truly fitting in. But then, the term 'belongings' also forefronts the ways in which these yearnings to fit in will always be diverse: at times joyous, at times painful, at times destined to fail. Perhaps more immediately, belonging brings forth images of leaving, carting one's possessions and baggage from place to place. Thus, while belonging may make one think of arriving, it also always carries the scent of departure – it marks the interstices of being and going.

On another level, but bound up in belongings, as a term it causes me to consider points of departure, of where we say we're leaving from, and why. Depending on your tastes, it is either a lyrical or a maudlin way of saying that as theorists, we all have epistemological allegiances and baggages that we cart through our writing and thinking. And while much theory seems to be hell-bent on arriving somewhere, belonging to one clique or another, fitting in, being in, travelling under the sign of the latest buzz-words, there is some merit in a mode of theorizing that is careful of where it is leaving from.

Departing, getting going, going on, getting (it) on, getting by – these are necessary terms. They are also terms that I need to make rhyme with desire, a desire to keep on going, a desire to keep desire moving. I sit and watch the planes float in. I shut my eyes and feel the brightness burn holes in my memories. I wonder if I can ever fit in here. I sit and feel nebulously touched by belonging; a vague shifting of desire for a woman, a woman past and a woman present. These images of desire are not merely whimsical; rather, as concrete memories they queer me again and again as they embed themselves in the possibility of desire now. Images and fragments: meeting in a doorway, a handshake, a kiss, seeing my features rearranged as I smile back at her. Desire for me is not a metaphor, it is a method of doing things, of getting places. I want to think desire as singular, I want to make the singularities of desire the *modus operandi* of my queer theorizing.

QUEER MEMORIES

A woman in a bar asks me what sign I am. Not a very original line, but a project of astral origins; I think that I give the wrong answer. (A past lover, a very rational type takes up astrology in her 50s, places me as an Aquarian and thus solves her problem of why I am what I am.) I should have been born under the sign of a plane: Delta, Southwestern, Air America. Wherever I am, people ask me where I come from and the answer is as evasive as my accent.

I have a few stock answers: I'm an army brat; I grew up in Wales; I am from no one where. In fact, my family myth places us under the sign of the train, recounting, recanting the story of my Canadian mother meeting a slightly hung-over British army officer on the Canadian Pacific. The story goes that she was leaving the west to get a job in External Affairs; he was brought over to teach Canadian soldiers home from the war how to skydive out of silos – a Cold War sort of thing. As the great train rolled on and on and on through the prairies, and remember this was the days of great trains, my mother's companion told her to offer that young man a drop of whisky. Wham, bam, thank you mam, her dreams rolled off the edge of that endless scape, and three months later she was an army wife.

So you see, I was born departing, watching from the sidelines the ways in which children seem to know as if by intuition who belongs and who doesn't. The product of a childhood of moving, boxing up belongings, carting them along with my mother's injunction never to get married. Crossing seas, continents, innumerable borders which stop our movement with the fear of lost passports, of being turned back, of watching others who belong even less being stopped short at the frontiers of economic hope.

As I sit on the roof watching the planes descend, watching the lines of flight, I wonder if I've lost the knack of feigning belonging. Have I lost the desire to belong? Is that already a condition of the desire for belongings? I wonder where desire goes. This isn't a new thing, I often ponder this, normally at the end but recently at the beginning (a disastrous move as we all know). I try to remember a moment when I felt 'belonged', when I first felt desire, when I was first moved by it. The desire to remember familiar desiring bodies and bodies that desire. An image of horses and a girlfriend come to mind, inextricably wound up in each other, bound up with the motive of motion and emotions.

Horses, planes and trains . . . strange points of departure. As objects, they seem so impossibly phallic. I remember what Raymond Bellour said of the horse in *Marnie*: that 'Marnie's fetishistic love for Forio . . . typically takes the place of a man and children' (1977: 84). In turn, Bellour doubly takes away Marnie's pleasure with her horse ('"Oh Forio, if you want to bite someone, bite *me*"') when he posits that, on the one hand, it is merely the 'pleasure of the signified . . . the horse, animality, the phallic substitute'. And on the other, this image is 'the condition necessary to the constitution of [Hitchcock's] phantasy' (ibid.: 85–6). In this scenario, the image of the horse impales desire as the desire for the phallus, for the family. It cannot be Marnie's desire; it always-already displaces hers as the condition of another's desire.

Not a very promising point of departure, I think you will agree. However, as stilted and dated as Bellour's reading may seem, it is hard to escape psychoanalytic interpretations of desire. Indeed, one could speculate that modern conceptions of desire were spawned with the birth of psychoanalysis.

So it is not surprising that, with notable exceptions, psychoanalytic assumptions inform the basis from which to consider questions of queer desire. On this front and as a theoretical point of departure, psychoanalysis is implicitly and outrageously caught up in belonging. It may well be one of the theoretical 'homes' that demands the most investment, that has the steepest dues to be paid before you belong. As a 'possession' it is hard won through the years that it takes to master its complex machinery. Although, for many reasons, I have not taken the time necessary to fit in with feminist psychoanalytic theory, I am impressed by those who have. To be truthful (in that my own point of departure is Foucault), I am more impressed by those who have possessed this machine, who made it belong to them and for them, only to depart from it. They also tend to be rare. However, a few years ago, after years of brilliant slogging through Lacan, Elizabeth Grosz departed from her point of departure and 'left' psychoanalysis. The reason seems to be simple, even if the logistics of leaving probably were not:

> I don't want to talk about lesbian psychologies, about the psychical genesis of lesbian desire. . . . I am much less interested in where lesbian desire comes from, how it emerges, and the ways in which it develops than where it is going to, its possibilities, its open-ended future.
>
> (1994: 68–9)[2]

In that essay, Grosz rigorously and elegantly moves on from psychoanalysis. But to stop for a moment, and to be crude, one can say that, in one form or another, desire still lurks as lack within much of contemporary cultural theory. Even in Judith Butler's reworking of Lacan, the movement of desire is 'impelled, thwarted by the impossible fantasy of recovering a full pleasure before the advent of the law' (Butler 1993: 99). Butler does, of course, reposition Lacanian and Freudian origins. Thus, like the judge who enacts the law by citing it but does not originate it, she argues that 'the law [of sex] is no longer given in a fixed form *prior* to its citation' (ibid.: 15). However, if Butler does an admirable job of dislodging sex as origin, she does not quite manage to shift desire from its Lacanian position as that which circles endlessly and compulsively around its constituted object. Here, desire 'misses' its object, as in the French, *son objet lui manque*; it misses and lacks its originary object.

Of course, desire as lack goes beyond the texts of Freud and Lacan, or, rather, Freud as cultural phenomenon has gone beyond himself. Thus, the OED first defines desire as 'unsatisfied longing or wish; or an expression of this', only to finally remind us of the Latin root, '*desidero*: to long for'. While it is, as I mentioned earlier, beyond my interest to engage in a rigorous critique of the role of desire within psychoanalysis, what I will do is suggest ways in which desire may be put to work as method within queer theory. To replay that, let me state that desire is my point of departure and my guide. This in turn involves reconceptualizing desire as well as the idea of departure

in theory. In a nutshell, as a problematic, desire compels me to work along the lines set up between and among longing, leaving, being, bodies, images, movement; in short, it causes me to depart from any strict and stationary origin.

This problematic that I am calling queer belonging is essentially about the movement between bodies and points of departure in theory. It is fundamentally about *milieux* not origins (to take up Deleuze and Guattari's distinction). As Deleuze describes it,

> a milieu is made of qualities, substances, forces and events: for example, the street with its matter like paving-stones, its noises like the cry of the merchants, its animals like the horses yoked, its dramas (a horse slips, a horse falls, a horse is beaten. . .).
>
> (1993: 81)

Indeed, Deleuze's essay about Freud's 'Little·Hans' ('Ce que disent les enfants') is a marvel of movement and a refutation of origins. In fact, Deleuze takes up 'Little Hans' and rescues him from his location as evidence for Freud's theory of Oedipal beginning. In other words, Deleuze frees 'Little Hans' from his position as belonging to Freud and to the history of psychoanalysis: this 'rage of possessiveness and of the personal [in which psychoanalytic] interpretation consists in finding the person and his possessions' (ibid.: 86). He looses 'Little Hans' from the grip of Freudian principles and lets him once again wander the streets, exploring his desire to get out of his family's building, his desire to meet up with the rich little girl taking him by the horses' stable. It is this meandering that Freud reduces 'to the father-mother: bizarrely enough, the wish to explore the building strikes Freud as the desire to sleep with the mother' (ibid.: 81).

Thus instead of origins (bizarre or normalized), Deleuze proposes that we follow a cartographic logic whereby 'maps superimpose . . . it is not a question of looking for an origin, but rather of evaluating *displacements*' (ibid.: 83–4, emphasis in original). This is movement that we can only catch and recreate through images; images, in turn, that with desire move through bodies. Each of these terms must take flight. Take, for instance, the body: the body as hallowed within feminist theory; the body as cairn. All those pages read and written about the body as location seem now to ring with a nostalgia of lost origins. Even Adrienne Rich's (1986) birth scene, that most cited of citations about the body, grounds the body – alright, *her* body – in a place of origins: the hospital. And while I have been inspired by Rich's use of her body, the strategy of naming the institutional markings (white, lesbian, Jewish) only takes us so far. It is a project of differentiating bodies on account of their locations; a project that speaks of where bodies belong but that can't quite write out of the desire for other belongings. Important as it is, it tends to slow the body down.

So instead of the body as location, let's take the body as *loca*-motion (to

borrow from Anzaldua's (1991) use of '*loca porque*'). Belonging set in motion which skewers as it remembers the marks of difference; motion that queers those necessary moments and memories of originary belonging. This body, these bodies, can only be understood as images. In Bergson's terms (1990: 168–9), the body as image 'is then the *place of passage* of the movements received and thrown back, a hyphen, a connecting link between things which act upon me and the things upon which I act' (cited in Massumi 1992: 185; emphasis in original).

TO QUEER THE OBJECT

The problematic of belonging that I propose thus foregrounds the body as a place of passage, moved through by desire and being moved in return. Images of past and present belongings, of necessity, pass through and on. But, of course, images of 'belonging' conjoin with images of leaving: points of departure. In turn, this causes me to reconsider where we start from when we do this relatively new thing called queer theory. And as Eric Alliez points out, 'the singularity of the point of departure . . . is to make of beginnings a problem so determinant that in the end we make the question of beginnings meet up with the problem of philosophy' (1993: 17). In other words, it matters where we begin from and how we formulate our beginnings.

While this essay makes no pretension to solve 'the problem of philosophy', I am concerned with how we formulate points of departure in theorizing queerness. As a matter of common sense, where we start from greatly influences where we end up. As Deleuze argues in *Bergsonism*, 'the problem always has the solution it deserves, in terms of the ways in which it is stated (i.e. the conditions under which it is determined as problem) and of the means and terms at our disposal for stating it' (1991: 16). For very evident reasons, much of gay and lesbian theory has been preoccupied by the need to distinguish homosexual[3] (gay and lesbian) desire from the overwhelming manifestations of compulsory heterosexual desire. While in many cases the emphasis has been on difference *from* the straight norm, the present history contains accounts that differ greatly: take, for instance, the difference between Adrienne Rich's (1986) continuum and Monique Wittig's (1992) complex argument that places lesbians outside of the straight mind.

Given the diversity of approaches, it would be false to posit a homogeneous set of methodologies within gay and lesbian studies. However, I will tentatively generalize horribly and state that we can discern a very rough common point of departure – a sort of shared set of theoretical belongings. Simply put, it seems to me that this common thread is expressed explicitly or implicitly in the figure of the choice of object desired. In other words, it is desire embodied in an object that is the condition for belonging as gay or lesbian. In making this broad statement I am not ignoring the different epistemologies that have been employed in the different strands of gay,

lesbian, queer studies. Generalizations notwithstanding, we have a long tradition of seeking out the homosexuality of historical subjects, the proof being founded in part through the excavation of their loved object. As an example of this, a recent essay founds the homosexuality, the lesbian desire, of Rosa Bonheur first and foremost in her 'companions' Nathalie Micas and Anna Klumpke and only secondly, and more intriguingly, in her paintings of horses (Saslow 1992).

Of course, the condensing of homosexual desire into and onto an object desired has a long history and a specific point of emergence. As Jeffrey Weeks, among others, points out, it is in the late nineteenth century 'that homosexuality represents a specific individual "condition" deriving from tainted heredity or a corrupting environment' (1993: 24). But the conditions for individualizing desire, for founding it in the individual perverse or inverse body, have continued apace throughout the twentieth century. Again, expressions of this homogenizing move are heterogeneous, but they turn around the individual body as source of homosexual desire or as the place where it is incarnated.[4]

Without denying the importance of previous work in gay and lesbian studies, I will suggest that the singularity of queer theory can only reside in the way in which it puts desire to work. I want to work against the tendency to fix desire. In part, this desire to always already fix desire may be due to a lack of precision about queer theory's point of departure. In other words, we excitedly leave our original disciplinary formations to 'do' queer studies without really thinking about what the common object of study may be. In part, this is the difficulty encountered in any truly interdisciplinary work (of which there is, in fact, very little): the object is posed as evident (it's 'about' sexuality) but there is scant consideration about how we get from 'here' (our training as literary critics, sociologists, etc.) to 'there' (the object of study). As Roland Barthes argued many years ago, truly interdisciplinary work changes the object, it changes the point of departure so that instead of 'founding' the object we follow it: it '*is experienced only in an activity of production* . . . it cannot stop . . . its constitutive movement is that of a cutting across' (1977: 157; emphasis in original). We need, therefore, to follow desire as we consider the aptness (*la justesse*) of our disciplinary belongings.

One of the compelling but problematic things about doing queer theory is that the boundaries are eminently porous. To put this crudely, different orders of questions tend to jostle together: is queer theory about real life (my life)? Do you have to be queer to do queer theory? Is it about politics? About representation? In short, questions revolve around the central and organizing one of 'what should the object of queer theory be?' – who or what is the object? In turn, these questions are pronounced in different ways: from Larry Kramer's chastising of Edmund White's decision to write a biography of Jean Genet instead of writing on AIDS to the entanglements of outing.[5] It's as if we don't quite know what to do about the force of longing, of desire, so we

proceed to incarnate it, to represent it in the body of a real person. As Gloria Anzaldua succinctly puts it, 'there is a hunger for legitimacy in queers who are always trying to "discover" gay movie stars and great writers' (1991: 256).[6]

An example that raises the more diverse movements of desire could be seen in the supposed lesbian moment on *LA Law*, a moment structured for lesbian longing. All those dykes all over the place desiring C.J., and I, along with many, would have liked her to have become a regular dyke character (and with someone more fun than the wimpy Abby). However, the emotion on the part of the lesbian audience seems to me to have little to do with whether Amanda Donahue is or is not a lesbian. A more recent example concerns ABC's proposal to can an episode of *Roseanne* which features Rosie in a gay bar, kissing a dyke. Again, while there should be outrage at ABC's timidness before the moral busybodies of this country, the issue is one of the politics of prime-time representation, not that Roseanne *Arnold* is or represents lesbians, or that she represents lesbian desire (although many may desire her). In other words, to conceptualize all of our perverse and persevering movements of desire as merely a longing for one individual–object is to severely curtail the idea of longing. Or, yet in other terms, is our longing and belonging as gay or lesbian getting mixed up with our theoretical belongings? Who or what is the object here?[7]

On another level, at a recent queer conference, I was struck by an example of a more ludic policing of the desired object, desire objectified. The conference finished with a simulation of a talk show hosted by Scott Thompson (the only out gay in the thoroughly queer TV show *Kids in the Hall*). One of the first demands that Thompson posed to the stars on stage was to confess whether or when they had last slept with a member of the opposite sex.[8] A straight answer would have effectively cancelled belonging to this 'hip' performance (as indeed was the case). A thoroughly queer response was from one dyke who fucked with a man with her girlfriend watching. Here, at least, desire is freed from one object – good or bad – and returned to lines of movement that presumably moved from the lover watching the lover who may have been watching her in return. (I know I've left out the guy but his actual presence – as opposed to his virtual and structured being in this scenario – really does seem to be superfluous.)

Banal and problematic as these examples may be, in various forms, desire has been and will continue to be stalled as a point of departure in gay, lesbian and queer theories as long as that desire is defined as desire located in an object. What I am interested in is proposing another mode of desire outside of the connected formulations of desire as lack and/or as inscribed in an individualized object. In other words, conceptualizing desire as lack, as the longing for an impossible object, is the condition of possibility for constructing desire as encapsulated within an object. Both seem to me to dead end: on the one hand, placing the origins of desire in lack implodes it as mere

érrance, and, on the other, placing it within an impossible object removes it from the realm of real, actualized desire. Desire in these terms is halted by what Deleuze and Guattari call the 'three errors' of lack, law and signifier:

> From the moment lack is reintroduced into desire, all desiring pro-
> duction is crushed, reduced to being no more than the production of
> fantasy; but the sign does not produce fantasy, it is a production of the
> real and a position of desire within reality.
>
> (cited in Grossberg 1992: 40–50)

As an apparently simple proposition, I want to follow on from what Michael Moon argues in his introduction to Hocquenghem's *Homosexual Desire*; namely 'that the object of a given desire does not determine the "nature" of that desire' (1993: 17). More suggestively, and in the words of Hocquenghem himself, at the same time that one cannot locate homosexual desire in its supposed object, nonetheless, 'the homosexual image ... expresses some-thing – some aspect of desire – which appears nowhere else, and that something is not merely the accomplishment of the sexual act with a person of the same sex' (1993: 50). While Hocquenghem is concerned with the specificity of homosexual desire, his argument can be made to meet up with an argument for the singularity of queer desire as theory.

As Eve Kosofsky Sedgwick eloquently puts it, 'Queer is a continuing movement, motive – recurrent, eddying, *troublant*. . . . Keenly, it is rela-tional, and strange' (1993: xii). Following queer desire turns us into readers who make strange, who render queer the relations between images and bodies. An example of this enactment of movement can be heard in a weird little exchange between Michel Foucault (who for me is very much a queer theorist) and Hélène Cixous (who usually isn't). In it they queer images taken from Marguerite Duras' *Moderato Cantabile*. Here the movement of an image of a breast brings Foucault to talk about the movement of *la drôlerie* (which may come closer to being a French translation of queer than would Sedgwick's *troublant*, although the two are inevitably involved together). Cixous raises the image of the breast and defines it as 'the image ... a regard [a look] of such extreme intensity' (Foucault and Cixous 1975: 10). For Foucault, the relation between the image and the gaze of the looker can be rendered 'drôle ... in the sense of something strange, avid, not quite graspable' (ibid.). In this sense, through desire I queer images by rendering their relation strange; queer images that become avid for other relations.

Taking these statements as my point of departure compels me to wend my way through a number of interconnected issues. Freeing desire from its location, its epistemological stake, in the individual necessitates rethinking the role of images, images and motion. For the queer image does indeed express something. From this intuition, it then becomes a question of how to express the singularity of queer desire, of how to queer the movement of images in a singular way. Following Henri Bergson's argument in *Matière et*

mémoire (1990) and Deleuze's (1991) exposition of Bergson, the question becomes complex but simple to state: is this difference that the image expresses a difference in degree or rather a difference of kind? Can we make of desire a method so as to avoid the 'false problems' of departure that would place desire in an object?

WOMEN ON WOMEN ON HORSES

In order to ease into these questions, or rather, to use Bergson's phrase, be introduced into them, 'like the passers-by that might be nudged in a dance' (cited in Deleuze 1991: 110), follow me back to the roof. I am sitting on the roof watching the sun render the sea into a dazzling line behind the buildings where the breeze makes the flags fly straight. Planes slide in. My longing for a woman past and present slips by me, latching on to images of summers of my childhood. The heat and the wind fan what is probably fantastical, or at least fanciful given the sodden norm of Welsh summers. Nonetheless, there it is, an image of girlfriends and me melded together by hot horse flesh; bodies strung together by the smell of elderflower branches slapping away the flies.

While I have always been fascinated by this connection of girls and girls and horses, body against body against body, I am far from alone in thinking that there is something wonderfully thrilling about the movement of women on women on horses. From *National Velvet* to *My Friend Flicka*, horses figure in any number of ways. And as far as I remember from the pony-club stories and experiences of my youth, it was always girls and girls and horses together, with nary a boy in sight (and if there were, they tended to be 'sissy boys' – but that's another story that requires another storyteller). Within popular culture this generalized coupling of girls and horses ('pony-mad') then operates in opposition to that of girls and boys ('boy-crazy'). Of course, equine associations vary – consider Jeanne Cordova's reaction to the onset of puberty:

> The day I became a girl, my life was over. 'This is the stupidest thing I ever saw.' I flung the bra out of the window and screamed at my mother 'You can't expect me to wear that. It's meant for a horse.'
>
> (Cordova 1992: 274)

Images of girls and girls and horses are, therefore, both common and individuated; present and fuelled by the past; virtual and actualized in cultural representations. To substantiate, let me offer some random equestrienne images. In *The Pure and the Impure*, Colette gives us a compelling description of some rather stylish *fin de siècle* Parisian butches:

> some of them wore a monocle, a white carnation in the button-hole, took the name of God in vain, and discussed horses competently. These mannish women I am calling to mind were, indeed, almost as fond of

the horse, that warm, enigmatic, stubborn and sensitive creature, as they were of their young protégées.

(1971: 65)

Indeed, in Colette's terms, the horses were more worthy of love than the *'petites amies'*: 'for these ladies in male attire had, by birth and from infancy, a taste for below-stairs accomplices and comrades-in-livery' (ibid.: 63). As Colette mourns the passing of what she calls 'the noble season of feminine passion' (ibid.: 91), she eulogizes their equestrienne, lesbienne existence: 'the dust of the bridle paths in the Bois still haloes, in countless memories, these equestriennes who did not need to ride astride to assert their ambiguity' (ibid.). From her description, we can hear a seamless articulation of horses, bodies and lesbian desire that allowed these women to move gracefully outside of heterosexual clumsiness. For, once 'mounted on the twin pedestal of a chestnut crupper . . . they were freed of the awkward, toed-out stance of the ballet dancer that marred their walk' (ibid.).

If in Colette's description, lesbian desire flows more freely once mounted, in *The Well of Loneliness*, Radclyffe Hall effectively transubstantiates the body of Stephen Gordon's first object of desire, Collins, the housemaid (again 'below-stairs'[9]), into that of her first horse: 'Laying her cheek against his firm neck, she said softly: "You're not *you* any more, you're Collins"' (1968: 42). As Hall puts it, 'Collins was comfortably transmigrated' (ibid.). In a later passage, horse and desire are folded upon themselves, as body upon body converse 'in a quiet language having very few words but many small sounds and many small movements, that meant much more than words' (cited in Whitlock 1987: 571). As Alison Hennegan aptly states, it is a 'description that can easily apply to satisfactory love-making' (cited in ibid.).

Now, given that Hall's championing of theories of inversion are well-known, some might be tempted to say that this equine transubstantiation of her lover for her horse translates as a psychological substitution of the lover for the horse and hence for the phallus. However, Hall's reading of Havelock Ellis also puts lesbian desire within the natural order. Of course, while it was in her nature to desire women, as Jean Radford argues, 'her inverted love is God-given, she is not, it seems, allowed to enjoy it' (1986: 107). She is, however, allowed to enjoy her love for Collins through her horse. In other words, we can consider the way in which the horse as image powerfully connected up with Hall's image of her body: her horsy outfits outed her as a 'masculine woman'. Moreover, the image of the horse meets up with the image of her lover. Drawn on by her desire, they are made to intersect at Hall's body.

These images of girls and girls and horses have no essence, no fixed reference; set off in tandem with my body, they may or may not meet up and touch off desire in yours. While they cannot be allowed to condense into categorized notions of being, they can, however, express longing; they do

11

throw us forward into other relations of becoming and belonging. Nicole Brossard articulates this idea in a rather more elegant way when she states that

> the image is a vital resource that forms complex propositions from simple and isolated elements. Each time an image relays desire, this image thinks, with unsuspected vitality, the drift of meaning. So it is that images penetrate the solid matter of our ideas without our knowledge.
>
> (1991: 196)

For example, in a poem by Ruthann Robson, an image of a 'stampede of wild horses' throws the narrator forward into a realization 'that what you want is to become'. And what she wants to become is caught up in the image of 'two women without berets . . . two mares at the river' (1992: 110). Or again, in Anzaldua's story of a woman who finally realizes she can love her lover, the final image is one of how 'It would start here. She would eat horses, she would let horses eat her' (1990: 388).

The image, thus freed from its post within a structure of law, lack and signification, can begin to move all over the place. It then causes different ripples and affects, effects of desire and desirous affects. Turning away from the game of matching signifiers to signifieds, we can begin to focus on the movement of images as engendering 'relations of effectuation' (Colin Gordon, cited in Grosz 1994: 75); we can follow their effecting and affecting movement. As Grosz has argued, this is 'to look at lesbian relations and, if possible, all social relations in terms of bodies, energies, movements, inscriptions rather than in terms of ideologies, the inculcation of ideas, the transmission of systems of belief or representations' (1994: 77–8).

In this way, the image becomes that with which we think and feel our way from body to body, as vectors thrust forward by the energies created in their different relationships. And the critical mode that can capture this movement is one that I call, after Lee Lynch's description of 'cruising the libraries' (1990: 410), a project of cruising images. However, let me be clear that this is not about policing images for their content. As Brossard asks, 'in the very carnal night of solstice, is the image lesbian because in reproducing it I want it to be so?' (1991: 196). In other words, it is important to emphasize that images work not in relation to any supposed point of reference but in their movement, in the ways in which they set up lines of desire. The image is lesbian because of the way it moves me to desire and of the way in which my desire moves it. The image is queer because I queer its relation to other images and bodies. This is to replay in a different key Hocquenghem's argument for the singularity of homosexual desire. A movement that only occurs in and through the image, a movement that refuses to be policed at the same time that it says, come to me, feel in me the surge that is queer. As Brossard writes,

the image slips, surprising re/source that slips endlessly through meanings, seeking the angle of thoughts in the fine moment where the best of intentions guiding me, worn out by repetition, seem about to close in silently on themselves. [But] [t]he image persists. . . . It goes against chance, fervent relay.

(ibid.)

In Brossard's description we feel the full force of the image: the hope that it carries in its subjunctive fashion. That movement of desire when desire questions itself: Is she looking at me? Is she interested? Is she available? (or as a Swiss friend used to say, 'does she have the same life as us?'). The image teeters, skitters between despair and longing; it gathers force just when the conditions of its possibility seem to be about to close in on it.

DESIRE'S METHOD

The madness of possibilities. But where is the method in all of this movement? Or again, you might say, why do we need a method, give, at best, the sociological drudgery, at worst, the pseudo-scientific pretensions, associated with such a term? In response to these motivated questions, I return you to the pervasiveness of images; the problem of realizing, interrupting, shifting, skewering their direction. For, if all matter is image, and the body as image compels and receives the movement of other images, all is not chaotic flux. As Bergson puts it, 'There is finality because life does not operate without directions' (cited in Deleuze 1991: 103). Simply put, and quite outside of any normative judgement, I need to be able to distinguish differences in kind from those of degree. For epistemological and political reasons, I want to avoid the false problems of departure that would either assimilate or reify queer desire. In short, I want a method for differentiation that refuses a logic of categorization; we need a non-taxonomic method. While taxonomic differentiation always rests on images of the past (it anchors itself in a certain conception of history), a different mode of differentiating desire requires other material relations of past to present. Here I think that we can usefully take from Bergson as he reworks the relation between past and present, virtual and actual, space and duration. As Deleuze explains, 'The subjective, or duration, is the *virtual* . . . it is the virtual insofar as it is actualized, in the course of being actualized, it is inseparable from the movement of its actualization' (1991: 42–3). Thus, we sense through intuition, sensibility or desire that some images move along and at a different rate than others.

This concept of duration which designates the relation between the movement of various images, allows me to return to the matter of how images can express queer desire as a desire that is different in kind rather than different in degree from other manifestations of desire. For the problem

with desire is that it literally pops up all over the place. In the midst of all the banal fillips of desire, I want to avoid casting queer desire as a variation on 'universal' love (I'm sure that it's only a matter of time before Hallmark cashes in on the GUMPIE market – gay upwardly mobile professionals). At the same time, I want to argue for this difference in kind at the expense of postulating gay and lesbian desire in terms of desire individualized (would the Hallmark text croon 'from your boyfriend to my boyfriend'?). The problematic becomes not one of sorting out which are good manifestations of desire and which are bad, but rather how can we define queer desire in such a way that it is not condensed in an individualizing logic and measure.

Put another way, the question is how can we use desire so as to analyse it as a specific queer form of movement and mediation between individuals. Or, in yet other terms, I want to say that there is a difference in kind, a movement that cannot be founded, condensed in *a* lesbian body, *a* lesbian being, *a* lesbian experience or, even, *a* lesbian aesthetic. To clarify: recognizing at any moment that the movement between us is queer cannot be reduced to two individual elements: me as lesbian and possibly you. While, of course, the identification of and as lesbian is important, the movement does not stop there; or rather, that recognition is not automatically desire (in simple terms, all lesbians do not desire all lesbians). In this way we can recognize the ways in which desire points us not to a person, not to an individual, but to the movement of different body parts. Desire set off in commotion, in connection with the motion of the muscles of her neck. The performance artist, Suzanne Westenhoefer captures this perfectly in her monologue about her desire for Martina Navratalova, a desire not for the whole of Martina but as an overwhelming longing to lick the coursing vein that pops out on the inside of Martina's forearm.

This image, in turn, may connect with others: her butchness, her accent, her skill, her physicality, her success. All these images conjoin on the body that we call so familiarly 'Martina'. Thus, it should be clear that I am talking about images, not individuals. In fact, I'll go further and state that the individual like all 'matter is an ensemble of images' (Bergson 1990: 1). In turn, this is to construct the image as having 'a certain existence . . . situated half-way between the "thing" and the "representation"' (ibid.). The productive force of desire can then be seen as it incessantly spins lines between the 'thing' and the 'representation'. Desire then is the force that connects or disconnects images and things. Hijacking Bergson's argument, we can say that it is desire as emotion, emotion as desire that 'does not have, strictly speaking, an object, but merely an *essence* that spreads itself over various objects' (Deleuze 1991: 110; emphasis in original).

Given this postulate, it becomes possible 'to now study, on bodies similar to my own, the configuration of this particular image that I call my body' (Bergson 1990: 13). This is obviously not to return to relations of sameness

as the point of departure. The similarity of bodies is a matter not of similar origins but rather is compelled by a similarity of desire to arrange one's body, to queer oneself through movement. As I see the configuration of my body as image on her body, I also can feel the configuration of hers on mine. However, this is not a constant or immediate fact; it has to be made, to be configured through the desire to conjoin images. And it is here that we can glimpse in action the difference of kind that queer desire seeks to embody. Far from essentializing queer desire within some individuals, this is to argue that this desire is an essence that spreads itself over objects. As we catch our bodies configured on bodies, desire 'communicates a kind of reminiscence, an excitement that allows him to follow' (Deleuze 1991: 111).

This movement of reminiscence is crucial in figuring the velocity of queer desire. For part of the movement of belonging is that of nostalgia. Eliot returns: 'There were times we regretted/The summer palaces on slopes, the terraces/And the silken girls bringing us sherbet' (1963: 109). As I sit on the roof in the very dead of winter, as I sit with the roar of planes arriving, I remember that feeling that I increasingly have when I take off. A small movement in my belly, a feeling that I have forgotten something, someone: the movement of regret. In turn, the image of girls and horses that connects and moves the image that I call my body is motivated by past images of desire, horses and queer belongings: a regretting of the past and a remembering in the present. Images that throw me back to a past and that then turn around to be actualized in the present. These images thus communicate to me a certain reminiscence. They prod at me to regret the long years of denying desire, kept still in a closet at once so silent, at once so filled with echoes of what I wanted but felt that I couldn't have: the belongings that always seemed to be just out of reach.

But while these images have a certain relation to reminiscence, they are not consumed by regret. Rather, regret and nostalgia form part of the movement of belonging; they regulate the speed with which images pass by. They slow down certain images so that I can grasp a fleeting sense of belonging. Memories of that long hard coming out settle in with other images that constitute my belonging. However, this nostalgia becomes productive only if it reminds me that belonging is always constituted in images, not in a golden past nor in a pristine future. The path is not teleological, there is no going home, there is only the temporary structuring of our various belongings.

It is in this way that we can constitute queer belongings; as milieux made up of actualized and virtual relations. Having displaced desire from its site and citing within a project of origins, we can return to another point: 'from the point of departure of our sexual choices, from the point of departure of our ethical choices, we can create something that will have a certain relation to gayness' (Foucault 1984: 27). In simple terms, queer desire is where we

15

start from and what we go with. While this may sound very ephemeral and abstract, I'll wager that nothing could be more concrete. But again, it all depends on your point of departure. For, as my mother used to say, if wishes were horses, women would ride.

NOTES

1 My thanks to Judith Halperstam for finding *and* reciting 'The Journey of the Magi' for me. I also want to thank her for the inspiring and challenging readings she performed on my writing while I was here.

 For those who have not had the pleasure of visiting San Diego, I should point out that the airport is located in the middle of the city; my apartment being pretty well underneath the flight path.
2 The reader will recognize my debt to Grosz and especially to her essay 'Refiguring Lesbian Desire' (1994) which is one of my points of departure here.
3 I'm using 'homosexual desire' from Hocquenghem's argument. I know that 'homosexual' is problematic as a term and I do not wish to conflate different queer desires by using it. I also know that Hocquenghem's theorization is considered incompatible with, or at least lacking in relevance to, questions of lesbian desire. However, I remain unconvinced as to this incompatibility; although Weeks' introduction to *Homosexual Desire* is a joy to read, I am particularly unconvinced by his assertion that the centrality of the anus renders Hocquenghem's thesis of little interest to lesbians. This seems to me to be false both on a theoretical level as well as on a practical one.
4 In another project that I am currently working on, I analyse the ways in which sexual choice is articulated through the Individual. Playing on the distinction between 'being by choice' as opposed to being 'for choice', I argue for a relational ethics of choosing that removes choice from the isolated individual (see Probyn, forthcoming 1995).
5 See Larry Gross (1993).
6 See Richard Dyer's essay 'Believing in the Fairies: The Author and the Homosexual' (1991) for a compelling problematization of the desire to discover and the process of discovering gay and lesbian cultural producers from the past.
7 Having invested a fair amount of energy in writing that tries to interweave 'real life', personal stuff and the analysis of forms of popular representation, I hope that it is clear that I am not advocating that we fixate on the strictly 'intellectual' (whatever that might be). Rather, I am suggesting here that we need to consider more carefully how we go about theorizing the 'work' of gayness across a number of levels.
8 The conference in question was 'Queer Sites', University of Toronto, May 1993 (proceedings forthcoming edited by Julia Creet and Fadi Abou-Rihan). On a related note, it is intriguing that an informal survey of queers finds Scott Thompson funnier in *Kids in the Hall* where he is flanked by supposed straights and plays to a presumed straight audience than when he performs solo to mainly gay and lesbian audiences.
9 Perhaps not surprising but nonetheless important, in both Colette and Hall's accounts, working-class women are portrayed as horses' equals. Indeed, the animals are placed higher on the hierarchy of 'breeding'. While I do not have time here to enter into it, in taking up Colette and Hall I do not wish to subsume their inherent class-based prejudices in favour of a celebration of lesbian love.

BIBLIOGRAPHY

Alliez, Eric (1993) *La signature du monde, ou qu' est-ce que la philosophie de Deleuze et Guattari*. Paris: Les éditions du Cerf.

Anzaldùa, Gloria (1990) 'She Ate Horses', in Jeffner Allen (ed.) *Lesbian Philosophies and Cultures*. Albany, NY: SUNY Press.

—— (1991) 'To(o) Queer the Writer – Loca, escritora y chicana', in Betsy Warland (ed.) *InVersions: Writing by Dykes, Queers & Lesbians*. Vancouver: Press Gang Publishers.

Barthes, Roland (1977) *Image-Music-Text*, translated by Stephen Heath. New York: Hill & Wang.

Bellour, Raymond (1977) 'Hitchcock, The Enunciator', *Camera Obscura*, 2: 69–94.

Bergson, Henri (1990) *Matière et mémoire*. Paris: Quadrige/PUF.

Brossard, Nicole (1991) 'Green Night of Labyrinth Park', in Betsy Warland (ed.) *InVersions: Writing by Dykes, Queers & Lesbians*. Vancouver: Press Gang Publishers.

Butler, Judith (1993) *Bodies that Matter*. New York and London: Routledge.

Colette (1971) *The Pure and the Impure*, translated by Herma Briffault. Harmondsworth: Penguin.

Cordova, Jeanne (1992) 'Butches, Lies and Feminism', in Joan Nestle (ed.) *The Persistent Desire: a Femme-Butch Reader*. Boston, Mass.: Alyson.

Deleuze, Gilles (1991) *Bergsonism*, translated by Hugh Tomlinson and Barbara Habberjam. New York: Zone Books.

—— (1992) 'Ethology: Spinoza and Us', in Jonathan Cray and Sanford Quinter (eds) *Incorporations*. New York: Zone Books.

—— (1993) *Critique et clinique*. Paris: Les éditions de minuit.

Dyer, Richard (1991) 'Believing in Fairies: The Author and the Homosexual', in Diana Fuss (ed.) *Inside/out. Lesbian Theories/Gay Theories*. New York and London: Routledge.

Eliot, T.S. (1963) 'The Journey of the Magi', *Collected Poems*. London and Boston, Mass.: Faber & Faber.

Foucault, Michel (1984) 'An Interview: Sex, Power and the Politics of Identity' (with Bob Gallagher and Alexander Wilson), *The Advocate*, 44 (August).

Foucault, Michel and Cixous, Hélène (1975) 'A Propos de Marguerite Duras', *Cahiers Renaud Barrault*, 89: 8–25.

Gross, Larry (1993) *Contested Closets. The Politics and Ethics of Outing*. Minneapolis, Minn.: University of Minnesota Press.

Grossberg, Lawrence (1992) *We Gotta Get Out of this Place. Popular Conservatism and Postmodern Culture*. New York and London: Routledge.

Grosz, Elizabeth (1994) 'Refiguring Lesbian Desire', in Laura Doan (ed.) *The Lesbian Postmodern*. New York: Columbia University Press.

Hall, Radclyffe (1968) *The Well of Loneliness*. London: Corgi Books.

Hocquenghem, Guy (1993) *Homosexual Desire*, translated by Daniella Dangoor. Durham, NC: Duke University Press.

Lynch, Lee (1990) 'Cruising the Libraries', in Karla Jay and Joanne Glasgow (eds) *Lesbian Texts and Contexts*. New York: New York University Press.

Massumi, Brian (1992) *A User's Guide to Capitalism and Schizophrenia*. Boston, Mass.: MLT Press.

Moon, Michael (1993) 'New Introduction', in Guy Hocquenghem, *Homosexual Desire*, translated by Daniella Dangoor. Durham, NC: Duke University Press.

Probyn, Elspeth (forthcoming 1995) 'Perverts By Choice. The Ethics of Choosing', in Diane Elam and Robyn Weigman (eds) *Feminism Beside Itself*. New York and London: Routledge.

Radford, Jean (1986) 'An Inverted Romance: *The Well of Loneliness* and Sexual Ideology', in Jean Radford (ed.) *The Progress of Romance: The Politics of Popular Fiction*. London: Routledge & Kegan Paul.

Rich, Adrienne (1986) *Blood, Bread and Poetry*. New York: W.W. Norton.

Robson, Ruthann (1992) 'Sabrina's Horses', *Common Lives/Lesbian Lives*, 42: 109–14.

Saslow, James M. (1992) '"Disagreeably Hidden": Construction and Constriction of the Lesbian Body in Rosa Bonheur's *Horse Fair*', in Norma Broude and Mary Garrard (eds) *The Expanding Discourse: Feminism and Art History*. New York: Harper Collins.

Sedgwick, Eve Kosofsky (1993) *Tendencies*. Durham, NC: Duke University Press.

Weeks, Jeffrey (1993) 'Preface to the 1978 Edition', in Guy Hocquenghem, *Homosexual Desire*, translated by Daniella Dangoor. Durham, NC: Duke University Press.

Whitlock, Gillian (1987) '"Everything is Out of Place": Radclyffe Hall and the Lesbian Literary Tradition', *Feminist Studies*, 13, 3: 555–82.

Wittig, Monique (1992) *The Straight Mind*. Boston, Mass.: Beacon Press.

2

THE 'CUNNING LINGUA' OF DESIRE

Bodies-language and perverse performativity

Dianne Chisholm

Reading Mary Fallon's *Working Hot* (1989) affects me erotically, moves me bodily, makes me hot. And it stirs me to wonder at the *ars erotica* which she foregrounds in a Brechtian manner as the labour and machinery of her ficto-theatre. This then is the general purpose of my essay: to explore the artistry of 'Receiving Registering and Returning pleasure . . . with very sophisticated devices' (Fallon 1989: 38) at work in the pornographic tableaux which compose Fallon's postmodern 'novel'.

Setting these tableaux downunder in 'Glebe Street Sydney New South Wales Australia' (ibid.: 4), Fallon charges the scene with an aura of the carnivalesque. Host city to the world's largest gay Mardi Gras in real life, Sydney hardly needs artistic-erotic embellishment to serve as a set for 'live' sex theatre. Yet Fallon situates her 'milieu' (ibid.: 1) of 'Glebe Street People' (ibid.: 4) in a 'humourised surrealised serialised pack-of-love life' (ibid.: 1), improvising the seedy calamity of everyday Glebe for the telling and narrating of postmodern sexuality. What charges the scene most efficiently is the lascivious gusto with which sex speaks in street-sleezy dialects and between-the-sheets doggerel. In every tableau sex is made volubly vocal and polyaudible: with a variety of unorthodox stage directions, we are cued to hear the whisperings, hustlings, solicitings, gossipings, bawlings, chortlings and cooings of Glebe's rabble as of a libidinal leviathan.

It is this excessive vocality and audibility of sexy languaging that especially intrigues me as an eroticizing capability. Mary Fallon has a 'gift of the gab' which she exploits in unedited abundance, imitating, arranging, multiplying, manipulating an array of colloquial, classical and popular parole. She performs speech in bawdy acts pitched to arouse desire beyond the pleasure principle afforded by the proprieties of cultural capital. It is my specific purpose to find a way to talk about this bawdy 'linguality' in bodily terms, avoiding a critical reading which reduces writerly strategy and readerly responsivity to mere textuality.

I will begin with 'loose' critical description. The chapter 'Sextec', which

19

will be the focus of my study,[1] opens with a serialized chorus of sexy voices figured as citations. Featured here are the wisdoms and wisecracks of sexperts, past and present, both populist and highbrow, exotic and generic, fictional and historical: we hear 'the Abalone Diver' ('"I am anxious for the red pearl"'), 'Gizmo the Pimp' ('"lesbianloveactsliveonstage/ animalacts crackafat oryourmoneyback/turnheronforlateron"'), 'the Leso- fem' ('"surely feminism is a failure if you can't fuck/your best friend"'), 'Mae West' ('"it ain't the woman in your life honey,/it's the life in your woman"'), 'John Rechy' ('"we made love together for long moments"'), musings of 'Mike Todd on Liz', 'Paul Newman on Joanna', 'Rita Mae Brown', 'Oscar Wilde'. Out of the din there emerges the 'solo' reveries and misgivings of Fallon's philandering protagonist, 'Toto Caelo'. A mixed media sex-tart-ist, Toto addresses her desire in letters, poems, telegrams, songs and ditties and drunken soliloquies while engaging in acts of sexual perversity. At once speech act and carnal act, Toto's talk functions doubly as voicings and as mouthings-tonguings, as sexual slur(p)s, teasing the reader's lascivious ear if not the ear of her designated lover.

In addition to these voicings and mouthings, there is the telling and plot- ting of Toto's serial love affair(s). But the narrative discourse is heavily punctuated with Toto's (totally gratuitous) speech–sex acts, so much so that instead of narrative flow the reader experiences what might be called discursive rupture or 'narrative interruptus'. Such rupture is nothing new in postmodern production, but instead of explaining it in semiotic terms as the surfacing of 'genotext' (Kristeva 1984) or 'text of bliss' (Barthes 1976), I would invoke the author's and the reader's predilection for 'cunning lingua', for simulated, exacerbated cunnilingus.

Fallon's narrating subject, Toto, is not, like the subject of Kristeva's and Barthes' semiotics, an ego subject to the bombardments of the signifier and thus to the *jouissance* of textual excess, of sense beyond meaning; instead she is a self-proclaimed slut for sex, mouthing off at every opportunity, playing with discourse and dialogue as oral sex toys, twisting and teasing the telling and plotting into lingual devices for a 'making sexual'. Even when her narrative takes a melancholic turn towards tales of frustration, dis- appointment and abjection, concluding with pronouncements of demystifying despair ('we women have all developed all sorts of cute little/devious ways of sustaining that hungry little organ/vampirism that's what it's all about life civilisation art/one lot of dead who in living off the blood and fat of the living simulate the twitchings and tensions of life to give the other dead – the consumers of culture – the illusion that they are alive' (Fallon 1989: 89)), the tone is kept buoyant by erotic interjections from her compound comic muse 'E.C.R. Saidthandone' ('"constant abrasive irritation/produces the pearl/it is the disease of the oyster"/E.C.R. Reminded/"you are ludicrously over- exposed with her"' (ibid.: 76)), and 'Inside information' ('"on the hole I prefer women/but then again/all that glitoris is not gold"' (ibid.: 75)).

We might bill Fallon's polyvocal cornucopia as 'she do the bawd in many voices', an antidote to T.S. Eliot's 'he do the police', that paeon to modernist man's sexual *ressentiment*. And speaking of police, we might describe Fallon's lingual capability as an erotic *tour de force* in an age where 'sexuality' has come to signify the Foucauldian nightmare, a deployment of discursivity as an instrument–weapon in the regime of knowledge–power where there is no pleasure which is not (already) the effect of a regulated desire to tell the truth of sex, and no *ars erotica* except insomuch as *scientia sexualis* is its sublimated form.[2]

Fallon's 'sextec' consists primarily of a technique of shifting epistemo-logical registers from the discursive–confessional to reverie–revelation. The effect of this shift is not merely parodic or ironic, but intensely, arousingly erotic. Toto almost always succeeds in tonguing her sulking lover, and even her own brooding self, into a lusty, carnal frame of mind. Out of tongue-twister cunt-teasers which she rolls around in her mouth in a voicing of pleasure, she creates and provokes desire. For instance, in one climactic scene the language shifts without cue from sex-talk to tongue-sex. One moment Toto launches a satirical diatribe against censorial reasoning which condemns all non-reproductive masturbatory ('surface'/superficial) sexuality as rapacious exploitation. In the next, she incants a lewd slang whose lingual performance accomplishes a move from the discursive–reactive to live intercourse:

> Toto: if you rub surfaces you are invariably and
> inevitably a sadomasochistic brute consumer
> consentor using and using up others as expendable
> interchangeable commodities all black cats look alike
> in the dark and all that
> Toto: ya wannabit a the old mons venis hey
> abituvataste uv the old monso veneseo she's a nice
> drop hey wanme ta go fa a bit uv a tit a tit wiv ya
> clit hey a bit atheoldbluetongue between the
> leggings lass want a bituv a tonguin where it counts
> do ya sheila
> aw playin possum are we
> [*they're at it again*]

<div align="right">(1989: 84–5)</div>

Such a seductively efficacious speech act points to the general notion or strategy of 'linguistic performativity' currently taken up by queer theory. 'I'm interested in the implications for gender and sexuality', Eve Kosofsky Sedgwick writes,

> of a tradition of philosophical thought concerning certain utterances
> that do not merely describe, but actually perform the actions they name:
> '*J'accuse*'; 'Be it resolved. . .'; 'I thee wed'; 'I apologize'; 'I dare you'.

Discussions of linguistic performativity have become a place to reflect on ways in which language really can be said to produce effects: effects of identity, enforcement, seduction, challenge.

$$(1993: 11)^3$$

In using language, or language matter, to seduce during the act of propositioning, Fallon uses language performatively. The speech act enunciated in 'hey wanme ta go fa a bit uv a tit a tit wiv ya clit' does what it proposes; the speaker presumes to titillate and clitoricize without waiting for assent from the implied 'you' to whom she addresses the proposition.

But where queer theory is interested in 'how powerfully language *positions*' (ibid.; emphasis in original) and particularly in the power of finding or placing 'queer' or 'femininity' in a subject (vs object) position and first- (vs second- or third-) person position and the social effects of these positionings on the speaker in his/her linguistic community,[4] Fallon (in 'Sextec') demonstrates an interest in the power of language to eroticize without concern for person or position.

Fallon's speaker/performer is a 'cunning lingamist' (1989: 72) and her speech act –

> a sextec
> sucking the soul through the cunt
> (ibid.: 72)

Cunning lingua is, properly speaking, an erotics-poetics whose fictional dialogues and sexual dialects perform a blasphemous act of seductive illocution. 'If we do not know the mysteries of turning/body into flesh into fantasy into fucking/what do we know worth knowing/the scum around the rim', Toto scribbles in her ' *Sweethearts September* notebook' (ibid.: 50). Language, for the cunning lingamist, does not belong exclusively to the discursive regime of knowledge–power; her strategy is to make love not war. 'knowledge/a spiritual exercise in sexuality', Toto muses; and further on: 'the orgasm the point of intersection the point where all erotica erotic language etc attain that apex of vibrating life' (ibid.: 54).

A perverse performativity, cunning lingua reflects and elaborates the gestures of cunnilingus. In the assertion, 'I found a tongue twister/engorged in the tuft of your muff/I stuffed' (ibid.: 60), the tongue in speech imitates the tongue in cunnilingus; the play on words is not just tongue-in-cheek, but tongue in mouth, tongue in cunt, tongue on clit, setting the participles in eroticizing motion:

this technique . . .
proceeds at first with a vibration of the clitoris on the
lover's tongue the clitoris as if it were vibrating tenderly of its own
accord
at this stage it is a little talking tongue from whence

22

comes the expression 'when your clitoris talks to itself'
and the answer of the ardent lover 'yes. . .'.

<div align="right">(ibid.: 72)</div>

This is more than sex-talk; it is a talking to the clitoris in a *langue* that touches 'it', in a cunning lingua that teases 'it' into 'talking' in turn.[5] Hence, as an initial step towards articulating a critical discourse suitable for analysing (and perhaps enhancing) Fallon's technique, we might describe more accurately the speech act of her art as 'lingual' as distinct from 'linguistic' performativity. The OED is instructive here:

> **Lingual**. *Anat., Zool.*, etc. Of or pertaining to the tongue, or to any tongue-like part. *Phonetics*. Of sounds: Formed by the tongue. . . . Pertaining to the tongue as the organ of speech.
> **Linguistic**. *adj.* Of or pertaining to the knowledge or study of languages. . . . The science of languages; philology.

Lingual performativity engages the body of speech, the organ of speech-making which 'talks' in ways/in words which speak most directly to that other organ at the core of woman's sexual body. Tonguing language so as to s(t)imulate cunnilingus, cunning lingua performs the sex that it speaks.

reading postmodern carn(iv)al: litcrit *cum* litclit

Like Eve Kosofsky Sedgwick, 'I'm the more eager to think about performativity, too, because it may offer some ways of describing what *critical* writing can effect . . .; anything that offers to make this genre more acute and experimental, less numb to itself is a welcome prospect' (1993: 11). It is possible that a critical study of cunning lingua can help effect, along with sex-art itself, a recovery of *ars erotica* which Foucault claims we (in the West) seem to have lost in the history of the ascension of truth discourses and their power regimes.

More specifically, such a study might effect a radical displacement of the sexual code which, according to Robert Scholes, dominates modern western literature as a textual prescription for clitoridectomy. In the well-known essay, 'Uncoding Mama: The Female Body as Text' (1982), Scholes applies semiotics to a critical reading of modern prose to 'expose' how sexual bodies are – far from being anatomically natural and hence naturally expressive – culturally codified. As Scholes demonstrates, the sexual code is phallic and functions in all representations of sexuality to foreground the penis and male pleasure to the exclusion of any representation of the clitoris and female pleasure.

That the signifier of sexual pleasure should always be the phallus/penis and not the clitoris (which has no symbolic equivalent to the phallus) is not an unmotivated linguistic fact, Scholes argues. Men have erected a phallic code

of sexual representability as a defence against their fear that women are sexier, enjoy greater pleasure (Scholes 1982: 131). Without a signifier of their own with which to signify their desire, women are forced to address the phallus/erect penis as the only flag of sex. As exemplary evidence, Scholes refers to John Cleland's *Memoires of Fanny Hill* which 'virtually introduced the pornographic novel into English literature in 1749' (ibid.).

Since Cleland, pornographic-erotic literature in English has been coded as phallic.[6] The erect penis has come to signify desire in general, and the clitoris has been excluded from the realm of erotic representation. Women, in effect, are forbidden the use of female sexual body parts to signify their desire. The clitoris was/is especially forbidden since, Scholes explains, it was/is understood to be the homologue of the penis, a penile simulacrum which might possibly replace, overlap, surpass the cherished penis. Modern society has decided that there should be only one sexual and erotic representative – the erect penis raised to the level of symbolic phallus.

It would be easy to extend Scholes' semiotic critique of phallocracy's textual clitoridectomy with an affirmative reading of Fallon's clitophany, to throw into relief her elaboration of cunning lingua as 'an efficient pleasuring machine' (Fallon 1989: 38) against Cleland's celebrated masculine 'machine' (Scholes 1982: 134–5). But my purpose is not to insist on the representability of the clitoris or to pursue the semiotics of female/lesbian desire. The criticism I should like to evolve will not be a reactive semiotics.

To my mind, there is no critical ground to be gained by reading 'cunning lingua' as a recoding of the phallus, that is, as symbolic substitute for the real thing. (Nor is there any ground to be gained by reading it as a 'perverse' displacement of the symbolic-imaginary (phallic/penis) conflation in psychoanalysis – but I defer my confrontation with the 'lesbian phallus' for the final section of my essay.) As a strategy of 'lingual performativity' Fallon's cunning lingua is capable of erotic action, not sexual identification. Cunning lingua is not so much a signifier or signifying system which stands in, as linguistic (or discursive) representative, for the erogenous zone of partial body whose excitability/erectability is supposed to be the unmediated expression of desire. Cunning lingua is not a representative of anything; rather it is an efficient and efficacious simulacrum, neither an abstract symbol nor a real organ, but a word–thing–act, a prosthesis composed of verbal matter, capable of forming, touching and arousing Fallon's interlocutors.

Cunning lingua does not represent the excited/excitable clitoris so much as it 'clitorizes', to use the verb from the Greek which Scholes says has been lost in the archives of our sexual etymology.[7] The cunning lingamist 'sucks the soul through the cunt' of cunning lingua. The clitorized reader is not prompted to identify herself as lesbian but to feel as if her 'clitoris' has been touched through contact with the print on the page. It is not the desire to be lesbian she feels but an erotic affectivity, a clitoral intensity or sexual mobility: com(cum)-motion.

'bodies-language' and the obscene art of the cunning lingamist

As a further step towards understanding Mary Fallon's *ars erotica*, I invoke the 'pornological' studies of Gilles Deleuze.[8] I think it particularly useful to draw critical analogies between what Deleuze postulates about Pierre Klossowski's 'bodies-language' and Fallon's articulation of cunning lingua. Deleuze's reading of Klossowski focuses on the novelist's 'technique' or 'linguistic function' of composing 'the obscene'. The philosopher is interested not so much in reader responsivity as in the linguistic per-formativity of the artist – but bodies are brought into the analysis as a 'force' (Deleuze 1990: 281) of pornographic efficacy.

More specifically, Deleuze is intrigued by the 'perverse' (ibid.: 280–1) capability of the pornologist to 'transcend' or 'transgress' (ibid.: 281) the linguistic 'structure' of language with a 'form' of (sexual) 'description' which enacts the 'mutual reflection' (ibid.) of body and language. 'In Klossowski', Deleuze observes, 'sexual descriptions appear with great force', clarifying that 'the presence of such descriptions assumes . . . a linguistic function' (ibid.). By 'linguistic function', Deleuze does not mean that sexual descriptions *represent* or *signify* the corporeal through a forceful but dis-embodied application of semiotic codes. But nor does he mean that these descriptions bring a corporeal presence into play from outside language. 'Being no longer a question of speaking of bodies such as they are prior to, or outside of, language, they form, on the contrary, with words a "glorious body" for pure minds' (ibid.).

It is this 'perverse' capability or 'flexion' (ibid.: 286) that makes Klossowski's literature so powerfully, so provocatively 'obscene'. Deleuze is emphatic: it is not illicit sexuality as such that gives Klossowski's language its pornological cutting-edge. 'There is no obscene in itself', he reiterates,

> the obscene is not the intrusion of bodies into language, but rather their mutual reflection and the act of language which fabricates a body for the mind. This is the act by which language transcends itself as it reflects a body.
>
> (ibid.: 281)

Bodies are not substituted by language nor is their corporeality reducible to textuality; the play in Klossowski's pornology is *between* bodies and lan-guage: a double reflection or what Deleuze calls 'flexion' to emphasize language's miming of the motion of bodies and to avoid confusion with the formalist notion of 'reflexivity' (the textually self-demonstrating text). Deleuze argues that Klossowski understands the body to be a 'pantomime' of gestures and language to be a 'mimicry' of reason (ibid.: 280); by imitating excessively the 'pantomime' of carnal acts between bodies, language exceeds

its own structures in a radical verbal performativity which Klossowski calls 'obscene'. 'There is nothing more verbal than the excesses of the flesh. . . . The reiterated description of the carnal act not only reviews the transgression, it is itself a transgression of language by language' (Klossowski; cited in Deleuze 1990: 281).

The transgression of language by language is not tautological because it is modelled on the gestural 'language' of the body which is not inside or outside language but doubly reflected in the mirror of bodies-language. Moreover, the 'language' of the body that language 'imitates' (Deleuze 1990: 286) is complex. 'In reflection', Deleuze proceeds, 'the corporeal flexion seems to be divided, split in two, opposed to itself and reflected in itself; it appears finally for itself, liberated from everything that ordinarily conceals it' (ibid.: 286).[9] In other words, the language of the body is a contradictory 'reflex' which appears 'in reflection' in the body of language.

> If language *imitates* bodies, it is not through onomatopoeia, but through flexion. There is an entire pantomine, internal to language, as a discourse or a story within the body. If gestures speak, it is first of all because words mimic gestures. . . . In flexion, according to Klossowski, there is a double 'transgression' – of language by the flesh and of the flesh by language.
>
> (ibid.: 286)

To illustrate that 'words mimic gestures' in bodies-language, Deleuze cites Klossowski from the introduction to his French translation of *The Aeneid*: '"Virgil's epic poem is, in fact, a theater where words mimic the gestures and mental states of the characters. . . . Words, not bodies, strike a pose; words, not garments, are woven; words, not armors, sparkle"' (ibid.). This is where I shall begin to demonstrate my analogy. In Mary Fallon's erotic theatre, 'words mimic gestures': 'such is the positive power of superior "solecism", or the force of poetry constituted in the clash and copulation of words' (Deleuze 1990: 286). In Fallon, as in Klossowski, the 'solecisms' of language reflect the 'flexion' of the body. 'Sextec' fucks with syntax in 'imitation' of the clashing, copulating 'language' of carnal bodies:

> by lavishing love tongue fingers gentleness palm teeth
> suction chewing affection care delight stroking to the
> clitoris labia anus vagina. . . .
>
> (Fallon 1989: 72)

For Fallon, as for Klossowski, 'words, not bodies, strike poses'; moreover, Fallon insists that words perform 'deliberately and to delight and excess the petite venus' (ibid.: 72), their 'linguistic function' exceeding mere sexual description, striking poses to enact a story and a discourse of seduction.

The cunning lingamist, like the pornologist, traffics in 'the obscene'. For Fallon, as for Klossowski, the obscene is that performative capacity of

language 'to fabricate a "glorious body" for the mind' which, while it 'reflects' the carnal gestures of bodies, surpasses and transgresses the gestural limits of the body at the same time it surpasses and transgresses the structural limits of language. What, for instance, makes the following passage 'obscene' in the Deleuzian sense is not the blasphemous content (the coupling of Christian and pornographic images), but the performative power of word-wanking whose erotic effect frighteningly exceeds the arousing capacities of both verbal description and carnal copulation:

> inside you (as far as I went that is) was that wet cave
> was that grotto and there was moisture running down
> the walls – rising damp – my two fingers were the holy
> couple and next time you'll let in the three wise men
> won't you darling (if this is a joke I'm jesus christ) does
> it frighten you that I let words wank do my dirty work
> for me. . . .
>
> (Fallon 1989: 45)

The cunning lingamist is aware of her erotic reliance on the obscene power of words, as is her lover who accuses her of relying too much on 'impotent flourishes at language/mind you carve those words well now use words to/ carve . . . up words with words' (ibid.: 56). But cunning lingua is not a play on words simply calculated and proportioned ('carved up') to titillate the mind. Word-wanking transgresses the articulate limits of self-knowledge. There are no ready-made tricks of language; Toto 'comes' to words which carnally 'be-come' her: '. . . There are words flying up words/words myself from this/beginning from/this unworded beginning/this unworded beginning' (ibid.: 57).

That cunning lingua, like pornology, is a matter of 'flexion', not onomatopoeia, Fallon demonstrates simply by speaking the word 'pleasure' forwards and backwards: 'pleasure erusaelp/pleasure erusaelp/pleasure erusaelp' (ibid.: 63) and by pronouncing the word 'and' in a 'handful' of 'blissful' ways: '. . . "and"/a conjunction/"and"/a word a bliss to say sometimes/ "and"/a handful/"and"/a clenched hand/"and"/a cupped hand/"and"/a poofed breath' (ibid.: 63). Fallon's language imitates while reflecting the pleasure-making gestures of copulating bodies. Repetition, reflection and disjunctive conjuction mime the gestural capacity of bodies; instead of an echoing of bodies making love there is a miming of the 'flexion' of bodies resisting and conjoining in disjunctive conjunction: the 'and' of fist-fucking bodies is a 'flexion' of clenching and cupping (no simple joining) of hands. As if, like Deleuze, Fallon herself is astonished by this climactic feat of language-theatre, she has Toto's lover reflectively declare '"what a performance"' (ibid.: 63).

27

the pleasure of the mouth, or auto-eroticism sucks

In explaining Klossowski's pornological technique with his notion of 'bodies-language' Deleuze takes the reader of litclit a long way in understanding the *ars erotica* of 'Sextec'. But such mind-boggling performances as 'sucking the soul through the cunt' conjure up morphological images which Deleuze's logo(ex)centric intervention does not and cannot address. Can I then extend my reading of Fallon's lingual performativity with psychoanalysis?

To pose the question in psychoanalytic terms: if cunning lingua is the technique of 'sucking' on the 'cunt' of language in an articulate exchange of pleasure, is symbolic castration obscenely and perversely avoided OR is this apparent reciprocation between tonguing and talking a mere 'femfetish' (Fallon 1989: 61)? Is fantasy the sole/soul medium of pleasure in this 'exchange' and, if so, what makes this pleasure homo- and not just auto-erotic? Can cunning lingua be both substance and symbol of sexual exchange?

According to Jean Laplanche and Jean-Bertrand Pontalis, sexuality originates in the projection of mobile, free-floating images of the erogenous body on to the psychical map of the emerging self. Fantasy is the faculty of projection and the setting for the psychical differentiation of desire from need. While fantasy itself may be modelled on some primary bodily function,

> sexuality lies in its difference from the function: in this sense its prototype is not the act of sucking, but the enjoyment of going through the motions of sucking (*Ludeln*), the moment when the external object is abandoned, when the aim and the source assume an autonomous existence with regard to feeding and the digestive system. The ideal, one might say, of erotism is 'lips that kiss themselves'.
>
> (Laplanche and Pontalis 1986: 26)

For Laplanche and Pontalis, then, the 'ideal' erotism is auto-erotism whose fantasies ensure psychic autonomy by delivering (maternal) desire from the needs of the body through the mechanisms of hallucinatory satisfaction (ibid.).

Jacques Lacan further elaborates this 'ideal of erotism' in a discussion devoted to sublimation. According to Lacan, the (oral) drive finds its 'ideal' aim and object in linguistic manipulation and exchange. The auto-erotic fantasy of 'lips that kiss themselves' which satisfies the drive of the pre-verbal infant finds its ideal setting in communicative speech; in other words, the pleasure of mouthing (having) the maternal body in infantile hallucination is re-embodied in the sublimated act of talking:

> In other words – for the moment, I am not fucking, I am talking to you. Well! I can have exactly the same satisfaction as if I were fucking. That's what it [sublimation] means. Indeed, it raises the question of whether in fact I am not fucking at this moment.
>
> (Lacan 1977a: 165–6)

For Lacan 'sublimation is satisfaction of the drive without repression'

(ibid.: 165), but the satisfaction afforded by sublimation is nonetheless illusory; the aim of the drive finds satisfaction in an hallucinated object, a symbolic substitute for the real thing (the maternal breast) made to seem real through the articulation of fantasy. What the speaking subject enjoys in articulating her desire in language is the imaginary 'pleasure of the mouth' that feeds on the 'nothing' of the linguistic object which stands in for the real object prohibited by paternal law.

The body that finds illusory satisfaction in the symbolic sublimation of desire is a castrated body; the lips of speech do not close on the real object of desire, but on a sublimated substitute, a desexualized token of loving affection. But talking can only stand in for fucking with any satisfaction because of the pleasure afforded by oral auto-erotism, the pleasure of the imaginary mouth whose lips, tongue, voice are the body's sole caress in the symbolic act of pronouncing and exchanging bodiless words and ideas. Oral fantasy supports the linguistic sublimation of desire by mouthing satisfaction short of actual consumption/consummation:

> Even when you stuff the mouth – the mouth that opens in the register of the drive – it is not the food that satisfies it, it is, as one says, the pleasure of the mouth. That is why, in analytic experience, the oral drive is encountered at the final term, in a situation in which it does do more than order the menu. . . . As far as the oral drive is concerned, for example, it is obvious that it is not a question of food, nor the mother's care, but of the memory of something that is called the breast. . . . If Freud makes a remark to the effect that the object in the drive is of no importance, it is probably because the breast, in its function as object, is to be revised in its entirety.
>
> (Lacan 1977a: 167)

What Lacan posits as an ideal of sublimated desire which finds support in auto-erotic fantasy, Fallon de-idealizes by resexualizing desire in a perverse configuration of speech. Cunning lingua is desublimated sex-talk which does not veil the cause of desire, but *acts* as outspoken cause and which claims to effect total satisfaction in the simultaneous verbalizing and corporealizing of homo-erotic fantasy. In breaking the law of desire, cunning lingua shatters narrative but suffers nothing, neither the schizophrenic slide into a solipsistic universe nor a fetishistic cover-up. It is scandalously anti-Oedipal:

> your mouth is that little red love-heart shape
> (perfect for cunnilingus I told your mother)
> a collage of fragments–fucking
>
> (Fallon 1989: 51)

The technique of cunning lingua is to deconstruct the Lacanian 'antinomy' between talking and fucking; 'mouthing' desire, the cunning lingamist talks with her mouth full. Her speech, like her mouth, is full of the sex of her

interlocutor – in word and in deed. Speaking with affective immediacy and erotic efficacy, the cunning lingamist sets the scene for a totally satisfying homo-erotic exchange; such a speaking/setting perverts the analytic scene of therapeutic dialogue wherein the analyst 'pricks up' his ears, keeps his 'ears cocked' (Lacan 1977a: 167) for the phallic cue which will prompt the analysand into 'full speech'.

Cunning lingua is the mouthing of fantasy which reflects bodily function without becoming mere 'onomatopoeia' (Deleuze 1990: 286); that is, speaking which sounds like eating, prosody which mimics the rhythm of fucking. Toto, 'the girl with the magic mouth' (Fallon 1989: 55), speaks (to) her lover, Freda Peach, in words that feed the oral drive, nurturing the sexual with the lingual. In a language delivered in the form of a voracious cunning-lingus, words are at once mouth-stuffing, tongue-teasing, ear-titillating. More than the menu is pronounced in this scene of pleasuring the mouth:

> . . . 'chew me'
>
> **the oyster eaters**
> and
> in my mouth full
> my imagination and
> imagining full of
> a flesh flower
>
> a fat marzipan rose
> an intricate radish rose
>
> a sex salad
> a lucky muff diver
> what a lucky licker
> muff diver dyke
>
> sportswoman chewer
> glutton. . . .
>> (Fallon 1989: 59)

Toto addresses Freda Peach in mouthfuls of words that edibilize sex in the same instant that sex is de-Oedipalized. Oral and genital drives are conflated in a language which stuffs mouths and muffs simultaneously. Since there is no difference between the pleasure of the mouth and the food that satisfies it, one could say it functions as a Toto-logy. As the 'peach' of the scene entitled 'Peaches – Peaches and Cream', Freda Peach hardly masquerades as a fetish substitute for the real thing (the nurturing breast, the ever inaccessible *objet a*); in speaking her name, Toto conjoins the signifier and signified of her desire in fruitful punning, whetting the appetite of fantasy for more mouthing of 'that body that Vienna loaf that Camembert that/avocado that glacé fruit that marzipan-iced fruit-cake' (ibid.: 55).

Cunning lingua is the flesh and heart and soul of the two love affairs staged in 'Sextec': there is no logos of love that is not a carnal play on words, literally a transgression of language by language: 'mind you carve those words well now use words to/carve carve up words with words/it's Scrabble and the word is lunch/to you the word is lunch' (ibid.: 56). Toto, 'the girl with the magic mouth', knows just those 'flourishes at language' (ibid.) which can tenderize the occasion for meating between the sheets, with a passion which intervenes in domestic routine: 'what about the table it won't get made/what about the paint it won't get bought/passion and excess (yum yum)' (ibid.).

We have seen this intervention before, in Gertrude Stein where quotidian ritual (dress-making) succumbs to the solecisms of lovemaking and to the voracious consumption of 'tender buttons':

> THIS IS THIS DRESS, AIDER.
> Aider, why aider why whow, whow stop touch, aider
> whow, aider stop the muncher, muncher munchers. . . .
> (Stein 1914: 28)

Since grammar is dead there is no god; the word is lunch, but who is feasting?

In this affair of the mouth do lovers set out to devour each other (to recall Salvador Dali's carnal cannibals[10]) in a mirror fantasy of incorporation? According to Laplanche and Pontalis, the 'discourse' of 'lips that kiss themselves' is one that is 'no longer addressed to anyone', and in which 'all distinction between subject and object has been lost'(1986: 26). Is the cunning of cunning lingua the play of fantasy in auto-eroticism? When Toto pronounces total satisfaction ('in this world of scarcity and lack you lack nothing/there is nothing stinting nor niggardly you are gorged/and sated' (Fallon 1989: 51)), does she do so without a word of exchange?

Luce Irigaray's allegorical 'lips that speak together' say 'I love you' without separating 'to let just *one* word pass' (1985: 208); these lips will not part for the Word, the phallus, the law of syntax/kinship (of copula/copulation[11]) to designate separable positions of the sexual relation, the 'you' or 'me', the 'she who loves, she who is loved' (ibid.). And yet these lips speak all the same in a language of immediacy that gestures: 'I/you touch you/me' (ibid.: 209). In a related gesture, Fallon figures homo-erotic exchange in a language which never forgets its lips.

But Fallon's is perhaps a more radical gesture of speaking which consumes its own subject. In cunning lingua, language is devoured as well as exchanged, expressing and exciting an abundance of sexual appetite: interlocutors stuff each other's mouths and cunts with arousing tongue-twisters 'until we/were no longer just I and I' (1989: 51). Fallon articulates an exchange of 'lust and fantasy' (ibid.: 43) in which language is 'desubjectivized'. Laplanche and Pontalis remind us:

In fantasy the subject does not pursue the object or its sign: he appears

31

caught up himself in the sequence of images. He forms no represen-
tation of the desired object, but is himself represented as participating
in the scene although, in the earliest forms of fantasy, he cannot be
assigned any fixed place in it (hence the danger, in treatment, of
interpretations which claim to do so). As a result, the subject, although
always present in the fantasy, may be so in a desubjectivized form, that
is to say, in the very syntax of the sequence in question.

(1986: 26)

'Desubjectivization' describes the scene of consuming passion in which
'we were no longer I and I', in which, that is, *two* subjects find sustenance
in the cunning lingua that mediates and stimulates the play of fantasy between
them – it taking two to dialangue: 'I found a tongue twister/engorged in the
tuft of your muff/I stuffed//OK now you try it' (Fallon 1989: 60). But
speaking subjects are not just lost in this lingual exchange; they are embodied,
digested and combusted. When Fallon's interlocutors engage in speaking/
tonguing until 'we were no longer I and I', they give up their capacity for self-
signification in favour of deploying a language in which 'bodies lose their
identity and the self its identity' (Deleuze 1990: 299). To return to Deleuze,
we might say that they come to speak a language which

loses its denoting function (its distinct sort of integrity) in order to
discover a value that is purely expressive or, as Klossowski says,
'emotional'. It discovers this value, not with respect to someone who
expresses himself and who would be moved, but with respect to
something that is purely expressed, pure motion or pure 'spirit' – *sense*
as a pre-individual singularity, or an intensity which comes back to
itself through others.

(ibid.)

'[A] kind of spiritual exercise in sexuality', as Fallon calls it (1989: 52),
cunning lingua might best be described as an 'expressionist language' which
articulates the consummation of bodies not in terms of coupling bodies or
body-egos but of bodies undergoing 'metamorphoses transmogrifications'
(ibid.: 87) in a universe of orifices open to a flood of incoming feeling: 'my
cells I tell you are/barnacles they open with tide-and-wave action my cells/
each cell in fact I tell you is a little open-mouthed anus/innings and outings
and sighings' (ibid.: 44).

When Fallon has her character announce 'there are no bodies/there are no
bodies/I don't know you/all I know is/how to give you/pleasure' (ibid.: 88),
she cites the mouth of pleasure which en-joys 'you' but es-chews the body-
ego and the scene of misrecognition. When Fallon's pleasure-makers address
each other in cunning lingua, it is not the 'person' they hope to move. They
speak, to re-cite Deleuze, 'not with respect to someone who expresses himself
and who would be moved, but with respect to something that is purely

expressed, pure motion or pure "spirit" – *sense* as a pre-individual singularity, or an intensity which comes back to itself through others' (1990: 299). Hence, post-coital talk evokes the 'I/you' of last night's coupling not in the copula 'I loved you' but in an expression of depersonalizing 'intensity':

> I was only a force last night you know I lost my
> body my sex my humanness the heart knew nothing
> of the onslaught – just a force – gravity momentum
> whatnot I was malevolent and ecstatic. . . .
>
> (Fallon 1989: 84)

In other words, cunning lingua has a queer way of saying 'I love you', addressing not 'she who is loved' but an expressive intensity which makes small change of personal integrity. Consider furthermore this 'report' of 'last night's' eruption:

> I heard on last night's news that unexplained red
> fireballs were reported hurtling at tremendous speed
> across the Blue Mountains and I heard on this
> morning's news that somewhere in America a woman
> spontaneously combusted while crossing at the traffic
> lights even her small change had melted together in
> the intensity of the heat . . .
>
> my stomach turns at the thought
> of the velocity
>
> (ibid.: 64)

If cunning lingua is a bodies-language deployed in the sexual exchange between women whose pleasure is total, can we say that for the expressive purposes of homo-eroticism, auto-eroticism sucks? While the psychoanalyst might read the cunning lingamist's pronunciations 'I'm going to suck your sexuality out into my mouth' (ibid.: 72) or '[I am] sucking the soul through the cunt' as the vulgar articulations of a fantasy of incorporation which defies phallic sense and value, the Deleuzian might read them otherwise as the 'transgression of language by language' which 'evokes' a wholly different reflection of body:

> Evoked (expressed) are the singular and complicated spirits, which do
> not possess a body without multiplying it inside the system of re-
> flections, and which do not inspire language without projecting it into
> the intensive system of resonances. Revoked (denounced) are corporeal
> unicity, personal identity, and the false simplicity of language insofar
> as it is supposed to denote bodies and to manifest a self.
>
> (Deleuze 1990: 299)

Like Klossowski's pornology, Fallon's cunning lingua revokes 'corporeal

unicity, personal identity', the denoting of bodies and manifest selves. And it evokes a multiplicity of bodies ('every cell in my body can open/I have too many/tongues too/many sweet tongues too sweet/for tongues'), partial bodies meeting in the spirit of bodies-pleasure ('when the anus/vagina and clitoris sing together in three-part harmony/I'll celebrate the mating' (Fallon 1989: 72)) and a disjunctive chorus of bawdy voices resonating allusively throughout the orifices of the text.

To the transgressive vocations of bodies-language we could add a third: evocation, revocation and 'ingest(at)ion' – as when the cunning lingamist pronounces her fantasy of 'forcing myself through my own cunt head first/a tricky stunt/of a meal. . ./. . . we have known eachother – carnally' (ibid.: 75). Such lingual evocations cannot easily be reduced to auto(phallo)-erotic fantasies of incorporation/invagination. An expressionist pronunciation which invokes/revokes Frida Kahlo's surrealist self-portrait of dying in giving birth to herself, head first out of her own cunt but still-born.[12] But there is a moral to Fallon's tale: the spirit of homo-eroticism expressively displaces the fantasies of auto-eroticism only when cunning lingua inspires lingual reciprocation. When the dialangue is reduced to one-sided nourishing, when Freda 'does not love her [Toto] enough to/learn. . . the big secret/of sustenance she's the eat-and-run type' (ibid.: 80), when there is no pleasuring that can 'come between a masturbatrix and her hand' (ibid.: 75), the marriage of tongues between Freda Peach and Toto Caelo (Freda Caelo) bears a fruitless death.

the lesbian phallon

Reading litclit is not reading for the phallus. Fallon's 'cunning lingua' contests any criticism which claims the erotic dominion of the Lacanian phallus and does so without making any phallic counter-claim. Like Judith Butler, the progenitor of the 'lesbian phallus' (1993), Fallon signals a desire for which there is no anatomical referent or (fixed) imaginary morphology. And like Butler's 'lesbian phallus', Fallon's 'cunning lingua' displaces the phallus as the signifier of sexual desire, whose structural hom*mo*-eroticism is felt by the subject as a desire 'to be' or 'to have' the phallus–penis.[13] But unlike the 'lesbian phallus', Fallon's 'cunning lingua' articulates an eroticism whose bodies-language is wholly excentric to Lacanian phallogocentrism.

Butler demonstrates how the Freudian/Lacanian text doubly idealizes the penis, first by positing the morphology of the erect genital to be the privileged organic form upon which the subject unconsciously reflects an auto-erotic self-image and models a body-ego; and, second, by designating the phallus as the symbol of sexual difference and pronouncing that women desire to 'be'[14] (men, to 'have') the phallus while denying any theoretical coupling between the imaginary and the symbolic.[15] Butler uncouples the erogenous organ from the empty signifier of desire, decentres the imaginary body and opens sexual

difference to a free play of gender, but otherwise leaves the phallus intact. The phallus still symbolizes desire as lack, as absence of the body in language, though it no longer privileges the negation of the penis.[16] For Butler, sexuality is still phallic in that sexual relations are constituted as the difference between 'having' or 'being' the phallus even though this difference is no longer the mark of gender:

> The question, of course, is why it is assumed that the Phallus requires that particular body part to symbolize, and why it could not operate through symbolizing other body parts.
> The viability of the lesbian Phallus depends on this displacement. Or, perhaps more accurately phrased, the displaceability of the Phallus, its capacity to symbolize in relation to other body parts or other body-like things, opens the way for the lesbian Phallus, an otherwise contradictory formulation. And here it should be clear that the lesbian Phallus crosses the orders of *having* and *being*
> Of interest here is not whether the phallus persists in lesbian sexuality as a structuring principle, but *how* it persists
>
> (Butler 1993: 84–5)

The 'lesbian phallus' may displace the privileged coupling between phallus-penis without displacing the phallic exchange in sexual relations, even though these relations may occur exclusively between women and the organ(s) symbolized in the exchange may be bodies or part-bodies other than the penis:

> Consider that 'having' the Phallus can be symbolized by an arm, a tongue, a hand (or two), a knee, a thigh, a pelvic bone, an array of purposefully body-like things. And that this 'having' exists in relation to a 'being the Phallus' which is both part of its own signifying effect (the phallic lesbian as potentially castrating) and that which it encounters in the woman who is desired (as the one who, offering or withdrawing the specular guarantee, wields the power to castrate).
>
> (ibid.: 88)

Butler insists that to say a woman 'has' it in a lesbian exchange, is not the same as saying that a man has it in a heterosexual exchange. 'The phantasmatic status of "having" is redelineated, rendered transferable, substitutable, plastic; and the eroticism produced within such an exchange depends on the displacement from traditional masculinist contexts as well as the critical redeployment of its central figures of power' (ibid.: 89). But Butler's logic of displacement begs the question she puts to phallogocentricism. She argues that the viability of lesbian eroticism produced in this 'redelineated' phallic exchange depends on the displacement of traditional masculinist contexts, just as the 'viability' of the lesbian phallus 'depends' on the 'displacement' of the symbolic-imaginary coupling of phallus-penis. But her designation of the lesbian phallus in place of the hetero phallus in itself

35

ensures neither the displacement of the penis nor of the traditional masculinist context even though 'the viability' of lesbian eroticism 'depends' on it. How can a radical displacement of masculinist eroticism be figured?

For Fallon, there is no radical displacement of traditional masculinist contexts if there is not also a displacement of the phallus. Cunning lingua is not a phallic tongue. It is not an imaginary organ so much as a lingual activity, at once real, imaginary and symbolic, mouthing an earful of erotic tonguing while designating homo-erotic exchange in a titillating tongue-twisting bodies-language, an 'obscene' language whose sole object is to arouse the clit of the mind and suck the soul of sexuality.[17] Cunning lingua is a matter not of 'being' or 'having the phallus' but of 'doing sex'. Instead of oppositional posing and positioning between actors who misrecognize themselves as having or not having the symbolic-imaginary power to castrate, cunning lingua abandons the specular arena of the split subject for the oral/aural medium of bodies-language; instead of symbolizing desire in a phallic exchange between the castrated and castrating eye/I of the actors, Fallon favours s(t)imulating desire by performing lingual sex on the clitorized ear of the reader.

There *are* scenes in 'Sextec' when the phallus returns to organize the exchange; the affair between Toto and Freda falters when Freda ('a fucking lazy lover' (1989: 58)) fails to put out the effort of technique required to displace the phallus and perform cunning lingua with sufficient intensity. The failure of this affair is not a failure of love,[18] but a failure to make pleasure. Or, more precisely, Freda for her part fails to exchange the passion of the mouth for 'the passion of the signifier' (Lacan 1977b: 284). Toto, on the other tongue, is loud and clear:

> . . . pleasure pleasure pleasure
> singing down through my open mouth onto yours and
> into yours and your jerked head and your shut eyes
> your left arm outstretched going down on you is all joy
> all exploration the eroticism of trust (even respect)
> saying 'you you you' with my tongue
>
> (Fallon 1989: 54)

In a *langue* which makes no distinction between saying and performing the copula, 'your jerked head', 'your shut eyes', 'your left arm outstretched' are literally predicated upon pleasure. Participles of lingual arousal in the copula/copulation of lesbian exchange, these are not imaginary organs that symbolize the phallus in lieu of the penis, like the 'arm, a tongue, a hand (or two), a knee, a thigh, a pelvic bone' facetiously suggested by Butler. There is no 'it' to exchange: pleasure *is* the exchange *is* cunning lingua: doing it while saying it in a bodies-language which stimulates the sex organs of the verbal imagination. Toto: 'such pleasure this morning – pleasure – the word warms/my groin runs circles around my clitoris rings it' (Fallon 1989: 54). When the

wording is good, the erotic exchange amounts to total satisfaction. Even Freda is outspoken: '"you are one of the only people I know who knows/how to love profoundly/you are a lover's lover" said Freda Subdued' (ibid.: 56).

But Freda reasons loving in terms of phallic illusions. More than carnal pleasure, she seeks a sign of her desirability. From the perspective of what Lacan designates as the 'feminine' position, or, as Freda herself puts it, from the perspective of a 'desire to be desired' (ibid.: 59), she assesses their affair with mercenary conviction. Like an ill-humoured Lacan, she sees through their lovemaking as specular comedy, as something lacking in love while yet 'seeming' as if a being-in-love:[19] 'yes I suppose one of the main reasons (but I do love/you) for being with you is the being-seen-with/being-/seen-to-be and I have refused any deep personal/commitment' (ibid.: 56). But despite this insight, Freda is no less subject to the *méconnaissance* of desire; in demanding a sign of something more 'deep', more 'personal', she erects a phallic barrier against a more mobile, lingual pleasure.

For Toto there is loving no more 'deep' than pleasuring, no being more expressive than cunning of the tongue, no copula more satisfying than the copulation of vulgar, vulvular words, the 'I mouth you' of lingual attentiveness:

> . . . Toto cursed to the shut black door 'you say
> there are barriers . . . between us that I am
> not responding to you sexually but it is precisely when I
> am responding to youjustyou in your hands on the end of
> your ten pin fingers (you bitch you had me on the end of
> a pin – escargot) and it was you you youjustyou
> I was responding to I wanted...'
>
> (ibid.: 56–7)

But in desiring a sign of love above a show of pleasure, Freda recasts the play between them into a phallic farce. Toto testifies to her success. Toto:

> oh you castrate me fret me/you make me make out with myself/you make me lie wanting you/I wait for some sign/you are still/monolithic/ (you are the golden phallus/the Easter Island statue)/it's such femfetish
>
> (ibid.: 61)

Despite her total commitment to making-pleasure, Toto is left wanting by Freda's desire: 'It was never like this before/you stop me/you start me/you make me wait for you . . .' (ibid.). Even where there is no imaginary penis to symbolize the stakes of the exchange, the phallus still (dis)organizes the field of sexual relations. For Freda, the meaning (affect) of the copula ('I love you') must be uncoupled from a copulation which speaks only itself and which has nothing (phallic) to show: 'you say you don't understand when/I love you/say I love you and fuck you/you say the loving has nothing much/ to do with the feeling fucking' (ibid.: 62).

Inevitably, the Toto Caelo–Freda Peach affair disintegrates into a scene of symbolic violence, threatening at one stage to devolve into sadistic theatre before Toto makes her exit. 'Freda to Toto: I'd have loved/you more if you'd had/the power to hurt me–/you didn't' (ibid.: 85). Fallon condemns the lesophallofailure of her characters to transcend the tortures of Oedipal desire as a pathological subversion of perversion. She has Toto declare: 'I'm not interested in that old pantomime you/know the eroticism around the sever of the suture/all I want is strength through pleasure no fascism/with the life force' (ibid.). Against Butler's premise that it is not possible for lesbian sexuality to enact an exchange outside the economy of phallogocentrism, Fallon proposes an exchange which takes place in the production of an *ars erotica* whose medium I am tempted to coin as 'pornologopoeia'.

There is a happy ending to this chapter. After divesting herself of Freda, Toto finds 'Top Value' in a woman who is pleasure-wise up to snatch. The final scene, a play within a play, entitled (again with Brechtian fore-grounding) 'A Play for Top Value', features a sequence of sexy tête-à-tête (tit-à-tit, tit-à-clit, tongue-à-clit), in which the pleasure of tongues says it all. Top Value: 'I warn you I have an incontinent heart and/every cell in my body can open up I have too many/tongues too many sweet tongues too sweet for/tongues' (84). Toto: 'ya wannabit a the old mons venis hey/abituvataste uv the old monso veneseo she's a nice/drop hey wanme ta go fa a bit uv a tit a tit wiv ya/clit' (ibid.).

TOTO finds TOP VALUE in a woman who makes her 'realise that all/the delight in the world begins in access to a loving/woman's loving body' (83), that there is no satisfaction in loving beyond making pleasure, beyond knowing 'the mysteries of turning/body into flesh into fantasy into fucking' (ibid.: 52). In place of having the 'phallus', there is the desire to have the 'sextec' to 'know how to touch the live wire . . . in the body' (ibid.: 84), to open every cell in the body (ibid.).

Desire is brought to fruition in the expressionist, surrealist and performative bodies-language of 'Sextec'. Using a lingual, instead of a phallic, function to mobilize the (dis)play of eroticism, a cunning lingua instead of a structuralist linguistics to articulate the fantasy of erotic satisfaction, Fallon's sex technicians tongue each other's appetite in word and deed without fear of castration: 'a split fruit of a woman we are neither of us/afraid to sink our teeth into the peach' (ibid.: 87). In other words, with Fallon's *ars erotica*, lesbians can have a peach of an exchange and eat it too.

ACKNOWLEDGEMENT

I would like to thank Liz Grosz for drawing my attention to Mary Fallon's exciting book and Teresa de Lauretis for lending me her copy. (Teresa, I owe you one.)

NOTES

1 'Sextec' is reprinted in this book. See Chapter 3.
2 See Michel Foucault (1980).
3 Sedgwick points to Shoshana Felman (1983) as 'one of the most provocative discussions of performativity in relation to literary criticism', adding that 'most of the current work being done on performativity in relation to sexuality and gender is much indebted to Judith Butler's *Gender Trouble: Feminism and the Subversion of Identity* (1989)' (Sedgwick 1993: 11).
4 'Does it change the way we understand meaning, for instance, if the semantic force of a word like "queer" is so different in a first-person from what it is in a second- or third-person sentence?' (Sedgwick 1993: 11).
5 Mary Fallon is not the first or the only postmodern writer to narrate the punning/conning play of cunning lingua. See also Nicole Brossard (1987) and Daphne Marlatt (1987).
6 For our purposes, the main features of the code are these:

1. There is no way a woman can achieve sexual satisfaction except by insertion of the male 'machine' in the female 'gap'.
2. Pleasure for the female is directly proportional to the size of the male 'machine'.
3. Unless the male is inadequate (which rarely occurs in this world) this pleasure always occurs simultaneously in both sexes and is marked by a simultaneous emission of fluid in both.
4. The number of times a woman achieves satisfaction is always equal to the number of times the male does, except when the male is inadequate. The woman is never satisfied more times than the man.
5. The male genitals are described in considerable detail and are individualized by unique features as often as possible.
6. The female genitals are described in a kind of soft focus, as if airbrushed, so that no details beyond hair color are reported. The clitoris is certainly invisible and for all practical purposes nonexistent.

(Scholes 1982: 134–5)

7 'The word *kleitoris* is both late and rare in Greek, appearing first in the second century A.D. in a medical text by one Rufus, called *Peri Onomasias* – "On Naming". Rufus has a verb, too, *kleitoriaso*, meaning "clitorize", to touch the clitoris. The Greek word *kletoris* has also a second meaning . . . "jewel" or "gem". No modern dictionary has cared to see any connection between the two meanings, though similar metaphorical processes frequently connect the male genitalia and jewelry in popular speech and in literature' (Scholes 1982: 130).
8 Deleuze outlines what he means by 'pornology' at length in his study of the 'avant-garde' languages invented by Marquis Alphonse de Sade and Leopold Von Sacher-Masoch entitled *Masochism: Coldness and Cruelty* (1989). My primary reference, however, will be section 3, 'Klossowski or Bodies-Language', from Appendix II, 'Phantasm and Modern Literature', in Deleuze's *Logic of Sense* (1990).
9 To illustrate what he means by 'flexion', Deleuze refers to passages from the pornographic novels which comprise the trilogy *les lois de l'hospitalité*. 'In an excellent scene of *La Révocation* [de l'Edit de Nantes] Roberte, thrusting her hands into the tabernacle, feels them grasped by two long hands, similar to her own. . . . In *Le Souffleur*, the two Robertes fight, clasp hands, while an invited guest "prompts": make *her* separate! And *Robert ce soir* ends with Roberte's gesture – her holding out a "pair of keys to Victor, which he touches though never takes"' (1990: 286).

10 Salvador Dali, 'Autumn Cannibals' (1936–7). See, for example, David Larkin (1974).

11 Irigaray implicitly contests Lacan's claim that the phallus is the privileged signifier of desire 'because it is the most tangible element in the real of sexual copulation, and also the most symbolic in the literal (typographical) sense of the term, since it is the equivalent there to the (logical) copula' (1985: 208). See note 15 and discussion of 'the lesbian phallus' below.

12 Frida Kahlo, 'My Birth' (1932). See, for example, *Images of Frida Kahlo* (1989).

13 'But one may, simply by reference to the function of the phallus, indicate the structures that will govern the relations between the sexes. 'Let us say that these relations will turn around a "to be" and a "to have"' (Lacan 1977b: 289).

14 'I am saying that it is in order to be the phallus, that is to say, the signifier of the desire of the Other, that a woman will reject an essential part of femininity, namely all her attributes in the masquerade. It is that for which she is not that she wishes to be desired as well as loved. But she finds the signifier of her own desire in the body of him to whom she addresses her demand for love. Perhaps it should not be forgotten that the organ that assumes this signifying function takes on the value of a fetish' (Lacan 1977b: 290).

15 In pronouncing that 'the phallus is a signifier', Lacan insists emphatically that 'the phallus is not a phantasy, if by that we mean an imaginary effect', and that 'it is even less the organ, penis or clitoris, that it symbolizes' (1977b: 285). And yet, in explaining why the phallus is the privileged signifier of desire in western culture, he couples its symbolic, imaginary and real dimensions:

> It can be said that this signifier is chosen because it is the most tangible element in the real of sexual copulation, and also the most symbolic in the literal (typographical) sense of the term, since it is equivalent there to the (logical) copula. It might also be said, that by virtue of its turgidity, it is the image of the vital flow as it is transmitted in generation.
>
> (ibid.: 287)

16 'If the Phallus *must* negate the penis in order to symbolize and signify in its privileged way, then the Phallus is bound to the penis, not through simple identity, but through determinate negation. If the Phallus only signifies to the extent that it is *not* the penis, and the penis is qualified as that body part that it must *not be*, then the Phallus is fundamentally dependent upon the penis in order to symbolize at all. Indeed, the Phallus would be nothing without the penis' (Butler 1993: 84; emphasis in original).

17 As a bodies-language, cunning lingua is at once real, imaginary and symbolic, a lingual act which eroticizes the total psychic field. The phallus can claim, at most, to embody these three dimensions with conceptual equivocation. See note 15 above.

18 In his phallic schema, Lacan assigns female homosexuality to love, male homosexuality to desire. Since the function of femininity/woman in the sexual relation is to signify the desire to be desired, to be loved, and since the signifier of desire (the erect organ symbolizing the phallus) is embodied by masculinity/man whose impotence is thus vastly more significant, more intolerable, than woman's frigidity, a woman–woman relation is likened to an impotent hetero-sexual love. Female homosexuality, Lacan claims, 'is oriented on a dis-appointment that reinforces the side of the demand for love' (1977b: 290).

19 Lacan describes the play for the phallus in sexual relations as mere 'show', a comic 'masquerade' in which the players participate with deluded gravity. What they think they recognize in love (him/her 'self') is in reality a reflection of his desire in the mirror of her desire to be desired – in other words, a charade of

'having' what it takes to 'be' loved or to 'be' in love. The play revolves around the infinitive 'to seem' of the illusory phallus:

> Let us say that these relations will turn around a 'to be' and a 'to have', which, by referring to a signifier, the phallus, have the opposed effect, on the one hand, of giving reality to the subject in this signifier, and, on the other, of derealizing the relations to be signified.
>
> This is brought about by the intervention of a 'to seem' that replaces the 'to have', in order to protect it on the one side, and to mask its lack in the other, and which has the effect of projecting in their entirety the ideal or typical manifestations of the behaviour of each sex, including the act of copulation, into the comedy.

<div align="right">(Lacan 1977b: 289)</div>

BIBLIOGRAPHY

Barthes, Roland (1976) *The Pleasure of the Text*. New York: Hill & Wang.

Brossard, Nicole (1987) *Sous la langue/Under Tongue*, translated by Susanne de Lotbinière-Harwood. Montreal: Gynergy.

Butler, Judith (1989) *Gender Trouble: Feminism and the Subversion of Identity*. New York: Routledge.

—— (1993) 'The Lesbian Phallus and the Morphological Imaginary', in Judith Butler *Bodies That Matter: On the Discursive Limits of 'Sex'*. New York: Routledge.

Deleuze, Gilles (1989) *Masochism: Coldness and Cruelty*, translated by J. McNeil. New York: Zone.

—— (1990) 'Klossowski or Bodies-Language', in *Logic of Sense*, translated by M. Lester. New York: Columbia University Press.

Fallon, Mary (1989) *Working Hot*. Melbourne: Sybylla.

Felman, Shoshana (1983) *The Literary Speech Act: Don Juan with J.L. Austin, or Seduction in Two Languages*, translated by C. Porter. Ithaca, NY: Cornell University Press.

Foucault, Michel (1980) *The History of Sexuality: Volume 1*, translated by R. Hurley. New York: Vintage.

Irigaray, Luce (1985) 'When Our Lips Speak Together', in Luce Irigaray *This Sex Which Is Not One*, translated by C. Porter. Ithaca, NY: Cornell University Press.

Kahlo, Frida (1989) *Images of Frida Kahlo*. London: Redstone Press.

Kristeva, Julia (1984) *Revolution in Poetic Language*. New York: Columbia University Press.

Lacan, Jacques (1977a) 'The Deconstruction of the Drive', in Jacques-Alain Miller (ed.) *The Four Fundamental Concepts of Psycho-Analysis*, translated by A. Sheridan. New York: Norton.

—— (1977b) 'The Signification of the Phallus', in Jacques-Alain Miller (ed.) *Ecrits: A Selection*, translated by A. Sheridan. New York: Norton.

Laplanche, Jean and Pontalis, Jean-Bertrand (1986) 'Fantasy and the Origins of Sexuality', in Victor Burgin, James Donald and Cora Kaplan (eds) *Formations of Fantasy*. London: Methuen.

Larkin, David (ed.) (1974) *Dali*. New York: Ballantine.

Marlatt, Daphne (1987) *Touch To My Tongue*. Edmonton: Longspoon Press.

Scholes, Robert (1982) 'Uncoding Mama: The Female Body as Text', in Robert Scholes *Semiotics and Interpretation*. New Haven, Conn.: Yale University Press.

Sedgwick, Eve Kosofsky (1993) *Tendencies*. Durham, NC: Duke University Press.

Stein, Gertrude (1914) *Tender Buttons*. San Francisco, Calif.: Sun and Moon Press.

3

SEXTEC

Excerpt from Working Hot

Mary Fallon

'I am anxious for the red pearl' said the ABALONE DIVER
fishing around in the aquarium of her mind
with a pretty finger

'lesbianloveactsliveonstage
animalacts crackafat oryourmoneyback
turnheronforlateron' GIZMO THE PIMP

'surely feminism is a failure if you can't fuck
your best friend' THE LESOFEM

'to some people sexuality is the water
they swim in to others
I know it's just toy ducks in the bath'

faint heart never won fair maid
'the woman in your life
the woman in your life'

'it ain't the woman in your life honey
it's the life in your woman' MAE WEST

'we made love together for long moments' JOHN RECHY

women fucking women
godalmighty what you get on your hands
and what you've got on your hands
– the spice of the nutmeg

the knowledge is stored in the tongue
in the memory of the tongue
Diagnosis of Lesbianism in newborn female child –
her tongue will be too big for her mouth
Treatment – nip off the tip or bonsai the roots
Prognosis – if left untreated the eyes will grow
too big for the belly
and/or she will be too big for her boots

'what's the most erotic object you can think of'
'ballbearings' said FREDA PEACH smiling at TOTO

'every minute that little dame spends out of bed
is wasted absolutely wasted'
MIKE TODD ON LIZ

'an efficient pleasuring machine is one which is capable of
Receiving Registering and Returning pleasure
so economically
that only a highly skilled technician
equipped with very sophisticated devices
would be capable of the 3R division
as we say in the jargon'
in *Sextec* by E.C.R. SAIDTHANDONE

'why should I go out for hamburger when I can have
steak at home' PAUL NEWMAN ON JOANNA

'I follow the scent of a woman
melon heavy ripe with joy
inspiring me to rip great holes in the sky'
RITA MAE BROWN

'pleasure is nature's test – her sign of approval'
OSCAR WILDE

introduction to a sextec
'embedded in sordid' you said
'it needn't be'

I
open my mouth and your
tongue
comes
soft
into the mucus
place
the moist place of silence
it is you who are so present
(that is you are divested of illusion
you are real in a real world)
we are where no words grow
then there is
after the orgasm time

43

for sexvision to begin
(for the process to begin)
time in the white light
space in the white noise
for the slender white boats
(fingers)
to sail
on and on on the surge and bulge
of white water
where there are no words
we can almost meet
(at least speak our good will
with fingers)
at least coax open
the fleshhinges of fear
at least and
at last
sail and
sail through the harbour heads
here
where there are no words
we curl around the core
we coil around the reason
for speech

we are in this place
this glass room inside and out
we have
slipped
sailed
transmogrified deifirgomsnart
into otni
topsyturvydom modyvrutyspot
on a rumtum mutmur a no
here
to take a step out
you must
take a step in
here
to speak
you must not
use words
here

to give yourself away all away
is to give yourself to yourself
and another as well and (twice as much)
back
that is
$1-1=(\rightarrow 2^n)$
here
explosion is implosion
(creation from desires
that is
creation from open mouths)
where psychic fission fusion
reactions account for the
resolution of the massive contradictions
here the resolution
is
a broken mirror?
a mirror underwater?
a mirror of water?
glass become protoplasm?

continuous molecular transformations?

(we women are not under glass
we are suspended in a
devitrified protoplasm and
a psychic fission fusion reaction
is required – perhaps the process
is a sextec – a sort of melting)
a certain butchness (not butchery)
in lying lesbian between

that is
there is no tree
(and you can grieve too long for the
death of the tree)
there are violets and vegies with runners
there is no crystal ball
(a solid unit ego to hold up
in the hands to the light)
there are marcasites and rhinestones

dear Freda

why shouldn't I explain no explode my joy to you my desire this wonderful still open mouth this green arm from my guts pushing up straining forward demanding and I can even laugh with joy at this big green revolution with little green fingers this baby that never gave up that never sucked sugar-coated dummies who never forgot I want no I won't who says so why should I givemegetmebuyme

and I want you and I also want everything else to come to me to be given to me why not have my cake and eat it too why not and so I accept less who cares what does it matter to know you will never have it all will never be given a whole box of world what the fuck does it matter and that I do not want to be powerful over that I do not want everything enough to contain myself and wait to manipulate pieces of the world around me like chessmen the world is not black and white enough for that the world is too multi-coloured for me to get a grip on a plan of action

and it is enough now that I feel this arrogant eye on your beauty that I watch the shape of your mouth the blush on your cheek spread like pink dye in a dye bath that the little animal devil in me is not dead and that I love the daemon who narrows her eyes with desire with erotic fantasies even while we eat melon on the sand that I am broken but not broken enough not to mend that even Evie was not enough with her sharp brutalities I would not lose myself in her final banalities psychic fogs (London suits her) a fuzz of moralities anxieties mythologies lies of the heart convenient feminist pop slogans that I will say the pain was unbearable and I have not beaten it it flows out and out but in flows joy and joy as well now and this pain is not a bomb not a cancer it is just pain and drains through my blood and hopefully out through the bowel I believe in strength through pleasure in creation from abundance not deprivation and discipline I believe in words said and said and said out from our heart and head the need to deny the security of false mysteries found in silence in enigma in innocence through omission false innocence through refusal to consciousness there is a simple truth the simplicity of the threaded beads of sincerity in 'I am I feel I know I act' they contain more mystery than you can poke a stick at that is we will never get to the bottom of it never finish the puzzle and there is no need to make things more complex than they are already so I will not waste my time in smoke-screening psychic smogs for you

let's get it straight

there is no doubt we are a sick people stuffed on junk-food philosophies of pop psychology we are in our relationships our loves as constructed as a house even prefabricated I search the aluminium and brick veneer for even borers or silverfish and there is still the revolutionary potential in that we are all still naughty children who want what they can't have who say 'no' and 'yes' inappropriately in their hearts that we make things with our hands even ridiculous collections and doodles which we keep in drawers or between four

46

walls or two sheets but there are still weeds and waste places still opportunity shops and garbage tips to sort through and no dragnet can contain and segment all
we live in lust and fantasy
there are not words for everything yet even words strung together in the wonderful mixed-metaphor the schizophrenic amalgamation (is it harder to hit a moving target) do not actually will not allow the containment they run along too many tracks it's a trick – under which walnut shell did I put the world – if you're tricky enough got enough of the devil in you no one ever guesses right (but some mornings we still wake and know we have no words . . .)

<div align="right">love
Toto Caelo</div>

dear Freda
. . . and I do have periods of madness when all my fuses blow have blown when my fingers numb and then peel at the tips – burnt-out socket plugs where there is so massive an input and the organs are not synchronized enough to cope when the energy just goes around and around and bursts and damages then I am mad when I see to the bones of actions too clearly too quickly too easily and it sickens me and I am then victim (I should bat this all back where it belongs of course)
. . . and if I could be mad I would be mad on top of a bearded mountain on some apex somewhere but instead I tread it under foot it burrows into vacated pockets in my organs some place I have not placed my hands or my mind lately which causes me to apply myself to a thorough nitpicking daily on one shoulder is the pole of death and on the other me to the nth power and a high tensile wire is strung between and I balance careful as a clown and there is no peace but on one pole or the other and both have a certain phallic quality which disturbs me
I find relief in your mouth however (you could say I relieve myself in your mouth – a golden shower) I climb into your hands and your eyes are real surely I have mined the mysteries bare and am left with the bare (simply beautiful) bones the bare facts taken scissors to the nets of illusion perfected iconoclasm your hands I tell you are waves of water my cells I tell you are barnacles they open with tide-and-wave action my cells each cell in fact I tell you is a little open-mouthed anus inings and outings and sighings
knowing – never having forgotten the pleasing in pleasure
but DO YOU WANT THIS LIVING BODY DO YOU WANT TO BEAT DEATH OUT FROM THE CODE OF EVERY CELL or will the dark mouth the iron ring of your fear bite off the hand that feeds it will you look a gift horse in the mouth will you use your rhetoric and give old death an easy time make shoo noises but turn a blind eye when it hides behind a curtain

<div align="right">love and kisses
Toto</div>

dear Freda

who is brave enough to let – corrupt and innocent enough to allow – this mouth of mine to kiss them this black slit that has fellated death the cracked old man in the park remember I told you about him (or did I) there is some bitter taste in my spit and will you also (this must be whispered) slide that razor tongue along the slit to where death rattled his false teeth are you afraid the salty taste is poison don't be afraid little one it is not addictive (I never douched with holy water) and it's enough if you hate these dark rings (the ones around our hearts the dog collar on each cell in our body) to let air and shit and light and mucus flow in and out with the love which accumulates in the gut in the bowel and spirals out and out or implodes will you throttle it bottle it detonate it explode it will you let me watch you do it will you let me put my finger in your mouth deep throat you with my Peter Pointer will you hook your eyes into mine and wrench upward into my face

inside you (as far as I went that is) was that wet cave was that grotto and there was moisture running down the walls – rising damp – my two fingers were the holy couple and next time you'll let in the three wise men won't you darling (if this a joke I'm jesus christ) does it frighten you that I let words wank do my dirty work for me. .

. .

. .

. .

all my love darling
Tote XXXXXXX

my dear Freda

. . . and then there were all those bubbles bursting last night all those dehydrated desires packed in every cell our fingers and tongues reconstituted with light and moisture all those scraggy little cells sitting up and opening their mouths again and then lying on their backs to have their tummies tickled and then is this called frustration because the lid was not put back on the bottle the orgasm was not had – an orgasm shouldn't be had like a woman it should be and is as coming and going as ever present as – let me think – waves yes or tides – it can be as orchestrated as a filmed tenth-take it can be like being hit by a car but it is what makes us the same as water or trees it is some energy which relates us to life

'one thing' wrote G. Stein Ms Gertie Stein 'one thing I've tried to tell people is that there can be no truly great creation without passion if they have not understood it is because they've had to think of sex first they can think of sex as passion more easily than they can think of passion as the whole force of man' it is not a box of sex it is not a step-by-step-home-handyman's-how-to – there is a wonderful gesture the hand makes reaching across making a definite statement taking a relationship/friendship from one dimension into another (and I'm not talking about that sly eye movement that old hairy

eyeball the disco kiss) offering opening grabbing full and empty and to be filled and emptied ritually occasionally joyfully grudgingly again and again I'm thinking of course of that night camping on Yamba Headland after the seagulls stole our fish and chips after dark between the freshwater lagoon and the ocean when I stretched my long arm across all that territory in the morning you told me it was where your parents had spent their honeymoon

the crab claw on a string around my neck is symbolic of nothing I found it in a rock pool it is orange and black it is not symbolic are you afraid that I will take/you will give something that cannot be reclaimed this is not the mechanism this need not be the dynamic it is not supply and demand it is the economy of water it could be represented as a flow chart I want to chew at your hair like a rat on a block of chocolate I want to untangle the psychic mess of your breast fears – you cried to realize you would always have breasts (Evie cried to realize she would have periods but you said you'd figured they'd stop at some point but you would always have breasts) you don't like them being touched generally you say they are hystericized you say it's the same feeling when I touch your belly button and it excites me this almostdisgust it makes me want to make you love them despite yourself I want to make you swim against the current of yourself

your hands say the same dry desire things men's do they are very sure despite your fears they are very sophisticated they have learnt the object they distance they desire I haven't been in capable hands since I had my tonsils out

the flesh of your face is delicate over a primitive bone structure

when I shut my eyes you are barbaric with them open (even in the dark) you are almost angelic these tensions created by the strong and the sweet by the incongruous excite me and excite me to write create orgasm diamantés and jeans

<div align="right">

I love you so much
Tote

</div>

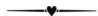

dear Freda
fitted and unfitted with braces
(desire erised)
if I lick into the corners near your incisors with my
finger
does the tantalizing of the pain of the memory of the
embarrassment of braces titillate you
do you know how I hold the whole of you on my
tongue and give you all and everything of what you
want and can (and it *is* dexterity) dexterity be taught it
is taut it is to be taught and sprung and loose and run
with a terror behind and in front it is to chase a terror
with a smile on its face and yet it is as subdued as

<div align="center">49</div>

lacemaking no doubt about it
you want satisfaction you are a glutton no doubt about
it snookems
a greedy girl but no glutton for punishment and I love
the tension
of pulling you even one step beyond
satisfaction stops here
I feel you pull back
my mouth strengthens in its resolve
and your fat yelps of cries
and I pull you out of your socket and you teeter
and as you are about to fly off the handle fly off into
my mouth and pass into me
you pull back *boing boing boing*
superball yo-yo that this game is
it's for real and keeps
and you fall back and rattle 'mo-oa-an'
good
but I'm at it again before you can say 'Jack Robinson
Jack-be-Nimble'
'no no' you go but there's that greed
cat and mouse around the hole
come on then yawannagodoya
come on then I'll take you on no trouble
can you get what you want without giving it away
come on just try it on girlie
hang on to yourself hang on here we go
no
no more roller coaster – I'm gravity the wind
momentum inertia laws inevitability
the pit of your stomach
now
your eyelids
your clenched
fists
I'm the bed you bounce on
the eyes watching the flat hand on the stomach
denying movement
no no no but the pelvis is a greedy pig
a woman wanting and then 'yes'
that 'yes' of yours
ohyes roses
the sound of a woman ascenting you said there's
nothing like it and you're right

you funny Spartan thing you with your brisk morning
walks and your A-to-B Monday-to-Friday nine-to-five
mentality your major chords and your minor
your thick dark strength of desire you want like a big
bass drum
a bassoon a double bass
and how you try now to be kind for us two and you say
quietly 'there you go back into your neurosis – everyone
lets me down' and it's true I do and you grab me back and
say 'no' and how you've stopped being so hard so now we
can be sweet to eachother for ages at a time and how
intoxicatingly erotic what a turn-on and what a turn-up
for the books what an about-face
for us masochistic sadistic porn-ridden lesbians with our
stiletto whip chains cigarette burns drugs broken bottles
flickknife fists leather crew cuts
back to the dormitory – yes – but straight to the bedroom
hope this finds you in the spirit
in which it leaves me

<div align="right">your Carry-all-Tote</div>

> **a mirror-image in black and white**
> **the positive and the negative of the**
> **mug shots the heart takes**
>
> when I heard you push the door open and come in
> – black silhouetted against white
> a door in my heart opened
> – white silhouetted against black
> it was that night I began having shadow orgasms

entry in Toto's *Sweethearts September* notebook

'. . . and she doesn't even know she's beautiful no one has ever told her and
her sexuality such a bird in the bush (I tell you I've seen it the featherless
white bird with orange eyes transparent as an axolotl) a humming bird hiding
all jewel-colouring enamelled even musical and I shake the bush and the shy
bird cries the shy sigh up through the mouth open to the sky my stick
fingers poke birds even birds' cries from your open mouth and you wet
yourself in fright of the flight oh the shy bird will go from cage to cage and
even further to a freedom and all my hand power even may do this who knows
who knows you are beginning to die I know I see the crack where the shadow
of death entered who knows that you have begun to dissociate yourself from
your body I know I can touch the places you have vacated and forgotten who
knows that the machines are beginning to wear out I know I can smell the
unoiled friction and I want to support your gymnastic roll into "I want you

to be my acrobat" I want us to learn this love together mining for gold and fool's gold (it's pretty enough) and come away with three bags full I want to touch the shudder of fear I want to be present I want to watch

I want affirmation of our relationship I want smiles from them all and nods of the head not discomfort or even antagonism being scared for us remembering how years of being bricked-up by bland or hostile reactions with Evie built a closet and the only exits were as built as any tunnel

Evie and I learnt what "being a lesbian" meant

at first we had just enjoyed found joy in eachother but we were so clever and we learnt and learnt until we were no longer just I and I

we'd paid the piper'

you toss me about toss me around between your hands 'not your common garden variety fuck' said Freda Peach

I roll my palm back and forth across your pubic hair

pudenda rolling soft dough flat on a board I have you dancing on the end of this pin doll I can wind the music box to a torture to a fever pitch I can make you toss and twitch a white boat on a sea of spit a white corpse eyes wide mouth open that old rock and roll washed over and into brought to life with these here electrified wires – ten fingers – in the right place plug into sockets I feel the jolt right up to the eyeballs you have been condemned to the electric chair I am the one with the responsibility to pull the switch – but I must admit I am the one whose back arches it is then we are in the thicket together the thickest and tightest part of the night's exercise and I know on this godforsaken planet in this world of scarcity and lack you lack nothing there is nothing stinting nor niggardly you are gorged and sated and that I have provided that there is no give and take no economy worth speaking about does the ocean count the number of waves it gives and tick and tote them up against the number returned there is no checkout chick in this bed no invoice or inventory

your mouth is that little red love-heart shape
(perfect for cunnilingus I told your mother)
a collage of fragments – fucking
mellowing
yesterday
today
acid

all the knowledge I want is in the heart
in the heart of the other
if we do not know how to find it
if we do not know the mysteries of turning
body into flesh into fantasy into fucking
what do we know worth knowing
the scum around the rim – knowledge

a kind of spiritual exercise in sexuality – holding
your image in my eyes and mind and heart
stripping away the flaccid – what do you care
that there are things I cannot control in myself
(no fascist with the life force)
things being needs ('joyous love needs of the body')
(you'd have to be kidding)

ah to pirouette on stilettos – to walk properly you must
balance on the head of a pin
perch on the tip of a dream of femininity
to wear stilettos is to dance and dance and dance
to remember your mother camping it up
to draw all yourself up just a little above yourself
and totter

to save ourselves from the brittleness of being
'the-one-who' this one that one
we must be prepared to fall out of our own sky
and find
a friend a lover with brown hair and green eyes and
a presence we can curl up into and
save ourselves and fall away
appear and reappear
and no way I mean no way this is not terrifying
but there is eroticism in trust when
we have finally ploughed through all the fantasies
all the barbarism and criminal elegance of
our imposed sexuality there is nothing left but
yourself real in a real world
when the divesting process is nearing completion
is complete
and all the tableaux of pain and oppression
rape and necrophilia
coprophilia pederasty and prostitution
are destroyed
when
we are finally descended finally here and now
and found and present in time and space

stilettos – to hold the dream in your head and heart
to live in it is a sort of spiritual exercise
if you fabricate it well enough (it is a balloon)
if you are strong and gay enough (you can fill it)
to exhale with all your will you can live in it

(Archangel Mademoiselle Montgolfier) just above
your own head
just out of reach
just where you want to
just fine
just just just going down on you
('I came as soon as you went down on me' you said)

I sometimes with my fingers make sure
I make the vagina
the labia majora
pink vermilion (we checked it on the British Hi-Gloss
colour chart) and make sure with my tongue it is fabric
and elastic and knows itself and I fill my mind and
mouth with the power my heart exhales and you are
the centre of the cyclone
sucking in and out
so hotsoft powerful
with my fingers fingering all the erections

the essence of what is in my hands running through to you in my mouth
batting like a moth a tongue around a bulb but breaking the bulb breaking
through to the live wire between my teeth satisfied (a knack for loving a skill
something I do well – well well well good for me) such pleasure this morning
– pleasure – the word warms my groin runs circles around my clitoris rings
it a noose a festoon that is strung from the tree in my guts and they strain and
bend with a weight as ponderous as pleasure – pleasure pleasure pleasure
singing down through my open mouth on to yours and into yours and your
jerked head and your shut eyes your left arm outstretched going down on you
is all joy all exploration the eroticism of trust (even respect) saying 'you you
you' with my tongue
(where do you hide your knives and the red eyes even going down and coming
up I am vigilant for the touch of steel of blade of pain you must hide
something somewhere we women have all baited booby-trapped our bodies –
I am not naive enough to believe there is no concealed weapon – come on
now honey let me frisk you)

'ah I madly love . . .' Genet 'but fate had ways of opening my eyes or of
opening the darkness in two so that I could see into it'
– the orgasm the point of intersection the point where all erotica erotic
language etc. attain that apex of vibrating life (a snap – this is me on my wild
goose chase) –
'then I was filled with the gloom that suddenly comes forth at the approach
of death – our hearts cloud over – we are in darkness'

PEACHES – PEACHES AND CREAM

'. . . you could cry like that every day'
said Freda Peach cold
'. . . do you mean ME – do you mean I could or one
could' asked Toto
'. . . anyone could we could all cry like that every day if
we wanted to if we didn't stop ourselves . . . come to me'
she said
now how many people can say that without it sounding
ridiculous but she can Freda can Freda Peach

that body that Vienna loaf that Camembert that
avocado that glacé fruit that marzipan-iced fruit-cake

you come over and over
so many times so quick
I'm thunderstruck
I'm flabbergasted
I'm in awe of my fingers
(the tips tingle if we haven't fucked for a few days)

'come and give me a kiss' said Toto
'here and here and here and one here'

'I can't get enough of your mouth' said Freda Peach and
she couldn't

I was a mouse running along a live wire between
two terminals
your hands
you ran me back and forth
back and forth I ran

going to sleep with you holding me saying 'I love you
because . . .' over and over
and you even had reasons
reasons like a contract

'the girl with the magic mouth' said Freda
and I was

waking up arms around your neck and breasts thinking
'oh shit the washing pay the rent buy the wood for the
table' and you wake up and we're kissing and it's so
warm and drowsy and I say 'no no today we won't
spend all day in bed today I must do the washing pay
the rent get the wood for the table ring about the
paint . . .'

'what about the washing'
'it won't get washed'
'what about the rent'
'it won't get paid'
what about the table it won't get made
what about the paint it won't get bought
passion and excess (yum yum)

'how comforting for you that there will always be the
big soft warm bed to come back to you sloth you
lounge lizard little forays in the mind that's all you
want to stimulate you titillate you
not go too far
impotent flourishes at language
mind you carve those words well now use words to
carve carve up words with words
it's Scrabble and the word is lunch
to you the word is lunch' Toto Rampant

'you are one of the only people I know who knows
how to love profoundly
you are a lover's lover' said Freda Subdued

'you just want me to fit into your cosiness just the last
little bit but necessary part to complete your total
comfort to give you the illusion of change challenge
passion' Toto Stillrampant

'yes I suppose one of the main reasons (but I do love
you) for being with you is the being-seen-with/being-
seen-to-be and I have refused any deep personal
commitment you're right – goodnight' Freda Unsubdued

'deep personal commitment? I respect you? wedlock
warlock' Toto cursed to the shut black door 'you say
there are barriers you feel barriers between us that I am
not responding to you sexually but it is precisely when I
am responding to youjustyou in your hands on the end of
your ten pin fingers (you bitch you had me on the end of
a pin – escargot) and it was just you you youjustyou
I was responding to I wanted lover lover lover with eyes
on you and just the usual burn of your fingers you get
so excited saying "I can feel it I can feel it ohyesyes yes
that's it that's the nerve that's the muscle hi chi g spot
there just feel it moan for me" you want me to you say
"moanmoreforme" and I do down there where I have

56

fallensafely to an extent off the wire down under your
two taw eyes the weight of covers blankets
ceilings skies and there are words flying up words
wording myself from this
beginning from
this unworded beginning
this unworded beginning'

snail's trail

you make me as sweet and juicy
as a chewed stick of sugar cane
and you the kanaka with the machete
and the breath from your mouth
as sweet and sticky as syrup during the crushing
licking your molassas lips
white juice on your jaws

the tide must have risen and fallen
during the night
leaving silvery saltwash lacetrails
around my mouth and on my
fingers

'keep your creepy crawly squashy maggots – your ten
white curled fingers off me
keep your sticky honeyheart away from my hands
your lovecrumbs in my bed sugar on the floor chalk
and cheese grating across a blackboard' said Toto
(sometimes called Offensive Hair)
'watch the theatrics Toto they'll land you in trouble'
'the pleasure of you on my tongue' replied Offensive Hair
as the guy said as he went to the electric chair 'this is
the first time in my life I've got what I wanted'

'. . . too much meaning you place too much meaning
around sex fucking Toto' said Freda
'no it's just that I know you go crazy when you lose
access to a loving woman's loving body you'll see'

bereft stranded beached
image
a woman with her legs apart masturbating furiously
under floodlights in an empty stadium
image
a swamp being drained
image
you deliberately sopping up gravy with chunks of bread

image
you treadling determinedly and mechanically
on an old Singer sewing machine
the needle stabbing in and out of the material under
your keen eye
image
the mystery as tight as a pearl milked from me

realizing you're just lazy
'you're just lazy Freda just a fucking lazy lover'
'yes I know – it's true – I am'
Toto masturbates
a voyeur rubs her breasts and belly

saying to herself
'it means too much
divest it
it means too much
divest it
it means too much
divest it'

oh I am bereft stranded beached
your body is sometimes
such a honeycomb
then
such a Canberra rock

I am suddenly
breaking
my
teeth
and
fall back
off you
humiliated

'we desire to be desired' says that bitch
Freda Peach 'chew me'
no stamina no straight answers
she whispered hoarsely 'chew me'

the oyster eaters
and
in my mouth full
my imagination and
imagining full of
a flesh flower

a fat marzipan rose
an intricate radish rose

a sex salad
a lucky muff diver
what a lucky licker
muff diver dyke
sportswoman chewer
glutton to some
you say
'you'll never have enough'
or
'you'd come at anything'
to be full of you
is to be full of myself
like a fat shadow

you fall asleep like a kid with a bellyful
apple cores and passionfruit skins
composting at the bottom of the bed

at the bottom of the bed
is where your head was

I found a tongue twister
engorged in the tuft of your muff
I stuffed

OK now you try it

a pleasure of a poem
a bliss on paper
you make me
wake
and waking me a mess
of white puff balls
exploding (poof)
into the blue mist of a dawn
(didIsaybluemistofadawn
ofcourse ohyes I meant
pinkskyoverthecity)

so crying so crying again
there at your feet
struggling beside you
with you know what
and so much of it too

and sometimes it's worth it
sometimes it clears away
everything clears and there you are
real in a real world
sometimes it is just suddenly so very there
so very me so very nice so very
scrunched up wound up sprung open
burst forth
sometimes it's so ohyes worth it all
all the straining after
hanging on
hanging in there
to explode white puff balls
handfuls of daddy christmas thistle
dandelion clocks
into a bluedawn of pinksky
is worth the effort uphill
after the carrot
and you
what about you then
you beaut
you beauty
choking out
you you you Tommy Gun
you you you April Fool
you you you Jack-be-Nimble
you you you Jack-in-the-Box

oh you castrate me fret me
you make me make out with myself
you make me lie wanting you
I wait for some sign
you are still
monolithic
(you are the golden phallus
the Easter Island statue)
it's such femfetish

you castrate me fret me
you tell me what to do with you
it was never like this before
you stop me
you start me
you make me wait for you to want me
(yet it was you who dreamt your two

front teeth were knocked out how come)
you say you don't understand when
I love you
say I love you and fuck you
you say the loving has nothing much
to do with the feeling fucking
you say I don't realize how violent
and degraded your sexuality is
I say it is this sexuality I have
handled for thirty years now
and it's this and your
saying this and then my love and running
between these three
that create the tension friction frustration
excitement orgasm in the end

my heart plops down sinker weight
like a lead moon
into dark water
plumbs depths and
jerks back into its pocket
locket on a chain

you are still
I am a moth batting a bulb
how we women can flap
around and around our desires
all night if necessary and wake
rampant jackbooted ugly
a terror in the office

you say you want me to just
fuck you poke and poke and poke
into you hard

and still waking wound around
our dawn bodies
'your dawn body' you said

and still we can play ping pong
all night with these contradictions
fears even a terror or two
and still we have danced and danced and
danced on glass on hot coals on booby-
trapped ground and come and come close

to coming and not come and it's still to come
done such juggling feats with a ball of bliss
a beanbagful of heartseedpeel
fingered and palmed down and balled so
much it's made a circus it's made us
make a circus of a night

what can be said –
only
pleasure leads us on
by the nose
pleasure brum brums our stomach
kicks the starter motor
is attached to the starter motor
is the starter motor
still
thirty years on
pleasure erusaelp
pleasure erusaelp
pleasure erusaelp
and this is an everyday miracle of course
'and'
a conjunction
'and'
a word a bliss to say sometimes
'and'
a handful
'and'
a clenched hand
'and'
a cupped hand
'and'
a poofed breath
and $Pl^{ea}s_{u}re$
$p \, l \, e^{a} \,_{s} \, u^{r} \, e$

'what a performance' said Freda Peach

I heard on last night's news that unexplained red fireballs were reported
hurtling at tremendous speed across the Blue Mountains and I heard on
this morning's news that somewhere in America a woman spontaneously
combusted while crossing at the traffic lights even her small change had
melted together in the intensity of the heat

I've lost my nerve
skiing across pages
my stomach turns at the thought
of the velocity

**the text that writes itself (or is written)
in the morning (or afternoon) after
lovemaking (or dreams about lovemaking)
is the best text**

I would wake with her
curled inside me
the fruit snuggled inside the skin

I would wake suffused with
the juice
and the light
of the fruit
I would wake willing
to dissolve
we were the sugar
and the water

I would
let me repeat
would wake willing
and wake willing nothing at all

wake knowing
there was nothing
of the night left
nothing
other than that
which had
plumped out
spun around
flowered and ferned

there were mornings
this made knowledge
as known
as the code in the cells
grasped as sure and fast as
the synapse

and all the magic mechanics
and mathematics of the
functioning of the whole
being
and
body was pleasure
spelt backwards
pleasure with a mirror
held to it
pleasure a bridge
reflected in still water
p-l-e-a-s-u-r-e one letter
on each side of the dice
and a whole handful
p-l-e-a-s-u-r-e the only letters
we could use in Scrabble
plea-sure each syllable
a hive of bees in my brain
and the flower fields my heart
and the flower fields my heart

pleasure the answer to the equation

pleasure the solvent
bliss the solution

(menstruum
menstruum
menstrua)

this is possible and occurs
when the dream and its reality
become the flame to the faggot
this has happened
and made me say with John Rechy
'we made love for long moments'
made me say with Pablo Neruda
'for it's in a woman's mouth that
sweetness has its place'
my dowry
a million cells of spun marzipan
a tumbling of Petits Fours
no bank or box just bakery
no bank or box necessary
it has been given into me
where nothing but empty shelves were

been given in by hands and desires of
the desirer and the determined satisfaction thereof
and I am neither thief nor custodian

I am running away
(as you can see)
I am running away
withall
withall
and poverty has been alleviated in
a certain third world country
alleviated at its root cause

the-stare-in-at-the-pastry-shop
we have dipped into the wallet of our desires
we have pulled out the notes necessary
the notes written all over with
needs
needs
needs
written and forgotten
not-to-forget-this-or-that notes

all wants whacked on the head
and no head to hold up in the end
except our own deadhead self
'he's a bloody deadhead'
my Father used to say

what point is bed without you Freda

**you do the magician's trick with your
fingers as teeth your arms as saws
you do the magician's trick of sawing the
woman in half**

sometimes your arms are like chainsaws sawing into me
and I'm conscious of the syrupy sap the tenderness of
the soft bark the sawdust
conscious of the hard dark pith you have gained
conscious that my arms are branches ineffectual tossled
are you conscious that your hands are dirty with work
that work has been done

65

that your actions have been neither irrelevant
nor ineffectual
that there is misery/ecstasy/beauty
weighing on us
that there is meaning
between our palms
between our eyes
between our legs
between us
screeching with life

that you have created with your hands
a ringbark
a newlife
a million words of sawdust and sap and splinters

I feel your tongue licking the sever
tonguing around the rim of the stump left
tonguing like a crazy woodchipperchopper
of an eccentric
with
habits
erotic with trees
loving the feel of the pulse of the tree
beating on my tongue
playing with osmosis and peristalsis
and feeling the beginning of leaf bud node nodule
of new life and the ecstasy of chlorophyll
the ecstasy of cholorophyll and coming
coming through the mouth and into the new leaves
coming over like cumulus
coming out like a winter sun
coming back to the sense of the bush
coming over to carry the tree off
coming into the bush to carry the wood off to the site
carrying away trunk leaves branches bark splinters resin
sawdust
grubs ants lizards
years in rings
the tree marries anew every year some say
to marry a tree well to marry any tree is risky and
eccentric
marry I will
and
marry I won't

THE MAIN BODY

a woman's face changing with love and passion
in your bed under your hands
this is a pleasure I have known

**'precious little good it has done
you' E.C.R. Saidthandone**

suddenly swamped
by the memory of lying
in eachother's mouths
like lizards in shallows

lacustrine
'of dwelling or growing in lakes' Mr Webster says
all these five birds ten birds hundred feathers
returning to that island there with the mountain and
the lake that valley there between the two steep
mountains that deep salt water lake that mountain
there with the pearl on top those five birds ten birds
hundred feathers returning bringing with them
monsoon wind loud cries Spring stirrings and dawn
settlings – staying eyesful – here in me – of birds settling
on water at dawn – sanctuary
you are here you are staying

'my hands are birds
they're landing' said Freda Peach
'this is the tip of your consciousness this is all you
know I am dancing on the pearl on top of the
mountain you are dancing on the tip of my finger I am
dancing on top of you dancing on you my feet on you
my heels twisting into you this is all you know this is
the tip of your consciousness'

**'dowsers and their divining
rods' E.C.R. Mellowing**

what is this called you said what is this then

the mountain I said me I said
what part of me you said
my little mountain I said
what's its name you said
Mt Clitoris I said
and what's this then
Lake Vagina then I said that's my vagina
and what's all this then you said what's all this wet
rain I said
why you said

67

the rainy season I said see your hands they open the
monsoon clouds

you said after I had finished you said you hate me
I said yes
you said you had had me on the end of a pin for ages
I said yes I know you liked it yes you said
you were shy you had had pleasure
I said you love anyone who lets you do that to them
you love them for that for their vulnerability
you said and you love someone for doing it to you
for making you be that vulnerable

there's nothing smoother you said flabbergasted nothing smoother in
the world in the whole world nothing as smooth or smoother and your
finger just rubs and rubs you love me and because I am wrecked like a
ship in a bottle a wrecked ship on a reef your love flows into even the
captain's cabin once so snug and dry ohfreda you are real pink you are
real white you are real soft you are real passionate you are real good in
bed you are real good to talk to your eyes are brown feathers green
grapes green grapes when I want to suck them dry brown feathers when
they tickle the inside of my rib cage
there's nothing softer you say nothing in the world softer it's like
stroking a cloud then parting it with your fingers to make the rain come
keel-hauled

'no prowess' E.C.R.

and the edge the edge of our lovemaking that's what
I like most
that is I love you dearly passionately and sadistically

linctus
a white eyeless slug being sucked out drawn out poor silly
instinctual thing and you puckered your lips around and
said
'I'm going to suck your sexuality out into my mouth'

a sextec
sucking the soul through the cunt
remembering Gide 'deprivation has fed nothing
but my soul'
cunning lingamist

by lavishing love tongue fingers gentleness palm teeth suction chewing
affection care delight stroking to the clitoris labia anus vagina (and
don't forget the bush-walk between Lake Vagina and Lake Anus) by
doing this deliberately and to delight and excess the petite venus (as I

affectionately call it) forgets its pain and deprivation directly and when this is achieved there is no more call for the soul (the soul as we know being the gladbag as it were for all our unfulfilled desires everything we can't have) of course this technique must not be applied every time or when one is not in the mood

thus the soul is sucked into the waiting mouth of the lover and digested it proceeds at first with a vibration of the clitoris on the lover's tongue the clitoris as it were vibrating tenderly of its own accord

at this stage it is a little talking tongue from whence comes the expression 'when your clitoris talks to itself' and the answer of the ardent lover 'yes but when the vagina answers I'll know I've got you' or 'when the anus vagina and clitoris sing together in three-part harmony I'll celebrate the mating'

note to Freda with a bunch of kangaroo paw wattle and christmas bush

I realized yesterday that the most comforting thing in the
world
is your head your little round soft brown head
between my legs
I rest then
I rest upon it
it is the only time I rest

with men I am balanced
on a pin
I wobble between
contradictions
but when sex is good with you
it is resting

it is handing you
this me

this messyuglycomplex
conglomeration
this psychosexual disastermiracle

and we are wandering
in regions of the confounded and contradictory
and we are equipped
you and I are equipped equally
with some measure of sophistication
namely love
intelligence
well-meaning

———♥———

'ah' said Freda 'the weight of a woman'
'and ahyes the sound of a woman ascending – ohyes and
ohyes roses'

the meat in the meal
pulling your tongue out
sucking clear to the roots
those tap roots and secondary
threads of roots that root
system
the last to go down my throat
poking between my lips like chaff

with all the oohs and aahs and
da das
(the sound of a woman ascending)
on the ends
like nodes and nodules

and then you fight me for
mine
for my tongue that is
this is called the give and take
die Sturm und Drang
of relationship
– lesbian that is

'darling' I say it over and over to excite myself 'it's just long
enough and noosed enough' I said 'it's just long enough to
reach a ring around my vagina it's like a crooked finger
that word'
you run rings around me Freda
your
breasts in my eyes over my
eyes
touching
your eyes with my thumbs
your face between my legs
the quivering of your eyes
under their lids as you
suck and eat
some mysterious
crustacean masochism – a marinated prawn on a plate
turning itself inside out
forcing myself through my own cunt head first
a tricky stunt of a meal of a prepared prawn

we have known
we have known
we have known eachother – carnally

when my hand holds my cunt my clitoris it is you
I clasp
your breasts your face your thighs – clutched
'come over tonight and do the same thing' said Freda
she had come between a masturbatrix and her hand

 'on the hole I prefer women
 but then again
 all that glitoris is not gold'
 Inside information

'wrap around joy'
that little bewildered look Freda would get on her face
when Toto would jokingly flash at her
Freda's voice would turn to water and she'd say 'come
here baby' or 'don't' if they were going out
or expecting someone
wrap around joy
certainly it was

Freda said 'the only music that in any way describes what
I feel about you is disco music'
ohfreda
ohfreda
down deep
out of the mouth
comes the desire
of the pearl diver
for the taste of the pearl
the roots of the tongue
require
the roots of the tongue
require
the roots of the tongue
have requirements
which I haven't the heart to name
ohfreda you are not here anymore

 'constant abrasive irritation
 produces the pearl
 it is a disease of the oyster'
 E.C.R. Reminded
 'you are ludicrously over-exposed
 with her'

'I suppose you and I are lovers' understated Freda
Undressing
'do you realize what this would be worth on the open
market Freda
fortunes king's ransoms are being won and lost on this
gaming table'

'I'll lick you good and proper'

your edges are feathered
with these here lappy little eyeshandtongue
I can lick the sheen back
keep you beautiful puss

being loved makes you beautiful
hands of sandpaper
softening angles
sprinklerfingered eyes splashing on you
flushing tired flowers after rain
– a child's smooth face after sleep
– smooth as a baby's bum

'it's the red pearl after all' E.C.R.

'I'm anxious for the red pearl' said the abalone diver
fishing around in the aquarium of her mind with a pretty
finger 'amongst the convoluted and scalloped lips and
innerfrettedpetal scraps that sway like anemones under
the weight and tide of ocean all that's as may be but
nevertheless I am anxious for the red pearl'

I love the way you watch me it makes me Object and it is
a relief to lie Object at times dangerous but a relief this
playing with pearlfire

the celebrant on the radio boomed . . . 'the way hands
want pleasure from you disregarding your pleasure – there
is something limp in fingering the other to give them
pleasure you must actively and virilely take pleasure in
giving it in watching it destroy the face of the other it is a
scurry between sadism and sainthood and worth waiting
for and worth working for'

having found the wailing wall

what is all this wailing
in women's arms
women wailing in
eachother's arms

wanting to get into eachother's
skins
pressed too hard together
all night

flagellated
flailing
around
on the tip of that
pin

she
having put the needle in the groove
on the edge of that
earth
being prodded and poked along
that tightrope
being
strung out
dragged along
by the thread and stream of mucus
and the scream as silent
as the space in which I come
and
your beautiful eyes making me
willing to wobble

'spreadem' Freda Yobbolesoguttersnipebardyke
'I love you'
'what we are doing now has nothing to do with love' said
Freda

what point
as I have said before is bed without you Freda

I can't keep my hands off you
in my mind
how can I make you
when I make you
from the absent one
be
come
suddenly salty

I'm saving myself like a biscuit for later
I can't keep my hands off you
some days I almost have the strength of desire necessary

to stir with memory and reconstitute your body
it's uncanny
unhealthy
a monster movie

obsessed by your thighs
being so wide apart
a g a p e
aghast at the loss of this
'I don't want to get into any ashram honey except the
one between your legs'
how could this blow
of beauty be gone
forced back into the guilty isolation of my own
imagination and then you arriving nightly at the
place of no singing after the slither and slide
for the red pearl you arrive and there is suddenly silence
down there in there then I scurry I am Hysteric
I scurry I tell you with explosives – words –
and word and word myself I word your fingers
I am brailleing I am exploding the silence –
ten dynamite fingers a kamikazi mouth

I tell you you detonate me you pull the grenade pin
'no one has ever made love to me as subtly as
passionately as intelligently'
we have put our money where our mouths are
'my word' said Freda Peach 'good job we know what
we're doing'

'when you are this sad' said Freda 'I feel like a
child must feel "don't cry mummy don't cry" is all
I can say I feel as impotent as a child
I love you so much
I keep losing you and finding you two days away'

> 'oh my body my body has
> become a terrible field of battle'
> cried E.C.R.
> 'what point is bed
> without you Freda'

the need your fingers make of my organs

I run across a minefield my sexuality
I am baited mind and body
tucked into my flesh are booby-traps bombs flickknives
there is no way now I can .

running across a minefield with a rose in my mouth

Toto Caelo said 'say you love me'
Freda Peach said 'no I'll only say it when I feel it
welling up inside me'
Toto Caelo said 'what are you thinking about Freda'
Freda Peach said 'the colour of y/our love it's
crimson – no – vermilion'
Freda said 'I love the way we ride our pleasure' and she
made waves
she said 'I use my hands more when I'm with you than
I do with anybody else you make me appreciate my
imagination I miss the mobility of your face'
you never try to hide your pleasure
your enjoyment gets stuck in my gut
I run with the line the truth is I'm hooked

**news from *Fishing News*
by E.C.R.
'whatever kind of lure anglers
use don't forget it's always
hooked and it gets you
in the softflesh when you
least expect it'
'shush don't tell her but Freda
does not love her enough to
learn the secret the big secret of
sustenance she's the eat-and-run
type' explained Toto's friend
E.C.R. Saidthandone 'Freda
used up her body like a tourist'**

'look there's Freda there she is in the shadows
what's she doing what's she got between her teeth'
'she's plundering the body of our love'
Toto dreaming she was spewing

**she looked back on the pain of that
relationship the way the dead must look
back on life**

Toto dreams she is wandering the flat earth
she is asking everyone everywhere
'is she still beautiful
is Evie still as beautiful'

she is carrying a postcard which reads
'your eyes are not the only blue and whiteness
there is Greece'

one night
someone asked 'Evie?'
'yes – you know – Evie' Toto said
instinctively pointing to her ribcaged heart

one day
after she'd been talking to Evie on the phone
I noticed she'd doodled
'please please please
s'il vous plait silvousplait
Sylvia Plate'
all over the front of the telephone book

A PLAY FOR TOP VALUE
(stage name CHANSON WA WA – professionally known as
CANDY MOUNTAIN)

'god god will it never cease
the sliding and the roar
and riding of tremendous seas
along tremendous shores?
there listen it comes again!
the foaming scuffling smother
the ponderous heave and the pain
of one love dragged from another' EVE LANGLEY

'last act
which is a fact' G. STEIN

> '**Top Value what a penny
> in the hand
> Evie what a pain in the heart
> Freda what a pain in the arse'
> frivolous little song by
> E.C.R. Festively**

TOTO: [*on the phone*] . . . and I thought I was the steadfast sincere type you know heart like a trap-door spider and all that well thank christ and all his virgin fucks I'm not remember how I used to be once I'd settled on some poor blighter I wouldn't budge until there was no more blood no more surface veins left like I was with Evie remember well I'm teaching this old dog of a heart of mine new tricks I am referring now my dear to my *deus ex machina* that is the new chick she's top value I can tell you I just thought one night awfugitanbuggait you've got the hots for her stop hanging in there after that bloody tart Freda you've missed that boat and a miss is as good as a mile to a blind dyke any day just go for it no sheila never got nuffin outa bein a good girl and doin the right thing

[Top Value finds her later that night singing that old Mortein ad over her bottle 'when you're on a good thing stick to it']

TOTO: Freda Peaches is no good
 chop her up for firewood
 if she is no good for that
 feed her to the old tom cat
 here's pubic hair balls to you Freebie
 I'll drink to that

[Top Value sits in the big comfortable chair – behind her is the open window through which can be seen the dark harbour and the moon through the camphor laurels]

TOTO: *[Shakespearian in a drunken monologue]*
 to have found you when you were there all the time
 the little hedge mazes once so tortuous to me
 now circle and recircle in a joyous dance of
 enclosure and release
 a waltz just above the grass
 a scamper where the soil itself tags at our feet
 a wild puppy
 and I clasp and release so very much something
 such a very real thing
 this distance and separation are the hands of the
 wizard of erotica
 performing that feat that sexmiracle – you as object
 and now I begin to weave out towards you
 webbing you into my life
 (wording you) the woof and the warp
 the days with my eyes closed
 the nights with my eyes open
 and in time we are confettied by the celebrating soil
 with its brown hands full of small flowers at our feet
 – nosegay pot-pourri

TOP VALUE: you should never be unattended it doesn't become you

TOTO: no and I don't come too good either
[walking over to Top Value – they are fucking around in the big chair]

TOP VALUE: lying beside your body all night is like sleeping at the bottom of the ocean and feeling the sand with my hands

TOTO: I dreamt all night last night that I was the flat earth and you were dark patches of water and bush and the pattern kept changing

TOP VALUE: that's because I kept talking to you for hours after you went

to sleep telling you that you were like the bottom of the ocean
and after I went back to my own bed I kept waking up and looking
over at you on and off all during the night it was like waking up on
the beach and seeing the wave marks on the sand as the tide rose and
fell – the white sheet across different parts of your body
lying on top of you is like lying in . . . sand

TOTO: that's a poem to single beds if ever I heard one

> [*singing*] **singing corpus christi**
> **corpus christi corpus corpus**
> **delectiae – E.C.R. Saidthandone**

you know last night you made me realize that all the delight in the
world begins in access to a loving woman's loving body
– that's what people take holidays for
'. . . a treasure buried alive
since the world's beginning' that's what Genet said

> **corpus corpus corpus christi –**
> **E.C.R. Still Festive**

TOP VALUE: your fingers turn whatever they touch into sweetmeat – when
I watch them touching anything it becomes an extension of my skin
and this
simulation just above the skin is more exquisite than actually being
touched I used to get almost delirious with this sensation when I was a kid
I suppose the body itself must have memory it's a wonderful thing and I
suppose this simulacrum business is the basis of fetishism

TOTO: I don't know about all that but you're the sweetmeat my girl
[*and they're at it again*]

TOTO: I was only a force last night you know I lost my body my sex my
humanness the heart knew nothing of the onslaught – just a force – gravity
momentum whatnot I was malevolent and ecstatic I went into you over you
between you the heart knew nothing of the onslaught I made you sing out
my name I pressed you on this point squeezed it out of you despite yourself
lying on top of you pressing you through to the bed springs making you
say it and remember when I gave you a fright and you said what's that do
you know what it was

TOP VALUE: no what

TOTO: your urethra – and when you were bearing down on to my fingers I
had three sweet erections and two deep orgasms from my fingers up my
arms and into my stomach

TOP VALUE: I warn you I have an incontinent heart and every cell in my
body can open up I have too many tongues too many sweet tongues too
sweet for tongues

we know how to touch the live wire the bone in the body we do not just rub surfaces rub surfaces
[*she said rubbing surfaces*]

TOTO: if you rub surfaces you are invariably and inevitably a sado-masochistic brute consumer consentor using and using up others as expendable interchangeable commodities all black cats look alike in the dark and all that

TOTO: ya wannabit a the old mons venis hey abituvataste uv the old monso veneseo she's a nice drop hey wanme ta go fa a bit uv a tit a tit wiv ya clit hey a bit atheoldbluetongue between the leggings lass want a bituv a tonguin where it counts do ya sheila
aw playin possum are we
[*they're at it again*]

TOP VALUE: it's a little bird's nest

TOTO: [*thinks*] no it's a mouse's nest

TOTO: [*grazing on the blonde grass around Top Value's neck and along her shoulders*] I'll never hurt you you know that

[*at this point in the proceedings
Inside Information gets
into the act –*]
Toto to Freda: why do you do
this I've never hurt you why
have you hurt me so much
[*a softinthehead song for the
tongueincheek chorus of a
toothless singer*]
Freda: it has to hurt
Toto: why
Freda: because I like the look
you get on your face
when it does
your little crushed face crying
under my gaze

TOP VALUE: yes I think so – I think I believe you it's just
that

Freda to Toto: I'd have loved
you more if you'd had
the power to hurt me –
you didn't
[*chorus continued*]
no killer instinct
no knee-jerk response
loserlover loserlover
loserlover loserlover
these tongues are weapons

these tongues are weapons
these tongues are weapons

TOTO: I'm not interested in that old pantomime you know the eroticism around the sever of the suture all I want is strength through pleasure no fascism with the life force

TOP VALUE: you turn me to butter

TOTO: well Gertie did maintain that the fact that butter melts is one of the important facts
here I'll whip that cream for you

[*and with that Toto had the joy of seeing her thrusting her head face-down into the pillow moaning stabbing her in the bum and cunt all night the index finger of her mind not so much tired out as wound up like a top*]

TOP VALUE: I like to be dominated I guess

TOTO: nonsense don't use that word it's wrong you just mean you want to trust someone enough and trust their desire for you sexually that you can relax yourself in their company in bed trust your body to them that's all nothing to do with domination submission and domination are just cheap take-away fast-food versions that make you despicable to yourself it's a perversion of women's phoenix ability

'the only way to salvation is to
salvage yourself'
E.C.R. Gnomic-as-Ever

TOTO: real masochism the true masochist is the one who keeps coming back to mummydaddy for more who knows she will never be satisfied until the hand that beats her caresses her who begs the question 'why did you always hate me' from the brute she keeps going back to

[*toward dawn*]

TOTO: I know you'd be a good lover when I noticed you always smelt books before you read them – especially hardbacks
[*joking*] now make love to me like a feminist

[*putting Judy Small on the record player*]

TOP VALUE: [*making a scoop of her hands*] it's like a coral bowl a coral bowl with all kinds of juicy fruits in it

[*later*]

sometimes your hands swim through the layers and layers of my flesh

[*later*]

there's a resort there under your arm a little bay and a sheltered place for resting

80

TOTO: [*as she leaves for the day she slings her arm around Top Value's neck and whispers in her ear*] your cervix contracts around my finger the way a baby's hand squeezes

TOP VALUE: [*pleadingly*] my little clitoris is going to talk to itself all day now

[*extract from note tucked into a bunch of lily-of-the-valley delivered by Interflora to Top Value during the day*]

'. . . stroking my whole body all night long until your fingers became fine sprays of white flowers until they became fine silver wires electrifying my epidermis until they became delicate instruments of torture and the night wore on for too many hours and I loved you irritably as dawn reprieved us we are two live-wire women wound and sprung together we are neither of us afraid of the metamorphoses transmogrifications the meltings the juices squelching in the body out of the body – a split fruit of a woman we are neither of us afraid to sink our teeth into the peach

it's not love or sex it's just that we are collaborating every night on a book called *The Pleasures of the Flesh Made Simple*

and then some days are spent restless to almost madness for something real human to equal the night's companionship'

[*Top Value replies through Interflora*]

'. . . you leave me with a lot you don't leave me at all'

[*that night*]

TOP VALUE: well I hope you're pleased with yourself you've ruined everything Kapok and I are through I can't make love to my pillow anymore and it's all your fault

every time I try to your pillow gets in between and smells of your hair and I lose track

TOTO: at last I've come between a masturbatrix and her hands [*kissing Top Value's palms*]

**E.C.R. knows what Toto is
thinking:
there are no bodies
there are no bodies
I don't know you
all I know is
how to give you
pleasure
Freda knew
there were no
bodies
she also knew that
nobody knows anything
but their own pleasure**

which must then be forgotten as
soon as possible and hopefully
destroyed
Toto to Freda: ah I'll know
you love me
when I can come between you
and your hands
Freda spits: likewise honey
likewise
Toto: I couldn't bear to be
the cause of your not being able
to open your legs like this
it's such a childlike gesture
of trust
a womanlike gesture of demand
I do not take this for granted

TOTO: there are no bodies

TOP VALUE:[*playfully*] prove it if there are no bodies you can kiss my heart
you should be able to put your hand right inside and hold my heart and kiss
it better if there are no bodies

TOTO: I can't stand your vulnerability Top Value it's my own sad face I
see it makes me as responsible for myself as I am for you and I feel I have
no strength to sustain either of us let alone both I am too far gone pet far
too far gone

TOP VALUE: we're both too far gone

TOTO: and you can't touch me I am populated unvirgin desperate to
depopulate I am peopled improperly with alien armies with my own savage
guards the praetorian guard and I have evacuated to the Great Divide of
my mind with my swag of evidence
my catechisms of names I name before sleep
I am too far gone
I am the complete john the complete whore I get my pleasure from the
observation of your pleasure in my hands under my mind within my grasp
and ken but it is the pleasure of an old lecher an old whore I'm cold to the
bone done for

TOP VALUE: but I've got enough central heating for both of us

TOTO: you know I want you because you aren't dead like me and I need
you and your innocence 'the comfort of an innocent presence' as Proust
says but one day you'll be like me too using live ones to feed on you
thought I was joking when I said that I made you say my name say I love
you for that little bag of blood my ego didn't you well I wasn't
we women have all developed all sorts of cute little devious ways
of sustaining that hungry little organ vampirism that's what it's all

about life civilization art one lot of dead who in living off the blood and fat of the living simulate the twitchings and tensions of life to give the other dead – the consumers of culture – the illusion that they are alive individually this vampirism is called maturity – collectively civilization – the more civilized a society the more heavily this vampirism is concealed the truth is we are all savages each to each and vampires upon the unsuspecting don't say I haven't warned you you'll end up like me one day living off the blood and fat of someone as trusting as you are

TOP VALUE: ooh you do say awful things sometimes mr wolf

TOTO: OK of course you don't believe me OK yesterday when I was drawing down at the Toxteth Pub a man came to the door and watched me and after a while he came up to me and whispered – 'draw a fork can you draw a fork' – 'piss off' I said and looked up into his smile – 'if you can draw a fork you'll know who I am' he said and as he left he leant down and said – 'Izzard the name's Izzard just ask for Old Horny' – OK now neither of us can say she hasn't been warned

TOP VALUE: I wish you wouldn't drink so much darling especially when you've got your period

TOTO: you know sometimes I get the funny feeling now don't get me wrong it's just a vague idea I know I'm way off but it sometimes occurs to me that this is what a relationship is supposed to be like

TOP VALUE: oh nonsense there's so little angst it's not worth talking about

TOTO: yes you're right you're too young to trust

TOP VALUE: ah we're both too tame and anyway you're guilty of the fault you find so disgusting in others

TOTO: huh what

TOP VALUE: well you detest those who still believe in 'nice' people and yet you think I'm 'nice' 'innocent' and all that you're a bullshit artist Toto

TOTO: KISSUCPISSUCKISSUCPISS
she's found me out

[singing together] she's so sweet
he's such a beautiful guy
you get what you deserve so
don't ask me to cryeyey

[Play ends with this poem]

when I had a woman to work my will
wreak vengeance upon
into the night
she lay there so softly
so brownly
so honeybun
I beat her severely with my sweet tongue
and my eyes
what she let me
where she let me
so often
lay across
come across
she would
with barely an asking
come across
with her 'oh's and her 'i i i's
grip me and 'no' me
I'd 'yes' her legs wider
spread table
lay meal
easylay meal
tuck in and
go for it
up to my eyes

the dessert was always some sweetmeat usually that
rare rosette puckered and pursed – lipless –
marinate? – ohyes always marinate for at least at the
very least fifteen minutes before hand before finger
then afore and aft shaft
'that was a great snack now what's for dinner'
me I suppose

I gotta crush on ya skin
petal thin for the perfume

creasing ya eyes
into blue crépe de Chine

when youse wa folded like a fan in me hand
it was a mystery ta understand
it was a fan ta open

colour
delicacy uv structure an practicality uv design
. fa tha hand and this amongst other things
is what me hands
wa made fa

a big white spoon
hand
in
blackcurrant jam
tossled hair her
above me

4

LESBIAN BODIES

Tribades, tomboys and tarts

Barbara Creed

Femme, vampiric, muscled, tattooed, pregnant, effete, foppish, amazonian –
the lesbian body comes in a myriad of shapes and sizes. Images of the lesbian
body in cultural discourse and the popular imagination abound. Various
popular magazines and newspapers have announced that it is now chic to be
a lesbian – 'in', fashionable, popular, desirable. The 'Saturday Extra' section
of the Melbourne *Age* recently ran a cover story entitled 'Wicked Women',
in which lesbians were described as 'glamorous gorgeous and glad to be gay'.
On the front cover of the August 1993 edition of *Vanity Fair* we find an image
of femme super-model Cindy Crawford shaving imaginary whiskers from the
boyish, smiling lathered face of k.d. lang, the out-lesbian country and
western singer. 'Oh, to be a lesbian, now that spring is here', seems to be the
latest media hype. Fashion aside, is there a quintessential stereotype, or
stereotypes, of the lesbian body?

Fashion photography which displays the look-alike bodies of female
models, often in an embrace, draws on the notion of the narcissistic female
double to sell clothes and titillate the spectator with suggestions of auto-
erotic, anorexic lesbian desire. Much pornography, intended for heterosexual
male consumption, displays an obligatory scenario of nubile female bodies
engaged in sexual acts. In pornography the body of the lesbian is constructed
as insatiable – a monstrous quicksand of desire. Myths of the warrior amazons
depict these women as heavily muscled and single-breasted – no comforting
maternal milk on offer here. The popular press still depicts lesbians as man-
hating, knife-wielding bra-burning amazons – more a creation of masochistic
male fantasies than a depiction of lesbians from the real world. *Fin-de-siècle*
art depicted the lesbian in a number of bizarre stereotypes (Dijkstra 1986:
152–9). In painting, lesbian contact between women was portrayed as an
inevitable extension of their narcissistic desires. Women were frequently
depicted as if mirror-images of each other: identical faces, hair, clothes. They
were usually shown as locked in a close embrace as in Fernand Khnopff's
The Kiss (1887), Edmond Aman-Jean's *In The Theatre Box* (1898) and Pablo
Picasso's *The Friends* (1903). Another popular image of the period was of

the lesbian as deadly siren who waits for her male prey while savouring an erotic embrace with her amoral sisters. *Fin-de-siècle* culture also, according to Dijkstra, represented the lesbian in more perverse roles: she was a depraved masturbator, sometimes endowed with a large clitoris that looked like a penis as in Felicien Rops's *Hermaphroditic Joy*; while at other times she was seen as bestial, prone to engaging in cunnilinctus with the household dog, also presumably a lesbian.

With the advent of the cinema, stereotypes of the lesbian, which draw so heavily on the visual, were represented in increasing variety. Here we find the lesbian in a range of guises: mannish imposter (*Walk on the Wild Side*), fanged vampire (*The Hunger*), virginal victim (*Vampire Lovers*), predatory school-teacher (*Vampire Lovers*), man-eating monster (*Basic Instinct*), child-woman (*The Killing of Sister George*), chic femme beauty (*Les Biches*), narcissistic double (*Single White Female*), prim professor (*Desert Hearts*), sophisticated seducer (*Morocco*), tomboy (*The Fox*), frustrated nun (*Extramuros*), depressed loner (*Rachel, Rachel*), suicidal depressive (*The Children's Hour*).

If all of the above describe popular images of the lesbian, they describe equally images of women in general. Regardless of her sexual preferences, woman in whatever form – whether heterosexual or lesbian – has been variously depicted as narcissist, sex-fiend, creature, tomboy, vampire, man-eater, child, nun, virgin. One does not need a specific kind of body to become – or to be seen as – a lesbian. All female bodies represent the threat or potential – depending how you see it – of lesbianism. Within homophobic cultural practices, the lesbian body is constructed as monstrous in relation to male fantasies.

Unlike man's body, the female body is frequently depicted within patriarchal cultural discourses as fluid, unstable, chameleon-like. Michèle Montrelay has argued that in western discourse, woman signifies 'the ruin of representation' (Montrelay 1978: 89). Julia Kristeva distinguishes between two kinds of bodies: the symbolic and the imaginary or abject body. In *Powers of Horror*, she argues that the female body is quintessentially the abject body because of its procreative functions. Unlike the male body, the proper female body is penetrable, changes shape, swells, gives birth, contracts, lactates, bleeds. Woman's body reminds man of his 'debt to nature' and as such threatens to collapse the boundary between human and animal, civilized and uncivilized (Kristeva 1982: 102). Bakhtin argued that the essentially grotesque body was that of the pregnant, birth-giving woman (1984: 339). When man is rendered grotesque, his body is usually feminized (Creed 1993: 122): it is penetrated, changes shape, swells, bleeds, is cut open, grows hair and fangs. Insofar as woman's body signifies the human potential to return to a more primitive state of being, her image is accordingly manipulated, shaped, altered, stereotyped to point to the dangers that threaten civilization from all sides. If it is the female body in general – rather than

specifically the lesbian body – which signifies the other, how, then, does the lesbian body differ from the body of the so-called 'normal' woman?

There are at least three stereotypes of the lesbian body which are so threatening they cannot easily be applied to the body of the non-lesbian. These stereotypes are: the lesbian body as active and masculinized; the animalistic lesbian body; the narcissistic lesbian body. Born from a deep-seated fear of female sexuality, these stereotypes refer explicitly to the lesbian body, and arise from the nature of the threat lesbianism offers to patriarchal heterosexual culture.

The central image used to control representations of the potentially lesbian body – to draw back the female body from entering the dark realm of lesbian desire – is that of the tomboy. The narrative of the tomboy functions as a liminal journey of discovery in which feminine sexuality is put into crisis and finally recuperated into the dominant patriarchal order – although not without first offering the female spectator a series of contradictory messages which may well work against their overtly ideological purpose of guiding the young girl into taking up her proper destiny. In other words, the well-known musical comedy, *Calamity Jane*, which starred Doris Day as the quintessential tomboy in love with another woman, could be recategorized most appropriately, in view of its subversive subtextual messages about the lure of lesbianism, as a 'lesbian western', that ground-breaking subgenre of films so ardently championed by Hollywood.

THE MASCULINIZED LESBIAN BODY

There is one popular stereotype about the nature of lesbianism which does posit a recognizable lesbian body. This view, which has been dominant in different historical periods and is still prevalent today, is that the lesbian is really a man trapped in a woman's body. The persistent desire to see the lesbian body as a pseudo male body certainly does not begin with Freud's theory of penis envy. We find evidence of the masculinized lesbian body in a number of pre-Freudian historical and cultural contexts: Amazonian society in which the Amazon is seen as a masculinized, single-breasted, man-hating warrior; cross-cultural woman-marriage (Cavin 1985: 129–37) whereby women don men's clothes and marry other women; female transvestism or cross-dressing; and the history of tribadism and female sodomy. It is the last category I wish to discuss in some detail.

In earlier centuries, prior to the invention (Katz 1990: 7–34) in the mid-nineteenth century of the homosexual and heterosexual as a person with a specific identity and lifestyle, women and men who engaged in same-sex relations – presumed to consist primarily of sodomy – were described as sodomites. Sodomites – heterosexual and homosexual – were 'guilty' of carrying out a specific act, not of being a certain kind of person with readily identifiable characteristics. Specifically, women were thought to take part in

sodomy with other women in one of two ways: through clitoral penetration of the anus or with the use of diabolical instruments. In general terms, however, the term sodomite was used to refer to anyone engaged in unorthodox practices.

In the early days of Christianity the term 'sodomite' had a range of quite different meanings – both sexual and political (Boswell 1980: 98, 283). It was not used specifically to refer to those – male and female – who practised anal sexuality, but rather was applied to anyone who engaged in unusual sexual acts. According to Boswell, one important theologian of the Carolingian era – Hincmar of Reims – used the term to refer to anyone who carried out non-procreative sexual acts such as oral sex, coitus interruptus, masturbation (Boswell 1980: 203–4). In the early Middle Ages, sodomy was even regarded as less sinful than adultery and therefore punished less severely. Adultery was punished with fourteen years of fasting; habitual homosexual anal sex with twelve years. By the fourteenth century, however, homosexuality was punished more severely and there were calls for the death penalty. The term sodomite was also used to refer to anyone who carried out in subversive acts such as questioning the teachings of the Catholic Church or the law of the state. Heretics, witches, werewolves, female transvestites, insurrectionists, papists, foreigners – all were sodomites. The sodomite was the evil 'other', the representative of satan, the dupe of the devil. Not until the late nineteenth century was sodomy specifically associated with homosexuality.

What was the status of the lesbian at the beginning of the Christian era and later? Although most of the literature refers specifically to male homosexuals, it seems clear that lesbians were seen in the same way. According to John Boswell, Hincmar of Reims, one of the few writers of the period to discuss lesbianism directly, and who adhered to the popular belief in female ejaculation, stated that lesbians – like male homosexuals – also released their 'seed' improperly, that is, outside procreation. Hincmar, however, did not accuse lesbians of penetration – that came later:

> They do not put flesh to flesh in the sense of the genital organ of one within the body of the other, since nature precludes this, but they do transform the use of the member in question into an unnatural one, in that they are reported [n.b.] to use certain instruments of diabolical operation to excite desire.
>
> (Boswell 1980: 204)

By the the time of the Renaissance however, it was believed that in some cases women with extremely large clitorises could commit acts of penetration – vaginal and anal – with another woman. One woman, accused of such acts, was said to possess a clitoris that 'equalled the length of half a finger and in its stiffness was not unlike a boy's member'. The woman was accused of 'exposing her clitoris outside the vulva and trying not only licentious

sport with other women . . . but even stroking and rubbing them' (Laqueur 1990: 137).

In *Making Sex*, Laqueur traces the way in which our views of sex and sexual difference have changed, along with cultural and social changes, over the centuries. Prior to the eighteenth century, thinking about the body was dominated by the 'one-sex model':

> In the one-sex model, dominant in anatomical thinking for two thousand years, woman was understood as man inverted: the uterus was the female scrotum, the ovaries were testicles, the vulva was a foreskin, and *the vagina was a penis*.
>
> (Laqueur 1990: 236; emphasis in original)

There was only one archetypal body: on the male body the organs had descended, in the female body, due to a lack of bodily heat, they remained bottled up inside. By virtue of her coldness, woman was, at best, a potential man, at worst, a failed one. By the late eighteenth century the one-sex model had given way to a new model – the two-sex model in which men and women no longer correspond but are radically different. In the one-sex model, a number of vital female organs had no names of their own – the ovaries were female 'testicles' while the vagina did not have a name at all before 1700. The clitoris did not even appear in this model.

Ambrose Pare, the sixteenth-century surgeon tells the tale of Marie, a young woman (or so it appeared), who jumped across a ditch while chasing some runaway pigs (Laqueur 1990: 126–7). Her energetic actions caused her bodily heat to rise and as a result her vagina descended to form a penis. She later grew a red beard changed her name to Germain and joined the army. In reality, Marie was always a boy but one suffering from a hormone deficiency which meant 'her' external sexual organs did not develop until puberty. This fanciful tale only makes sense in a one-sex world. Girls were also warned that they should keep their legs crossed at all times otherwise their internal organs may drop through and they would become boys. (The price one pays to remain a 'lady'!) Similarly, it was also thought that boys could spend too much time in the company of women, lose the hardness associated with the male body – forged through heat – and become effeminate. According to Jones and Stallybrass, it was also believed that men should have periods – hence the popular practice of causing a male blood flow through leeching and cupping. They also point out that what is most remarkable about the one-sex theory is its fluidity, the fact that it does not ground gender: 'there is no master discourse which is called upon to fix the essence of gender' (Jones and Stallybrass 1991: 81).

In 1559 Renaldus Columbus (obviously a popular name for explorers) announced that he had discovered the clitoris – 'the seat of woman's delight' – which he compared to the penis and described as 'a sort of male member' (Laqueur 1990: 64). Columbus' claim was strongly contested by his col-

leagues. This had been common knowledge, they argued, at least since Antiquity. I would add, common knowledge perhaps among men since then; no doubt women had discovered their seat of pleasure – their 'precious jewel' – long before that. According to Barbara Walker one crucial reason for male ignorance in medieval times was that pious couples wore the *chemise cagoule*, a large nightdress with a small opening through which the penis was inserted – such men and women would never have seen each other naked. That ignorance of the clitoris was widespread is clearly demonstrated in a witch trial of 1593 when a woman, accused of witchcraft, was physically examined by the goaler who discovered what he labelled 'a devil's teat'. At first he did not plan to announce his discovery because it was next to 'a secret place which was not decent to be seen; yet in the end, not willing to conceal so strange a matter' he showed it to others who claimed never to have seen such a strange thing before. The witch was burned (Walker 1983: 171).

Regarded as an equivalent of the male penis, the 'discovery' of the clitoris initially did not upset the hegemony of the one-sex model but was absorbed into that model via some rather imaginative thinking. Because the male body and the penis continued to represent the norm, when the female 'penis' was discovered the labia became the foreskin. Laqueur concludes that such confusions could only occur because during the Renaissance 'the anatomical representation of male and female is dependent on the cultural politics of representation and illusion, not on evidence about organs, ducts, or blood vessels' (Laqueur 1990: 66). As I will argue shortly, the same is true for the representation of the lesbian body – its apprehension also dependent on illusionism and the sexual politics that inform modes of representation.

Given the conceptualization of woman's body as a thwarted male body and the clitoris and labia as penis and foreskin, it is no wonder that desire was also thought of as masculine. Along this continuum of desire, where male desire is hot and female cold, where the sexes are in danger of changing from one to the other, lesbian desire, the active desire of one woman for another, was seen as aggressive and virile. In this context, the body of the desiring woman, heated by active passion, no doubt threatens to become male like that of Marie/Germain. The active female body disturbs cultural definitions of gender and collapses the inside/outside boundary that constitutes the social division into female and male.

As Laqueur points out, while Renaissance society assumed there to be only one sex, it was quite clear there were two genders with very different social roles, rights and responsibilities: 'Creatures with an external penis were declared to be boys and were allowed all the privileges and obligations of that status; those with only an internal penis were assigned to the inferior category of girl' (Laqueur 1990: 135). Officially, it was strictly forbidden to adopt the role of the other sex – or to try and dress above one's station in life. These rules were strictly reinforced via the sumptuary laws.

After the official discovery of the clitoris, the notion of the lesbian body

as a pseudo male body becomes more credible because the clitoris is seen as a male penis which, it was also believed, ejaculated semen. What are the implications of this for the lesbian? In normal man–woman sex, the woman was the one rubbed against, that is, she assumed the passive role – despite her smaller 'penis'. But in cases where the clitoris is deemed too large (a complaint never directed at the penis) and the woman therefore is capable of adopting the active rubbing position in sex with another woman, she stands in violation of the sumptuary laws (Laqueur 1990: 136). Some women are therefore potentially capable of performing sodomitic acts on the bodies of other women. The woman who assumed a male role in sex with another woman was deemed a 'tribade'. The lesbian/tribade is a pseudo man, her body an inferior male body. In cases which were brought before the law, the offender, if found guilty, was usually burned as a tribade. In such cases the size of the female penis was crucial.

In 1601 Marie de Marcis was accused of sodomy. She declared publicly that she was a man, altered her name to Marlin and announced her intention to marry the woman she loved. At her trial (women could be tried for sodomy in French law) she was sentenced to be burned alive, but a sympathetic doctor intervened and demonstrated she was really a 'man' because when her genitals were rubbed a penis emerged which also ejaculated semen. She was decreed a man and escaped execution, although she was forbidden to have sex with women (and men) or dress as a man until she was 25 (Laqueur 1990: 136–7). In another case, in Holland in the early seventeenth century, Henrike Schuria, who donned men's clothes and joined the army, was caught having sex with another woman. Her clitoris was measured and found to equal the length of half a finger. She was found guilty of tribadism and sentenced to the stake, but the judge intervened and ordered she be sent into exile after enduring a clitoridectomy (Laqueur 1990: 137; van der Meer 1990: 191).

It is relevant to point out that laws against sodomy not only varied according to place and time, but that they were not universally applied. In England at the time there were no laws against sodomy or cross-dressing – only dressing outside one's class was illegal. Nonetheless there is still a strong stigma attached to lesbianism. In Renaissance England, Ben Jonson accused a female critic of literary tribadism in order to denigrate her. He accuses her of raping the Muse:

> What though with Tribade lust she force a Muse,
> And in an Epiceone fury can write newes
> Equall with that, which for the best newes goes . . .
> (Jones and Stallybrass 1991: 103)

In eighteenth-century Holland, however, a wave of sodomy trials took place in which women figured prominently and were referred to as committing 'sodomitical filthiness' (van der Meer 1990: 190). In France, after the rediscovery of the clitoris, the hermaphrodite was classified as a woman with

a large clitoris who could legally be tried for engaging in acts of sodomy with other women (Jones and Stallybrass 1991: 90). Women were, of course, also punished for committing other sexual acts with women, such as mutual masturbation, but these were not seen in the same light as sodomy which was a far more serious offence.

In the cases discussed above, the solution to the female body which threatens to confuse gender boundaries is either legal ('she really is a man') or surgical ('cut her back to size') or lethal ('burn the witch'). In all three instances the offending body challenges gender boundaries in terms of the active/passive dualism, a dichotomy which is crucial to the definition of gender in patriarchal culture. Marie de Marcis was not judged a woman with a large clitoris but a man. There is a clear distinction here between penis and clitoris in which the former grants its possessor the status of manhood and all of its attendant rights. Henrike Schuria was not lucky enough to be deemed a man; rather, she was judged a freakish woman and forced to have the offending organ cut out. As Laqueur points out: 'Getting a certifiable penis is getting a phallus, in Lacanian terms, but getting a large clitoris is not' (1990: 140–1).

The tribade is the woman who assumes a male role in sexual intercourse with another woman – either because she is the one 'on top' or because she has a large clitoris and can engage in penetration. She threatens because she is active, desiring, hot. Theo van der Meer argues that the tribade does not really fit into the world of romantic, but asexual female friendships, nor into the tradition of female transvestism. Van de Meer claims that perhaps the tribades, with their overtly sexual desires, 'may represent the more – if not the most – important and direct predecessors of the modern lesbian' (1990: 209). I have used the word tribade for the early modern period, because, not only did the term 'lesbian' not exist in the eighteenth century, but 'lesbian' also conveys the idea of a sexual identity which was not really invented for the female homosexual until the mid-nineteenth century. According to Barbara Walker (1983: 536), in Christian Europe, lesbianism was 'a crime without a name'. The sixteenth-century definition of the tribade as a pseudo male has much in common with Freud's later definition of the homosexual woman as one suffering from unresolved penis-envy. Both definitions adopt male anatomy as the defining norm. The difference is that Freud's model of sexual difference is based on the two-sex theory; in this, woman is not an ill-formed man, she is the 'other' – a creature who has already (in male eyes) been castrated. The lesbian body of Freudian theory is one that attempts to overcome its 'castration' by assuming a masculine role in life and/or masculine appearance through clothing, gesture, substitution.

In the one-sex model, the tribade is guilty of assuming the male role which she is seen as perfectly capable of doing because she is already potentially a man; in the two-sex model the lesbian is deemed ultimately as incapable of even assuming a pseudo-male position because, like all women, she signifies

an irremediable lack. Her genitals are not in danger of falling through her body and transforming her from male to female, nor does she possess a clitoris that might be taken seriously enough by a judge or medical doctor to suggest she might adopt an active, rubbing role in sex – she signifies only castration and lack. Her lack, however, can be overcome artificially by the use of a dildo – a popular male fantasy about lesbian practices. It is worth noting that the phallic woman, the woman with a penis, who is central to the Freudian theory of fetishism, has much in common with the image of the sodomitic tribade. The phallic woman, who straps on a dildo and sodomizes the male, is a popular figure in pornography specifically designed for the burgeoning male masochist market. Perhaps the phallic woman of male fantasy is not just a Freudian fetish but also represents male desire for an active, virile woman – a lesbian!

¶Freud attributes lesbianism not to woman's own specifically female desires but to her desire to be a man. The lesbian is the woman who either has never relinquished, or seeks to recover, her repressed phallic sexuality. She refuses to relinquish her pre-Oedipal or phallic love for the mother and develops a masculinity complex. She may also become a lesbian out of a desire for revenge. In his single study of lesbianism, Freud (1920) argues that the woman becomes a lesbian to enact revenge on her father who she feels betrayed her because he made the mother, her rival, pregnant. He states that 'she changed into a man, and took her mother in place of her father as the object of her love' (1920: 384). He notes the 'masculine' physique of his client and states that only inverts assume the mental characteristics of the opposite sex. Freud likens the female homosexual to the male heterosexual – both desire the feminine woman. In his footnotes to the Dora case history, Freud refers to Dora's 'homosexual (gynaecophilic) love for Frau K.' as the 'strongest unconscious current in her mental life' (1905a: 162) and to her aggressive identification with masculinity. Although Freud does not appear to see lesbianism as pathological (he does not prescribe any form of therapy) his emphasis on vaginal – not clitorial – orgasm as offering the only true source of sexual pleasure for women makes it clear that he regarded lesbian sexual practices as inferior and immature. On her journey into proper womanhood, the girl gives up the pleasures of clitoral orgasm for vaginal orgasm. In his discussion of proper femininity and masculinity, Freud writes: 'Maleness combines [the factors of] subject, activity and possession of the penis; femaleness takes [those of] object and passivity. The vagina is now valued as a place of shelter for the penis; it enters into the heritage of the womb' (Freud 1923: 312).

In the Freudian model of sexual difference, the vagina – no longer an inverted penis – is now 'a place of shelter for the penis'. It passively awaits the male member, husband, master of the house. The clitoris loses its earlier active prowess and becomes 'like pine shavings' waiting to be 'kindled' in order to make the home warm, friendly: 'to set a log of harder wood on fire'

(Freud 1905b: 143). The woman who refuses to see her sexual organs as mere wood chips, designed to make the man's life more comfortable, is in danger of becoming a lesbian – an active, phallic woman, an intellectual virago with a fire of her own.

Freud's theory regarding the shift of pleasure from the clitoris to the vagina has no basis in fact. He seems bent on ascribing a specific role to the vagina as a means of convincing women that they should assume a passive position within the family and society. Not only Freud, however, feared the active woman. Bram Dijkstra points out that at the time there were a number of popular beliefs in circulation about the dangers of the active, masculine woman who threatened to destroy the fragile boundary which kept the sexes different and separate. He cites the work of Bernard Talmey who believed that masturbation made women into lesbians and led to abnormal conditions such as 'hypertrophy of the clitoris' which caused the clitoris to expand and become erect: 'The female masturbator becomes excessively prudish, despises and hates the opposite sex, and forms passionate attachments for other women' (Dijkstra 1986: 153). The lesbian body is a particularly pernicious and depraved version of the female body in general; it is susceptible to auto-eroticism, clitorial pleasure and self-actualization.

Freud's narrative of woman's sexual journey from clitorial pubescence into mature vaginal bliss is a bit like the transformation fairy tales in which the ugly duckling matures into a beautiful swan and marries the handsome cygnet. Literary and filmic narratives replay this scenario of female fulfilment through the figure of the tomboy. The tomboy's journey is astonishingly similar to that of the clitoris. During the early stage, the tomboy/clitoris behaves like a 'little man' enjoying boy's games, pursuing active sports, refusing to wear dresses or engage in feminine pursuits; on crossing into womanhood the youthful adventurer relinquishes her earlier tomfoolery, gives up boyish adventures, dons feminine clothes, grows her hair long and sets out to capture a man whose job it is to 'tame' her as if she were a wild animal.

We see this narrative played out in *Calamity Jane* where the heroine (Doris Day) relinquishes her men's clothing, foul language, guns and horse for a dress, feminine demeanour, sweet talk and a man. She also gives up the woman, Alice, with whom she has set up house and whom she clearly loves. Katherine Hepburn in *Sylvia Scarlett* adopts the name of Sylvester, dons boy's clothes and masquerades as a youth until she falls in love and exchanges her masculine appearance for a feminine one. *Queen Christina* depicts the lesbian queen (Greta Garbo) in the first part of the narrative wearing men's clothes and long riding boots, striding about the palace accompanied by two great danes and muttering to her manservant that all men are fools and she will never marry. Predictably, she falls in love, throws off her mannish trappings, gives up the Lady Ebba and redirects her erotic desires towards the Spanish ambassador, one of the 'fools' she vowed she would never marry.

In *Marnie*, the journey into womanhood is presented in the context of a psychological crisis. Marnie, played by Tippi Hedren, is sexually frigid, a thief who steals from her male employers. She loves only her mother and her horse, Forio. Before she can begin her transformation into proper womanhood, and learn to desire the man she has been forced to marry, she has to shoot her horse, which has a broken leg, and give up her criminal activities. Her horse/virile ways are replaced by his. Passivity and propriety are essential preconditions for the transition from active, virile femininity into passive, feminine conformity.

The liminal journey of the tomboy – one of the few rites of passage stories available to women in the cinema – is a narrative about the forging of the proper female identity. It is paralleled by Freud's anatomical narrative about the journey of the clitoris which is, at base, a narrative about culture. The tomboy who refuses to travel Freud's path, who clings to her active, virile pleasures, who rejects the man and keeps her horse is stigmatized as the lesbian. She is a threatening figure on two counts. First, her image undermines patriarchal gender boundaries that separate the sexes. Second, she pushes to its extreme the definition of the active heterosexual woman – she represents the other side of the heterosexual woman, her lost phallic past, the autonomy she surrenders in order to enter the heritage of the Freudian womb. In this context, it is the lesbian – not woman in general – who signifies the 'ruin of representation'.

ANIMALISTIC LESBIAN BODY

The stereotype that associates lesbianism with bestiality also pushes representation to its limits. As discussed earlier, woman is, in the popular (male) imagination, associated more with the world of abject nature because of her procreative and birth-giving functions. In religious discourse, her sinful nature makes her a natural companion of the serpent. The embodiment of mother nature, woman represents the fertile womb, the Freudian hearth of domestic bliss. Whereas woman's function is to replicate that of the natural world, man's function is to control and cultivate that world for his own uses. Like the animal world, woman has an insatiable sexual appetite that must be controlled by man. Modern pornography depicts woman's link with nature in images of women posed in the 'doggy' position or engaged in sex with animals – particularly horses and dogs.

In the first part of the twentieth century, woman was particularly aligned with nature because of a widely held belief in a pseudo-scientific theory known as the theory of 'devolution'. According to this belief, while man was in general constantly evolving, some men and all women were in danger of devolving to lower animal forms. Dijkstra presents a fascinating study of the representation of devolution in *fin-de-siècle* art. He points out that whereas 'half-bestial creatures [such] as satyrs and centaurs' were used to

depict such men, often caricatured as semitic or negroid, 'there was no need to find a symbolic form to represent [woman's] bestial nature' as 'women, being female, were, as a matter of course, already directly representative of degeneration' (Dijkstra 1986: 275). Hence many paintings of the period depicted women frolicking with satyrs and cavorting with animals in the dark recesses of the woods. If women in general were associated with the animal world, the lesbian was an animal. Dijkstra also refers to the work of Havelock Ellis to support his argument. Drawing on Darwin's view that animals could become sexually excited by the smell of women, Havelock Ellis argued that 'the animal is taught to give gratification by cunnilinctus. In some cases there is really sexual intercourse between the animal and the woman'. Apparently, Ellis drew connections between lesbianism in young girls and 'later predilection for encounters with animals' (Dijkstra 1986: 297). The association of homosexuality with bestiality, however, extends much further back than Victorian England. One of the most widely read books of the medieval period, said to be as popular as the Bible, was the *Physiologus*, also known as 'the medieval bestiary'. It consisted of a collection of stories, many without any accuracy whatsoever, about animal behaviour and its relationship to human behaviour. It was widely translated, and its influence felt for centuries. According to Boswell it was a 'manual of piety, a primer of zoology, and a form of entertainment' (1980: 141).

The *Physiologus*, which incorporated the *Epistle of Barnabas* from the first century AD, advanced various arguments about animal behaviour that were used to decry homosexual behaviour. It claimed that he who ate the meat of hare would become 'a boy-molester' because 'the hare grows a new anal opening each year, so that however many years he has lived, he has that many anuses' (Boswell 1986: 137–8). Those who ate the meat of the hyena would, like the hyena, change their gender from male to female every year. So women could develop male sexual organs and vice versa. Those who ate the weasel would become like those women who engage in oral sex and who conceive and give birth orally. The abject practices of the hare, weasel and hyena were associated with homosexual practices, abnormal birth and sex changes. In this context, homosexual acts were seen as unclean and animalistic.

Desire transforms the body; abject desire makes the body abject. This belief is similar to the view that women gave birth to monsters because of the kinds of desires they experienced during pregnancy (Huet 1993: 13). Desire can also affect the sexual organs. The story of the hyena was used to explain gender changes for both male and female. The image of a hare with multiple anuses constructs the body from the perspective of the feminized creature, the one being penetrated. It also suggests a fantasy about passivity and an excess of pleasure. No doubt the medieval story of the hare was applied primarily to the male sodomite, but given that the female homosexual was also seen as a sodomite, she would have been associated with the monstrous, transforming body of the hare.

A recent film, *Face Of A Hare* (Liliana Ginanneschi), which explored an unusual friendship between two women, draws on associations between woman, the hare and repressed lesbian desire. The narrative tells the story of two women who have lost their daughters. One woman, a derelict, who lives on the streets, takes up a maternal role in relation to the younger woman in that she appears to possess knowledge about the meaning of life that the younger woman needs. In this way, the film constructs three mother–daughter relationships. Men have no place in the story. In the pre-credit sequence, we are told the story of the 'Moon and the Hare' in which the moon, referred to as 'she', punishes the hare for delivering a false message to men about the meaning of life. The moon hit the hare on the snout with a stick and flattened its nose forever. We are then told that the younger woman, Elena, who visibly resembles a hare, also felt 'flattened like the hare'. The hare, with its flattened/castrated nose, is associated with woman. The two women are also symbolically castrated in that both have lost their daughters. They form an unusual and close friendship – brought together by their mutual experience of loss and their feelings of despair. But a growing bond of friendship helps to ease their pain. At one point the older woman announces she is Marlene Dietrich, a star whose screen persona has always signified lesbian desire, and shortly after seizes the younger woman in an embrace and begins to dance with her. The women form a couple but, as in virtually all male friendship films, one of the couple dies.

Babuscio has argued that the death of one or both friends has become a narrative convention of the buddy film; it works to suppress questions of homosexual desire at a point where the narrative has run its course and the audience is wondering what these men will do next (Babuscio n.d.: 24). The buddies have rejected both society and heterosexual domesticity – will they declare their love for each other? We see a similar convention at work in other female friendship films with lesbian undertones such as *Single White Female*, *Fried Green Tomatoes*, *Beaches*, *Outrageous Fortune* and *Poison Ivy*. It is impossible to tell whether or not the filmmakers of *Face Of A Hare* consciously drew associations from the ancient connection between the hare and female homosexuality; the interesting point is that the connections are there at a subtextual level in the film. Woman is an outsider, associated with repressed lesbian desire, the pain of loss and separation and the world of the outcast animal. This scenario is not completely gloomy; the status of outsider provides a perfect place from which to explore, to skirt boundaries, to embrace difference. As I mentioned earlier, gender was not grounded or rigidly defined in the bestiary – perhaps the symbol of the woman/hare, while linking woman to the animal world, also frees her from the dictates of the man-made world.

Another popular image of the lesbian as non-human creature appeared in stories of the female vampire. A seductive creature of the night, the lesbian vampire – still a popular monster of the horror film – not only attacked young

girls but also men whose blood she drank in order to assume their masculine virility. Like an animal, the lesbian vampire was prey to her own sexual lusts and primitive desires.

The tomboy, the girl whose sexual identity is androgynous, is almost always associated with animals, particularly the horse and dog. The image of the lesbian as part of the natural world – as distinct from the civilized – might repel some, but it is also immensely appealing.

NARCISSISTIC LESBIAN BODY

A popular convention of *fin-de-siècle* painting, the cinema and fashion photography is the image of two women, posed in such a way as to suggest one is a mirror-image of the other. We see the image of the lesbian as narcissist in films about lesbianism. After the two women in *Les Biches* begin a relationship they start to imitate each other in dress and appearance; the women in *Persona* also wear identical clothes and beach hats, making it almost impossible to tell them apart; in *Single White Female* the mentally disturbed girl, in love with her flatmate, deliberately vampirizes her appearance and behaviour until they look like identical twins. In lesbian vampire horror films, such as *Vampyres*, the female fiends are also depicted as identical, even the blood that smears their lips seems to trickle from identical mouths and fangs.

Contemporary fashion images in magazines and shop windows also exploit the idea of female narcissism, using models dressed in similar clothes and similar poses – sometimes caught together in an embrace – to sell their products. More overt forms of lesbian behaviour (butch–femme displays) are now also used, particularly as many younger lesbians, who have rejected the lesbian refusal of fashion associated with the 1970s, opt to explore fashion possibilities. Whether or not the general buying public reads lesbianism into these advertisements is another matter. In her discussion of lesbian consumerism, Danae Clark points out that advertisers, as a matter of conscious policy, now attempt to appeal to the gay community through what they describe as 'code behaviour' that only gays would understand: 'If heterosexual consumers do not notice these subtexts or subcultural codes, then advertisers are able to reach the homosexual market along with the heterosexual market without ever revealing their aim' (Clark 1991: 183). However, images that exploit the notion of the feminine/lesbian narcissism draw on a much older tradition than that represented in the contemporary fashion industry. If this tradition suggests that woman is, by her very nature, vain, the lesbian couple represents, by definition, feminine narcissism and autoeroticism *par excellence*.

In a chapter entitled, 'The Lesbian Glass', Dijkstra (1986) discusses the popular belief, championed by Havelock Ellis, that women are vain, narcissists capable of completely losing themselves in self-admiration.

Turn-of-the-century medical writers pointed to the supposed connection between masturbation in women, narcissism and lesbianism. Masturbation increased the size of the clitoris; the woman with a large clitoris was likely to become a lesbian and to engage in those 'excesses' called 'lesbian love' (Gilman 1985: 89). According to Dijkstra, women were painted kissing themselves in mirrors – vain, self-absorbed, completely uninterested in men: 'Woman's desire to embrace her own reflection, her "kiss in the glass", became the turn of the century's emblem of her enmity towards man' (ibid.: 150). Dijkstra cites the eponymous heroine of the film, *Lulu*, played by Louise Brooks, the notorious *femme fatale* whose beauty attracts both men and women, is depicted as a completely self-absorbed narcissist. At one point she says: 'When I look at myself in the mirror I wish I were a man . . . my own husband.'

Women were also depicted in turn-of-the-century painting, kissing other women, but such was the nature of male arrogance, they argued that when a woman kissed another woman it was like kissing herself. The other woman symbolized her own reflection. Dijkstra (1986) points out, however, that a number of artists and intellectuals, keen to show they were abreast of the times, deliberately set out to represent lesbian lovers in works such as *The Two Friends* by Egon Schiele and *After the Bath* by Pierre-Georges Jeanniot. What is most remarkable in almost all of these paintings and sketches is the way in which the women are drawn as mirror-images of each other. They wear similar clothes, adopt similar poses, their bodies blending into each other.

Like masturbation, lesbianism was seen as inextricably linked to self-absorption and narcissism. Men were shut out from this world – hence they understood the threat offered by the lesbian couple. (According to popular male mythology, what the lesbian really needs is a good fuck, that is, a phallic intrusion to break up the threatening duo.) The representation of the lesbian couple as mirror-images of each other constructs the lesbian body as a reflection or an echo. Such an image is dangerous to society and culture because it suggests there is no way forward – only regression and circularity are possible.

Representations of the lesbian as female narcissist in painting, film and fashion images almost always depict the lesbian as conventionally feminine. This is the key area in which popular fantasies about the nature of lesbianism do not draw on the cliché of the lesbian as a thwarted man. The narcissistic femme lesbian, however, almost always adopts an ambiguous position in relation to the gaze of the camera/spectator. She is on display, her pose actively designed to lure the gaze; the crucial difference is, however, that the spectator is shut out from her world. He may look but not enter. Images of the lesbian double are designed to appeal to the voyeuristic desires of the male spectator.

In the first two stereotypes discussed, the lesbian body is constructed in terms of the heterosexual model of sex which involves penetration; there was

no attempt to define the nature of lesbian pleasure from the point of view of the feminine. The threat offered by the image of the lesbian-as-double is not specifically related to the notion of sexual penetration. Instead, the threat is associated more with auto-eroticism and exclusion.

Representations of the lesbian double – circulated in fashion magazines, film and pornography – draw attention to the nature of the image itself, its association with the feminine, and the technologies that enable duplication and repetition. The lesbian double threatens because it suggests a perfectly sealed world of female desire from which man is excluded, not simply because he is a man, but also because of the power of the technology to exclude the voyeuristic spectator. But exclusion is also part of the nature of voyeuristic pleasure which demands that a distance between the object and the subject who is looking should always be preserved. Photographic technology, with its powers of duplication, reinforces a fear that, like the image itself, the lesbian couple-as-double will reduplicate and multiply.

THE LESBIAN BODY/COMMUNITY

The body is both so important in itself and yet so clearly a sign or symbol referring to things outside itself in our culture. So far I have discussed the representation of the lesbian body in terms of male fantasies and patriarchal stereotypes. Historically and culturally, the lesbian body – although in-distinguishable in reality from the female body itself – has been represented as a body in extreme: the pseudo-male, animalistic and narcissistic body. Although all of these deviant tendencies are present in the female body, it is the ideological function of the lesbian body to warn the 'normal' woman about the dangers of undoing or rejecting her own bodily socialization. This is why the culture points with most hypocritical concern at the mannish lesbian, the butch lesbian, while deliberately ignoring the femme lesbian, the woman whose body in no way presents itself to the straight world as different or deviant. To function properly as ideological litmus paper, the lesbian body must be instantly recognizable. In one sense, the femme lesbian is potentially as threatening – although not as immediately confronting – as the stereotyped butch because she signifies the possibility that all women are potential lesbians. Like the abject, the stereotyped mannish/animalistic/auto-erotic lesbian body hovers around the borders of gender socialization, luring other women to its side, tempting them with the promise of deviant pleasures.

Within the lesbian community itself, however, a different battle has taken place around the definition of the lesbian body. This battle has nothing to do with the size of the clitoris, animals or self-reflecting mirrors. Preoccupied with the construction of the properly socialized feminine body, lesbian–feminism of the 1970s became obsessed with appearance, arguing that the true lesbian should reject all forms of clothing that might associate her image with that of the heterosexual woman and ultimately with patriarchal

capitalism. The proper lesbian had short hair, wore sandshoes, jeans or a boiler suit, flannel shirt and rejected all forms of make-up. In appearance she hovered somewhere between the look of the butch lesbian, who wore men's clothes and parodied men's behaviour and gestures, and the tomboy. She was a dyke – not a butch – whose aim was to capture an androgynous uniformed look. Lesbians who rejected this model were given a difficult time. In debates that raged in Melbourne in the mid-1970s, some of us who refused the lesbian uniform were labelled 'heterosexual lesbians', an interesting concept that constructs a lesbian as an impossibility – a figure perhaps more in tune with the queer world of the 1990s.

From the 1970s onwards, the lesbian community has adopted a series of fashion styles ranging from flannel shirts to the leather and lipstick lesbians of the 1990s. A recent film, *Framing Lesbian Fashion* (Karen Everett, 1991), pays tribute to the flannel lesbians while celebrating the changing styles of recent years. The film is structured around a series of inter-titles which point to the key changes in style which have involved flannel, leather, corporate drag, tattooing and body piercing. There are a series of interviews with lesbians who have lived through these changes, as well as a lesbian fashion show. The opening credits are accompanied by the words 'I like to shop, shop, shop, shop – shop until I drop'. The film concludes with a tribute to the lesbians of the 1970s who set out to liberate themselves from the patriarchal stereotypes of feminine dress and appearance. The problem was that they also imposed a fairly rigid code of dress on themselves and anyone who wanted to join the lesbian community. There was certainly no place for femme or older style butch lesbians. Only with the butch–femme renaissance of the 1980s did butch and femme lesbians come out of the closet and begin to assert their own needs to express themselves without fear of retribution. Today, with the liberating influence of queer theory and practice (often quite separate entities), almost any form of dress is acceptable.

The film makes one thing very clear: most women enjoyed wearing the different 'uniforms' such as flannel, leather, lipstick because it gave them a sense of belonging to a community, the gang, the wider lesbian body. They speak of having a sense of family and shared identity via their common forms of dress. The need to construct a sense of community, through dress and appearance, suggests quite clearly that there is no such thing as an essential lesbian body – lesbians themselves have to create this body in order to feel they belong to the larger lesbian community, recognizable to its members not through essentialized bodily forms but through representation, gesture and play. The 1990s lesbian is most interested in playing with appearance and with sex roles. Women interviewed in *Framing Lesbian Fashion* were very clear about the element of parody in their dress styles. One woman who cross-dressed even wore a large dildo in her leather pants ('packing it') to simulate the penis – the male penis as well as the one that male fantasy has attributed throughout the centuries to the lesbian and her tribade forebears. Unlike

Calamity Jane, whose outfit would have caused a sensation at *Club Q*, the 1990s lesbian refuses to exchange her whip and leathers for home, hearth and the seal of social approval. She has a body that is going places.

ACKNOWLEDGEMENTS

Thanks to Lis Stoney for her perceptive comments and suggestions. This article is indebted to Thomas Laqueur's brilliant book *Making Sex: Body and Gender from the Greeks to Freud*.

BIBLIOGRAPHY

Babuscio, J. (n.d.) 'Buddy Love: Men and Friendship in Films', *Gay News*, 117: 24.

Bakhtin, M. (1984) *Rabelais and His World*, translated by Hélène Iswolsky. Bloomington, Ind.: Indiana University Press.

Boswell, J. (1980) *Christianity, Social Tolerance, and Homosexuality*. Chicago, Ill. and London: University of Chicago Press.

Cavin, S. (1985) *Lesbian Origins*. San Francisco, Calif.: Ism Press Inc.

Clark, D. (1991) 'Commodity Lesbianism', *Camera Obscura*, 25–7: 181–201.

Creed, B. (1993) 'Dark Desires: Male Masochism in the Horror Film', in S. Cohan and I.R. Hark (eds) *Screening The Male: Exploring Masculinities in Hollywood Cinema*. London and New York: Routledge.

Dijkstra, B. (1986) *Idols of Perversity: Fantasies of Feminine Evil in Fin-de-Siècle Culture*. New York: Oxford University Press.

Freud, S. (1905a) 'Fragment of an Analysis of a Case of Hysteria ("Dora")', *Case Histories 1* (Pelican Freud Library, vol. 8). Harmondsworth: Penguin, pp. 31–164.

—— (1905b) 'Three Essays on The Theory of Sexuality', in J. Strachey (trans. and ed.) *On Sexuality* (Pelican Freud Library, vol. 7). Harmondsworth: Penguin.

—— (1920) 'The Psychogenesis of a Case of Homosexuality in a Woman', *Case Histories 11* (Pelican Freud Library, vol. 9). Harmondsworth: Penguin.

—— (1923) 'Fragment of an Analysis of a Case of Hysteria ("Dora")', *Case Histories 1* (Pelican Freud Library, vol. 8). Harmondsworth: Penguin.

Gilman, S.L. (1985) *Difference and Pathology: Stereotypes of Sexuality, Race and Madness*. Ithaca, NY and London: Cornell University Press.

Huet, M. (1993) *Monstrous Imagination*. Cambridge, Mass. and London: Harvard University Press.

Jones, A.R. and Stallybrass, P. (1991) 'Fetishizing Gender: Constructing the Hermaphrodite in Renaissance Europe', in J. Epstein and K. Straub (eds) *Bodyguards: The Cultural Politics of Gender Ambiguity*. New York and London: Routledge.

Katz, J.N. (1990) 'The Invention of Heterosexuality', *Socialist Review*, 20, 1: 7–34.

Kristeva, J. (1982) *Powers of Horror: An Essay on Abjection*, translated by L.S. Roudiez. New York: Columbia University Press.

Laqueur, T. (1990) *Making Sex: Body and Gender from the Greeks to Freud*. Cambridge, Mass. and London: Harvard University Press.

Montrelay, M. (1978) 'Inquiry into Femininity', *m/f*, 1: 83–102.

van der Meer, T. (1990) 'Tribades on Trial: Female Same-Sex Offenders in Late Eighteenth-Century Amsterdam', in J.C. Fout (ed.) *Forbidden History: The State, Society and the Regulation of Sexuality in Modern Europe*. Chicago, Ill. and London: University of Chicago Press.

Walker, B. (1983) *The Woman's Encyclopedia of Myths and Secrets*. San Francisco, Calif.: Harper & Row.

5

TELEDILDONICS
Virtual lesbians in the fiction of Jeanette Winterson

Lisa Moore

How to make sense of bodies? Lesbians are asked to account for our bodies –
for the ways in which they are presumed not to line up with the bodies of
'women' – by the dominant culture and, in turn, by many feminist and lesbian
theories of the body that take for granted a certain disjunction between lesbian
bodies and normative femininity. And much recent postmodern work on the
disintegration of the body – on the increasingly blurred boundaries between
bodies and machines, or humans and animals – suggests that bodies of all
genders and sexualities are pressed, under current cultural conditions, to
expose their distance from the Cartesian fantasy of the bounded, knowable,
normative body. For lesbians, it has been argued, such pressure also presents
an opportunity, since we have never benefited much from normative assump-
tions, particularly those about sexual bodies. But what would it mean to take
account – psychically as well as theoretically – of the discontinuous,
heterogeneous experiences, sensations, desires and identifications that pulse
through us as we experience our 'bodies'? After all, those rigid identity
categories we're so busy deconstructing serve the practical purpose of
organizing what might otherwise be an unbearably chaotic and over-
whelming, rather than liberating and expansive, psychic register of the
material world. To begin to explore the question of the body of the decentred
postmodern subject requires that we face this dystopian possibility, that we
go beyond the utopian terms of previous lesbian writing and theory that has
celebrated the lesbian body's distance and difference from language and the
dominant culture. This essay examines a particularly powerful attempt to
imagine[1] a lesbian body without a liberatory political agenda.

WINTERSON, POSTMODERNISM, LESBIAN WRITING

'Virtual Reality is on its way', Jeanette Winterson claims in her most recent
novel, *Written on the Body* (Winterson 1993: 97). She goes on to explicate

104

the potential of this computer-generated 'reality' for the realignment of sexual hierarchies:

> As far as your senses can tell you you are in a real world. . . . If you like, you may live in a computer-created world all day and all night. You will be able to try out a Virtual life with a Virtual lover. You can go into your Virtual house and do Virtual housework, add a baby or two, even find out if you'd rather be gay. Or single. Or straight. Why hesitate when you could simulate?
>
> And sex? Certainly. Teledildonics is the word.
>
> (Winterson 1993: 97)

This passage makes explicit the narrative strategies that structure the ambiguous status of lesbianism in Winterson's fiction. Even while it insists upon a constant deferral of fixed sexual identities ('gay . . . single . . . straight'), Winterson's fiction imagines the space in which such deferral can take place as linguistically or imaginatively lesbian – for example, in the way the word 'teledildonics' as a term for 'virtually' all sexual possibilities playfully summons up the lesbian sex toy, the dildo.

Hailed by the mainstream, her novels (winners of the Whitbread Award, the John Llewellyn Rhys Memorial Prize and the E.M. Forster Award) have also generated a passionate following among lesbians. This, despite the fact that except for in the coming-out novel *Oranges Are Not the Only Fruit* (1985b), lesbians appear only as minor characters in her novels. What is 'lesbian' about these fantastic narratives of displacement in time and space, of all-absorbing love that takes one outside of social norms and bodily boundaries, and of vertiginous experiences of discontinuous and incoherent identities? Of course, as a recent interview in *Mirabella* noted, Winterson 'is a lesbian and makes no bones about it' (Begley 1993: 32). But the above passage's notion of the 'virtual' suggests something more interesting than authorial biography about the relation between the postmodernity and the 'lesbianism' of her fiction.

In this essay, I want to explore the category of the 'virtual lesbian' (understood as a designation for both characters and structures in Winterson's fiction) as a field of possibilities that calls into question assumptions about both postmodern fictions and lesbian ones, evaluating its theoretical and narrative implications through a reading of *Written on the Body* and its less obviously 'lesbian' pre-texts, *The Passion* (1987) and *Sexing the Cherry* (1989). For all the obvious ways in which we can line up these novels with either of the slippery terms 'postmodern' and 'lesbian', Winterson's fiction also significantly refuses or complicates each of them. Readers of cyberpunk or David Lodge, for example, will find in Winterson's novels a perhaps disturbing faith in the transforming powers of romantic love, a Romantic investment in self-knowledge and sexual obsession, that accords ill with postmodern conventions of irony and isolation. These features of the novels,

however, will be familiar to readers of lesbian fiction, in which 'all for love' is a recurrent theme and romantic obsession a structuring form; such themes and forms have characterized the important interventions lesbian novelists have made into the hegemony of the heterosexual love story, in the process creating their own canons and conventions. But Winterson's take on love is both romantic and Romantic, a fusion that produces interesting results. Her Byronic investment in love-as-philosophy takes the form of a critique of the Cartesian subject that admirably furthers the goals of some postmodern theories. Perhaps surprisingly, the novels that most successfully challenge the modern regime of the subject-supposed-to-know are those set in its originary era, the European seventeenth and eighteenth centuries.

Winterson's early modern settings allow her to make an argument about the inextricability of postmodern unravellings of the subject and the founding moments of modern subjectivity itself.[2] In other words, the regime of the subject and the colonial technologies that produced it can be seen to be historically specific ways of addressing the felt sense – in history and in representation – of the incoherence and fragmentation of human life. The regime of the coherent, Cartesian subject is produced, in Winterson's fiction, by colonial technologies such as maps, clocks and hero-based histories. Its wishful and fantasmatic status is exposed through her exploration of narrative points of view that resist or exceed the boundaries of modern subjectivity, with its reliance on personal history and the bounded and knowable body. This recasting of modernity allows Winterson to reimagine such modern categories as sexual bodies, sexual boundaries, sexual objects and sexual identities, and offers instead a postmodern history of the virtual lesbian.

Its provocatively pomo title and decayed contemporary setting notwithstanding, *Written on the Body* is finally a less interesting account of the vagaries of the subject and its body than the earlier fictions set in Puritan London and Napoleon's Europe. And by the same token, these 'colonial' novels also offer a more intransigent challenge to the norms of modern gendered and sexual identity than the neat trick of *Written on the Body*'s 'ungendered' narrator obsessed with a beautiful woman can finally provide. The fact that *The Passion* and to an even greater extent *Sexing the Cherry* do the 'postmodern' work of fragmenting and multiplying the subject more efficiently than the novel that seems to engage postmodernity's conventional settings and terms most explicitly, suggests that Winterson's fiction enacts a challenge to the (often ungendered, desexualized) status of such postmodern critiques.[3] By reading the 'lesbianism' of these texts 'virtually' (that is, by insisting on the importance of love and desire as well as that of the exploded subject), I want to argue that *Sexing the Cherry* might be Winterson's most 'postmodern', most 'lesbian', most postmodern–lesbian text – even while I take my title and central metaphor from *Written on the Body*.[4]

Winterson's fiction poses a problem for lesbian theory, for it operates without reference to a founding assumption grounding many theories of

106

lesbian cultural production and representation: that of the essentially marginal status of lesbianism. Judith Roof, in her recent book *A Lure of Knowledge: Lesbian Sexuality and Theory*, states the paradigm this way:

> By implicitly challenging the habitual heterosexual paradigm, representing lesbian sexuality conspicuously unmasks the ways gender and sexuality normally coalesce to reassert the complementary duality of sexual difference. . . . As a point of failure [of representation], lesbian sexuality is a phenomenon that evades the rules; as a point of return, it is the example that proves the rule and reveals the premises upon which the rules depend.
>
> (Roof 1991: 2–5)

These are the very assumptions Winterson's fiction rejects. In the world of her novels, culture doesn't have to and doesn't always operate to assure the successful 'rule' of heterosexuality; representation does not depend on the centrality of 'the heterosexual paradigm', nor on the inevitable 'duality' of femininity in relation to masculinity. Lesbian experience can be at the centre and not the margins, not only of postmodern culture but of modernity itself. For Winterson, the 'rules' don't work for anyone (even heterosexual men), and never have. She offers neither a critique of heterosexual culture nor a salvific account of lesbianism, largely because she refuses to accept that conventional distinction in the first place; that is, while she mobilizes certain conventions of lesbian self-representation, she understands them to produce an identity no less fractured than those (like heterosexuality) produced by other, equally conventional, textual strategies. Instead, she takes a certain lesbian narrative space for granted – a space both romantic and postmodern, sincere and ironic. Thus the 'virtual lesbianism' of Winterson's fiction challenges the notion that the fragmentation of the subject also means the end of desire. This recognition helps account for one of the puzzles of the novelist's style. At times, her writing is intensely cliché-ridden in its depictions of the power of romantic love, depictions that make her work continuous with the genre of lesbian romance. But Winterson pushes these clichés to extremes, literalizing nearly-dead images such as 'I can't live without you' and 'I'd follow you to the ends of the earth', cracking such phrases open to mine their violent potential for transformation and dislocation.

Winterson's fiction, then, makes the kind of contribution to understandings of lesbian representation that Annamarie Jagose calls for in her recent article 'Way Out: The Category "Lesbian" and the Fantasy of the Utopic Space'. Jagose carefully critiques 'this tendency to construct "lesbian" as functioning utopically, that is, as designating an identity exterior to symbolic ordering and regulation' (Jagose 1993: 265). Rather than 'essentializing the lesbian subject as transgressive and revolutionary' (ibid.: 286), Jagose argues that 'the category "lesbian" is not essentially radical or subversive. Indeed, the

category "lesbian" is not essentially anything. It does not have a fixed valence, a signification that is proper to itself rather than contextually produced' (ibid.: 287). Like Jagose's 'not essentially anything', the 'virtually lesbian' strategy I'm arguing for produces a flexible narrative and characterological space: one that can accommodate, at different moments and for different readers, Romantic investments in the ego and lesbian–romance love plots, ironic decentrings of the subject and apocalyptic narratives, a space that takes its own importance for granted without claiming a utopic innocence. Such a space, in Jagose's words, 'recognizes itself and the mechanisms of power to which it is opposed as thoroughly coterminous' (ibid.: 287). (Such a claim, I would argue, must also be made on behalf of 'postmodernism'; its ironic relation to Enlightenment unities cannot construct for it a 'pure' space beyond them, only an acknowledgement of its own implication in them.) In Winterson's novels, we see an even more radical assertion of this coterminousness, for she represents lesbianism simply as central, rather than 'opposed' to anything. There is very little representation of homophobia, very little that is recognizably 'political' in her fiction. Hers is an intervention that can be read as political, but which takes itself so seriously as to never need to argue its own importance. In that sense, then, its very refusal to contest its assumption of its own centrality, may pose the most fundamental challenge to what Jagose calls 'lesbian utopics'.

COLLIDING SUBJECTS AND TEXTUAL FUSIONS: *WRITTEN ON THE BODY*

In *Written on the Body*, the narrator's undeclared gender makes the space of narration a 'virtual' space, a technical construction that can be manipulated to accommodate (and frustrate) a variety of libidinal investments on the parts of readers. It isn't difficult, for example, to make the case that the narrator is actually clearly identified as a lesbian for readers attuned to the social conventions of lesbian relationships and the narrative conventions of lesbian fiction. The lovers elicit familiar homophobic commentary from passers-by who see them kiss: 'You should be ashamed of yourself. There's families here' (Winterson 1993: 11). The narrator's sexual activities come to the attention of the National Health Service: 'Now, it's a serious matter to have "PERVERT" written on your NHS file and some indignities are just a romance too far' (ibid.: 18). And a feminist lover criticizes the narrator's lack of interest in making a women's revolution in the terms of lesbian–feminist cliché: 'She said I wasn't fit to be an assistant in the fight towards a new matriarchy because I had QUALMS' (ibid.: 22). The speech patterns, cultural references and relationship problems made conventional by lesbian fiction are scattered liberally about the text.

In asserting that the narrator 'is' a lesbian, however, a reading like the above evinces a desire for identitarian certainty that may be motivated not

only by an anti-homophobic assumption that lesbians can be Romantic heroes, but also by a too-easy misreading of many passages in which Winterson carefully structures the gender ambiguity of her narrator. The pastiche of disparate narrative styles, points of view and temporal, spatial and bodily locations typical of Winterson's fiction enact a challenge to traditional categories of sexual identity. Importantly, however, Winterson accomplishes this continuous deferral of coherent identification in and through linguistic and representational conventions drawn from lesbian culture. I'd like to read the following scene in some detail in order to establish the fluidity and relentlessness of this structure.

Early in the novel, the narrator and qualmless feminist terrorist girlfriend Inge have embarked on a round of urinal-bombing. The movement of the characters in and out of this male-gendered space provides the opportunity for numerous identifications and counter-identifications (on the part of both characters and readers) with those who have entered through the door marked 'Men'. Initially, the narrator keeps her gender undeclared: 'My job was to go into the urinals wearing a stocking over my head' (Winterson 1993: 22). In describing the experience of repeating this entrance over and over again, however, the tone shifts: 'A typical occasion would be to find five of them, cocks in hand, staring at the brown-streaked porcelain as though it were the Holy Grail. Why *do* men like doing everything together?' The final question evokes a feminist (or at least feminine) complaint that seems firmly to locate men as Other, and the narrator as a woman. Next, however, the narrator qualifies and ironizes her relation to feminism: 'I said (quoting Inge), "This urinal is a symbol of patriarchy and must be destroyed."' The identification of that feminist statement as a quotation distances the narrator from the feminist position sketched earlier. Teasingly, Winterson then offers us the narrator's account of an authentic voice:

> Then (in my own voice), 'My girlfriend has just wired up the Semtex, would you mind finishing off?' What would you do under the circumstances? Wouldn't impending castration followed by certain death be enough to cause a normal man to wipe his dick and run for it?

The narrator's 'own voice' is an informal one, perhaps one familiar with urinals – suggesting that it may be male. The apostrophe to the reader that follows can be read a number of ways, but surely the first level of meaning is to establish the narrator as a 'normal man' appealing to the reader as a normal man as well. A few sentences later, however, this assumption is undermined in its turn:

> the urinating men just flicked the drops contemptuously and swapped tips about the racing. I'm a mild-mannered sort but I don't like rudeness 'Hands up *boys*,' I said. 'No, don't touch it, it'll have to dry in the wind.'
>
> (ibid.: 23; emphasis in original)

The narrator's rage at the men's contempt and the emphatic diminution of their male power expressed by the epithet 'boys' returns us to a female and feminist point of view. As the densely-woven threads of this scene's construction of audience and point of view demonstrate, Winterson's narrator is not an androgynous figure, the imprecise claim of some reviewers; neither is the narrator sometimes a man and sometimes a woman. Rather, this is a figure (or perhaps a narrative space or category) that appropriates the experiences and investments of variously gendered and sexualized beings in a structural enactment of Winterson's particular Virtual Reality. This is a figure constructed of disparate body parts, desires, identities and histories, put together in a postmodern pastiche that nonetheless allows for the grand romantic obsession of lesbian romance fiction in the best identitarian tradition of lesbian cultural politics. This difficult fusion, we may speculate, characterizes Winterson's lesbian postmodernism.

Winterson's employment of the technical terms of disparate vocabularies enacts another structural and thematic fusion, and offers another way to read the postmodernism of her text. In *Written on the Body* she continues a practice that originated in her first novel, a coming-out story set in an industrial Midlands city among Protestant fundamentalists: that of using both millenarian religious language and virtuoso discussions of the post-Einsteinian physical world. Both give her ways to imagine the unimaginable: infinite desire, love without end, apocalyptic exile. These fusions allow her to construct the narrator's obsessiveness and arrogance in *Written on the Body* as simply a recognition of the insights of science and religion: the world is ours to alter by acts of imagination. It is and always has been Virtual Reality. Acknowledging, finally, that desire for Louise means the end of a relationship with Jacqueline, the narrator reflects on the power of this imaginative act itself: 'But now, standing in this familiar unviolated space, I have already altered my world and Jacqueline's world for ever' (Winterson 1993: 38). Such a statement is overdetermined by the book's lush layering of these rhetorics of excess: it is arrogance, scientific insight, recognition of sin. The world is altered by an act of imagination that has physical force and is as effective as history. 'The old music of romance is played out in modern digital ways' (ibid.: 96).

This fusion of the informatic and the millenarian also characterizes cyberpunk fiction; it is used most notably in William Gibson's *Neuromancer* (1984), which describes the dilemma of the protagonist, Case, whose cyborg-like ability to gain access to cyberspace via electronic and chemical body alterations has been stripped away. This dilemma becomes the object of an extended metaphor that structures the novel's sense of both apocalypse and exhilaration: 'For Case, who'd lived for the bodiless exultation of cyberspace, it was the Fall. . . . Case fell into the prison of his own flesh' (Gibson 1984: 6). Like Winterson, Gibson offers technological definitions that just barely exceed technological reality, pushing current trends to their logical

conclusions: 'Cyberspace. A consensual hallucination experienced daily by billions of legitimate operators, in every nation, by children being taught mathematics' (ibid.: 51), and also by 'cowboys' like Case whose brains are wired like computers. Winterson's discussions of molecular docking (Winterson 1993: 61), gene therapy (ibid.: 66) and chronobiology (ibid.: 80) coexist with romantic literalizations of biblical injunctions: 'And so the word was made flesh' (ibid.: 33); 'I know the stigmata of presumption' (ibid.: 131). In Gibson's cyberpunk world, love is ironic, simulated, treacherous. Winterson, however, adopts the extreme vocabularies of technology and Christian myth to produce a millenarian reinvestment in the sexual body: 'Myself in your skin, myself lodged in your bones, myself floating in the cavities that decorate every surgeon's wall' (ibid.: 120). In this reinvestment, *Written on the Body* recalls not the masculinized postmodernism of cyberpunk, but lesbian fictions of obsessive love such as Sarah Schulman's *After Dolores* (1988) and Renee Hansen's *Take Me To the Underground* (1990).

Even more strongly, the latter sections of *Written on the Body* (as well as its title) resonate with Monique Wittig's *The Lesbian Body* (1975), with its violent, loving catalogue of body parts and their dissolution. For Wittig's narrator, the lover's body is flayed and vivisected in order to be known:

> Each drop of your blood each spurt from your arteries striking m/y arteries vibrates throughout m/e. *I* am unable to stir, *I* await an apotheosis a glorious end in this place where the primary colours are not lacking, *I* tremble before the bright red efflux from your arteries
>
> (Wittig 1975: 21)

With a gaze equally obsessed, equally medically informed, equally intent on exposing the body's interiors, Winterson's narrator confesses: 'I didn't only want Louise's flesh, I wanted her bones, her blood, her tissues, the sinews that bound her together' (1993: 51). Louise's leukaemia diagnosis provides the opportunity for Winterson to write a catalogue of the body, complete with titles from 'The Cells, Tissues, Systems, and Cavities of the Body' through 'The Skeleton', 'The Skin' and 'The Special Senses'. The lists of body parts and their functions which follow each title could be a literal and grimly humorous revision of Wittig's apotheotic exploration of the beloved's blood, skin, bones and organs. This section of *Written on the Body* shares with Wittig's novel an episodic structure that renders clinical description in the form of the poetic stanza.

The various intertextualities produced by *Written on the Body* suggest that Winterson's novel occupies a unique place in the canons of both postmodern and lesbian fiction. Insisting on the fusion of the scientific/ millenarian vocabulary of 'masculine' cyberpunk fiction with the plots of romantic love and delight in the body characteristic of lesbian romance novels, Winterson carves out a 'postmodern lesbian' narrative style that exceeds both categories.

LISA MOORE

NEUTRAL ZONES: *THE PASSION*

Although *The Passion*'s protagonist is Henri, a young soldier in Napoleon's army, lesbian or bisexual women are ubiquitous in the text; indeed, Villanelle, the woman Henri loves and follows across the European continent after the siege of Moscow, is involved in her own romantic search for (or flight from) the wife of a wealthy Venetian merchant. Even more significant, however, are the minor characters whose lesbianism is taken for granted. For example, the whore Henri visits kisses another prostitute after she has been brutalized by a soldier, and Henri acknowledges, 'She would never do that to me' (Winterson 1987: 15). Henri's respect for lesbian relationships (including Villanelle's passion for the Venetian woman), the way in which they seem to dwarf his own, suggests a lesbian perspective made possible (paradoxically) by Winterson's use of a male narrator. For Henri, lesbian relationships exemplify the kind of passion for which he is searching. Thus lesbianism in *The Passion* is exemplary and definitive, rather than marginal and to-be-defined.

The novel's most sustained representation of lesbian cultural objects and conventions occurs in the 'Queen of Spades' section, when the novel is narrated from the point of view of Villanelle, a Venetian boatman's daughter. Villanelle is a girl born with boys' body parts–the webbed feet characteristic of the males in her father's family fall to her. Birth attendants want to 'cut off the offending parts straight away' (ibid.: 52), but the fans of flesh between her toes resist the knife, and Villanelle's hermaphroditism remains intact. As an adult, Villanelle cross-dresses in her job as a casino worker partly because 'that's what the visitors liked to see' (ibid.: 54), but adds a moustache 'for my own amusement. And perhaps for my own protection' (ibid.: 55). Villanelle declares, 'I am pragmatic about love and have taken my pleasure with both men and women' (ibid.: 59–60), but she loses her heart when a wealthy bookseller's wife touches her on the shoulder for a moment in the crowded casino. Their lovemaking is decidedly non-phallic:

> She lay on the rug and I lay at right angles to her so that only our lips might meet. Kissing in this way is the strangest of distractions. The greedy body that clamours for satisfaction is forced to content itself with a single sensation and, just as the blind hear more acutely and the deaf can feel the grass grow, so the mouth becomes the focus of love and all things pass through it and are re-defined.
>
> (ibid.: 67)

This 'redefinition' of erotic climax as centred in the lips can be understood as the kind of bodily rearrangement explored by Luce Irigaray in 'When Our Lips Speak Together'. In that essay, Irigaray constructs a theory and a poetry of lesbian eroticism centred in the lips – those of mouth and those of the vagina. For Irigaray, giving priority to the lips is giving priority to one's own sexual

112

pleasure as well as one's connection to other women: 'By our lips we are women: this does not mean that we are focused on consuming, consummation, fulfillment. Kiss me. Two lips kissing two lips: openness is ours again. Our "world"'. (Irigaray 1985: 209–10). As in *Written on the Body*, Winterson chooses images and acts that resonate with potent conventions in lesbian writing, suggesting a richness of allusion especially available to lesbian readers. Such a context once again establishes the way in which a lesbian frame of reference is made unobtrusively available – or quietly assumed.

Indeed, some of Villanelle's quests reflect the structuring problems of much lesbian romantic fiction: 'Could a woman love a woman for more than a night?' (Winterson 1987: 69). 'It was a woman I loved and you will admit that is not the usual thing' (ibid.: 94). Such references are as close as Winterson comes to acknowledging homophobia in any of her fiction after *Oranges Are Not the Only Fruit*. Her later novels are concerned with romance, passion and philosophy, all inflected by lesbian narrative conventions, frames of reference and points of view, but very little with politics, the staple of much speculative fiction that shares these elements. It is this decisive distance from contemporary sexual politics that most clearly distinguishes Winterson's fiction and determines the way in which it will approach questions of history, identity and community. Such issues for Winterson are transcendent; her characters are engaged in the production of histories, identities and communities in ways that do not vary predictably along the lines of gender, sexual practice or historical period. This Romantic investment in the transhistorical qualities of human nature means that unlike other postmodern lesbian novelists such as Sarah Schulman, Winterson is not intervening in or attempting to correct homophobic misrepresentations of or assumptions about lesbian relationships.[5] Conflict in this fictional world is always romantic conflict; even war is primarily an opportunity for Henri to express his obsessive love for Napoleon by following him to Moscow. Thus, Winterson's novels may be read politically, but they themselves make no explicit political argument. For all the richness of resonance with lesbian theory and fiction in her novels, then, Winterson violates their one crucial convention by refusing to engage in debates around the social and political meaning of lesbianism. The absence of an explicit engagement with these issues, of course, does not mean that these novels fail to intervene in those debates at all; simply that they do so by refusing to treat lesbianism as marginal, as an inherently more problematic or unstable construction of identity than heterosexuality, masculinity or any other category.

The problem of identity, however – a staple of both theoretical and fictional lesbian writing – fascinates Winterson. The provisional and fictional status of identity is a frequent topic in *The Passion*. Memory plays a crucial role in constructing subjectivity. But unlike the Lockeian function of memory – to preserve consciousness through time in order to guarantee identity – the *loss* of memory here is what makes sense of the world.[6]

They say that every snowflake is different. If that were true, how could the world go on? How could we ever get up off our knees? How would we ever recover from the wonder of it?

By forgetting. We cannot keep in mind too many things.
There is only the present and nothing to remember.

(ibid.: 43)

Forgetting is the function of memory that guarantees sanity, hence consciousness, hence subjectivity. In reversing the Lockeian hierarchy of consciousness over unconsciousness, Winterson revises the meaning of identity even as she reaffirms its centrality in the efforts of her characters to make meaning in the world.

Thus Napoleon's doom: 'He talks of the past incessantly because the dead have no future and their present is recollection' (ibid.: 134). Exiled to a rocky island, Napoleon is deemed dead by Henri because of his inability to inhabit the present, 'all there is'. Thus his memories of the past only confirm his loss of subjectivity, since they take up the space that in life is occupied by experiencing the present. Subjectivity is a potential or virtual space rather than an accomplished fact in this novel. Two major paradigms represent the character of this space, available to both occupation and evacuation: the philosophical category of love and the geographical location of Venice.

Henri's wish for love is what takes him to other geographical spaces, for his passion for the emperor he has never met is the reason he first leaves home. 'Wherever love is, I want to be, I will find it as surely as the land-locked salmon finds the sea', he asserts (ibid.: 44). Although conceived in clichéd terms of romantic obsession, this image of movement and fluidity acquires new layers of meaning as we follow it through the novel. For what Henri experiences is not the loss of self conventionally associated with romantic love, but a multiplication of selves, a proliferation of possible histories and identities: 'Perhaps our lives spread out around us like a fan and we can only know one life, but by mistake sense others' (ibid.: 144). Henri's passion for Villanelle offers a vertiginous bridge between these potential histories: 'If I give in to this passion, my real life, the most solid, the best known, will disappear and I will feed on shadows again like those sad spirits whom Orpheus fled' (ibid.: 146). Passion is located variously in the novel: 'between fear and sex' (ibid.: 62), 'between God and the devil' (ibid.: 68). The very imprecision of these locations constructs the 'virtually lesbian' space in which characters and readers move through various subject positions and narrative points of view as possible libidinal identifications (for characters and readers) within the novel.

It is in Venice that this protean quality of subjectivity is most explicitly felt. For Villanelle, her native city is 'a meeting place', a 'neutral place', populated by Venetians with 'Siamese' doubled souls (ibid.: 57). These are images of emptiness on the one hand and multiplicity on the other. But such

connotations are not opposites; in this novel, they represent the contracting and expanding space of subjectivity, at once nothing and everything, nowhere and somewhere, present and absent. For Villanelle, finally, Venice is 'the city of disguises. What you are one day will not constrain you on the next. You may explore yourself freely and, if you have wit or wealth, no one will stand in your way' (ibid.: 150).

After Henri's imprisonment in the asylum of San Servelo at the end of the novel, Villanelle retreats from this space: 'I don't dress up any more. No borrowed uniforms. Only occasionally do I feel the touch of that other life, the one in the shadows where I do not choose to live' (ibid.). The novel's ironic and diminished ending is characterized by such a retreat on the part of both characters. Henri's retreat into madness, like Villanelle's refusal to dress up, constitutes the kind of refusal to live in the present that Henri had noticed and condemned in Napoleon. What remains at the end of *The Passion*, as Henri narrates his hallucinations from San Servelo, are two things: romantic love ('I review my future and my past in the light of this feeling' (ibid.: 159)), and writing itself (the final line, which has been repeated throughout the novel: 'I'm telling you stories. Trust me' (ibid.: 160)). Both are technologies that continue to produce the subject, in however fragmented and illusory a form. Such illusions remain effective even when we lose our 'innocence' about them; it is perhaps in the degraded form of madness that we can 'trust' them most.

The breaking down of Enlightenment unities is located historically in Winterson's development of a colonial geography of the body in this novel of imperial conquest.[7] Comparing the risks of falling in love with those of a sea journey, Villanelle reflects:

> Travellers at least have a choice. Those who set sail know that things will not be the same as at home. But for us, who travel along the blood vessels, who come to the cities of the interior by chance, there is no preparation. We who were fluent find life is a foreign language.
>
> (ibid.: 68)

This scenario of spatial and linguistic dislocation maps neatly on to the plot of imperial aggression in the novel, which follows Napoleon's military career through the disastrous siege of Moscow. The mediating and potential quality of Venice is also expressed geographically. Henri recalls:

> I got lost from the first. Where Bonaparte goes, straight roads follow, buildings are rationalized, street signs may change to celebrate a battle but they are always clearly marked. Here, if they bother with street signs at all, they are happy to use the same ones over again. Not even Bonaparte could rationalize Venice.
>
> (ibid.: 112)

This is a postmodern hyperspace universe but also a fairy-tale forest; it

115

evokes both the anti-rationalism of magic and the post-rationalism of technological proliferation and penetration. Like a voyage of colonial exploration, the journey to such a land is made possible by both technology and fantasy. Winterson collapses the distinction between modern and postmodern journeys even further when she takes colonial travel as a major theme in *Sexing the Cherry*.

THE SUBJECT TRAVELS: *SEXING THE CHERRY*

This novel rewrites the origins of European modernity – colonial exploration, the rise of empirical science and Enlightenment notions of the unified self. Through the narration of Jordan, who accompanies one of the heroes of early modern exploration and scientific discovery as his apprentice, these technologies of modernity are called into question, their fantasmatic status and their limitations revealed. Thus modernity itself – the regime of the subject, of the bounded body, of fixed identity – is rewritten as only one of many possible ways of describing human experience, and postmodern understandings of fragmented bodies and multiple subjectivities are seen to have been there all along, produced by (and thus in some sense proper to) the impossible demands of Enlightenment modernity rather than challenging or rejecting them. Such an understanding deconstructs modernity's investments in fixed and knowable gender and sexual identities: the protagonists of this novel either move between and among gender and sexual identifications (Jordan), or simply exceed them (his foster mother, the Dog Woman). Once again, an understanding of the malleability of gender and sexual boundaries characteristic of the point of view of a marginalized sexuality is represented not as a minority position, but as the unproblematic possession of the novel's most admirable characters. In these terms, then, both Jordan and the Dog Woman can be understood as occupying flexible gender and sexual positions, as 'virtual lesbians' sharing the protean and potential narrative space developed in the other novels.

Many reviewers have described this novel as another view on the story of the historical figure John Tradescant, the explorer who brought botanical wonders, including the banana and the pineapple, back for the imperial scrutiny of Charles I: as a fictionalized version of an obscure but nonetheless verifiable aspect of early modern history.[8] But Jordan, Tradescant's apprentice, begins the story of his colonial voyages by discounting their importance:

Every journey conceals another journey within its lines: the path not taken and the forgotten angle. These are the journeys I wish to record. Not the ones I made, but the ones I might have made, or perhaps did make in some other place or time. I could tell you the truth as you will find it in diaries and maps and log-books. I could faithfully describe all that I saw and heard and give you a travel book. . . . I discovered that

my own life was written invisibly, was squashed between the facts, was flying without me. . . . The longer I eluded myself the more obsessed I became with the thought of discovery. Occasionally, in company, someone would snap their fingers in front of my face and ask, 'Where are you?' For a long time I had no idea, but gradually I began to find evidence of the other life and gradually it appeared before me.

(Winterson 1989: 2–3)

Not the famous journeys he took with Tradescant, but the journeys he 'might' have made, are the subject of this novel. The print technologies of colonial hegemony (travel books) are dismissed, as are the 'facts' that these early modern print narratives established as their own claim to authority. 'Discovery' means not strange fruits and stranger lands and people, accounts of which fuelled the English imagination for three centuries, but a psychic or imaginative discovery of the 'invisible life'. Jordan replaces the exploration of an external world mapped and codified by the tools of the Scientific Revolution with an exploration of the alternative selves and lives obscured (although also invented) by the assumptions of that very revolution, its threatening unknowability held at bay by maps, histories and the emergence of scientific disciplines.

In a series of adventures reminiscent of *Gulliver's Travels*, Jordan encounters 'the city where love is an epidemic' (ibid.: 84) and, just like Gulliver, a city floating above the earth (ibid.: 107). Such 'discoveries' make nonsense of the careful mapping that was one of the goals of colonial exploration. Weird geographies are subject to no particular remark; Jordan does not distinguish between physical and psychic journeys for us. Readers are left to understand each in terms of the other. Jordan comments on the march of progress, delimiting ever greater areas of the globe under compass, graph and pencil: 'maps, growing ever more real, are much less true' (ibid.: 88). Following this remark is a series of anecdotes and propositions attesting to the permeability of space, time and consciousness. Not only do these categories penetrate one another, we are told, but attempts to delimit their boundaries or impose order on their flux are always inadequate. Returning to the fiction, we read Jordan's words: 'My experience of time is mostly like my experience with maps' (ibid.: 98) – that is, modern technologies of the subject are inadequate to Jordan's experience and to the story the book tells.

But the novel is principally preoccupied with a challenge to Lockeian notions of identity as the duration of consciousness through time. 'Did my childhood happen?' (ibid.: 102) asks the speaker of these anecdotes (not clearly Jordan, but not clearly another character either). Childhood, that most sacred and naturalized of institutions of consciousness, has the status of a necessary fiction here:

I will have to assume that I had a childhood, but I cannot assume to have had the one I remember.

117

Everyone remembers things which never happened. And it is common knowledge that people often forget things which did. Either we are all fantasists and liars or the past has nothing definite in it. I have heard people say we are shaped by our childhood. But which one?

(ibid.)

This critique of coherent notions of identity persists. The Dog Woman tells the story of her childhood as a freakish giant whose father wants to exhibit her. In retaliation, she kills him, then tells us: 'I have forgotten my childhood, not just because of my father but because it was a bleak and unnecessary time' (ibid.: 122). Childhood, the founding experience of identity in the Lockeian schema, is for these characters malleable and 'unnecessary', unknowable even when remembered, forgotten even in the act of recounting.

In the light of these failures of modernist print, scientific and philosophical technologies, Jordan insists: 'I've written down my own journey and drawn my own map' (ibid.: 115). This is a journey that can only be mapped through attention to the very gaps and inconsistencies that trouble Enlightenment unities. By attributing this insight to Jordan, the colonial explorer of the 1650s, Winterson resists the notion that this shift in perspective is a product of history – a product, that would mean, of the very Enlightenment notion of linear time that it critiques. Instead, the novel suggests, the authors of modernity themselves were troubled by the questions unravelled by post-modern theory: the seeds of modernity's deconstruction lie in its own account of itself.

A non-narrative series of anecdotes and propositions connects the first part of the novel, the Dog Woman's and Jordan's stories, with its conclusion, the stories of a naval officer Nicolas Jordan and an unnamed feminist/ecologist terrorist who share the memories of their early modern counterparts. In this series of brief exercises in post-Einsteinian physics and post-Saussurean philosophy, the novel explicitly theorizes its investments in the decon-struction of modern certainties about linear time and its relation to identity:

Thinking about time is to acknowledge two contradictory certainties: that our outward lives are governed by the seasons and the clock; that our inward lives are governed by something much less regular – an imaginative impulse cutting through the dictates of daily time, and leaving us free to ignore the boundaries of here and now and pass like lightning along the coil of pure time, that is, the circle of the universe and whatever it does or does not contain

Until now religion has described it better than science, but now physics and metaphysics appear to be saying the same thing.

(Winterson 1989: 99)

This convergence of discourses – religious, philosophical and scientific – produces a dislocated notion of identity. The novel insists, however, that this

notion is already inherent in conventions of language and ordering that are supposed to control it: 'the most prosaic of us betray a belief in the inward life every time we talk about "my body" rather than "I"' (ibid.: 100). Acknowledging this split at the heart of language and subjectivity 'tells us that we are multiple not single, and that our one existence is really countless existences holding hands like those cut out paper dolls, but unlike the dolls never coming to an end' (ibid.). This is the same recognition that the Dog Woman's descendant or alter ego, a chemist driven to terrorist tactics by the decaying environment, arrives at as she camps by the shore of a hopelessly polluted river: 'If I have a spirit, a soul, any name will do, it won't be single it will be multiple. . . . It may inhabit numerous changing decaying bodies in the future and in the past' (ibid.: 144). Once again, Winterson fiercely literalizes cliché, forcing it to do the work, not of convention, but of critique.

Jordan and the Dog Woman are both ambiguously gendered and sexually nonconforming characters. Jordan cross-dresses frequently, usually as a prostitute (ibid.: 27, 71). Jordan compares his access to the world of women with his colonial explorations: 'In my petticoats I was a traveller in a foreign country' (ibid.: 29). One of the things he discovers is that the women in the brothel have lovers in a nearby convent (ibid.: 28). Both lesbianism and cross-dressing are unremarkable, even usual in Jordan's world: 'I have met a number of people who, anxious to be free of the burdens of their gender, have dressed themselves men as women and women as men' (ibid.). Later, he hears the stories of the Twelve Dancing Princesses, who tell him that as the fairy tale says, they lived happily ever after, 'but not with our husbands' (ibid.: 48). One falls in love with a mermaid and keeps house with her 'in perfect salty bliss' (ibid.); another, named Rapunzel, 'went to live in a tower with an older woman' (ibid.: 52).

The story of the Dog Woman's mysterious genesis is imagined by Jordan and anticipates the chemist's riverbank explorations. Jordan, found by the Dog Woman in the river, reflects,

> I think she may have been found herself, long before she found me. I imagine her on the bank, in a bottle, the bottle is cobalt blue with a wax stopper wrapped over a piece of rag. A woman coming by hears noises from the bottle, and taking her knife she cuts open the seal and my mother comes thickening out like a genie from a jar, growing bigger and bigger and finally solidifying into her own proportions.
>
> (Winterson 1989: 86)

This genesis, both magical and potentially lesbian (imagining as it does the chemist penetrating and liberating the body that 'contains' the Dog Woman), links the Dog Woman with the mysterious fruit of the novel's title whose story just precedes hers. The hybrid cherry is the product of the new technique of grafting. Jordan notes: 'There are many in the Church who condemn this practice as unnatural, holding that the Lord who made the world made its

flora as he wished and no other way' (ibid.: 85). The Dog Woman is also seen as a freak of nature, and is the sworn enemy of the Puritans who condemn grafting. However, the Dog Woman herself rejects this comparison, calling the cherry a 'monster' and saying 'such things had no gender and were a confusion to themselves' (ibid.). But Jordan asserts: 'the cherry grew, and we have sexed it and it is female' (ibid.). This process gives rise to his own fantasy of homosexual union: 'What I would like is to have some of Tradescant grafted on to me so that I could be a hero like him' (ibid.). Cross-gendering, like cross-dressing, gives rise to images of homosexual pairing.

The Dog Woman's physical monstrosity makes her the novel's most powerful character. When her weight on the end of a see-saw catapults an elephant into invisibility, she notes with modest pride:

> It is a responsibility for a woman to have forced an elephant into the sky. What it says of my size I cannot tell, for an elephant looks big, but how am I to know what it weighs? A balloon looks big and weighs nothing.
>
> (ibid.: 21)

The social consequences of such a version of female power are more equivocal: 'I know that people are afraid of me', she acknowledges. She has been protected from isolation, though, by Winterson's favourite magic, the transforming power of love. Although she broke her father's legs by sitting on his knees, her tiny mother 'could swing me on her back and carry me for miles. There was talk of witchcraft but what is stronger than love?' (ibid.). By bringing together these images of physical power, witchcraft and love in the service of (or at least with the effect of) the crippling of paternal authority, Winterson invests the Dog Woman with a mythic status that refuses to idealize. The Dog Woman, after all, has a flat nose, heavy eyebrows, few and black teeth, and pock marks in her face large enough to house fleas (ibid.: 19). One of her weapons against impudent Puritan men is her rank body odour. Another is to tear out their eyes and teeth, which she collects in a great sack. Clearly, then, she exceeds and ironizes normative femininity. Her sexuality is also too much for the world in which she finds herself:

> I did mate with a man, but cannot say that I felt anything at all, though I had him jammed up to the hilt. As for him, spread on top of me with his face buried beneath my breasts, he complained that he could not find the sides of my cunt and felt like a tadpole in a pot. . . . I saw that I had pulled him in, balls and everything . . . my friend came in with her sisters, and with the aid of a crowbar they prised him out. . . . He was a gallant gentleman and offered a different way of pleasuring me. Accordingly, he burrowed down the way ferrets do and tried to take me in his mouth. . . .
>
> 'Madam,' he said, 'I am sorry, I beg your pardon but I cannot . . . I

cannot take that orange in my mouth. It will not fit. Neither can I run my tongue over it. You are too big, madam.'

... When he had gone I squatted backwards on a pillow and parted my bush of hair to see what it was that had confounded him. It seemed all in proportion to me. These gentlemen are very timid.

(Winterson 1989: 120–1)

These images of enlarged sexual parts form part of a discursive representation of the lesbian body that came back from voyages of colonial exploration as did exotic fruit like the banana that fascinates Jordan, which the London crowd mistakes for 'the private parts of an Oriental . . . yellow and livid and long' (ibid.: 5). Colonial explorers were also bringing back tales of 'Hindoo women' whose 'peculiar conformation, from an elongation of the *clitoris*', render them 'capable both of giving and receiving venereal pleasure, in intercourse with women'.[9] Such exotic monstrosities inevitably suggested sexual aberration, providing lesbian readers with a way to read the Dog Woman's excess as success, her powerful monstrosity as virtually lesbian.

The Dog Woman also wonders, 'How hideous am I?' (ibid.: 21). Reframing female 'hideousness' as power is a project of 'cyborg feminist' Donna Haraway. In her book *Simians, Cyborgs and Women*, she argues that female monsters (whether produced in the discourses of physical anthropology, as simians, or that of postmodern body-machines, as cyborgs) are 'promising and non-innocent' (Haraway 1991: 2), promising because non-innocent, because implicated unapologetically in the technologies that produce their outsider status. Such monsters, she argues, represent 'the kind of persons we might be', persons who 'can no longer be, if they ever were, master subjects, nor alienated subjects, but – just possibly – multiply heterogenous, inhomogenous, accountable, and connected human agents' (ibid.: 3). Crucially, such a figure is not inherently transgressive or politically useful; the cyborg, Haraway's most potent monster figure, is 'also the awful apocalyptic *telos* of the "West's" escalating dominations' (ibid.: 150). Only by seizing this figure for purposes of connection and resistance can it be wrenched from its place in such an escalation. 'Monstrous' origins lie in technology, not in birth; like the Dog Woman's, the cyborg's origins do not constitute its claim to our attention. Haraway says:

an origin story in the 'Western', humanist sense depends on the myth of original unity, fullness, bliss and terror, represented by the phallic mother. . . . The cyborg skips the step of original unity, of identification with nature in the Western sense.

(1991: 151)

Winterson writes such an anti-origin story. In her fictional worlds, there is no originary unity from which postmodern subjects in history fall away, or decay. Instead, like the Dog Woman, they find their children in polluted

rivers; like Jordan's, their significant maps and journeys are virtual ones. Like the Dog Woman, for whom dogs are intimate companions and fleas internal to the body, and like Jordan, for whom the compass and the telescope are no less a part of the body than its ability to fly, cyborgs 'are not afraid of their joint kinship with animals and machines, not afraid of permanently partial identities and contradictory standpoints' (Haraway 1991: 154). Winterson's romantic/ironic hybrid narrative style is such a cyborg as well, documenting the penetration of technology into 'nature' at the founding moment of modernity in its title image, that of the cherry grafted but nonetheless sexed. Winterson's writing fulfils the canons of what Haraway calls 'cyborg writing':

> Cyborg writing must not be about the Fall, the imagination of a once-upon-a-time wholeness before language, before writing, before Man. Cyborg writing is about the power to survive, not on the basis of original innocence, but on the basis of seizing the tools to mark the world that marked them as Other.
>
> (ibid.: 75)

This absence of innocence, this seizing, is what makes *Sexing the Cherry* most recognizable and useful to its lesbian readers.

NOVEL'S END, WORLD'S END

Winterson's fiction suggests revisions to certain normative assumptions in both postmodern and lesbian writing. These novels, especially *Sexing the Cherry*, resist the idea that postmodernity displaces modernity historically by insisting on the coterminousness of both experiences of subjectivity and the body. They also challenge the convention of lesbian theory that lesbians and their point of view are excluded by the normative identity categories of modern culture; Winterson's fiction instead installs a particular lesbian narrative space at the centre of the novels and their understanding of history, sexuality and identity. Winterson's novels demonstrate that when critiques of the subject entail an abandonment of passion and desire, they construct new illusions of their own 'purity', their own lack of implication in the technologies of modern subjectivity, that renders them inefficient for their own purposes. For Winterson, the subject can be fragmented yet still obsessed – identity with all its impossibilities still has its effects as well as its pleasures. Crucial to the understanding of the 'virtual lesbian' is the acknowledgement of the subject's necessary implication in conventional narratives of its own origins as well as its implication in the failures of those narratives. The lesbian romance novel, in Winterson's hands, exposes the millenarian fantasies of those who would declare the end of subjectivity. Just as the fragmentation of modern identity categories is visible in their own origins, so in their final days their seductions and powers mutate and persist.

This essay has concerned itself entirely with one discursive machine: the novel. But in some ways, to talk about the novel as a technology for decentring a modern self or constructing a postmodern one is already an anachronism. At least in North America, the future of fiction seems virtual indeed, as the hegemony of the novel is assaulted from at least two directions: by electronic bulletin boards and Internet communities available to anyone with access to a computer and a modem; and by the flourishing underground culture of 'zines, cheaply-produced, contestatory periodicals responsive to ever-more specialized gender, sexual and identity-based communities. Although like many technological innovations, these ones were initially male-dominated, women and particularly lesbians have colonized both with a speed characteristic of the accelerated pace of current technological change. Elizabeth Meese recently described some of the queer interactions among women that take place 'on the Net' (Meese 1993), interactions made possible by the anonymity and strictly textual status of the participants, who construct personae with whom to 'play' with others. In these disembodied interactions, the body is paradoxically foregrounded for the purposes of erotic description and connection: bodies may sport disparately gendered parts, and characters' desires and acts are not limited by conventions of reading gender, sexuality and identity into particular kinds of visible, physical bodies. The most successful lesbian appropriation of the 'zine format must be that of Diane di Massa, whose comic strip-style narratives of the adventures of Hothead Paisan, Homicidal Lesbian Terrorist, have zoomed from fringe to cult status in less than three years. First published as a smudgy no-budget xerox in 1991, the Hothead narratives have recently been collected and published in book form by Cleis Press (1993). Disturbingly and unashamedly violent, the narratives picture Hothead castrating, torturing and murdering male rapists and sexual harassers in a gritty, familiar and dangerous urban setting. Hothead's body, hyped-up on caffeine and subject to indigestion, constipation, sleeplessness and bad dreams, is a fantastic one: she can hold a paper coffee cup, balance her cat Chicken on her back and do a perfect splits in order to cave in a rapist's face with her Doc Martened foot, all without losing her trademark demonic grin and bulging eyes. Hothead is crazy, violent, depressed and powerful; these narratives give us access to a lesbian body in which the first three terms would not make the last impossible.

Perhaps, then, Winterson's novels will be the last we read as new forms of representation emerge under the pressure of the postmodern conditions in which the physical world, decaying economically and environmentally, seems increasingly inadequate as a medium of exchange. Like the fantasies of the Net and the 'zines, Winterson's characters offer us hitherto un-represented experiences of the body as disparately gendered, inconsistently sexualized, capable of acts and emotions that never make it to the realm of the physical. The bodily moments that don't add up to recognizable identities are the ones we have been trained not to acknowledge. These postmodern

123

lesbian fictions are troubling because they insist on the intransigence of these disruptive moments – moments that, under the glare of these fictions, we can no longer successfully deny, even while we suspect that they may be neither innocent nor wholly liberating.

ACKNOWLEDGEMENTS

I'd like to thank the following friends and colleagues for their invaluable editorial advice and insights about lesbian theory, postmodernism, Winterson and more: Sabrina Barton, Ann Cvetkovich, Kim Emery and Naja Fuglsang-Damgaard. The writing of this essay would have been a much less pleasurable and even possible task without their work. I'd also like to thank my research assistant, Janet Hayes, for her painstaking bibliographical work.

NOTES

1 More accuarately, we might say that Winterson is not 'imagining' such a body but simply trying to describe it, since such a chaotic relation to the material is presumably what identity exists to distract us from, and hence something we do, on some level, experience.

2 Elspeth Probyn both invokes and critiques the postmodern assumption I have in mind here when she notes that 'it could be argued that what has been labelled as the postmodern dilemma was precipitated not by the supposed passing of modernism but by the questions feminists brought to diverse modern disciplines' (1990: 178). Probyn offers another way to problematize the notion that postmodernism displaces modernism historically through a feminist insistence on the politics of the local.

3 Thanks to Ann Cvetkovich for pointing this out to me.

4 Both 'postmodern' and 'lesbian', of course, are terms under fierce debate in current theory, debates too complex to detail here. In this essay, I use both terms in an intentionally 'sloppy' way, to refer to certain conventions that have solidified around each of them in popular-academic consciousness. For 'postmodernism', I have in mind notions of fragmented, multiple, impossible subjectivities, of the breakdown of distinctions between the body and technology, between technology and nature and of a consequent alienation from or irony about both subjectivity and the body – which has tended to imply a refusal of the possibility of romantic love because of its presumed status as an illusory discourse of authenticity. For 'lesbian', I am thinking here of a slightly narrower field, that of lesbian romance fiction, with its investments in the discovery of an authentic sexual identity, in the experience of that identity in romantic love (usually entailing a discovery of an authentic body and desire as well) and in community, and in the possibility of political action and change made possible by such connections. For discussions of debates around postmodernism, see Nicholson (1990) and Haraway (1991); around lesbianism, see Stein (1993), Allison (1984), Hollibaugh and Moraga (1983) and Zimmerman (1990).

5 The fictional strategy I'm describing here is distinct from Winterson's very 'out' and politically engaged public persona, particularly in Britain. Hilary Hinds documents this in her article on the reception of *Oranges Are Not the Only Fruit*, quoting Winterson's insistence that the explicit lesbianism of the novel be retained

for the BBC2 'art television' production aired in 1990. In her published script for the television play, Winterson states:

> I know that *Oranges* challenges the virtues of the home, the power of the church and the supposed normality of heterosexuality. I was always clear that it would do. I would rather not have embarked on the project than see it toned down in any way. That all this should be the case and that it should still have been so overwhelmingly well received cheers me up.
>
> (cited in Hinds 1992: 162)

My argument, then, is not that Winterson 'herself' is uninterested in lesbian politics but that the political intervention made by her fiction is one that breaks with certain conventions of lesbian representation, conventions that insist on the depiction of the challenges faced by lesbians as part of their critique of homophobia.

6 See, for example, the section 'Of Identity and Diversity' in *An Essay Concerning Human Understanding*: 'as far as . . . consciousness can be extended backwards to any past action or thought, so far reaches the identity of that person' (Locke 1690, 1920: 247). For a contrasting account, at the moment of the emergence of postmodernity, of the necessity of forgetfulness in the achievement of psychic health, see Nietzsche's *The Genealogy of Morals*: 'The temporary shutting of the doors and windows of consciousness . . . is the utility . . . of the active forgetfulness, which is a very sentinel and nurse of psychic order, repose, etiquette' (Nietzsche 1954: 668–9). Thanks to Elizabeth Grosz for pointing out this connection with Nietzsche and to Kelly Oliver for providing pertinent references.

7 These metaphors of colonial exploration, discovery and evangelism, which I want to emphasize in my readings of *The Passion* and *Sexing the Cherry*, also occur (though more sparsely) in *Written on the Body*, suggesting that Winterson's insistence on the status of postmodern fracturings as interior to modern technologies and practices also works the other way: in decaying post-capitalist London, the narrator 'has the hope of a saint in a coracle' (1993: 80); she begins lovemaking by announcing, 'I began a voyage down her spine' (ibid.: 82).

8 See, for example, the review in the *Times Literary Supplement*, which argues in part,

> The Dog Woman's depiction of the death of the King points up one of the pitfalls of fictionalizing real events: the supersubtlety of assuming the reader knows that Charles wore *two* shirts lest his shivering be misinterpreted as fear risks robbing his end of much of its dignity and pathos.
>
> (Mackay 1989: 1006)

Winterson's novels have all been reviewed in the British literary press (*Times Literary Supplement*, *New Statesman and Society*, *Observer* and others) as well as in the American feminist press (*Ms.*, *Women's Review of Books* and others) and in the *Village Voice*. Beginning with *The Passion*, her novels have also attracted consistent notice from the American literary press (*New York Times*, *Kirkus Reviews* and others) and the American gay and lesbian press (*Gay Community News*, *Lambda Book Report*). So far, Winterson's work has been the subject of only four scholarly articles, all on *Oranges are Not the Only Fruit* (Hinds 1992; Lainsbury 1992; O'Rourke 1991; and Suleiman 1990).

9 See my article (1992), '"Something More Tender Still Than Friendship": Romantic Friendship in Early Nineteenth-Century England', in which I argue that images of Africans and Indians found in travel literature and the legal discourse produced by colonial administration crucially shaped the emergence of notions of

sexual identity in the late eighteenth century, particularly representations of feminine virtue and its 'sapphic' Other.

BIBLIOGRAPHY

Allison, D. (1984) 'Public Silence, Private Terror', in C. Vance (ed.) *Pleasure and Danger: Exploring Female Sexuality*. New York: Methuen.

Begley, A. (1993) 'Winterson's Tale', *Mirabella*, January 1993.

di Massa, D. (1993) *Hothead Paisan, Homicidal Lesbian Terrorist*. Pittsburgh, Pa. and San Francisco, Calif.: Cleis Press.

Gibson, W. (1982) *Neuromancer*. New York: Ace (reprinted 1984).

Hansen, R. (1990) *Take Me To the Underground*. Freedom, Calif.: The Crossing Press.

Haraway, D. (1991) *Simians, Cyborgs and Women: The Reinvention of Nature*. London: Routledge.

Hinds, H. (1992) '*Oranges Are Not the Only Fruit*: Reaching Audiences Other Lesbian Texts Cannot Reach', in S. Munt (ed.) *New Lesbian Criticism*. New York: Columbia University Press.

Hollibaugh, A. and Moraga, C. (1983) 'What We're Rollin Around in Bed With: Sexual Silences in Feminism', in A. Snitow, C. Stansell and S. Thompson (eds) *Powers of Desire: The Politics of Sexuality*. New York: Monthly Review Press.

Irigaray, L. (1985) 'When Our Lips Speak Together', in L. Irigaray *This Sex Which is Not One*, translated by Catherine Porter. Ithaca, NY: Cornell University Press.

Jagose, A. (1993) 'Way Out: The Category "Lesbian" and the Fantasy of the Utopic Space', *Journal of the History of Sexuality*, 4, 2: 264–87.

Lainsbury, G. (1992) 'Hubris and the Young Author: The Problem of the Introduction to *Oranges Are Not the Only Fruit*', *Notes on Contemporary Literature*, 22, 4: 2–3.

Locke, John (1690, 1920) *An Essay Concerning Human Understanding*, edited by M.W. Calkins. Chicago, Ill. and London: The Open Court Publishing Company.

Mackay, S. (1989) 'The Exotic Fruits of Time' (review of *Sexing the Cherry*), *Times Literary Supplement*, 15–21 September.

Meese, E. (1993) 'Between the Sheets', unpublished talk given at the Modern Language Association, Toronto, Canada.

Moore, L. (1992) '"Something More Tender Still Than Friendship": Romantic Friendship in Early Nineteenth-Century England', *Feminist Studies*, 18, 3: 499–520.

Nicholson, L. (ed.) (1990) *Feminism/Postmodernism*. New York and London: Routledge.

Nietzsche, F. (1954) *The Philosophy of Nietzsche*. New York: The Modern Library.

O'Rourke, R. (1991) 'Fingers in the Fruit Basket: A Feminist Reading of Jeannette Winterson's *Oranges Are Not the Only Fruit*', in S. Sellers (ed.) *Feminist Criticism: Theory and Practice*. Toronto: University of Toronto Press.

Probyn, E. (1990) 'Travels in the Postmodern: Making Sense of the Local', in L. Nicholson (ed.) *Feminism/Postmodernism*. New York and London: Routledge.

Roof, J. (1991) *A Lure of Knowledge: Lesbian Sexuality and Theory*. New York: Columbia.

Schulman, S. (1988) *After Dolores*. New York: Plume Books.

Stein, A. (ed.) (1993) *Sisters, Sexperts, Queers: Beyond the Lesbian Nation*. New York: Penguin.

Suleiman, S. (1990) 'Mothers and the Avant-Garde: A Case of Mistaken Identity?', in F. van Rossum-Guyon (ed.) *Femmes Frauen Women*. Amsterdam: Rodopi.

Winterson, J. (1985a) *Boating for Beginners*. London: Pandora Press.

—— (1985b) *Oranges Are Not the Only Fruit*. London: Pandora Press.

—— (1987) *The Passion*. New York: Vintage Books.

—— (1989) *Sexing the Cherry*. New York: Vintage Books.

—— (1993) *Written on the Body*. New York: Alfred A. Knopf.

Wittig, M. (1975) *The Lesbian Body*, translated by D. Le Vay. Boston, Mass.: Beacon Press (reprinted 1986).

Zimmerman, B. (1990) *The Safe Sea of Women: Lesbian Fiction 1969–1989*. Boston, Mass.: Beacon Press.

6

GREEN NIGHT OF LABYRINTH PARK

La nuit verte du parc Labyrinthe

Nicole Brossard
Translated by Lou Nelson

It is a story. I did not see the night. I entered the night one solstice day in Barcelona. Exiting the Montbeau Metro, I walked side by side with the voice of Nonna Panina to the gates of Labyrinth Park. In the incalculable green of the night, already hearing the music and first sounds of celebration, I slowly climbed the steps that lead to the terrace overlooking the labyrinth. There, among the voices and eyes that have loved as many books as I have, I walked between Traude Bührmann and Liana Borghi, between Mireia Bofill Abello and Susanne de Lotbinière-Harwood. For a long time in the eyes of Lea Morien I watched the waters of the Rhine follow their course to Mexico in the hair of Adriana Batista. I did not see the night, only the blue shawl slipping from Simone Carbonel's shoulders. Then other women appeared. I saw but the white of their T-shirts, their nipples pressing against the names of Virginia Woolf, Frida Kahlo, Gertrude Stein and **Mujeres sublimes**. Farther off, other women declined verb tenses with mysterious signifiers in the curve of their lips. I did not see the night but Sonia looking for the end of the world in Catalan, Sonia who closed her eyes saying that the night, this night, was the most beautiful the West had known for centuries. It was then, in the **només per dones** night, that I turned my eyes to the labyrinth, scintillating in all its mystery in the **for women only**† night that amplified all senses.

The night was green, I could not place limits on desire and words. The night was as perfect as a celebrated lesbian with the ability to bypass the word country without nostalgia. I was about to go down into the labyrinth when a woman behind me said: 'The sea creates fissures in political life.' Another: 'In Ireland, the noise is unbearable at night when a woman doesn't want a child.' And another: 'The taste of strawberries is an indelible taste in the mouth of Québec mothers.' I moved slowly towards the labyrinth, steeped in the fragrance of cypress and orange blossoms.

Gradually the sound of voices fades away. I am alone. I want to be alone like poets are when questions follow on one another in archipelagos of meaning. The night is green, I will seek its centre. Even if poetry makes me look at the world, the pain, and winter sometimes when snowflakes fall on your forehead, I wish only to be hurt by beauty, too much beauty. The night is green. I will find the exit. I will walk in humility, I will have the caution and wisdom of one who does not want war. I walk between perfectly shaped bushes, too shaped, like history. My eyes are many, vigilant, loving, restless. They are at work under the stars of the **solo mujeres** solstice night. **I am breathing in rhetoric, in the never ending process of hope.**†

FIRST BEND

the sea creates fissures in political life

life teaches us to use pronouns well. To set them all about the I in order to recognize, within us, the others, without too many collisions.

[] Para mi la politica es una grand passion. Es la passion de la libertad y de la verdad.
[] My politics have brought me as far as I could dream but being politically correct doesn't seem to improve my writing.†
[] A political statement is always a statement of principle on which it is easy to graft solidarity and slogans, intolerance and lies. Life is a principle that wears itself out in anecdotes.
[] Creo que para una feminista, la politica es un methodo practico de eleminar la mierda de los hombres y creo tambien que para una lesbiana, la politica es un methodo practico de abrazar las mujeres de sus brazos ardientes.
[] Life is not in the principle of life, but in the mouth that speaks the principle. Saliva, bacteria, tongue, mucus, palate. Life is transmittable like illness, knowledge and power. Thus it is in your mouth that I must seek the principle.
[] Political life can be like a spell if you can't spell your name with a woman in mind.†

the sea creates fissures in the political life of pronouns and the pronouns, some faces within us more than others, are one day transformed in turn into essential figures. Thus there is no I who is untouched by memory and the figurative meaning that enters into the composition of our political choices.

SECOND BEND

questions that follow on one another in archipelagos

first, there was the tranquil water of my childhood. Then life began giving its heterosexual explanations on art, love, nature and history. Naturally, life took

129

its course, but each time I addressed questions to art, love, nature and history, these questions became pebbles. In continuing to question, I finally found myself on an island composed entirely of question-pebbles which I had trouble walking on, at first. But in trying to soften the pain caused by the pebbles, other questions came to me, so many that they in turn formed another island. One could have said that I was **here and there** at the same time, here on the now familiar ground of the first island, and there on the still foreign ground of the second one in view. The islands multiplied and created a beautiful archipelago. Over the years, I learned to travel with ease from island to island. My questions created new islands, my answers served to move me from one to another. Between the islands, I could now make incredible leaps that were soon transformed into beautiful silent gliding flights. And with that my vision changed. From terrestrial and partial, it became aerial. It was at that time that I multiplied the trips between the islands until the day when, from all evidence, I realized that I had finally succeeded, thanks to the archipelago, in diverting the normal course of tranquil explanations that life had once given me about art, love, nature and history.

THIRD BEND

the blue shawl slipping from Simone's shoulders

the image is a vital resource that forms complex propositions from simple and isolated elements. Each time an image relays desire, this image thinks, with unsuspected vitality, the drift of meaning. So it is that images penetrate the solid matter of our ideas without our knowledge. Here at the third bend, I must decide on the meaning of the image, on the direction that the blue will take, when we do not yet know if the blue comes from the colour of Simone's eyes or if it has some symbolic value. Decide also if the shawl should fall here and no longer interfere with Simone's gestures, or if between Simone's eyes and her bare shoulders, I discover my intentions. The image is a powerful allusion that slips silently into our thoughts. Without the shawl and its slowly freeing movement on Simone's shoulders, would the beauty of her shoulders have blazed its way into me with such intensity? In the very carnal night of solstice, is the image lesbian because in reproducing it I want it to be so, or should one simply assert that this image is fruit that is not of chance. The image slips, surprising re/source that slips endlessly through meanings, seeking the angle of thoughts in the fine moment where the best intentions guiding me, worn out by repetition, seem about to close in silently on themselves. The image persists. It is blue in the green night like a made-up story. It goes against chance, fervent relay.

FOURTH BEND

the ability to bypass the word country

we are all born young between a woman's legs. We are also born young in a country where the males sow women with repetition and tradition. Each one of us loves a country and knows that every war is hateful.

the country that enters into us through the senses, music and colours, is a country that is shared like the memory of fruit, seasons, heat, rain and storm winds. The country that enters into us through history and its violence is a country that divides us in memory of the pride of the conquerors and the pain of the conquered. The country that enters into us through the mouths of men of law is a country that denies our rights. The country that enters into us through the face of God and his heroes is a country that brings us to our knees. The country that enters into us through the language and tongue of a lovher is a country that unites us. The country that enters into us through the beauty of trees, the fragrance of flowers and the shared night is a country that transforms us. The country that enters into us through male politics is a country that divides us. The country that enters into us like dreaming into life is a country that invents itself.

is there then a single country that is not an affair of vestiges and nostalgia? **Sometimes, I wonder.**† My love, speak to me in the tongue of the unsubjected. The full hour that leaves us without country prolongs our lesbian lives.

FIFTH BEND

when snowflakes fall on your forehead

this image leaves me perplexed. See how already it becomes two, vertical in the joy of the first snow, horizontal in death and silence. I would like to be peaceful and take pleasure in telling you how this morning, at the simple contact of the air, I expected snow, an embrace in the snow. I would also like to tell you how, in writing *your forehead*, I was seized by the thought that a lovher in her final rest takes with her some of the eternity that sleeps within us. I would like to be peaceful and share with you the sensation of that very particular humidity, just before it snows, that turns senses and memory inside out. Death is impartial, I know. She would touch, they say, the imaginary zone in us that is most difficult to transpose, most difficult to share; the zone, they say, that helps us recapture our destiny.

i also add this paragraph: the snow falls and traces a series of images in the air, air that we sometimes lack when trying to translate **bonheur de l'instant**. It is extremely soft and peaceful and our cheeks are made ever

wetter by large snowflakes that are destined, when they fall on our cities and meet the warmth of our faces, to be confused with tears.

i would like to be that peaceful when one of us escapes definitively from representation.

SIXTH BEND

life is in the mouth that speaks

multiplying ideological anchors, escapes ahead, syntheses, feints and perspectives, always seeking a mirror, drifting on a word, butting up against another, obsessive or distraught, thought remains the most modern of the language games that unleash desire. In one's mouth, thought is living proof that life is a statement that experiments with the truth of **je thème**.[1]

thus, the lesbian **I love you** that unleashes thought is a speaking that experiments with the value of words to the point of touch, stretching them out so that they can simultaneously caress their origin, their centre and the extreme boundary of sense.

in the lesbian mouth that speaks, life discerns itself by the sounds pleasure makes as it rubs up against a speaking.

SEVENTH BEND

between history framed in visions

i have been walking in the labyrinth for more than two hours now. I think I have passed the same place several times, but I am no longer sure. Each bend resembles another. All as green as the night. Breeze, hints of fragrance, vertical silence. Shoulders that rub up against the night like an absolute **in the never ending process of hope.**† I no longer know if I seek the centre or the exit, I know only that in the distance, between the beautiful bushes of the jardin del laberinto, I see the first French ships that sailed up the St Lawrence River. I watch them brush against the whales and the horizon, I see them on the shore, unloading – in the midst of provisions, weapons and tools – a French language that will soon be used to describe the aurora borealis, the north wind and the vertical silence of snowy shores. That was a long time ago. My eyes no longer know where to look, to the river and the rhythm of the waves, or to the **solo mujeres** night and the rhythm of dancing bodies. My eyes seek the long black eyebrows of Frida Kahlo, the piercing eyes of Gertrude, the floating body of Virginia. Then the ships returned, this time filled with rondos, sonnets, madrigals, odes, books of fables and parodies that

resisted the successive snows. I am now surrounded by whales and moose, by a flock of seagulls; I enter into the torment of shapes, swimming suddenly in my rising desire to see, between my lips, my tongue slipping on the very tender flesh of the word clitoris. **Breathe your silence, respira en tu memoria**, impregnate rhetoric. In history and the present I am shaping the subjectivity of she whose mouth resembles mine.

EIGHTH BEND

mysterious signifiers in the curve of lips

the process is always the same: it is in wanting to precipitate the necessary word that mysterilaugh signifiers apparaissent au coin des livres. Comme si un choeur entier se levait en nous pour entonner une passion secrète et lécher publiquement chaque mot sous tous ses angles, dans tous ses états de rire et de rût.

la langue de rue que l'on parle aux habitués en traversant la vie hétérosexuelle se charge de signifiants mystérieurs quand la pensée sucrée de la sacrée amoureuse qui aime parier d'amour sur les mots s'aventure dans la bouche nacrée du désir.

la procession des perles dites signifiantes déjouent les gens d'armes. C'est en quoi les dites dykes enclines dans l'herbe et les grands jardins à courir les perles n'ont jamais peur de se tremper dans le plaisir.

le processus est toujours le même si en voilant les précipices de la parole nécessaire, on se précipite au coin des rues pour apparaître. Le coeur lâche pudiquement des sons secrets qui étonnent et sécrètent en chaque mot des mets sucrés que les habitués de l'état ne sucent jamais. Seule, l'amoureuse sucrée tourne dans sa bouche les perles d'éclat comme on décline un verbe sans jamais avoir peur de se tromper.

NINTH BEND

I am breathing in rhetoric†

i am writing this text on several levels because reality is not sufficient, because beauty is demanding, because sensations are multiple, because putting a great deal of oneself into language does not eliminate the patriarchal horror, does not explain the composition of my subjectivity and all these images that move like a woman in orgasm. Energized by the raw material of desire, I write. Word matter, when it is too cold or too soft or so crazy that it is hard to contain in our thoughts, this matter that is eternally contemporary

with our joys and energized bodies, murmurs and breathes, opens us to the bone and sews in wells and depths of astonishment. I exist in written language because it is there that I decide the thoughts that settle the questions and answers I give to reality. It is there that I signal assent in approving ecstasies and their configurations in the universe. I do not want to repeat what I already know of language. It is a fertile ground of vestiges and vertigo. Depository of illusions, of obsessions, of passions, of anger and **quoi encore** that obliges us to transpose reality. I am even more unwilling to retrace my steps since, in this very beautiful fragrant labyrinth of the solstice night, I owe it to myself to not erase the memory of my path, to not erase the strategies and rituals of writing that I had to invent in order to survive the customs and phallic events of life.

TENTH BEND

in the eternal process of tears

whoever writes must imagine that the imaginary has already gone through it, traversed her city and her tongue, and must fully weep her hope at the end of sentences. The body of men needs tears because for centuries his hard thinking has dried up women's life. The body of women keeps her tears even after dying. Lesbian cyprin[2] continues to sing long after death, approving ecstasies and their configuration in the universe. Life does not come through the neuter. At the far end of great fields of interlaced signifiers and signifieds, each generation marks the horizon, eyes filled with tears, arms filled with myths. Here in this labyrinth where the only horizon is a spiral of desire, I have no time to weep and yet I can, endlessly, at each bend or in remaining still, too much. Too much is a safe port where feeling returns full of images and the unsuspected vitality provided by certainty. Certainly tears have, for each woman among us, a short sentence to propose: **breathe in your memory, your anger, your desire/for women only/the silk/self road**. Even when they use no verbs, tears, when they propose, put what is necessary at our disposition.

ELEVENTH BEND

for women only

now is the time to reaffirm that in surrounding themselves with women, lesbians constantly pose the question of representation, identity and seduction. The **for women only** that takes shape with each generation of lesbians is a power of dreaming that extends the creative life and love of every lesbian. Space, free movement and energy come from a **for women only** that

safeguards the lively and proud spirit of the lesbian traveller. I am forgetting here the word territory because every territory has its barbed wires and men of arms: sooner or later you have to give the right password or bare your fangs. Let us say that I think there are places and space and that each time a woman approaches a lesbian with mysterious signifiers in the curve of her lips, they invent a **here and there** that is called presence of spirit.

It is a story. I did not see the night. I came out of the labyrinth at dawn and found women had become couples, shoulders and arms ardent among the cypress. The taxi let me out at Las Ramblas, near Ferran Street. I walked, thinking that there was too much description in books and that the time had not yet come to tell my life like someone taking off her shoes before going to bed. I thought about how tomorrow each of the women in the labyrinth park night would go back to a country in which she would have to choose between the battle of the sexes and exile.

Thus, well before the solstice night began, knowing the existence of the labyrinth and knowing that I could not avoid it, knowing that that night I would risk all for everything and that I would look at the same sky a hundred times, astonished at what anguish and solitude do to humans, in that afternoon preceding the green night I took the precaution of loving long and well a woman who, like myself, had dived into many books, without ever being afraid of drenching herself in dream and reality.

WRITER'S NOTE

On 24 June 1990, 400 women gather in the Park d'Horta to celebrate the last night of the IV International Feminist Book Fair. Many are lesbians, which tips the celebration to the side of the orchids. Most of us had taken the metro at Drassens station. At each station we had left behind a goddess who now watches over women travelling alone. Over the years and generations, a natural curiosity develops about texts and how they are made. Such curiosity is completely legitimate because it is good to be able to imagine that what we are reading is not simply a matter of imagination. It is always pleasant, during a reading, to recognize a name here, a place there, a tree here, 'the truth' there. It is good to know that reality exists. So I think it is fair to tell whoever will read this text that at no time during the night did I enter the labyrinth. As for the afternoon preceding solstice night, I spent it alone, walking in Old Barcelona. Except for a brief encounter with Angela Hryniuk, I spoke to no one before 7.00 p.m., when I met Rachel Bédard, Lisette Girouard, Ginette Poliquin, Louise Cotnoir and Ginette Locas for dinner. You will now believe that from sentence to sentence, I was led to speak the truth. It is true that when a story can be followed mechanically it gives this impression. But this is not a story. It is the soft flow in present time of a sharing and an immense love for every woman's creativity.

NOTES

† Dagger indicates English in the original.
1 Translator's note: *Je thème*, translated literally, means 'I theme'. However, it is also pronounced the same as *Je t'aime*, 'I love you'.
2 Cyprin: female sexual secretion. From the French *cyprine*, from the Greek Cyprus, – birthplace of Aphrodite, goddess of love. Created by Susanne de Lotbinière-Harwood in her translation of Brossard's *Sous la langue/Under tongue*.

SELECTED PUBLICATIONS

Books in translation

A Book (*Un livre*), translated by Larry Shouldice. Toronto: Coach House Press, 1976.
Turn of a Pang (*Sold-Out*), translated by Patricia Claxton. Toronto: Coach House Press, 1976.
Daydream Mechanics (*Mécanique jongleuse*), translated by Larry Shouldice. Toronto: Coach House Press, 1980.
These our Mothers or: The Disintegrating Chapter (*L'amèr*), translated by Barbara Godard. Toronto: Coach House Press, 1983.
Lohvers (*Amantes*), translated by Barbara Godard. Montreal: Guernica Press, 1986.
French Kiss (*French kiss*), translated by Patricia Claxton. Toronto: Coach House Press, 1986.
Sous la langue/Under tongue (bilingual) translated by Susanne de Lotbinière-Harwood. Montreal: L'Essentielle, éditrice, and Charlottetown, Canada: gynergy books, 1987.
The Aerial Letter (*La lettre aérienne*), translated by Marlene Wildeman. Toronto: The Women's Press, 1988.
Surfaces of Sense (*Les sens apparent*), translated by Fiona Strachan. Toronto: Coach House Press, 1989.
Mauve Desert (*Le désert mauve*), translated by Susanne de Lotbinière-Harwood. Toronto: Coach House Press, 1990.
Picture Theory (*Picture theory*) translated by Barbara Godard. Montreal: Guernica Press, 1991, and New York: Roof Press, 1991.

Co-authored books

With Daphne Marlatt, *Mauve* (bilingual chapbook). Montreal: NBJ (collection Transformance) and Writing Presses, 1985.
With Daphne Marlatt, *Character/Jeu de lettres* (bilingual chapbook). Montreal: NBJ (collection Transformance) and Writing Presses, 1986.

Edited books

The Story So Far/Les stratégies du réel (bilingual). Toronto: Coach House Press, 1979.

7

ACTS OF CREATION
The brainchildren of certain
psychoanalytic fictions

Anna Gibbs

Let me begin by retelling a story. This a story with two characters, Joyce McDougall, a psychoanalyst,[1] and a woman she calls Benedicte, her analysand, a lesbian who is also a novelist and who comes to consult with McDougall because she finds herself blocked and unable to finish a novel on which she has been working (McDougall 1989). It is a story (or perhaps two stories) originally told by McDougall that I am retelling here.[2] And like any retelling – including McDougall's own account of Benedicte's analysis – this one involves a certain violence, decipherable in the operations of selection and quotation (forms of cutting), paraphrase and recontextualization (translation), the collapsing of temporality and the conferral of certain forms of coherence (interpretation), and the transformation of the narrator of her own case study/story into a character in mine. But such violence is to be recognized and its consequences acknowledged, rather than simply abhorred, for it may be that it is a condition of (textual) production. It is a violence, in any case, that redoubles the violence of analytic interpretation itself and that, like the latter, begs the question of whether violence must be conceived as activity inflicted on a passive body (of flesh, of words). Activity and passivity: what is it that this opposition works to obscure? This is a question to which we will have occasion to return.

To return to the story: at the first meeting of the pair, Benedicte speaks extremely hesitantly, with long pauses between phrases – as if, McDougall says, she was 'unwilling to allow her words to reach me, or as though each phrase had to be checked before being uttered' (1989: 206). What Benedicte requests from McDougall is explicitly not an analysis, but a collaboration in order to help her finish her book. 'I don't think it's a real analysis that . . . er . . . I need . . . but some one like . . . er . . . you . . . who writes as well' (ibid.). But an analysis lasting around nine years does take place, in the course of which a story (one, perhaps, of many possible stories) unfolds and is progressively added to, fleshed out, rewritten, interpreted and transformed through the indissociable operation of memory and fantasy, and through the

iterative dialogue between analysand and analyst in which some things remain 'literally unspeakable' for years at a time.

Benedicte has been brought up by her mother, whom she loathed for her 'unreal' femininity and whom she experienced as violently intrusive and potentially engulfing, after the disappearance of her father into hospital when she was about 15 months old. But he did not simply disappear: in fact he died, as she learned from a neighbour at the age of 5. Benedicte's mother never spoke to the neighbour again and Benedicte subsequently remembers her mother's refusal to allow her to play games in which she identified with various masculine figures (Batman, Superman), and her mother's destruction of a play she had written – a play with an all-male cast in which a 'little boy is betrayed by an old man and, broken hearted . . . he throws himself under a train' (McDougall 1989: 213). Such is the first part of the story constructed by McDougall in her case-study, and a propos of which she wonders

> Did [Benedicte] have a little girl's fantasy that her father, in abandoning her, had castrated her? That he had left her to the mercy of her mother so that she was driven to keep him alive in fantasy, in games, and, later, in her written stories? And was she thus able to maintain her own feeling of integrity and identity?
>
> (ibid.: 313)

Here I think it is clear that McDougall sees the paternal function as a protection against merging with or being overwhelmed by the mother, all the more so since

> it is through words [and hence fantasy, games and stories] that bodily perceptions and fantasies become organized as verbal constructs, aiding the child to maintain a clear representation of the difference between its own and its mother's body. This becomes a protection against the *voice* of the siren (rather than her words) since her voice and presence awaken fantasies of the wish for fusion with the consequent loss of both subjective and sexual identity.
>
> (ibid.: 213)

It seems to McDougall that for Benedicte in particular, words are 'the embodiment of paternal power and presence', and that 'the paralysis of her creative possibilities represented, among other aspects, an imaginary way of renouncing her secret link with her father through language and story-building, a link that was forbidden by her mother' (1989: 213). When Benedicte is able to bring the image of her father to life in the course of the analytic process, 'mobilising dynamic thoughts and fantasies in its wake' (ibid.), she is able to write again. At least, this is McDougall's version of the story.

But there is more: a kind of coda to the story that takes place after the publication of McDougall's case-study and which she later presents as a paper

(McDougall 1993). It seems that after about seven years of analysis the two of them agree that they are near termination, but at this point Benedicte develops potentially life-threatening endometriosis and is forced to undergo a hysterectomy. Why is it, we might ask with McDougall, that the body should suddenly begin to speak in this way and what is being communicated in such 'speech'?

... To be written, be it mortally and to be changed into a recognised word.

(de Certeau 1988)

Elsewhere in her work McDougall differentiates between psychosomatic symptoms and those of conversion hysteria on the basis of a distinction between sign and symbol (McDougall 1990). Hysterical conversion makes use of symbolization: it is a 'result of repressed fantasy elaborations' of instinctual conflict (ibid.: 359) and it can be read as narrating the story of these processes. Psychosomatic symptoms, by contrast, imply the denial of the instinctual body via the mechanism of splitting so that 'the ego may achieve complete destruction of the representations or feelings concerned' (ibid.: 357). The somatic signs produced instead of fantasies or conversion symptoms may be regarded as messages, but not symbols (ibid.: 356).[3] That McDougall speaks of somatic productions as messages is crucial. For presumably the messages written on the body of the analysand during analysis have an addressee: the analyst, or perhaps the analytic couple in their collaboration. Now McDougall also refers to psychosomatic productions as 'acts' and speaks in this context of 'action disorders' (ibid.: 370). Action disorders, she points out, take us into the domain of transitional phenomena[4] where we 'are witnesses to *the attempt to make substitute objects in the external world do duty for symbolic ones which are absent or damaged in the inner psychic world*' (ibid.; emphasis in the original). Later she argues that 'such an object or situation will then be sought addictively' (ibid.: 385). Is the message of this particular act that Benedicte has become addicted to analysis? What does analysis represent for her in this case? To what is it, precisely, that she might be addicted and what is meant by addiction here? Further, though, while it seems clear enough that these 'action messages' or 'message-acts' take the body of the analysand as their point of departure and seem to have the analytic couple as their destination, their actual origin is much less obvious. Can we speak of Benedicte as the author of these communicative acts? In what sense might this be possible, since the acts themselves are involuntary? It is precisely the nature of psychosomatic forms of expression that the body speaks *in place of* the psyche – as McDougall puts it, the body 'does its own "thinking"' (1990: 345). What is this body that is apparently capable of its own thought, even at the expense of the psyche with which it is inextricably imbricated? (Might one conceive of the

body's speech as a sign of the coming apart at the seams of this complex conjoining?) From one perspective the body that speaks here is irreducibly individual: it is Benedicte's body and her life alone that is threatened by its sudden bid for independence. But from another perspective, the situation is more complex. For the body, as Michel de Certeau so clearly shows, is a surface for the multifarious writings of the social, and it is this writing that at the same time constitutes the body as individual, as distinct from other bodies (de Certeau 1988). De Certeau describes the various 'writing tools' that comprise the 'law's writing machine – the mechanical system of a social articulation':

> This machinery transforms individual bodies into a social body. It makes these bodies the text of a law. It is doubled by another machinery, parallel to the first, but of the medical and surgical type rather than the juridical. It uses an individual and not collective 'therapeutics'. The body it treats is distinguished from the group.
>
> (ibid.: 8)

On the one hand, it is the distribution of roles in the analytic situation that reinscribes the specification of Benedicte's body as distinct and individual. On the other, it is this same situation that provides an apparatus through which the law can write on and through her body, rejoining it to the body politic, even at the expense of life itself. In order to see further how the analytic situation provides a medium for the writings of the social, we need first to try to understand a little more of what happens in the analytic process.

ON MOVING AND BEING MOVED

As McDougall reminds us, 'the psychoanalytic adventure, like a love affair, requires two people. It is not an experience in which one person "analyzes" another; it is the analysis of the relationship between two persons' (1990: 1). This process might best be described not as the recovery of memories and the interpretation and working through of the meanings of these memories, but rather as the elaboration of fantasy[5] (which might use recovered memories as a starting-point or which might even be said to constitute memories). For analysis itself might be said to constitute a *Nachtraglichkeit*, a deferred action, in which what were events which are unorganized or meaningless are retroactively organized into meaning: 'If the trace of an old encounter all of a sudden begins to exert impact, it is because the *present* symbolic universe of the subject is structured in such a way as to be susceptible to it' (Zizek 1991: 202). And the psychoanalytic encounter is precisely what renders the analysand's symbolic universe susceptible to these traces, and what provides the framework for the inclusion of such traces in a new symbolic network. We might say that the agency of this action is interpretation, on condition that this is not understood simply as the delivery of insight. For the process

in question is not simply intellectual, but above all affective: psychoanalysis has relinquished its status as a 'science of dreams' to concentrate instead on 'the experience of what speaking voices change in the dark grotto of the bodies that hear them' (de Certeau 1984: 162). To turn for a moment from metaphors of inscription, we could say that the body in analysis is constituted by its ability to move and be moved. And in so doing we might open the question of the relations between the capacity for motion and emotion. The analytic setting is a dynamic *rewriting* of the psychosoma of the analysand in the sense that it transforms emotion (or affect) into motion.

The medium of this work is language. Words can be 'used by the secondary process for purposes of communication even though they also continue to carry cathexes derived from instinctual sources', and, in fact, 'it is this dual function of words that makes psychoanalytical treatment possible' (Rycroft 1986: 237). It is important to note here that one learns to talk within the context of object relations and that this leads 'as a result of the introjection of objects, to the formation of sanctions prohibiting the formulation and expression of other ideas, which become repressed' (ibid.). Now speech in the analytic setting acquires some special characteristics, or at least foregrounds characteristics of discourse that are minimized in other discursive contexts. That of the analysand takes on a kind of double valency in which anecdotes may become symbolic, or where narrative redoubles itself so that the analysand is always its subject, whatever is ostensibly the case. The analyst's speech also takes on an effectivity different from its everyday effectivity. My friend can tell me over and over that writing means risk (one I'm unable or unwilling to take) and I may agree intellectually, even passionately, but nothing happens. My analyst says the same thing just once at the right time and I am galvanized. I have been acted upon in a way that is transformative and henceforth I can act. We might say the difference is one of context, of the situation produced by the analytic setting (which includes regularity, privacy, uninterruptedness and confidentiality – and all that these things come to signify).[6] The analyst's speech draws its capacity to act on the body in such a way as to produce a reorganization of the unconscious from the affective state of affairs composed both of this special situation and of the entire flux of signs – the physical qualities of the voice including tonal inflection and pace, and also gestural language, each of which may emphasize, qualify or even contradict what is actually being said – emitted by each member of the couple in response to a creative and constitutive misunderstanding (which may feel like understanding) of the signs of the other. It is this situation which confers on interpretation the quality of an event. Psychoanalysis

is the science of events, on the condition that the event should not be treated as something whose sense is to be sought and disentangled. The event is sense itself, insofar as it is disengaged or distinguished from

the states of affairs which produce it and in which it is actualised. Over states of affairs and their depth, their mixtures and their actions and passions, psychoanalysis casts the most intense light in order to reach the point of emergence of that which results, that is, the event of another type, as a surface effect.

(Deleuze 1990: 211)

Speech may refer to the past, but it always acts in the present. It is in this sense that '[P]sychoanalysis is the psychoanalysis of sense. It is geographical before it is historical. It distinguishes different countries' (ibid.: 92–3). The geography is of course that of the analytic situation, while history might refer to the Oedipalizing narratives of the family romance or to the etiology of the symptom. These narratives, however, need not be considered as intrinsic to analysis but might instead be reconsidered simply as the medium of dialogue between analysand and analyst. The dialogue in the present will have a range of contexts, which may be different for analyst and analysand (psychoanalytic theory, politics of professional organizations, family history, etc.), or they may be to some extent shared (discourses of gender). These contexts are always encountered (implicitly or explicitly) through the speech in the present of the analytic setting. Nor are such contexts simply given: they are always selectively mobilized and deployed within the specificity of the analytic relationship – hence they have the structure of text. But this is above all a performance text: like opera, as de Certeau describes it, the analytic situation is above all a

space for voices [which] allows an enunciation to speak that in its most elevated [or inspired] moments detaches itself from statements, disturbs and interferes with syntax, and wounds or pleasures, in the audience [or the analysand], those places in the body that have no speech either.

(de Certeau 1984: 162)

An interpretation, then, is an act of speech with the power to touch whether by tone of voice or turn of phrase, and via that touch to transform, to make possible a certain movement on the part of the analysand who has been moved or played by such a touch. If the analysand is an instrument on which the analyst plays, not every analysand is the same kind of instrument. The analyst must learn to play each analysand, to remake the capacities of her own body in relation to the particular capacities and qualities of the various instruments which offer themselves to or resist her touch. Interpretation, then, is not a unilinear mode of action or inscription on a passive body, nor a mode of statement that simply translates as if from one language to another, from the unconscious to the conscious. An interpretation does not reveal hidden meaning but is an act of capture and transport: an act that takes the analysand by surprise, an act of liberation from the already known. Say, from the repertoire of voluntary recall to the *unheimlichkeit* of involuntary memory,

the unpredictable nature of which suggests the activity (rather than the passivity) entailed in receiving an interpretation.

But what is a memory which one does not recall?
(Proust, cited in Deleuze 1973b: 58)

Perhaps it is their traumatic nature that prevents access to even voluntary memories, especially those of early childhood which may only have been experienced as traumatic because the events which constitute them occurred in the life of a child. This is the classical psychoanalytic theory of repression. Other psychoanalytic theories emphasize the psychosocial organization of meaning over the energetic intra-psychic model of drive theory, in which case memories are not so much repressed as written out of (excluded by) certain frameworks that organize meaning. These frameworks may be logical (involving presupposition), or perhaps narrative, or may involve the refusal or inability to experience or acknowledge certain affective states and hence, we might speculate, the knowledges or memories associated with them.[7]

This would seem to be supported by the work of Russian novelist Esther Salaman, who describes the way in which the very act of writing her autobiography late in life generated a resurgence of memories, and cites examples of other writers' similar experiences:

De Quincey believed there was no such thing as forgetting, but that our memories, or as he calls them 'the secret inscriptions,' are 'waiting to be revealed when the obscuring daylight shall have withdrawn.' Proust expressed the same idea, using a different image. Marcel says that the echo of his tears, in his traumatic memory of demanding his mother's kiss, never ceased, but was not audible until life grew quiet, like those convent bells which are drowned in the noise of daytime, and sound out again in the silence of the evening.

(Salaman 1982: 51)

Perhaps the seclusion of the analytic situation may lend itself as well as old age to the dissolving of the 'too much' that obstructs vision or hearing. But the question of involuntary memory 'which comes unexpectedly, suddenly, and brings back a past moment accompanied by strong emotions, so that a "then" becomes a "now"' (Salaman 1982: 62; see also Deleuze 1973b: 58–9 on this point) suggests a more complex rearrangement of internal structures than these metaphors of receding excess allow. This becomes more understandable if we extend the concept of *Nachtraglichkeit* or retroaction into a fully textual model of memory, as John Frow does:

The time of textuality is not the linear, before-and-after, cause-and-effect time embedded in the logic of the archive but the time of a continuous analeptic and proleptic shaping. Its structure is any dynamic

143

but that of the closed system, where all moments of the system are co-present, and the end is given at the same time as the beginning. In such a model the past is a function of the system: rather than having a meaning and a truth determined once and for all by its status as an event, its meaning and truth are constituted retroactively and repeatedly; if time is reversible then alternative stories are always possible. Data are not stored in already constituted places but are arranged and re-arranged at every point in time. Forgetting is thus an integral principle of this model, since the activity of compulsive interpretation that organizes it involves at once selection and rejection. Like a well-censored dream, and subject perhaps to similar mechanisms, memory has the orderliness and teleological drive of narrative. Its relation to the past is not that of truth but of desire.

(Frow 1995)

The analytic situation, then, provides an organized locus for the rewriting of memory; that is to say, analysis is a site for the transformation of the present, which necessarily entails a reordering of the past. Hence the emergence of involuntary memories. These memories, Salaman explains, may enlarge on conscious memories, or transform them. They always involve strong emotion, whereas a voluntary memory may not be strongly emotive, or may involve explanation or rationalization. The involuntary memory, because of its strong emotional content, is immediately accepted as 'true' (Salaman 1982), but, as Frow's discussion might suggest, it is not so much the repetition as the difference internal to it that is crucial: the memory 'rises up in a pure past, co-existing with two presents, but out of their reach, out of reach of the present voluntary memory and of the past conscious perception' (Deleuze 1973b: 59). What is essential in the analytic process is not concentration on the past in and of itself (and still less the recuperation of the past into Oedipalizing familial narratives), but the creation of a space in which presence can be radically unsettled. The affective process of analysis affords a space for the production of involuntary memory, one form (among others) of the violent reorganization of the field of the unconscious as it is affected by (or rather in relation to) the speech – and hence the unconscious – of another. Thus it is for Benedicte, when, in response to interpretations hinging on her need to create an internal image of her father and of both parents in relation to each other so she could find her own place in the configuration of family relations, she constructs what McDougall calls a 'recurring screen memory' involving

two dolls that some one gave me when I was nearly 3, a boy and a girl
. . . . I only ever played with the boy, talking to him, dressing and undressing him . . . then one day my mother said they needed repairing. When they came back, both were girls. The boy . . . my mother killed

144

him! I still recognized him by a tiny trace, but I never touched the dolls again.

(McDougall 1989: 215)

There is clearly a felt truth here, but eventually this memory dissolves as the field of desire is reorganized in relation to the desire of the analyst, which is also not fixed but fluid. The 'felt truth' of involuntary memory may contribute to the analysand's sense of self, but this is a relational construct, as constantly subject to rewriting as the field of memory itself.

BIO-FEEDBACK: THE ANALYST AS PROSTHESIS

There is a semi-permeability between analysand and analyst in the analytic space. Sometimes this amounts to a kind of bio-feedback in which the analyst takes on a prosthetic function, becoming part of the circuit through which discourse (and its accompanying affect) must travel in order to return, transformed, to sender. It is not unlike the figure of the messenger boy in Beneix's film *Diva*, whose illegal recordings of the voice of the diva are what finally allows her to hear herself, to admit her voice to consciousness. The illegality of the recordings is crucial here, since it represents not perfect understanding, communion, oneness, but precisely the imperfection of 'understanding', the creative misunderstanding that allows the tape to perform a transformation. This misunderstanding is the mark of the other, always unpredictable: what is returned to sender – analysand or analyst – is not what was sent, but a 'communication' that has been worked over by another, address unknown. If the analyst is a prosthesis, an extension of the psychosoma of the analysand, she is not so much a 'false' limb covering a deficit as a tool that has been incorporated into the body and which extends its possibilities. At the limit, the prosthesis will become integrated – digested – rather than simply incorporated or swallowed whole, and this is the difference between simply devouring the other and assimilating the other in such a way as to change your own body. We tend to think of eating as something that merely perpetuates the body as it is, that enables it to go on being. But most women can tell you that to eat is to remake the body, and any anorexic can tell you that not to eat, to refuse the other in an attempt to retain total control over an island self, is to condemn the body – at the limit – to death. Life in fact depends on the ability to be (selectively) permeable to the other, to be open to transformation by the other as one in turn might transform.

In this optic, the analyst is simply the agent of the analysand's morphing, of her transformation of herself into a new life form, and psychoanalytic practice might be described as a refiguration of one body in relation to another – a refiguration in which there is reciprocity but not symmetry. The asymmetry of the analytic situation is partly the result of the fact that in it,

one person (mostly) listens, and the other (mostly) speaks. But it is also the product of the discursive formation that constitutes subjects through their division into professional and client or expert and non-expert that subtends any individual analytic situation, for these bodies-in-transformation in their apparent isolation within the analytic setting from any outside do not in fact exist in isolation from the rest of the social network. In particular, the body of the analyst is not in a state of total detachment from the heterogeneous body of psychoanalytic theory she has encountered in her training. She might fancifully be imaged as the woman in the 1950s ads for domestic appliances who appears as the smiling mediator of a terrifying technology (see Stone 1994), at least to the extent that she does not integrate this technology, make it her own and hence transform it a little in her own image. Now the analyst needs to have a handle on theory, the handle of any machine being the place where human agency acts on form in such a way as to change it (ibid.), usually in quite predictable ways. But the operation of the psychoanalytic handle implies a high degree of unpredictability, for apparently similar interpretations may be offered to different analysands with strikingly different effects in each case. But transformations that take place at the psychoanalytic site tend to be regulated by a medicalizing discourse which positions analysands as 'patients' under the care of the analyst–doctor and which enables a series of judgements to be made (by those qualified as experts, and this by definition excludes the patient – even if she is also an analyst herself) about the transformations undertaken as it distinguishes, for example, between 'pathological' and 'normal' or 'mature' object relations. Such a discursive organization not only perpetuates the illusion that in analysis it is the doctor who performs the mind surgery while the 'patient' is out cold or perhaps just out to lunch, but attempts to constrain the degree of predictability of the analytic operation and to direct its ends in particular ways.

Speech leaves no mark in space; like gesture, it exists in its immediate context and can reappear only in another's voice, another's body. . . .

(Stewart 1993: 31)

Or, after a fashion, in another's writing. For if the speech of analysts finds its target in the body of the analysand, the speech of analysands occasionally migrates into the writings of analysts and in the process becomes subject to reworking by what Michel de Certeau has called a heterology, a science of the different which attempts 'to *write the voice*' (de Certeau 1984: 159; emphasis in original). Heterologies 'depend on the fulfilment of two conditions: an object, defined as a "fable," and an instrument, translation' (ibid.: 160). The fable locates the other (the analysand, in this case) in a 'speech that "does not know" what it says' and hence requires interpretation so that '[S]urreptitiously, the distance from which the foreign voice comes is

transformed into the gap that separates the concealed (unconscious) truth of the voice from the lure of its manifestation' (ibid.: 160). Further, translation 'makes it possible to move from one language to another, to eliminate exteriority by transferring it to interiority, and to transform the unpredictable or non-sensical "noises" uttered by voices into (scriptural, produced and "comprehended") "messages"'. (de Certeau 1984: 160)

Unlike writing in the 'so-called exact sciences', writing in the hetero-logical sciences proceeds 'by means of a passage through or by way of the other. [It] advance[s] by means of a "sexual" process that posits the arrival of the other, the different, as a detour necessary for [its] progress' (ibid.: 161). Hence heterological writing can be considered 'an erotics: it is the inaccessibility of its "object" that makes it produce' (ibid.: 162). Psycho-analytic writing when it takes the form of a case-study is clearly hetero-logical, the more so as analysts attempting to explore the workings of countertransference or the effect of interpretation in the analytic situation give greater attention to the to and fro of analytic dialogue, flavouring their writings with the dreams and fantasies, or simply the halting and uncertain speech of their analysands. This is the terrain on which McDougall writes, focusing on the *experience* of analysis for both its partners in those analyses which, as J.-B. Pontalis suggests in his blurb for one of McDougall's books, 'touch the limits of what is analyzable, representable and narratable' (McDougall 1990).

Writing is specifically imaged as an erotics in McDougall's work, though an erotics of a quite particular kind, one modelled on the workings of heterosexual reproduction in which the cultural fantasy of a symbolic equivalence between book and baby is clearly spelled out. What is striking, though, is that the heterosexual coupling that enables writing now takes place in the psyche of the writer and is complicated in certain ways by that fact:

> It has always seemed to me that the pleasure experienced in intellectual and artistic achievements is pregnant with considerable narcissistic and homosexual fantasy since in such production, every one is both man and woman at the same time. Our intellectual and artistic creations are, in a sense, parthenogenetically created children. Furthermore, clinical experience has taught me that conflicts over either of the two poles of feminine homosexual wishes – that is, taking over the mother's creative power as well as the father's penis – may create serious inhibition or even total sterility in the capacity to 'put forth' symbolic children.
>
> (McDougall 1986a: 221–2)

Here McDougall embroiders the classical Freudian theory of psychic bi-sexuality, but the image of 'putting forth' symbolic children turns out to have some surprising consequences. One might perhaps expect that the image of writing as psychic gestation is a metaphor particularly suited to women, as indeed Hélène Cixous seems to suggest:

147

The unconscious tells us the book is a scene of childbirth, delivery, abortion, breastfeeding. The whole chronicle of childbearing is in play within the unconscious during the writing period.

(Cixous 1993: 74)

And:

I don't know how men dream when they start writing, though I do wonder about it. I can't imagine they dream that they bear children. So it must be something else. I'd like to know what the equivalent or substitute is.

(ibid.: 78)

However, men's acts of creation have often been imaged by them in terms of pregnancy of one kind or another, whether parthenogenic as in the case of Zeus' production of his daughter Athene directly from his head and in Nietzsche's pregnancy, or simply an act of intercourse in which no woman figures, as in Deleuze's startling image of the history of philosophy as 'a sort of buggery, or, which comes to the same thing, immaculate conception' (Deleuze 1973a: 111; my translation). Deleuze goes on to speak of his own work as a kind of innovation along these lines:

I imagined myself taking another from behind, giving him a child which would be his, but which would also be monstrous. That it really be his child is important, because the author really had to say all that I made him say. But that the child be monstrous was also necessary, because it had all sorts of decenterings, slippages, breakages, secret emissions which gave me pleasure.

(ibid.; my translation)

Now parthenogenic pregnancy and the implied psychic bisexuality necessary to it has long been constructed in a particular literary discourse as a special capacity of male writers; most famously, of course, in Flaubert's well-known statement that 'Madame Bovary, c'est moi' and in Tolstoy's much remarked identification with Anna Karenina. This imagined special capacity is a function of the philosophical construction of 'man' as representative of the universal, from which women can only differ to form a particular case. Not surprisingly therefore, women writers have historically been derided for their imagined inability to identify with their male characters – an inability said to render their artistic productions inferior to those of men. This culturally assumed difference between the relative abilities of men and women to represent the universal makes writing in the historically male-dominated domain of analytic theory particularly problematic for women, as McDougall seems to sense:

There is a feeling of transgression allied to the very act of thinking a new thought – perhaps of creating anything that has not already been created. . . . Moreover, the necessity of integrating what appeared new

in my thinking into the classical body of psychoanalytic meta-psychology gave me further insight into the underlying libidinal significance of the 'child–parent' aspect of scientific research: one may either produce one's own brainchildren or leave such activity to the 'spiritual fathers'.

(McDougall 1986c: 37)

This 'feeling of transgression' generated by the creative act may be greater for women than for men under some circumstances – in spite of the fact that women would seem to have a privileged relationship to the act of creation conceived in terms of childbirth. What on the face of it seems like a helpful metaphor for women writers turns out instead to present a particular problem, for when it comes to producing brainchildren, men historically have had the edge.[8]

Nevertheless, the problem of transgression and the relationship of the writer to (analytic or other) authority is actually central to all writing (even if the degree to which this is the case for men and women may be different), since learning to talk (and hence to think, to write) is a social and socializing process which leads

as a result of the introjection of objects, to the formation of inner sanctions prohibiting the formulation and expression of other ideas, which become repressed. Formulation and communication of a previously unconscious idea involves, therefore, the overcoming of an internal resistance deriving from the superego – or, to state the same thing in terms of fantasy, defiance of an internal object. . . . This is . . . why the formulation of original ideas, even those of a scientific and impersonal nature, requires moral courage. The analysand and the original thinker or artist both have to face the fear of being neither understood nor approved. They face the fear of isolation from objects, both internal and external.

(Rycroft 1986: 239–40)

Now, the 'passage through the other' on which the psychoanalytic case-study depends provides an antidote against the potential isolation about which Rycroft speaks and the narcissistic wound such isolation might entail, in the form of an engagement with clinical work that lends the writer support in the face of disciplinary authority. Clinical work provides a basis for generalization – though in fact generalization is often a highly problematic operation in psychoanalytic writing, as when McDougall attempts to generalize about 'lesbian psychology' on the basis of a sample of five women and without questioning whether one can actually speak of a coherent lesbian psychology at all.[9] The same reservation may perhaps also apply to her assertions about the psychology of writing, which she argues for on empirical as well as theoretical grounds. But it is not just a question here of a certain critique of

McDougall's methodology. Rather, one must recognize that the 'passage through the other' represented by the presentation of clinical work in psychoanalytic writing has a necessary function for the writer which is narcissistic as much as it is 'scientific'. Moreover, the metaphor of the parthenogenic pregnancy applied to the production of analytic writing actually works to conceal the real contribution of the voice of the other – the erotics at the heart of such writing – at both the narcissistic and 'scientific' levels of the enterprise. But the fruits of this unacknowledged[10] intercourse with the other may inscribe themselves elsewhere, in altogether astonishing media – such as the body of the analysand.

spoken words may go awry, as if they were attracted by the depths of bodies. . . .

(Deleuze 1990: 23)

The metaphor of parthenogenic pregnancy seems to be – as far as one can judge from the published case-study – latent in McDougall's interpretations as they focus on the need for Benedicte to form internal images of both parents, just as it is latent in her writing. These interpretations aim at freeing Benedicte from the need for collaboration with the analyst and at increasing her capacity to allow collaboration or communication between the different objects of her internal world for which the analyst supposedly substitutes. The importance of collaboration with a real object is minimized in the face of intercourse between internal objects representing the parents, and it is this latter form of intercourse that is held to be productive of the book-baby. But these different forms of collaboration are not mutually exclusive, as we have seen in relation to analytic writing, and it may be that the substitutive paradigm does not adequately encompass the relationship between the two. Hence the striking appropriateness of Benedicte's endometriosis in the context of an analysis which is about to end, ending also the asymmetrical collaboration between analysand and analyst which has enabled – though doubtless in different ways – both members of this couple to produce intellectually. For during the analysis McDougall writes two papers which deal exclusively with the case, and Benedicte writes novels and finally a play. But termination, the end of the collaboration, turns out to threaten death for one member of the couple. Benedicte's body develops an illness that cries out for a cure, the cure of the continuation of analysis and productive collaboration (the cure for endometriosis was once said to be pregnancy and childbirth). In fact Benedicte is forced to have a hysterectomy, during the course of which she fantasizes that twin foetuses, a boy and a girl (and with them the possibility of continued generation?), have been aborted. After the operation the analysis is resumed, and eventually Benedicte abandons a novel involving exclusively male characters on which she has been working and writes a play, this time dealing exclusively with female characters. Around

this time the analysis finally ends. Perhaps it is not too fanciful (without any direct knowledge of Benedicte's writing) to read her choice of the genre of the play as a move towards a medium – the theatre – that opens up a space for the action of bodies, and a potential space for what Derrida, speaking of Artaud's perhaps unrealizable theatre of cruelty, has called 'the aspect of oppressed gesture in all language', a space which might lay 'bare the flesh of the word' (Derrida 1978: 240) in the arena of social action rather than necessitating its inscription on the vulnerable individual body.

Now the theatre also opens the possibility of a collaboration beyond the confines of the heterosexual couple, and here one might wish that psycho-analytic theory itself would follow suit in constructing new metaphors for the creative act, metaphors more suited to contemporary social relations not necessarily organized around heterosexual norms or even 'natural' methods of conception and childbirth. Here McDougall's own work might provide a starting-point; in several of her writings, she speaks of various 'neo-sexual inventions' ('perverse' practices and their enactment in various scenarios) which may be homo- or heterosexual and which function to repair rifts in sexual and subjective identity (that is, they have a narcissistic function), and also, secondarily, to preserve introjected objects from the subject's hatred and destructiveness (McDougall 1986b). For McDougall, such sexualities are only to be termed perverse when their enactment has an ineluctably compul-sive dimension (though she does not specify except by the notoriously slippery standard of degree the way in which this might differ from the compelling nature of all sexual feeling), but at the limit it is the case that for her only particular relationships, not sexual preferences themselves, may count as 'perverse'. On the contrary, in fact, neo-sexualities often represent 'the shackling of Thanatos and the triumph of Eros over death' (McDougall 1986b: 29), and in this respect they seems to me to be not so much merely marginalized or deviant sexualities as emblems, in their inventiveness, of sexuality itself. And it is for this reason that they, rather than the biological process of reproduction, make an apt metaphor for the creative act. It must be acknowledged in this context that creativity may satisfy needs for narcissistic wholeness which, far from excluding real relations with an other, may in fact depend on them.[11]

NOTES

1 Joyce McDougall is a New Zealander who has been a practising analyst for almost thirty years and lives and works in Paris. Her first publication in 1964 dealt with lesbianism and she has subsequently published other articles and book chapters based on case histories of lesbian analysands (McDougall 1986c, 1989, 1990) and on the homosexual components of all female sexuality (1986a). She has also written more generally about sexual 'perversion' and its relationship to creativity (McDougall 1989, 1990) making her one of the most prolific contemporary analytic writers on homosexuality. The normative assumptions underlying much

of this extremely interesting work have been thoroughly critiqued by Noreen
O'Connor and Joanna Ryan (1993).

2 The first part of the story is told in McDougall (1989), the second in a paper
presented to the NSW Institute of Psychotherapy in April 1993.

3 Both hysterical conversion (a neurotic symptom) and psychosomatic production
are distinguished from psychotic processes in which the links between mind and
body are actively destroyed, and the instinctual body is instead hallucinated through
delusional constructions like those of Schreber: see McDougall (1990: 357).

4 On the concept of transitional phenomena, see Winnicott (1991).

5 Fantasy in this sense is implicit in everyday speech to the extent that it detaches
itself from the concrete – I do not want to privilege unconscious fantasy here.

6 See Winnicott (1991).

7 For a formulation of the unconscious that differs fron the Freudian model, see
Stolorow and Atwood (1992). My thanks to Tessa Philips for an introduction to
this work and for several very helpful discussions about the theory and practice
of contemporary psychoanalysis.

8 In the literary domain, women's writing has historically been far more likely to
be read as disguised autobiography and hence, implicitly, an inferior imaginative
production than men's writing, and one might speculate on the connection with
the metaphor of pregnancy here: is it because childbirth 'comes naturally' for
women that this has been the case?

9 O'Connor and Ryan's (1993: esp. 102–33) criticisms on these and related issues
go right to the point.

10 I am not speaking of the problem of individual debt so much as of the problem
of the structural debt of analytic writing in general at both the narcissistic and
'scientific' levels.

11 I have not had the space in this essay to engage with Kleinian views of the creative
process. However, Hanna Segal describes the creative act as a 'reparative
reconstruction' of the object which involves a 'restoring in one's internal world
of a parental couple creating a new baby' (Segal 1991: 95), and goes on to mention
an analysand in whom she witnessed a

> shift from a narcissistic position, in which the artistic product is put forward
> as self-created faeces, with a constant terror that one's product will be
> revealed as shit, to the genital position in which creation is felt to be a baby
> resulting from meaningful internal intercourse.
>
> (ibid.: 95)

Janine Chasseguet-Smirgel, critiquing the Kleinian view of creativity as an attempt
to repair the object, argues instead that the most 'authentic' forms of creativity
are those which represent an 'attempt to achieve integrity' or to 'attain narcissistic
completeness' and hence involve a repair of the self (Chasseguet-Smirgel, 1984:
400). (My thanks to Zoe Sofoulis for this reference.) Elsewhere Chasseguet-
Smirgel writes more directly on the question of the book as symbolic baby:

> at some level, the creative process does represent giving birth, and the work
> represents a child-penis. But having children places one within the bio-
> logical order, within the common lot, of women at least, in which men
> participate by virtue of their paternal role and particularly by virtue of their
> dual identification. And even if, as has been said, creativity were linked in
> men to the desire to be able to procreate like women, it is nonetheless the
> case that the work is much more a narcissistic product; it is, for the artist,
> much more 'a child of his own heart'.
>
> (Chasseguet-Smirgel 1985: 145)

It seems to me that different views of narcissism are at stake in these different positions and that a further exploration of the issues addressed in this essay will only be possible in the context of a closer study of different psychoanalytic conceptions of narcissism.

BIBLIOGRAPHY

Chasseguet-Smirgel, J. (1984) 'On the Concept of Reparation and the Hierarchy of the Creative Acts', *International Review of Psychoanalysis*, 2: 399–406.
—— (1985) *The Ego Ideal: A Psychoanalytic Essay on the Malady of the Ideal*, translated by P. Barrows. London: Free Association Books.
Cixous, H. (1993) *Three Steps on the Ladder of Writing*. New York: Columbia University Press.
de Certeau, M. (1984) *The Practice of Everyday Life*, translated by S. Rendall. Berkeley, Calif.: University of California Press.
—— (1988) 'Tools For Body Writing', *Intervention*, 21–2.
Deleuze, G. (1973a) 'Lettre à Michel Cressole', in Michèl Cressole, *Deleuze*. Paris: Editions Universitaires, pp. 107–18.
—— (1973b) *Proust and Signs*, translated by R. Howard. London: Allen Lane, The Penguin Press.
—— (1990) *The Logic of Sense*, translated by M. Lester. New York: Columbia University Press.
Derrida, J. (1978) 'The Theatre of Cruelty and the Closure of Representation', in J. Derrida, *Writing and Difference*. Chicago, Ill.: University of Chicago Press.
Frow, J. (1995) 'Toute la mémoire du monde: Repetition and Forgetting', in F. Barker (ed.) *Memory*. Manchester: Manchester University Press.
McDougall, J. (1964) 'De l'homosexualité féminine', in J. Chasseguet-Smirgel (ed.) *La sexualité féminine*. Paris: Payot.
—— (1986a) 'Eve's Reflection: On The Homosexual Components of Female Sexuality', in H. Meyers (ed.) *Between Analyst and Patient*. Hillsdale, NJ: Analytic Press.
—— (1986b) 'Identifications, Neoneeds and Neosexualities', *International Journal of Psychoanalysis*, 67: 19–31.
—— (1986c) *Theatres of the Mind: Illusion and Truth on the Psychoanalytic Stage*. London: Free Association Books.
—— (1989) 'The Dead Father: On Early Psychic Trauma and its Relation to Disturbance in Sexual Identity and in Creative Activity', *International Journal of Psychoanalysis*, 70: 205–19.
—— (1990) *Plea For A Measure of Abnormality*. London: Free Association Books.
—— (1993) 'Problems of Sexual Identity and Creativity', paper presented to the NSW Institute of Psychotherapy, Sydney, 22 April.
O'Connor, N. and Ryan, J. (1993) *Wild Desires and Mistaken Identities: Lesbianism and Psychoanalysis*. London: Virago.
Rycroft, C. (1986) 'An Enquiry into the Function of Words in the Psychoanalytical Situation', in G. Kohon (ed.) *The British School of Psychoanalysis: The Independent Tradition*. New Haven, Conn. and London: Yale University Press.
Salaman, E. (1982) 'A Collection of Moments', in U. Neisser (ed.) *Memory Observed: Remembering in Natural Contexts*. San Francisco, Calif.: W.H. Freeman.
Segal, H. (1991) *Dream, Phantasy and Art*. London and New York: Routledge.
Stewart, S. (1993) *On Longing: Narratives of the Miniature, the Gigantic, the Souvenir, the Collection*. Durham, NC and London: Duke University Press.

Stolorow, R. and Atwood, G. (1992) *Contexts of Being: The Intersubjective Foundations of Psychological Life*. Hillsdale, NJ and London: The Analytic Press.

Stone, Allucquere Roseanne (1994) 'Desire, Vampirism, Memory and Double Entry', paper presented at Artists' Week forum, Adelaide Festival of Arts, February.

Winnicott, D.W. (1991) *Playing and Reality*. London: Routledge.

Zizek, S. (1991) *For They Know Not What They Do: Enjoyment as a Political Factor*. London: Verso.

8

'I EMBRACE THE DIFFERENCE'
Elizabeth Taylor and the closet

Melissa Jane Hardie

Is *fat*, in diva iconography, a malicious synecdoche for *woman*?

(Koestenbaum 1990: 16)

Food . . . [is] the commodity most definitely appropriated: its value exhausted in its use, it is the one acquisition that becomes quite literally inalienable from the body.

(Culver 1988: 101)

The body of Elizabeth Taylor, extravagantly augmented, or merely extravagant, haunts accounts of her life and career, not excepting her autobiographical writings, as an out-of-control metonymy for both the out of control and the seriously contained. Brenda Maddox, questioning the inaccessibility of this public figure, writes:

Elizabeth Taylor is nothing like a senator or an astronaut or the head of AT&T. She has been called a great natural wonder. In fact she is a great natural resource – of which she is the owner. Like an oil well, the asset depletes with time. The owner has absolutely no incentive to share it unless she sees it to her advantage.

(Maddox 1977: ix)

Taylor becomes the owner of herself; her own best asset. Such a figuration, which reads Taylor as resource, may be the logic of most biographical representations of her life, but it cannot be reconciled with her 1987 autobiography *Elizabeth Takes Off: On Weight Gain, Weight Loss, Self Image and Self-Esteem*, a text which explicitly invites the reader to share her life with her, and purely for the reader's advantage. *Elizabeth Takes Off* is a memoir whose narrative urgency is routed through its reader, a diet book which seeks to offer the advantage of weight loss – the incentive of depletion – to its audience.

Camille Paglia offers a more complex account of the accessibility of Taylor's 'resource'. For Paglia, Elizabeth Taylor is 'the greatest actress in film history' (Paglia 1992a: 16), the 'tabloid diva' (Paglia 1992a: 14),

155

Hollywood's 'one living queen' (Paglia 1992a: 14). Paglia's paean is a euphoric attempt to describe Elizabeth Taylor's extraordinary impact on our understanding of screen culture; like most discussions of this phenomenon, her analysis returns compulsively to Taylor's cinematic body:

> In both *Cat on a Hot Tin Roof* and *Butterfield 8*, Taylor appears in a tight white slip that looks as if it were sewed onto her body. What a gorgeous object she is! Feminists are currently adither over woman's status as sex object, but let them rave on in their little mental cells. For me, sexual objectification is a supreme human talent that is indistinguishable from the art impulse. Elizabeth Taylor, voluptuous in her sleek slip, stands like an ivory goddess, triumphantly alone. Her smooth shoulders and round curves, echoing those of mother earth, are beyond the reach of female impersonators.
>
> (Paglia 1992a: 17)

Paradoxically, Paglia offers the figure of Taylor as a counter to feminism by translating her physical characteristics to those 'feminists' she castigates. Moving adroitly from a description of Taylor's body squeezed into her slip to one of feminists whose containment is mental, Paglia's description is compelling precisely because it employs this rhetoric of disclosure and concealment, whose paradoxical status she notes (Paglia 1992a: 17). Launching her familiar rebuke to feminism on the back of Elizabeth Taylor, Paglia situates Taylor's body beyond the reach of feminists and female impersonators alike. Beyond Paglia's reach, however, Taylor's body remains permissive enough to provide Paglia with the metaphors she delights in, and to justify a feminist analysis of objectification, impersonation and their complication in an account of bodily disclosure and concealment.

Paglia's scathing dismissal of a feminism sure of its own terms of analysis suggests instead that the power of Taylor's body is indeed to prompt the rearrangement of our 'mental cells', an isomorphism between brain and discipline which reminds us of the body's status as trope. The 'mental cell' describes the inextricable link between corporeality and intellect. 'Cells' are at once fractional representatives of the corporeal, and the space of corporeal (mental) sequestration. They figure both the venue and the field of this enquiry, which attempts to address the challenge implicit in Paglia's rhetoric, to think again about Elizabeth Taylor's body. Part of this process may be in thinking again about its effect upon our 'mental cells', and Taylor's autobiography offers one avenue for this analysis, not the least because it represents an exemplary instance of this exchange between mental and bodily 'cells', Taylor's autobiographical account of the relationship between her body and herself, her body and others'.

If the intellectual incarcerations Paglia speaks of are used by her to figure the diminished capacity of feminism to argue its understanding of the corporeal, they work equally well to figure another set of physical and

epistemological incarcerations. For Eve Kosofsky Sedgwick, the operation of the closet as signifier *par excellence* of sexual knowledge provides the locus for an historical reconstruction of sexuality as a set of discourses which interpellate crucial axes of intellectual action. Sedgwick argues that 'many of the major nodes of thought and knowledge in twentieth-century Western culture . . . are structured – indeed fractured – by a chronic, now endemic crisis of homo/heterosexual definition, indicatively male' (Sedgwick 1990: 1). The failure of which Paglia speaks, located in the 'mental cells' of feminism, mobilizes the figure of the cell-as-closet to structure a repressed, eroticized feminine space of spectatorship. The 'mental cells' of feminism become metonymy for a heterosexualized or mediated relationship between women whose logic is exclusive and exclusionary. My reading of Paglia does not rehearse a dichotomy of sexual difference as the constitutive premise locating the different positions available to men and women as spectators and spectacles. Instead sexual difference itself is complicated with an account of sexuality, subsumed in Paglia's case to an allegory of reading practice and subject position which follows the logic of Sedgwick's assertion that the crisis of definition the closet figures is 'indicatively male':

> One of the most spectacular moments of my moviegoing career occurred in college as I watched Joseph Losey's bizarre *Secret Ceremony* (1968). Halfway through the film, inexplicably and without warning, Elizabeth Taylor in a violet velvet suit and turban suddenly walks across the screen in front of a wall of sea-green tiles. . . . This is Elizabeth Taylor at her most vibrant, mysterious, and alluring, at the peak of her mature fleshy glamour. I happened to be sitting with a male friend, one of the gay aesthetes who had such a profound impact on my imagination. We both cried out at the same time, alarming other theatergoers.
>
> (Paglia 1992a: 18)

This essay suggests that the sudden appearance of Taylor and the arbitrary location of Paglia beside a 'gay aesthete' are coincidences whose juxtaposition is in no way arbitrary; just as aesthetics (and particularly the aesthetics of allegory) limits the designation of textual incident as arbitrary, so Paglia's 'arbitrary' juxtaposition of her cry and her friend's allegorizes an historical and cultural location for her reading which serves equally for this essay: the rereading of feminine spectacle and spectatorship through discourses of sexuality and disclosure. The arbitrary or inexplicable textual moment is arbitrary precisely because it cannot be reconciled to a model of narrative as chronological and achronological disclosure; because it pivots the text upon that moment as the one which problematizes narrative's function *of* disclosure. Similarly, Paglia's testimony depends upon the juxtaposition, in no way accidental, of her cry with that of her friend, a narrative feature which in fact offers an overdetermined allegory of spectatorship, 'indicatively

male' but pedagogically useful for women. This moment of double reading, accounted for in the cancelled preface to *Sexual Personae* as her 'odd point of view from the disputed borderlines of the sexes' (Paglia 1992b: 110), locates its problematic *in* that borderline, as I do in reading Taylor's autobiography through the logic of sexual and textual disclosure.[1]

Taylor's autobiography can be read as a scandalous memoir, an autobiographical form that dates from the seventeenth century. Scandalous memoir offers the text as a forum in which women might both produce themselves as autobiographical subjects and consume themselves as readers (Nussbaum 1989: 180). Having in common with other models of autobiography as confession the premise of 'private emotional interiority as the "truth" of identity' (Nussbaum 1989: 179), their record of sexual misdemeanour and moral instruction may be read, as Nussbaum suggests, as both apology and defence, both excusing and promulgating aberrant or disruptive sexualities (Nussbaum 1989: 180). Nussbaum's historical account of scandalous memoirs and their ambivalent structure of self-pity and self-justification (Nussbaum 1989: 185), pivoted around sexual radicalism, resembles Taylor's work. Unlike its 1965 predecessor, *Elizabeth Taylor by Elizabeth Taylor*, in *Elizabeth Takes Off*, Taylor's autobiographical narrative focuses on retelling her life's tragedies and excesses – professional, sexual, gustatory. Taylor offers anecdotes of diet and lifestyle with a specific pedagogical purpose and address; she writes that she wants to 'pass on some of the ways I was able to shed my own false attitudes about being fat' (Taylor 1987: 20). Shedding weight is married to a pedagogy which operates through a similar grammar of loss as disclosure. As scandalous memoir, *Elizabeth Takes Off* proposes a relationship between reader and writer whose heuristic benefit is imitative and vicarious, a pleasurable teaching which depends upon mechanisms of identification and instruction, one which locates for itself a feminine audience. It complicates an account of interiority, however, by resolutely marrying an account of 'self-esteem' with 'self-image', interior with exterior, as when she announces her sexual conservatism: 'It's probably because of some of my "quaint" attitudes that I've been married so many times. Basically, I'm square' (Taylor 1987: 36). The 'square' body of Taylor metaphorizes the paradoxical logic in her morality of many marriages, a serial monogamy whose 'interior', moral truth is figured through the paradoxically square (or straight) body. *Elizabeth Takes Off* draws attention to the various readings available for 'taking off': loss, revelation, transcendence, transvestism, impersonation; bodily disclosure *and* deception. If all these acts are implicated in the cultural history of Taylor's body, they are equally implicated in her text, in which Taylor skilfully negotiates the terms in which she is most usually described.

Sheila Graham once said of her that 'she looks like a woman who has everything and is wearing it all' (cited in Parker 1989: 234). Richard Burton wrote of his arguments with Taylor:

we battle for the exercise. . . . I love arguing with her except when she's in the nude . . . it is quite impossible to take an argument seriously with Elizabeth naked, flailing about in front of you. She throws her figure around so vigorously she positively bruises herself.

(cited in Parker 1989: 235)

For Graham, with everything, and for Burton, with nothing, Taylor's body marks its own excess equally well in the public and the private domains. Graham and Burton choose to characterize its 'effects' with the decorum of their respective positions as cultural commentator and erstwhile lover. While for Graham she provides an exemplification of redundancy as rhetorical display, for Burton, Elizabeth Taylor's body stymies precisely the love of serious argument. It supplements this verbal pleasure with a masochistic physical performance which ultimately figures the contradictions implicit in 'having' a body, let alone 'having it all'. Taylor has her body, but her body has her: it is simultaneously the instrument of her self expression, figured in both quotes as a rhetorical instrumentality and an instrument of containment as she becomes 'simply' but redundantly a body. If rhetoric may be defined as 'an art of positionality in address' (Bender and Wellbury 1990: 7), Taylor's positionality is cemented in and by her body. It is stretched across the conundrum of feminine corporeality as both expanse and circumference, the demarcation of limit and the sign of excess. This puzzle (like that of the 'mental cell') is rhetorical marked by the logic of supplementarity which subtends both quotations. Graham's observation turns on the ambiguity of simile: to resemble 'a woman who has everything' offers Taylor's look as a vulgar excess matched materially by her dress; to have herself – her body – is already to have too much. Burton presents Taylor's body itself as supplementary to Taylor: she 'throws' it, it 'bruises' her. Both quotations elide their potential subject, remarking instead upon this effect of supplementarity. Kitty Kelley reports that Burton responded to being cast against Taylor in *Cleopatra* by commenting '"Well, I guess I've got to don my breastplate once more to play opposite Miss Tits"' (Kelley 1981: 193). His quip figures bodily supplementarity through imitation and prophylaxis; a masculine prosthesis, the hard breastplate, becomes the ironic signifier of stymied engagement as well as of public performance.[2]

Recent representations of Taylor's body as unattractively abundant, as perilous and physically uncontainable – as having overstepped the mark – ground themselves in her historic sex appeal, and collocate the magnitude of her physical fall from grace with the degree of her weight gain. In the 1980s, Taylor's body was worked most exhaustively as iconic of the unconstrained female figure, a reading which coincided with a period in which her professional life was at low ebb. For so long a figure whose bodily manifestations were always read in terms of a career at full tilt, in the 1980s Taylor's body outstripped its cinematic life, and became the star in

159

extra-cinematic representations of its own life. Analyses of Taylor's body, and most particularly her own, *Elizabeth Takes Off*, incorporate features familiar to the history of figuring the feminine–woman as animal, woman as flesh, woman as sense-object, woman as topography, woman as text. This series of figurations is particularly noticeable in *Elizabeth Takes Off* and Marianne Robin-Tani's *The New Elizabeth: Better and More Beautiful Than Ever*, published a year after *Elizabeth Takes Off* and subtitled *How Elizabeth Taylor Reclaimed Her Life, Looks and Self-Respect*. Robin-Tani's biography supplements *Elizabeth Takes Off* as a recapitulation of Taylor's text, rehearsing similar anecdotes and favourably assessing the strategies the earlier text lays out for bodily and intellectual rescue. Both texts work figural, generic and historical understandings of the female figure to develop a rhetoric adequate to the task of arguing for her as a woman in danger of literally and not-so-literally losing her figure, or being lost in it. Recovery becomes reclamation, the right to seize property.

Accounts of Taylor's body, which chronicle her weight loss and weight gain in a seemingly endless cycle, can be read through an examination of their interest in it as a travelling sideshow of sexuality; as a reference point for the simultaneous construction of cinematic female sexuality and private feminine passion. This is the double construction that battles in the notion of the movie star: the private public figure. It also exists in the notion of the body as both the space in which subjectivity is contained – 'interiority' – and as the sometimes compliant, sometimes treacherous signifier or bearer of self in the public sphere. In both constructions the body's various organic and inorganic additions may be included; 'excess' weight and 'excess' adornment: the body and its effects.

Between these two extremes lies a whole history of representation that is bedevilled by the difficulties inherent in the distinction between a private and a public body, representations made problematic by the difficulty of finding an appropriate register in which to argue the 'rhetoricality' of the body. 'Rhetoricality', coined by John Bender and David A. Wellbury, expresses the condition of modernity and its particular rhetoric: '*Modernism is an age not of rhetoric, but of rhetoricality*, the age, that is, of a generalized rhetoric that penetrates to the deepest levels of human experience' (Bender and Wellbury 1990: 25; emphasis in original). For Bender and Wellbury, 'rhetoricality' represents a rhetoric that is uncontainable, 'infinitely ramifying' (Bender and Wellbury 1990: 25) in its effects, a rhetoric not unlike Taylor's body as it is represented in visual and written discourses; a rhetoric in which, after Nietzsche, 'appearance is not the opposite of truth, but rather includes truth as one of its varieties' (Bender and Wellbury 1990: 26). Such a rhetoric recasts the conventional 'truth' of the body as possession which is registered grammatically in the conventional possessive of 'having a body'. Autobiographical disclosure also offers truth as one of its varieties, and Taylor's

text reveals the 'truth' of her body as one of its 'appearances', or resemblances, or impersonations: a 'take off'.

From the early discovery that her distinctive look depended in part on a freakish set of double eyelashes around each eye, and not on the gratuitous application of mascara, the 'natural' body of Elizabeth Taylor has been denaturalized and renaturalized as an ideal site on which to work notions of a constructed female self, at once revealing and disguising its own naturalness and its own artificiality. An early biography introduces its subject through an explicit collocation of eyelash and material asset:

> Poverty has produced some very persuasive personalities, particularly in the Hollywood scheme of things. . . . Elizabeth Taylor is a golden exception. She was born with a Georgian silver spoon in her porridge, an Aubusson rug under her feet, and a double set of eyelashes around her violet eyes.
>
> (Westbury 1964: 13)

For Westbury, the power of persuasion – rhetorical power – is exceptionally located in Taylor's body, an exceptional rhetoric which becomes a commonplace in biographies of Taylor. Robin-Tani reports Taylor's defence of her eyelashes on the set of *Lassie Come Home* in 1943: '"It isn't makeup. It's me!"' (Robin-Tani 1988: 11). Yet she returns to them at the end of her biography to trope femininity at its most theatrical: she embroiders Taylor's response to Robert Wagner's 1986 invitation to co-star with him in a television movie *There Must Be a Pony*, suggesting Taylor 'batted her double rows of eyelashes, smiled her prettiest, and said yes' (Robin-Tani 1988: 163). In Taylor's case, it becomes painfully obvious that her body does most of the work in accounts of her career and love-life, as its various public manifestations are made to produce private meanings. In a plasticity of registers commensurate with their rendition of her plastic body, Taylor's biographers merge accounts of her physical and psychic well being with an analysis of her career successes and failures, and chart success through an arbitration of her sexual and marital careers. These deliberations offer her body as grotesque, a characteristic apparent as much in its ability to shed as to gain weight. For Elizabeth Taylor, however, her bodily versatility is a characteristic inalienable from her identity as a film star; for her, it is the material that made her 'star material' from the first.

In *Elizabeth Takes Off*, Taylor represents her marriage to John Warner as the point at which private personality and public persona become implicated in the collocation of sexuality and diet. Recounting her experiences on the campaign trail as Warner worked to secure a Senate position, Taylor notes that her 'Hollywood training and discipline certainly were assets in adapting to political life' (Taylor 1987: 37), but did not compensate for the rigours of the campaign trail: 'Playing a character on the stage or screen is simply playing. Campaigning for office exposes you to a degree that I, in all my years

as a working actress, had not encountered' (Taylor 1987: 37). By substituting political for cinematic representation, Taylor rewrites the campaign as a feast, one whose regional specialities (Warner was campaigning in Virginia) provided the undoing of her dietary regimes. From 'mouthing dialogue' to consuming fried chicken, Taylor's campaign offered a reorientation of her role as actor in terms of the logic of democratic representation, a reorientation that was mapped on to the topography of the campaign trail. 'Mouthing' the words of her 'friends' (Taylor 1987: 38) in a cautionary prosopopoeia she reports their doubt that she could endure the campaign: '"You realize, Elizabeth, you have to touch every corner of the state of Virginia, and some of those corners can only be reached by Greyhound buses."' (Taylor 1987: 38).[3] Taylor's status as conjugal representative rendered her as a physical caress or 'touch', leaving her with a permanently disabled hand-shaking hand (Taylor 1987: 40) and the desire to shed weight that is chronicled in her book. In fact, it merely rehearses a scheme of representation which has framed her career, and textually serves to introduce a potted account of her life, read under the auspices of diet.

In *Elizabeth Takes Off*, the progress of a child star is commensurate with bodily maturation: '[g]rowing up in Hollywood' (Taylor 1987: 53) takes on a very specific meaning for her as she recounts her desire to take the role of Velvet Brown in *National Velvet*:

> I'm still convinced I won my role in *National Velvet* by sheer will-power. . . . I totally identified with the young heroine who, disguised as a boy, enters the Grand National, but at eleven I was too slight to pull off the male masquerade believably. Except for size, everything else was going for me. . . . Miraculously, I grew almost three inches and gained nearly ten pounds.
>
> (Taylor 1987: 54)

The process of bodily transformation which permits her performance is narrated with another story, in which *National Velvet* director Clarence Brown insists on Taylor's hair being cropped, on precisely the same grounds of believability, but is duped when she dons a wig (Taylor 1987: 54–5). Noticeably, bodily transformation is matched by the use of prosthesis as narratively inter-implicated models of transformation; Taylor's growth permits precisely the masculine impersonation which is figured in the wig *as* impersonation. The grotesque has always been coded into representations of Taylor as a tautological physicality incarnate: the 'full figure', as Wayne Koestenbaum points out, speaks not only of excessive weight, but also of sexual maturity (Koestenbaum 1990: 16). Taylor's sexual precocity marks a reading of her whole career. Beyond the reach of the female impersonator, according to Paglia, but able to impersonate masculinity in the calibrations of the physical development of a 'full' female figure, Taylor's anecdote demonstrates the asymmetry of impersonation within an account which

marries bodily and prosthetic augmentation. Her pliability is structured as an essential feature of her profession; as actor, she is the impersonator whose capabilities stretch as far as sexual difference. In an acting career whose first celebrated performance demonstrated the mobility of gender as one of its trade secrets, Taylor's public performances give new meaning to her own condition as the material representative of femininity.

Certainly, Taylor's career has been remarkable in producing a whole series of historical iconic moments: from the slight Velvet Brown of *National Velvet*, to the voluptuous heroine of sagas such as *Giant, Raintree County* and *A Place in the Sun* in the 1950s, *Secret Ceremony, Who's Afraid of Virginia Woolf* and *X,Y and Zee* in the 1960s and 1970s, Taylor has been able to epitomize each decade in which she has worked. Only Elvis Presley, perhaps, in his progression from pomade and peg-legged suits to aloha shirts and finally the extraordinary jumpsuits of the 1970s commands a similar diversity in iconography. This iconic diversity in Taylor's case may be read through its constant attention to her physicality, and registers itself in a bodily practice of self-invention which may also be read as involving questions of the sexed body. As Taylor herself writes, or writes of herself, 'I believe in the difference between men and women. In fact, I embrace the difference' (Taylor 1987: 36).

As Taylor's body has been depicted as waxing and waning, her sheer capacity has been troped through her marriages as a symptom of excessive plurality. The task of figuring plurality is an onerous one for Taylor, and most often realized in an account of her many marriages as instance of the woman 'larger than life'. In Taylor's case, the effects of this discourse are registered in her name. If Taylor's proper name operates iconically, as her figure does, it is in its deformation or augmentation that sexual plurality is recorded. In *Elizabeth Takes Off*, she scathingly reports a dinner at which she was introduced as 'Elizabeth Taylor-Hilton-Wilding-Todd-Fisher-Burton-Burton-Warner' (Taylor 1987: 42). Robin-Tani refers to Taylor's desire in the 1980s for 'a seventh permanent shoulder' (Robin-Tani 1988: 119) to cry on. Taylor's first name, by contrast, is commonly truncated to 'Liz'. Robin-Tani reports that the shortened name first appeared in her brother's nicknames 'Liz the Cow' and 'Liz the Lizard' (Robin-Tani 1988: 166). If this truncated name is collocated with her animality, its expansion is likewise reworked as *copia*:

> Hamilton bought her a $5,000 pendant which spelt out 'Liz' in diamonds. She was so angry ... that she had Hamilton send the necklace back and have the remaining letters in her proper name added, at a cost of many thousands of dollars.[4]
>
> (Robin-Tani 1988: 166–7)

Taylor also borrows from the proper name its capacity to figure paradoxical singularity as she notes 'I don't think I've ever been so alone in my life as when I was Mrs. Senator' (Taylor 1987: 43), a formulation which erases her

own name entirely to offer one which depends solely upon the marital and political registration of impersonation. Taylor's dietary fall from grace, which may be metaphorized through the augmentation, contraction and elision of her name, is most recently traced by Taylor and others to her association with the southern states as 'Mrs Senator', an association troped through her marriage to Warner and reproduced in her cameo appearance in the television mini-series *North and South*.

Television, read as a debased venue for a cinematic realization of the 'real' Elizabeth, operates equally well as the site of a debased relationship to diet, as the mini-series' catering provides the opportunity for dietary debasement: 'The delicious southern-style cooking proved to be her downfall, and she indulged herself in the fried chicken, mashed potatoes, biscuits, and gravy she adores' (Robin-Tani 1988: 128). That physical containment so eroticized for Paglia in *Butterfield 8* and *Cat on a Hot Tin Roof* was carnivalized in her costume, a 'spine-crushing fifty pounds' (Robin-Tani 1988: 128) of velvet, lace, hoops and petticoats which 'she literally had to be laced into' (Robin-Tani 1988: 128) and which caused her to be hospitalized.

Generically and narratively, *Elizabeth Takes Off* textualizes the process of reclamation, rendered as *her* recovery, as a 'coming out'. This narrative owes much to the notion of a 'writing cure' in twelve-step programmes, and chronicled, for instance, in Betty Ford's 'different kind of autobiography' (Ford and Chase 1987: xiii–xiv), *Betty: A Glad Awakening*. Ford metaphorizes her early refusal to address her drinking problem as closeting: 'I did not want to open the closet door' (Ford and Chase 1987: xiii). This 'writing cure' as coming out is the subtext for Taylor's own work, where the autobiographical subject is constructed through an account of its own grotesque body. The impetus to write and to diet resourced in the experience of a cure at the Betty Ford Center. Robin-Tani details the 'writing cure' at the Betty Ford Center in a summary which might as easily summarize Taylor's own text's revelation of the disorder of overeating: 'Topics the patient must examine in writing include: listing twelve consequences of their drinking which occurred during the last two years, ways they can improve how they feel about themselves, and incidents such as "My Most Humiliating Experience"' (Robin-Tani 1988: 67). The rhetoric of 'coming out' is paradoxically coincident with the experience of 'going in', a semi-voluntary incarceration. This paradox is rhetorically effected, as it is made possible, through the writing tasks, in which physical incarceration is textualized as a 'coming out': personal, autobiographical and anecdotal. The paradoxical status of a 'going in' as 'coming out' is reproduced in Taylor's account of dieting – slimming – as 'coming out', revelation by contraction.

It is equally well forecast in Taylor's intertextual metaphor of revelation. For Taylor, the point at which a dietary 'coming out' becomes imperative is signalled by an imaginary 'click', an auditory hallucination borrowed from the script of *Cat on a Hot Tin Roof*. In that movie, Brick (Taylor's husband

in the movie, played by Paul Newman) reveals that it is only when he hears a 'click' in his head that he knows that his drinking has succeeded in dulling his experience of life, and not the least contact with Taylor's character. In *Elizabeth Takes Off*, Taylor translates this 'dangerous and self-deluding' (Taylor 1987: 30) hallucination to the recuperative discourse of diet regime, changing its polarity from 'negative' to 'positive' (Taylor 1987: 30). Learning from the movies, and in an impersonation which registers gender reversal as the move from 'negative' (male) to 'positive' (female) as it translates from drink to food, Taylor's 'click' offers an identification between alcoholism and overeating which is textually ramified by her 'writing cure'.

The identification of diet, drink and subject is neatly summarized in her anecdote of one diet failure: 'Richard and I went on the Drinking Man's Diet after we made *Who's Afraid of Virginia Woolf?* It worked for a while and then we dropped the 'diet' and just continued drinking' (Taylor 1987: 140). Following such a regime after working on *Who's Afraid of Virginia Woolf?* signals another instance of the intertextuality of film and 'real' life; the 'Drinking Man's Diet' is an appropriate coda to the film. But her failure to maintain the regime is instated in the diet's name, a name which marks the diet's adoption as gender specific. The diet is allocated a polarity not subject to the same reversals as the 'click'. Instead, Taylor becomes the Drinking Man, as much because of the diet as because of its failure. This diet, which is adopted as part of a conjugal regime, marks another function of the incarcerations of diet and cure, the possibility of a heterosexualized recuperation; it is not coincidental that Taylor's sojourn at Betty Ford precipitated her most recent marriage, another conjugation of closet, cure and sexuality.

Although Taylor makes use of the model of the writing cure and the figure of the 'click' to plot her own dietary adventures, *Elizabeth Takes Off* embodies the specificity of *its* disease through the rhetorical figure of *dilatio*, a figure which Patricia Parker discusses as rhetorical expansion, dilation and deferral, a figure traditionally associated with the fat woman, and signalling also a concern with walls, or partitions, and with the control of excess and deferral as constitutive textual features (Parker 1987: 9):

> This tradition of rhetorical *dilatio* – with its references to the 'swelling' style or its relation to the verbal 'interlarding' produced through an excessive application of the principle of 'increase' – provides its own links between fat bodies and discoursing 'at large', between the size of a discourse and the question of body size.
>
> (Parker 1987:14)

To dilate means variously to expand and to adumbrate, to defer and to generate; the rhetorical figure of *dilatio* reads the text organically to diagnose texts which *go on*: for their 'amplified textuality and dilated middles' (Parker 1987: 15). Parker notes that '"Dilate" comes to us from the same latin root as Derrida's "différance" and involves . . . that term's curious combination

of difference and deferral, dilation, expansion, or dispersal in space but also postponement in time' (Parker 1987: 9). *Dilatio* is also interested in the ways in which texts are partitioned, in the 'dividing of a discourse': 'Dilation . . . is always something to be kept within the horizon of ending, mastery, and control, and the "matter" is always to be varied within certain formal guidelines or rules' (Parker 1987: 14).

Taylor's autobiographical memoir variously uses *dilatio* in its expansive survey of her favourite foods and most desperate eating adventures, and in its excessive concern with division: the book is part story, part textbook, and within this division distinguishes memoir and diet, diet food and maintenance regime and so on. Taylor is also careful to classify disorders or addictions, and to clearly limit her subject: Taylor says of her other addictions, to drugs and alcohol, '[t]hat is another book – and a big one' (Taylor 1987: 16). Here textual *copia* is both signalled and deferred, a pleasure, like the pleasures denied by a diet regime, both foregrounded and put off. We as readers are starved of the account of the non-food addiction in this saga of starvation, in an aside that simultaneously signals the 'writing cure' as a model, and limits its applicability. For in urging us to realize the specificity and selectivity of her story of overeating as a deliberate construction of self, we are alerted to another model, of rhetorical and consumable deferred pleasures, which is hardly curative.

And this textual 'coming out' is implicated in another grammar of disclosure, that explored by Sedgwick in her account of the closet, what she calls the 'reign of the telling secret' (Sedgwick 1990: 67). Sedgwick implicates a number of unstable binarisms in an epistemology grounded in the construction of the closet as 'the secret of having a secret' (Sedgwick 1990: 205). She signals, in the medicalization and morbidization of sexual definition in the nineteenth century, the construction of homosexuality and heterosexuality as epistemological categories of identity, and the development of various new subject positions centred on the ability to *know* a sexuality, an emphasis on sexual object-choice ('preference') over sexual aim (the homosexual vs the sodomite), and on the closet as 'spectacle' (and thus public, effectively empty and objectified) or 'viewpoint' (and thus private, inhibitingly occupied and subjectified). Homosexuality, like alcoholism and like heterosexuality, once identified as a practice, becomes a position, translating a '(sexual) doing' as a '(sexual) being'. Along the way, Sedgwick argues, assignments such as vicarious/direct, voluntary/addict, artificial/ natural, identification/desire and spectacle/viewpoint represent polarized positions, and just as quickly threaten to demonstrate the instability of their regulation. Sedgwick chooses to articulate these oppositions through the figure of the (opening and closing) closet, as the closet is both a creation necessitated by such a polarization and its logical undoing, for its existence makes definition a dubious undertaking.

Taylor's 'click', which she borrowed from her fictional husband in *Cat on*

a Hot Tin Roof, translated alcoholic indulgence into eating constraint. In *Cat on a Hot Tin Roof*, Brick's 'click' in fact marks the return of the repressed, translating alcoholism as the effect of homosexual closeting, narrated though the story of a failed homosocial football escapade. If, for Sedgwick, men in crises of homosexual panic are attractive to 'most women' (Sedgwick 1990: 209), Taylor has reworked that attraction, plotted in the film as marital and dynastic, as an allegorical counterpart to her own allegory of diet: metaphorizing her diet through the 'click' takes on the consequence also of owning this 'click' as the textual marker of psychical repression, a repression whose effects are registered in the 'closet'.

The account Taylor provides is one which both depends upon and, in doing so, makes problematic the distinctions signalled in the oppositions of voluntarity and addiction, spectacle and viewpoint, vicarious and direct. The vicarious identification with Brick serves to ramify the addictive nature of her own closeted pleasures. It serves also to raise the textual stakes of her autobiography, suggesting that the vicarious structure of allegory always results in 'direct' comparisons. These distinctions are collocated with her dual positioning in the text, as public persona and private person, and with her tactic of making visible in writing the question of the visibility and invisibility afforded by the body: she says of her weight gain 'I had taken my image and scratched it with graffiti' (Taylor 1987: 48). The public body, being, like all bodies, in the world, but also in the *limelight*, is also the body that betrayed her private habits (overeating). It is both the closet into which she withdrew, and out of which she springs, as reconstructed woman and as self-author. The partiality of *Elizabeth Takes Off* inheres in its selectivity and is what makes it a disclosure: Taylor's life is so abundantly recorded, so copiously chronicled and captured in print and in pictures that read together offer a double narrative of her life and her movie life. Her disclosures and dilation can only be of a selectivity that constitutes subjectivity. If she is always a visual text, always a 'take off', her text operates as a radical containment, and, like her weight gain *and* weight loss, as writing on top of the movie still. If the copious accounts of her are troped by Taylor as her own *copia*, then in her paring down of her representations, she produces a personal, public mirror-image in lieu of her own overworked body, which she takes pleasure in feeding: '[n]ow I have a truer picture of myself, and I am catering to that portrait' (Taylor 1987: 17–18).

Taylor's racehorse is called 'Basic Image' (Robin-Tani 1988: 132). And '"Whoa, great white whale"' is what she says 'to her [basic] image' when she sees in her full-length mirror 'the telltale bulge around the beltline' (Taylor 1987: 141). Taylor's conversation with her mute-whale 'image', her parodic recuperation of the 'basic image' through objectification as racehorse (reminding us of her early success in *National Velvet*), mimics the role of women as object of desire, a role instantiated in the female (animal) body: the *Cat on a Hot Tin Roof*, undesired and thus unmade. In *Elizabeth Takes*

Off, the trajectory of such loaded relationships as the connotative link between woman as object/as animal is parodically retraced, from *National Velvet*, to her first screen kiss in *A Date with Judy* ('One minute I was kissing a horse and the next I was kissing [Robert] . . . Stack. And I loved it' (Taylor 1987: 56)), and the 'Cat' of *Cat on a Hot Tin Roof*. In this case, it is *her* body as artifact and her 'image' as icon – from 'Cat' to 'Brick' – which she acknowledges in these moments, transferring a public fetish into a private rebuke. Yet these metaphors work to destabilize such an identification, as they both contain the terms of iconic recognition (the thoroughbred, the narcissistic gaze) and deride the object. That derision is inflected by her role as self-derider, which signals the possibility of her occupying an ambivalent subject position in this objectifying discourse. Here the closet, metonymy for clothing, operates as a counter-intuitive metaphor for nakedness: nakedness as the 'telling secret' (Sedgwick 1990: 67), revealing not simply the 'true self' but rather the mechanisms of objectification, concretized in the disguising-of-self fat body. Clothing operates as a closeting of the closet, and thus properly *as* a closet in Sedgwick's formulation of the closet as not simply the hiding of a secret, but as 'the secret of having a secret' (Sedgwick 1990: 205). She thus speaks both from the viewpoint of the closet, and of or to the spectacle of the closet: to an image that talks back in her own words. The body, for which corporeality itself constitutes a closet, is nonetheless uncloseted through nakedness: the 'strip and survey' procedure Taylor describes as intrinsic to her recognition of her food addiction (Taylor 1987: 23–4). Clearly, then, the sheer fact that her eating addiction had visible ramifications is repressed, not in her account, but in the logistics of its recognition, because it is always a closeting. And her refusal of that identification of body/clothing/closet with visual image is textualized in Taylor's diet regime, which, taking into account the ambiguity of the term 'diet', as both a regular and irregular eating practice, is punningly called the 'Taylor-made Diet' (Taylor 1987: 147).

The representation of the autobiographical subject in *Elizabeth Takes Off* works over the iconography of the star through a textual reordering of the performative function of the visual object, to take account of the problematic of self-recognition. Most importantly, however, Taylor's book effects the switch from object to subject of desire through an emphasis on the proximate senses: taste, touch and smell, and a subordination of those senses not reliant on proximity: sight and hearing. Sedgwick notes of Nietzsche, in *Ecce Homo*, that he 'gives himself over . . . to the other three senses – taste, touch, smell, those that least accommodate distance, the ones that French designates by the verb *sentir*' (Sedgwick 1990: 149).

For Sedgwick, Nietzsche is 'the psychologist who put the scent back into sentimentality' (Sedgwick 1990: 149); reading ' *ressentiment*' as 'resniffing' (Sedgwick 1990: 149) becomes a signal instance of the operation of rhetoric-ality as (in Bender and Wellbury's words (1990)) 'limitless ramification'.

Elizabeth Takes Off follows the logic of this rhetorical reordering by manipulating tropes of affect, sense and sentimentality, a manipulation accompanied by Taylor's new career as perfumier: her first (autobiographical) perfume, 'Elizabeth Taylor's Passion', was released the same year as her autobiography.

In this rhetorical reordering, food is overdetermined as affective: 'I adore good food . . . the call of the double-chocolate fudge . . . chocolate creams . . . whisper in my ear' (Taylor 1987: 14–15). It provides an allure that is never contested, simply displaced; one of the pleasures of her regime is that at times she can put on weight: '[T]he idea that I have something to gain is delicious' (Taylor 1987: 20). Taylor's diet, which permits a fortnightly 'pig-out', demonstrates her interest in an aesthetic regulation, or poetics, of affective artifice. Similarly, her identification with her perfumes works as both a direct identification and demonstration of her 'passion' through the proximate and artificial offices of scent, and as a vicarious assertion of aestheticized self through reduction and quintessence.

In his biography of Elizabeth Taylor, Alexander Walker describes a banquet to celebrate Taylor's forty-sixth birthday, and the climactic appearance of a birthday cake in the shape of Taylor's body: '[Taylor] cut off one of her confectionery breasts and handed it to Andy Warhol to eat. . . . "Elizabeth looked like a belly-button – like a fat little kewpie doll", Warhol recorded in his secret diary' (Walker 1990: 506). Walker's anecdote strings together weight, food and their production as material artifacts through the body, real and imagined, of Elizabeth Taylor, sourcing its effects in the secret or closet diary of the most infamous fan, entrepreneur and hoarder of camp, of the twentieth century. If Warhol's portrait of Taylor might be regarded as the epitomized tribute of fan to star, Taylor borrows from the vocabulary of the fan to transform her own position from object of desire to desiring subject. This is effected through restructuring her relation to her image as a camp-recognition. For Sedgwick, 'the sensibility of camp-*recognition* always sees that it is dealing in reader relations and in projective fantasy (projective though not infrequently true) about the spaces and practices of cultural production' (Sedgwick 1990: 156).

In *Elizabeth Takes Off*, Taylor concludes her biographical sketch by revealing the climax of a dinner to celebrate her fifty-fifth birthday:

> At the end of the party, each woman was given a ring, a cut-glass Cartier reproduction of the Taylor–Burton diamond, inscribed 'E.T. 2/27/87'. Can you imagine all of us flashing those gigantic 'diamonds'. 'Camp' yes, but I loved it!
>
> (Taylor 1987: 106)

Between these two banquets, camp, as impersonation, is signalled equally well in the fake diamonds as in the use of quotation marks to imply a series of impersonated categories: camp, as 'camp', a category which is founded on

its own status as impersonation, projection, a phenomenon of proximation or proximity. Taylor's most recent perfume, 'Elizabeth Taylor's White Diamonds', redeploys the 'camp' of the birthday dinner, correlating artifact-as-impersonation with sense by following the syntactical logic of 'Elizabeth Taylor's Passion'; the articulation of white diamonds *as* passion is effected through smell.

Elizabeth Takes Off is premised on the impossibility of distinguishing the 'real Elizabeth Taylor', announcing the epistemological problem of identification in its dedication:

> This is dedicated to You
> (You know who you are)

and its opening line, 'My name is Elizabeth Taylor' (Taylor 1987:13). Dedications orient the text deictically – grammatically – as much as culturally; in this case, the duty of orientation is displaced instead to the reader – ideal, circumstantial – who knows who they 'are'. The personified, proper noun, 'You', operates as an umbrella term for the autobiographical subject and the reader alike; Taylor's deictic complication avoids reinstituting Taylor as subject or object of her own text, marking instead where she 'takes off'. Through her memoir, she reduces the codifying distance of objectification by imposing instead an affective relation of artifact that both allows herself *as* object and as subject of her text, and of texts around her. As an identity circumscribed by public revelation, and by the objectifying relation inherent in the cinematic collocation of life and work, Elizabeth takes off: she reveals, mimics, launches; or else she simply leaves, her exit marked in the rhetorical space between 'I' and 'You'.

ACKNOWLEDGEMENTS

My thanks to Judith Barbour, Susan Conley, Elizabeth Grosz, Robyn Hardie, Elspeth Probyn, Elizabeth Wilson and most particularly to Kate Lilley.

NOTES

1 Paglia's article was originally published in *Penthouse*, an oblique venue from which to address feminists, but a juxtaposition which follows a similar logic to the shared cry of Paglia and aesthete in the auditorium.
2 Prosthesis means not merely augmentation but also to place 'before or in public' (Lanham 1991: 124), and rhetorically may be read as the preliminary statement of an oration, to be followed by a proof (Lanham 1991: 124). Prosthetic supplementarity is ancillary to debate, action and argumentation, not an addenda. Metaphorically, Taylor's body is the prosthetic preliminary to her own public subjectivity, a move which Burton's breastplates parodically mimics.
3 Prosopopoeia is 'the rhetorical exercise known as the speech in character or impersonation' (Lanham 1991: 124). Prosopopoeia, which may be read by implication to collect all the usual functions of fictionality, operates more

peculiarly, and noticeably, as an impersonation in autobiography, which takes as its premise the collocation of authorial speaking subject with author.

4 Lanham defines *copia* as 'Expansive richness of utterance as an educational technique and stylistic goal' (1991: 42).

BIBLIOGRAPHY

Bender, John and Wellbury, David A. (1990) 'Rhetoricality: On the Modernist Return of Rhetoric', in John Bender and David A. Wellbury (eds) *The Return of Rhetoric: History, Theory, Practice*. Stanford, Calif.: Stanford University Press.

Culver, Stuart (1988) 'What Manikins Want: *The Wonderful World of Oz* and *The Art of Decorating Dry Goods Windows*', *Representations*, 21 (winter).

Ford, Betty with Chase, Chris (1987) *Betty: A Glad Awakening*. London: Robson.

Kelley, Kitty (1981) *Elizabeth Taylor: The Last Star*. London: Hodder & Stoughton.

Koestenbaum, Wayne (1990) 'Callas and Her Fans', *Yale Review*, 79, 1: 1–20.

Lanham, Richard A. (1991) *A Handlist of Rhetorical Terms*. Berkeley, Calif.: University of California Press.

Maddox, Brenda (1977) *Who's Afraid of Elizabeth Taylor?* New York: M. Evans and Company.

Nussbaum, Felicity A. (1989) *The Autobiographical Subject: Gender and Ideology in Eighteenth-Century England*. Baltimore, Md. and London: Johns Hopkins University Press.

Paglia, Camille (1992a) 'Elizabeth Taylor: Hollywood's Pagan Queen', in Camille Paglia, *Sex, Art and American Culture*. New York: Vintage Books.

—— (1992b) '*Sexual Personae*: The Cancelled Preface', in Camille Paglia, *Sex, Art and American Culture*. New York: Vintage Books.

Parker, John (1989) *Five for Hollywood: Their Friendship, Their Fame, Their Tragedies*. London: Macmillan.

Parker, Patricia (1987) *Literary Fat Ladies: Rhetoric, Gender, Property*. London: Methuen.

Robin-Tani, Marianne (1988) *The New Elizabeth: Better and More Beautiful Than Ever. How Elizabeth Taylor Reclaimed Her Life, Looks and Self-Respect*. New York: St Martin's Press.

Sedgwick, Eve Kosofsky (1990) *Epistemology of the Closet*. Berkeley and Los Angeles, Calif.: University of California Press.

Taylor, Elizabeth (1965) *Elizabeth Taylor*. New York: Harper & Row.

—— (1987) *Elizabeth Takes Off: On Weight Gain, Weight Loss, Self Image and Self-Esteem*. New York: G.P. Putnam's Sons.

Walker, Alexander (1990) *Elizabeth*. London: Fontana.

Westbury, Ruth (1964) *Elizabeth Taylor*. London: Pan.

9

PARIAH BODIES[1]

Sue Golding

one must *learn* to love. . . .
(Nietzsche)[2]

but not without a *certain* style,
grace,
and trash.
(Master Johnny-Boy)

chapter one

How to begin?

This record of our existence is *not* for posterity! It is not – yet – a museum artifact neatly arranged for selective viewing, well behind protective glass. If what you want is to 'ooohh' and 'aaahh' from the other side, with your upturned noses pressed against the *supposed* boundary between us, then: go away! For this is about skin. Our skin. About our living, pariah skin; the memory of our skin; the unforgettable landscape of our skin; the molecular, danceable, corruptible, sickening journey of our skin; the times of our skin; the celebration of our skin: the skin of mine, of yours and of all the bodies shoved otherwise in, between, *us*. Skin.

Let's face it: we're all in this together, oh gentle reader, and no one – and that includes you and me, both – gets out of here, alive.

But if there is one more play, conference, film, essay, book, lecture series, talk show (TV and radio included), where a division is once again established between gay men and lesbian women (as if this tiny thing called 'gay' were not exactly and fervently a part of our *collective* butched up or femmed down drag queen life, encased, as is wont to be the way, in the genitalized body of a female, transsexual or anything else similar or yet to be invented); if, once again, there is some grab for the word 'queer' to name the supposed marginal of the marginals – *rather than using it as an expression* of our unquantifiable strangeness and unclassifiable curiosity slip-sliding around sex itself; if one more sentence is uttered that obsesses over our differences without at least alluding to the one thing we have in common; to wit: our fantastical, drippy,

colourful, tacky, often diseased, sometimes pimply and otherwise bizarrely adorned, skin ... if one more revolting 'expert' spews forth words like Liberation, Democracy and Sex all in the name of Guilt or Shame or Lack or Death or some (usually binary) variation on Gender without actually getting *down to the nitty gritty* of our multiple criss-crossing lives – our fluid, mad, exiled, mutated, villainous, impossible, uncontainable, consumer-literate, fashion accessible, sometimes rather boring and, yes, very, very queer, lives (grim or great funerals included) – whole hordes of us will have to resort to the very un-fun inhalation of non-recreational drug use. In fact, don't kid yourself: many of us already have; driven beyond the wall of despair by an unrelenting Morality which refuses the sideways ethicality of a forever mutating skin.

Oh, that flawless Morality! born of good intentions and wrapped, as is so often the case, in the vacuous, but no less sticky, clear wrap of a 'safety-in-separation' philosophic prose. Dear, dear reader: how to begin to tell our story, without exploding into a million disconnected pieces or appearing to melt into one big globular humanistic blob? As we make a grab for its impossible truth, how many more lives need be ravaged before we come to our senses and rid ourselves once and for all of that putrid split-box, that binary categorical imperative so blithely called 'The Lesbian and Gay Community'?

If we cut ourselves, do we not bleed?

chapter two

'My Daddy is dying! My Daddy is dying!', sobs a young leather-clad boy of 18. We are breathing in together the green colour of hospital sheets draped around a green living body, interrupted only by the wild explosion of karposi purple and the short green jabs of gurgle-hizzing oxygen pulsating over Lorne's face. And his father, a fundamentalist Christian who spells homosexuality in the old fashioned way (h-e-l-l), looks up at me anxiously: 'That boy over there said something about a daddy ... can it be true about my son?' He queries urgently and with hopeful tears: 'did he have offspring?'

How to begin?

We step from Lorne's death room into the hallway of the undead: 'I do not think there is anything harder in the world than for a parent to bury his child', I say, not knowing what to say. We look like two ugly warts, having spored from nowhere but now oddly stuck to each other's skin. I make another stab: 'I cannot possibly understand what hideous despair you must be going through; but I can empathize with the depths of your sadness (he nods, weeping). Now, try to follow me on this: your son, Lorne, was a great teacher.'

We both inhale the information together: '– Yes, he was always a great teacher', adds the father.

'That boy you overheard by his bed was one of his pupils.' Our eyes narrow together and, holding back the tears, we focus on a leather dot somewhere else in the future. 'And the subject Lorne taught best was the subject of sex; and he had many, many students, your son, Lorne; and he taught them well and he taught them hard; and they loved him for it; and he loved them back.'

'But there is one thing you should know: rather than his students calling him Professor or Doctor or Teacher, they called him, very simply – Daddy.'

'Do you understand what I am saying to you?'

'– My Lorne was always a great teacher', wept the father, 'I do not understand this . . . but, I can empathize.'

Empathy. One may not understand, but one learns many, many things when they bear witness: just how chilly the chill of the death rattle can be, for example; or the terrifying regularity of grey, mucky spittle, for another. The 37,000 variations on how to keep the meds down while keeping the spirits up (throw out that alcohol, baby, let's top-up the stemware with an endless stream of pills . . . bring on the new T-shirts (at least two a week) to mix and match with the adult diapers, bedpans and other un-glorious paraphernalia). The downstairs kitchen fills with heady, angry talk, first circling around Chris and Ruth's solid research for or against an immunological take on HIV prevention – and with it, what food, experimental drugs, shots and what-not should or should not be ingested and in which order. Bob is way ahead of the medical practitioners, having read every viral report he can get his hands on. I find myself bristling at Sara's infamously well-intentioned but sadly unworkable homeopathic remedies which always include some sage, thyme, garlic and crystals (not to mention the question of Mexico thrown in for good measure). Cool-hand Sammy breaks the deadlock with the 'I-don't-give-a-damn-give-me-every-recreational-drug-on-the-market-scoop-me-out-of-the-gutter-if-I-make-it-that-far-in-the-morning' only to be disgusted by Ricky's suffer-in-silence approach versus the steady, monotonous, 'motoring on', as Jamie puts it, 'motoring on' in the face of it all. In the goddamn brutal face of it all.

And on the way to the chemist I want to howl at passers-by: 'MURDER! MURDER! TREASON!' This criminal disease is not inside *all* of us – at least not yet . . .; but no matter: it surrounds our every step. Robby's dementia is giving substance to my own: as he rushes to and fro, while moving not at all, utterly obsessed with painting canvasses he no longer can touch or smell or see, I want to rip the hair from my head; I want to tear my clothes; I want to walk shoeless. If it made any difference at all, I would climb a thousand mountains, picket every single Wellcome Institute, spit in the faces of drug companies everywhere. With tears and anger, or steady bravado or whatever it takes to get the message across, those still in the land of the undead gather up the condoms and the pamphlets and the lectures about safe sex between men and men or between women and women or between men and women or between dogs and cats, for god's sakes, shouting on every corner: REMEMBER YOUR

SKIN! ALL SAFE SEX COMES FROM THE FACT THAT THE SKIN IS YOUR BEST CONDOM! If it is not broken, it cannot weep or exchange blood or viruses or anti-bodies. Safe sex does not require a c.v. on Morality to know about the skin and the sex and the sweetness of the fuck.

So listen, please, oh kind and gentle reader! Do not turn your back on us. It is not just a Daddy who is dying! It is our brothers who are dying! It is, in fact, a whole people who is dying! A whole sexual community who is under seige and dying! And you dare to tell me this is not a lesbian 'issue'? You dare to say that I am on the 'outside' of the gay community because I am a dyke! I have lost over forty members of my pretend-family, each one precious and wild; each death more hideous than the next! You cannot and will not divide us from each other: we are all in this together, fighting as we must so do, as this Death keeps coming after us, and after us, and after us. And it keeps on coming after us, even when it's not.

Sex and blood and rock 'n' roll, genitals notwithstanding. If you fail to understand what I am saying to you, can't you at least empathize?

chapter three

Last week she killed herself without a word to anyone about the impending disaster which was to befall herself, not to mention those she left behind. These are very, very grim times, indeed. And when the four of us carried her coffin on our shoulders into the crematorium, jam-packed with fellow mourners – who among us did not wish to scream out: WHAT A WASTE! What a waste of a beautiful, crazy, talented life. We are going to miss you, Tessa Boffin!

A black leather sea of mourners, with a sprinkling of feather boa dragsters and formally be-suited beings, tear stained the cold cement floor. Some just sat there glaring and numb. Huge flowers and a magnificent 2 foot photo of Tessa in a formal gold and red sequined dress, black gloves up to her elbows and an overpowering slut-fashioned wig covering her head, adorned the otherwise barren walls. Here was our skin: dead in a box! And the rest of it, moulting without replacement, so exposed, so damaged, held gingerly together by selections of her favourite music, now eerily wafting through the cracks of our collectively laboured breathing. I was asked to speak, and I did speak. And this is, in part, a record of what I said on that day, on that grey and wicked day:

If I close my eyes, I can see floating about in the not too far away past her obsessions with angels and the whiteness of their wings; the crazy videotapes she made; the funny scenes she conjured up around regular household effects: plumbing tubes, for example; carpentry bolts for another, all dipping into the well of sexual bravado, limits and, of course, a weighty amount of leather. For her intellectual curiosity drove her like a playful, but untamed filly – drove her from field to field to try things on . . . often just for size. or shape.

or colour. So, I want to tell you then, and in light of that – not really about her intellectual, artistic and personal greatness – though, clearly, this could be done and in magnificent detail. Rather, I want to say something a bit more modest; something which, at the end of the day, will, I hope, give all of us in these despairing times a little bit of comfort.

I want to tell you about the clothes she wore.

Sometimes, when she was in her queer-*boy* mood, she would throw on a black leather jacket, jeans and mustache (or 'tache' as she always called it): 'i am a fag boy', she would claim. *And she meant it*. Or take the time she wore a white wedding dress to Kinky's, adorned with many jewels including the requisite crystal dildo (of course): 'i am a dyke who wants to have sex on the dance floor', she would scream defiantly. *And she meant it*. Once, when we were at a conference together, a fairly 'straight' academic conference on 'homosexuality' (this is how you can always tell it's so straight: they don't even use the word lesbian; and the word 'gay' is mutated into its medicalized vernacular); once when we were at that conference, she scandalized the participants by wearing a rubber skirt, a wavy rubber skirt, a bit too short, a bit too 'tart'; and she would flash her eyes and spit out at some unsuspecting conference participant, 'I am a sexual pervert, a queer; that's called: being smart', she would say. **And she meant it**.

In every case, in all her clothes, in all her haircuts and tattoos and pierces and leather, people often responded by being scandalized first, and never (or rarely) in the second place, hearing what she said. Or, that she meant it.

Two weeks ago I received this postcard from Tessa. The front has a picture of Santa Rita, bleeding from the forehead, looking adoringly at the cross. The back reads, in part:

> Dear Sue: This is the only sort of masochism Spain openly blesses. Nerina and I had to restrain ourselves when we saw the confessional box in the Cathedral . . . Barcelona can't cope with anything other than religious perversions; they are having a hard time with our piercings, our leather and our butchness. Even the (lesbian and gay) scene isn't very tolerant – a 70s John Travolta look prevails, and they charge women £2 more to get into, what they call, a queer club.

And I thought to myself: Spain?? With the exception of John Travolta, this sounds exactly like home to me: with our excessive inability to hear and tolerate each other's differences. No, rather, with the inability to RESPECT our differences; with the all too often problem of being 'scandalized'; with our inability to be anything other than nasty, brutish and short with each other most of the time; silent, the rest of it.

Tessa's clothes.

Tessa's mutating clothes, which she wore, tried on, mixed and matched. The material skin-flints she used were called: dyke, fag-boy, bisexual, queer, martyr, hero, villain, vampire, gothic queen, all of the above, none of the

above – and material identities we haven't even thought of – swirling around her (and all of us) relentlessly; though sometimes, swirling not at all. Tessa's insistence on the right to be different and, as confusing as this may sound, *on the right to be the same*, on the right to be profoundly interesting and terribly couch potato whenever she so chose, at the varying times she chose without fear of rejection or overbearing analysis or slotting her into some neat and well-defined category, good, bad or indifferent. . . . Tessa's insistence on the right (not the privilege), on the right, simply, *to be loved*. And respected.

If there is anything at all 'good' that comes from this terrible, terrible death: Oh Tessa! if there is anything at all good from this suicide, let it be this: a little bit of kindness extended to each of us – *by each of us toward each of us*; a little bit of gentleness; an extended hand of friendship to those who might otherwise have been considered erstwhile 'enemies' or 'different' or just not able to be 'slotted'. Life is too short and too bloody fragile to leave to it to the Muses. It's time we try, once again, to re-remember – not just how to love – but that we *must* love in the fullest sense of the word Respect for all the mutating, unchartable and unbearable differences each of us have within us. Is this not precisely, at least in part, what it means to be gay in all its damnable, gossipy, campy and heartbreaking ways?

I shall close these remarks with the poem by Rilke that she and Sunil Gupta dedicated to David Ruffell at the entry of their book, *Ecstatic Anti-Bodies: Resisting the AIDs Mythology* (1990):

> But the living are wrong
> in the sharp
> distinctions they make.

> **But the living are *wrong***
> **in the sharp**
> **distinctions they make.**[3]

> Angels, it seems,
> don't always know
> if they're moving among
> the living or the dead.

Good bye, sweet Tessa. May you rest in peace.

chapter four

Mourning and melancholia. While it is true that death teaches us many things, it, most of all, teaches us one thing. And that one thing is about the nakedness of death itself; the relentless finality, the no-going-back of life. One could shed 120 tears for every day of Sodom; one could spit into the wind or prostrate oneself forever and always – or not at all. One could stamp

a foot; one could write three long poems; one could lay down in the street *en masse*; one could laugh out loud; one could memorialize to eternity all the beauty of all the people gone gone gone; one could replay their anger, their whimsy, their philosophies, their cooking sense or even the way they look when they wake up in the morning. But, in the end, it simply doesn't matter: They are not coming home. And that's the whole, damn, sickening truth, no matter how you cut it. Or how it cuts you.

This putrid skin! Would it not to have ever been so alive!

chapter five

After all this, how does one begin (again)?

How do we begin, once again, always again, endlessly and forever, again; how to begin to tell our story, caught in mid-run, outside the run, while on the run: our very bodies the tattoo of this run, this deadly, sticky, pariah run? How to preserve, conserve and reinvent in all its various forms: a living beginning, a truncated beginning, a re-beginning, a childhood beginning, a something-else or something other beginning which survives quite beyond the infamous division between the evil and the innocence of the babe in the wood?

Well, once upon a time there was a nightgown and a frog. The nightgown figured that if only it could jump high enough it might be able to outjump the frog with whom it was always in constant battle. Part of the problem lay with the frog itself: for this frog liked to torment the nightgown by rubbing its left leg against the bottom section of the gown. And as the frog was always a bit slimy (while the gown was clean cotton dry) the latter found itself in a perpetual state of agitation and, at times, outright disgust. To make matters worse, as soon as the gown would sweep itself upwards and away, the frog, too, would leap high into the air, kicking out its legs and laughing hideously at the stupidity of the gown. Every now and then it would manage an air-strike swipe, and that would enrage the gown even further. In short: they hated each other, pure and simple, day after dark day, week after week.

One evening an eye and a shoe were passing by at exactly the same spot where the gown and the frog were conducting their intense little battles (the cruelty of which had now become legendary, fine tuned – as would be expected – almost to a mad science, one that escaped all boundaries of rationality, but somehow and nonetheless seemed perfectly, even artfully, reasonable). As it was not usual in those parts of the world to see gowns and frogs leaping about in general, the eye felt compelled to say something to the shoe.

'– Go kick that frog so that the odds are more equal.'

Since the shoe, being merely a shoe, was only (in the main) used to taking commands rather than giving them, it readily jumped into the fray, almost with wild abandon. The most extraordinary scene could now be recorded: The shoe went after the frog, every now and then inflicting a serious bruise on to one of the outstretched limbs; the frog, doubling fury with pain, still managed

to target the gown, who by now had brownish goo smeared on various parts of itself. The nightgown was beginning to feel weighted by all the mess, so it began to chase after the shoe with the sole intention of resting upon, what it mistook to be, its friend – attempting in so doing, to drape itself (very elegantly it has to be said) over the untamed kicker. The shoe, not realizing what the gown was up to, all of a sudden felt persecuted and afraid and found itself both chasing the frog and running from the gown. Up and down, round and round the frenzied three went – well into the night – deadlocked and sweaty, until such time as the eye, utterly bored (and slightly annoyed that its voyeuristic yearnings had not quite been met) cried out in righteous indignation: 'Are you all mad! Look here, shoe! I was only trying to even the odds when I suggested that you enter the fray. But now, it seems, you're just like all the rest!'

The claustrophobic silence that descended upon whatever civility had been left was finally squashed by an out-of-breath, and seriously insulted, shoe, who, as it turns out, had waited years to come back at the eye with: 'You always think that just because you see everything, you know everything as well'. The eye's pupil shrank with rage, glowering with the kind of glower only an eye can muster at the exact moment a wounding truth has been mounted and no sufficient reply is ready at hand.

There is no, truly accurate, information on precisely how this next part happened – or even why the nightgown would have had one to begin with – but, somehow, an open switch blade fell from its pocket. It spun out, reckless and entirely beyond anyone's control, slicing haphazardly through the left leg of the frog (who had by now begun to leap about in a crazed, indeed demented, manner, bounding higher than ever, ever before). All of us who were there can still hear its grisly howls of pain, that murderous shriek, echoing with every bounce.

Down, down, down, the blade fell, careening through air and wind and deep red frog blood, until finally, unable to stop itself, it managed to land right smack dab in the centre of the eye. In a violent rush, the shoe furiously kicked away at the knife, but managed only to slice up the eye more severely. Those who were able, pulled off the shoe, and, gathering the frog and its leg, carefully wrapped both together in the gown – who was by now sobbing uncontrollably. A magnificent black flat-bed carriage drawn by eight white Percherons stood nearby, ready to carry them away, wherever they might wish to go, whenever the moment would seem right.

*

Once upon a time, oh gentle and thoughtful reader, there was a journey, a time, a city, a space, which only and always began at the beginning, and ended, in exile, somewhere thereafter, once upon a time.

So, once upon a time. . . .

179

NOTES

1 This is an angry, melancholic piece about death and dying and carrying on. It tries to lace together the rawness of those problems with the vitality and courage that all of us have had to muster in order to begin again, always and forever again, whether this 'us' be packaged as dyke or fag or tranny or queen or bisexual or queer or anything else yet to be invented. The people and their situations recorded are personal and particular; the deaths diverse and painful; yet their lives resonate at the more universal – dare we say 'political' – level. At the risk of saying both too much and too little, what has become clear for all of us who are a part of *this* community, this glorious gay community (stuffed to its multiple gills with frivolity, mutation and decay), is that our 'beginnings' create the very surface of an adult version – not to put too fine a point on it – of *childhood* itself. But this is an odd, often cruel form of childhood – one that skates upon the carnal knowledge of sex and sweat, encapsulated at the boundaries of our skin. We are the adult-children who refuse to give up our friendships and our loves in the face of this damnable brutality. We are the horror-children, the exiles, the journeyers, with the wrong outfits, wrong loves, wrong jokes, wrong sicknesses, wrong deaths, carrying on, despite all odds. A bravado etched across always-already-beginning beginnings, making us, in one word: pariah.
2 F. Nietzsche (1974: 240).
3 I have repeated the first verse and emphasized it.

BIBLIOGRAPHY

Boffin, Tessa and Gupta, Sunil. (1990) *Ecstatic Anti-Bodies: Resisting the AIDS Mythology.* London: Rivers Oram.
Nietzsche, F. (1974) *The Gay Science; with a prelude in Rhymes and an Appendix of songs*, book 4, translated by Walter Kaufmann. New York: Vintage.

10

SEXUALIZING SPACE

Sue Best

Time and Space are Real Beings. Time is a Man Space is a Woman.
> (William Blake; cited in Bal 1988: 169)

'Father's time, mother's species', as Joyce puts it; and indeed, when evoking the name and destiny of woman, one thinks more of the *space* generating and forming the human species than of *time*, becoming or history.
> (Kristeva 1986: 190)

Could it be ... that femininity is experienced as a space that often carries connotations of the depths of night ... while masculinity is conceived of in terms of time?
> (Irigaray 1987: 120)

The humanities are experiencing what could only be described – in the words of Meaghan Morris – as 'a boom' in studies of space (1988: 15). Indeed, space has become a truly interdisciplinary problematic, attracting the attentions of not simply its traditional interlocutors – geographers, philosophers and scientists – but also soliciting the interest of literary critics, historians, art historians, architectural theorists and cultural critics. Yet, in this now considerable body of work, apart from the highly suggestive evocations of Luce Irigaray and Julia Kristeva, virtually no mention is made of the persistent link between women and space. This oversight is very surprising given that, seemingly, wherever you turn the question of space is bound up with the question of woman.

Indeed, in an extraordinary array of contexts, space is conceived as a woman. This is particularly noticeable in relation to the 'bounded' spatial entities which are seen as the context of, and for, human habitation: the world, the nation, regions, cities and the home. For example, the contours of countries and districts are frequently drawn by using the concepts of motherland or mother tongue, and cities, and even whole countries, are frequently personified as women – Britannia stands for Britain, Marianne for Republican France. Moreover, the most written about and valorized cities,

the so-called capital cities of the nineteenth, twentieth and twenty-first centuries – Paris, New York and Los Angeles, respectively – are all women.

Paris, the 'capital of the nineteenth century', is described by Marina Warner as quintessentially feminine, a city of ladies. The whole public space of Paris is cushioned by accommodating feminine flesh, the buildings are even described as having 'bosomy and vaginal contours . . . pillowy roofs and open-mouthed entrances' (1985: 36–7).

New York, 'capital of the twentieth century', is not quite so accommo-dating, offering a much more speedy twentieth-century style of romance. Scott Fitzgerald has but one nocturnal affair with New York. She was, as he put it, 'essentially cynical and heartless – save for the one night when she made luminous the Ritz Roof' (1971: 143). As befits a twentieth-century woman, New York has an active libido – unlike Oedipalized, vaginal Paris – and hence she has a clitoris at the entrance to her harbour, or, rather, a 'clitoral appendage', as Rem Koolhaas refers to Coney Island (1978: 23).

Thoroughly postmodern Los Angeles, the capital-to-be of the twenty-first century, predictably perhaps, is a simulacrum of woman.[1] According to Lyotard she is just a stretch of white skin, a surface without openings or depth. Los Angeles is:

> but a game of chess, whose squares are drawn by its highways and forty-mile-long boulevards, squares which are occupied only temporarily, as in the game. This chessboard is not the coat-of-arms (*le blazon*) of the feminine body (whose openings, whose eyes and ears, are emblems of depth), but rather of skin as white woman – a jointing harsh and by chance.
>
> (1989: 64)

Penetration is thus no longer possible. An erotic encounter with this city of highways is an arid affair, mediated, of course, by the car. The car becomes a hand seeking out the remaining erogenous zones of this vast, stitched, patchwork body: 'The blindness of the car in the labyrinth of LA is none other than the blindness of the palm as it traverses the length of thighs, the span of shoulders, of groins' (Lyotard 1989: 64).

Finally, in relation to the smallest and the largest spatial units of acknowl-edged human dwelling – the home and the world – the figure of the mother is again invoked. Our whole world, the vast expanse of nature, was perceived in pre-modern times as a nurturing mother (Merchant 1990: 2). More recently, in the shadow of the ecological crisis, this idea of the world as a female organism has re-emerged (Merchant 1990: xv).

For many male writers, most notably Gaston Bachelard in *The Poetics of Space*, the house is a woman – a warm, cosy, sheltering, uterine home. Bachelard explicitly refers to the 'maternal features of the house' (1969: 7) while also implicitly conjuring images of the house as the realm of perfect maternal care. In this realm 'paradise' seems to be attained through evo-

cations of being both inside and outside the womb. The house is at once 'a large cradle', the dweller is infused with well being 'enclosed, protected, all warm in the bosom of the house'; and, at the same time, the house is a place of 'enveloping warmth', where being is 'dissolved in the comforts of adequate matter' and 'bathed in nourishment' (Bachelard 1969: 7).

On the face of it, these very diverse examples seem to simply indicate the pleasures and comforts offered by feminized space – the sexual *frisson* of the metropolis, the safe familial haven of earth, motherland and home. Yet the sheer quantity of examples, and this brief survey is but a small sample, speaks of a persistent desire to domesticate space, to bring it within a human horizon and, most importantly, to 'contain' it within this horizon. As Mary Douglas notes 'The body is a model which can stand for any bounded system. Its boundaries can represent any boundaries which are threatened or precarious' (1991: 115). In other words, the use of the body-model indicates the demand or desire for a clear limit or boundary – it seems to bestow, or at least to promise, precisely this – and yet it is when the body is invoked that the boundary is probably most uncertain.

Thus feminizing space seems to suggest, on the one hand, the production of a safe, familiar, clearly defined entity, which, because it is female, should be appropriately docile or able to be dominated. But, on the other hand, this very same production also underscores an anxiety about this 'entity' and the precariousness of its boundedness.

This use of the body to hedge against the threat of insecure boundaries is all the more evident when the female body is used to produce more abstract or general concepts of space, because, unlike the examples above, in these instances there is not even an accepted edge or mappable boundary. Henri Lefebvre provides a very curious example of this. He uses the female body to produce his concept of contemporary neocapitalist space. He states:

> The ways in which space is thus carved up are reminiscent of the ways in which the body is cut into pieces in images (especially the female body, which is not only cut up but also deemed to be 'without organs'!).
>
> (1991: 355)

This is not the maternal body, nor even the sexually available female body, it is the fragmented female body of the postmodern culture industry. This example is unusual because it seems to flaunt what is only implicit in most feminizations of space, namely the precariousness of the boundary – the body's integrity is violated by being cut into pieces. Yet the body, even in this state, is still understood as a female body and hence it manages to deliver the sense of a limit or edge to what is generally regarded as no longer mappable in conventional cartographic terms. Indeed this is precisely Lefebvre's point when he argues that neocapitalist space is 'whole and broken, global and fractured, at one and the same time' (Lefebvre 1991: 356). Yet postmodern, neocapitalist space, according to most commentators, is not

183

a 'whole' – it no longer has a distinct edge or boundary. Frederic Jameson (1988: 351) goes as far as stating that it defies 'adequate figuration' and yet Lefebvre has indeed figured postmodern space. The female body delivers a conception of bounded mappable space, space which can still be understood as a totality even if it is internally fractured or carved up. Recourse to the female body in this example seems to deliver and secure the idea of space as still a bounded entity, still a sort of container.

The idea of space as a container is remarkably persistent despite more recent refutations of this idea.[2] Indeed this theory or concept of space seems to underlie the innumerable examples of bounded feminine space referred to above. This particular theory of space, and its production with the body-matter of woman, seems to be inaugurated by Plato. Certainly, according to Aristotle, Plato was the first to not simply assume the existence of space but to attempt 'to tell us what it is' (cited in Jammer 1968: 31). In this explanation, as Ann Bergren notes, 'the female . . . *chôra* "place, space"' (1992: 20–1) has two moments: 'earlier' and 'later' *chôra*, and is characterized differently in each.[3] It is in the later version of *chôra* or space that Plato invokes the figure of the mother. He states:

> It [the receptacle/space] can always be called the same because it never alters its characteristics. For it continues to receive all things, and never itself takes a permanent impress from any of the things that enter it; it is a kind of neutral plastic material on which changing impressions are stamped by the things which enter it, making it appear different at different times. And the things which pass in and out of it are copies of the eternal realities, whose form they take . . . we must make a threefold distinction and think of that which becomes, that in which it becomes, and the model which it resembles. We may indeed use the metaphor of birth and compare the receptacle to the mother, the model to the father, and what they produce between them to their offspring.
>
> (1965: 69)

It is this later *chôra*, which Bergren refers to as 'passified' (1992: 26), that has set some of the key terms for subsequent philosophical debates about the nature of space. That is, whether space is a container for things or the relation between things and whether it is material or ideal. Indeed, even with the advent of the theory of spacetime, this debate still continues.

The earlier 'pre-cosmic' version of *chôra*, which Bergren refers to as 'active' (1992: 23, 26), is compared by Plato to a winnowing basket that shakes and sorts its contents. This active version – redeployed more recently by Julia Kristeva (1984: 25–30) among others – may perhaps have more appeal now that curved substantival spacetime has also been retheorized along more active lines.[4] However it is the later passive female space that has tended to dominate our imaginary even in recent times as the examples

above should indicate. In light of this seemingly ineradicable persistence, the production and reproduction of feminized space demands close examination.

METAPHOR

This pervasive enfolding of the body of woman in the question of space would usually be described as a 'metaphoric' transfer of the attributes of woman to space.[5] This understanding of metaphor presumes that two discrete terms, in this case space and woman, are in some way 'compared' through this transference.[6] If the comparison is based on a perceived or produced similarity – a characteristic proper to both terms – the comparison should mutually implicate both terms.[7] But by claiming that the characteristics of woman are *transferred* to space, the comparison seems to flow in only one direction – woman is supposed to illuminate or illustrate concepts of space. So, in effect, woman – in Marx's terms – is rendered as the 'equivalent term' which gives value and meaning only to space.[8]

This reduction of the transferred term is made explicit by Hegel. He argues that when a metaphor becomes part of everyday language, only the kernel of meaning remains – the sensible husk disappears. The transformation of metaphor into literal or proper meaning, he argues, is enabled by our willingness to grasp in the image only the meaning. However, he also contends that image and meaning are thereby no longer distinguished. Nevertheless, despite this radical inmixing, he states that the image 'directly affords only the abstract meaning itself instead of a concrete picture' (1975: 404). The concrete sensuous picture is supposed to be both 'lost and exchanged for a [higher] spiritual meaning' (Hegel 1975: 404). But if the image (concrete or otherwise) is exchanged for the higher meaning, in the sense that it acts as a sign of the higher meaning, to what extent is it actually lost? The image must be retained in order to 'directly afford the abstract meaning' but must be somehow siphoned of all reference to concrete sensuality in order to act only as a conduit for the higher meaning.

But how is the image to be rendered into a transparent conduit for the abstract meaning? The image must be like Plato's maternal space, devoid of all character, but able to hold impressions. According to Plato's elaboration of *chôra* as maternal, it must be devoid of all character in order to receive in itself every possible character, like odourless liquid prepared to receive scent or soft substances made as smooth as possible to receive impressions. This characterization of *chôra* as a receptive substance seems to represent the desired state for the transparent image. The image should be a kind of neutral substance upon which meaning can be impressed – meaning, and only meaning, gives the substance form. For, if the image were to be granted some character of its own, it would contribute to the formation of meaning, rather than simply being given form by it.

This formative role is allowed to the image when it is argued that metaphor

gives form to the unknown via the known.[9] In this instance space becomes the idea or concept – what I.A. Richards would call the tenor – and woman, the image, is reduced to being the 'vehicle' or container that conveys the idea (see Hawkes 1972: 61). But if this is the case, how does one return to the proper meaning of space if the concept is formed in this borrowed container? How can the concept return to itself, if it does not have a proper place? The spatial relations are reversed here; woman does not move over to illuminate space but rather space moves in and inhabits woman.

These conflicting spatial metaphors, used to describe the very operation of metaphor itself, should indicate that metaphors do not simply illustrate concepts. The term 'illustration' conjures a much more conventional model of representation in which metaphors should only embellish or duplicate a meaning or concept which is already understood. In this schema, the concept should both precede and succeed the metaphoric operation, the metaphor simply stands in for the concept. This representational model ignores or elides the *means* of representation, that is, *how* woman is able to represent space through the transference of the attributes of woman to space or the conveyal of space by the body of woman. These conflicting movements (transference, conveyance) cannot be reduced to substitution or duplication because they produce different entanglements of vehicle and concept, image and meaning. In other words, these entanglements are not able to be formulated into the neat original-copy schema which underpins the ideas of both substitution and duplication.

If metaphors do not simply illustrate concepts then how is the metaphoric operation to be understood? Gayatri Spivak has noted the continual reliance in both literature and philosophy upon the figure of woman. She argues that concepts are not simply illustrated, but are *produced* by the metaphor of woman (1987: 169). If the concept of space is produced by the metaphor of woman, then it follows that the metaphor of woman is an essential and constitutive part of the concept of space. In other words, some 'detachable' attributes of woman are not simply carried over to 'illustrate' an already fully formed concept of space, nor are concepts of space merely conveyed by the vehicle woman, but rather woman's body gives these concepts form. So, for example, Plato's notion of space would not be possible without the understanding that, for the Greeks, women played no active part in gestation (see Lloyd 1984: 3). Similarly, Lefebvre's notion of space as *both* a unity and yet something which is experienced as fractured, would not be possible without the body of woman providing the model for this contemporary contradiction. Thus woman is not simply compared to space, the body of woman is integral to the production of these concepts of space. This conclusion is not strictly speaking continuous with Spivak's understanding of the production of concepts with the metaphor of woman. Shifting from the 'metaphor of woman' to the 'body of woman' actually takes Spivak's

argument one step further: the concept of space is not simply produced by the metaphor of woman, it is constituted through the body of woman.

This further step is taken by Luce Irigaray. Her work has consistently pointed to the workings of this basic problematic, that is 'the exploitation of the body-matter of women' in the symbolic process (1985b: 85). In particular, Irigaray has drawn attention to the way in which philosophical oppositions – such as time/space, subject/object, intelligible/sensible, culture/nature, etc. – continually exploit the body-matter of woman. This is one of the central issues of her work and is supported by a sustained and subtle argument that is woven through her investigations of a number of philosophical texts and problematics.

To substantiate this argument Irigaray establishes that these oppositions are organized hierarchically and can be understood as subtended by the opposition man/woman: 'there is one pole of the opposition (the masculine) which constitutes the limit of the system and which plays with the other pole (the feminine) according to its needs' (1988: 160). This unequal sexual arrangement is argued to be the basic structure of all oppositions. The hierarchical ordering of these oppositions explains how the subordinated terms associated with woman – space, nature, etc. – are rendered as the support, the complement and the malleable matter for man.

Woman is rendered as the *body-matter* for man and philosophy by this very same ordering. Woman becomes the body-matter for philosophy as the necessary condition for man to appear to transcend his corporeal, material existence through reflection and speculation. According to Irigaray, woman is the body-matter for man to imprint, the '"Matter" upon which he will ever and again return to plant his foot in order to spring farther, leap higher' (1985a: 134). This manoeuvre, which constitutes woman as the body, the earth, the springboard for man, enables man to appear removed from matter and corporeality: his domain is the higher realm of the intelligible and ideas. Man is thus positioned as the transcendent subject whose only connection to the corporeal is his imprint left upon 'his' object – the body of woman.

However, woman subtends and enables this claim to transcendence; she is '[a] body-matter marked by their signifiers, a prop for their soul-fantasies. The place where their encoding as speaking subjects is inscribed' (1985b: 96). As the place for the inscription of man's speaking position, woman is rendered as the necessary corporeal support for man's subjectivity. So, in effect, both terms of the opposition subject/object are inscribed in the body-matter of woman. This leaves woman as the sole guardian of body-matter.

The subordinate feminine terms of philosophical oppositions are thus 'associated' with woman by being imprinted in this malleable body-matter. Woman, as the pole formulated according to the needs of masculinity, is 'the *resource* of reflection – the red blood of resemblance' (Irigaray 1985b: 151), '*the living mirror*' for man's reflection and speculation (Irigaray 1985a: 221).

This basic structure, which positions woman as the 'living mirror' required

by man, is traced by Irigaray through various philosophers' writings. In marked contrast to many other commentators, Irigaray sees this process as integral to the constitution of woman.[10] Hence, she highlights the importance of metaphors: 'the necessity of "reopening" the figures of philosophical discourse . . . in order to pry out of them what they have borrowed that is feminine, from the feminine, to make them "render up" and give back what they owe the feminine' (1985b: 74). And she argues that one way to challenge philosophy's construction of woman is by using the very same tools that have inscribed the body of woman: 'The tool is not a feminine attribute. But woman may re-utilize its marks on her, in her . . . to get back inside their ever so coherent systems' (Irigaray 1985b: 150). So, while woman is not considered apart from her relation to man, and hence woman as a specific subject is not considered, for Irigaray, this does not mean that these constructions can be simply rejected as false.[11] This utilization of woman by philosophy is how woman is constituted by philosophy's rhetoric.

If woman is constituted by the imprinting of her body-matter by rhetoric then it follows that the concept which shares this body-matter must also be constituted by this rhetoric. Hence, to return to the consideration of space, one term of the pair – space/woman – cannot, as it were, 'move' without the other. Irigaray's work, as should be evident from the discussion above, demonstrates an acute awareness not only of how concepts ensnare and produce woman but also how conversely woman provides the matter for concepts. Indeed Irigaray notes that not only is woman 'rolled up in metaphors' (1985a: 144), but that, concepts are 'rolled up' in the body-matter of woman, as she puts it: '[man] envelops himself and his things in her flesh' (1987: 123). This observation is made during her discussion of the way in which space constitutes woman – what could be termed the spatialization of woman – that is, the way in which woman becomes both a place and an envelope for man. However, in response to what could be termed the 'double action' of metaphor, that is, the way in which metaphor both spatializes woman and feminizes space, she has, it seems, chosen to concentrate upon the spatialization of woman rather than the feminization of space. And, in general, her concern is with the problematic of woman rather than with the concepts produced by woman. However her investigations of the problematic of woman have profound implications for the production of concepts. Just as conversely, given that concepts are enveloped 'in woman's flesh', to view this 'double action' metaphor from the other side – that is, from the neglected point of view of space – must have profound implications for how we view women.

SEXUALIZATION

To think about concepts as enveloping the body-matter of woman is certainly an extremely challenging proposition. Indeed, Irigaray's repeated references to the body-matter of woman have deeply troubled many commentators. The tendency is to defend this reference to the body-matter of woman by insisting that Irigaray does not mean to invoke the real material body.[12] In other words,

there is a firm commitment to maintaining the very binary opposition Irigaray is attempting to challenge, namely, materiality/ideality. This binary is reinstated by confining her work to one side of the pole – ideality. Irigaray, it is argued, is being metaphorical, not literal, when she refers to the body-matter, the flesh and blood of woman. Hence it is assumed that she is only dealing with ideas or images of woman but not the literal body-matter of woman. This is rather ironic given that Irigaray's work questions this narrow reading of metaphor.

Irigaray's work very specifically undermines the idea of 'gender-dichotomies' as simply metaphors or images of woman, whose circulation is restricted to the confines of learned discourse. Or rather, if the word 'metaphor' is retained, as perhaps it should be, she suggests a different understanding of metaphor. For Irigaray, metaphor grounds the operation of philosophy in woman's body and thus philosophy spins its concepts from this matter just as it inscribes woman with this very same gesture. This rewriting of metaphor as grounded in body-matter prevents philosophy from being able to recuperate metaphor or absorb it into the masculine side of the binary – the realm of ideas, the intelligible and ideality. This very effectively problematizes not only the narrow reading of metaphor, but also the binary order which privileges ideas over matter and thus enables ideas to constantly represent and mediate matter. This operation is certainly in keeping with Irigaray's general project. She states:

> We have to reject all the great systems of opposition on which our culture is constructed. Reject, for example, the oppositions: fiction/truth, sensible/intelligible, empirical/transcendental, materialist/idealist. All these opposing pairs function as an exploitation and a negation of a relation at the beginning and of a certain mode of connection between the body and the word for which we have paid everything.
>
> (1988: 159)

Rethinking metaphor is perhaps one way to make apparent this repressed connection between the body and the word for which we have paid everything. This rethinking, however, must consider that this connection of body and word not only affects the body-matter of woman but also affects concepts.

In order to think the enfolding of the female body in concepts and concepts in the female body we can no longer assume the existence of a beginning point with two discrete terms – a natural body and pure thought. Instead, one would have to assume what Derrida terms 'an originary synthesis not preceded by any absolute simplicity' (1974: 62). This 'originary synthesis' neatly correlates with Irigaray's notion of 'a relation at the beginning'. Derrida calls this movement *différance*, 'the being-imprinted of the imprint', 'the formation of form' (ibid.: 63). Differences are 'the *work* and the *fact*' made possible by *différance* (ibid.). This movement or process is how the difference between body and concept is able to be thought, but because this 'origin' is not itself

cognizable, their mutual dependence is suppressed (or, as Irigaray (1988: 159) puts it, the connection is negated and yet exploited). Instead, analysis starts with 'determined differences' (Derrida 1974: 63), eliding what makes them possible by giving one term primacy. This is evident in Plato's account of maternal *chôra*: ideality or masculine form is the term given primacy, it alone shapes indeterminate matter and produces the sensible things as poor copies of itself. This myth of origin thus instantiates the model–copy schema which still dominates our thinking about metaphor and, indeed, representation in general.

The notion of an originary synthesis upsets this model–copy schema; we do not start with either a fully formed idea of space or a fully formed notion of woman. We can only start with an imbrication – the result of which can be summed up by Sarah Kofman's phrase 'a *sexualisation of text* and a *textualisation of sex*' (1989: 127). This 'starting position' denies the usual binary ordering which gives precedence to one term at the expense of the other. Rather, the same movement produces a sexualization of text – or sexed concepts – and a textualization of sex – corporeal texts.

CONCLUSION

The thorough imbrication of space and woman 'at the very beginning' could account for the widespread appearance of feminized space. Indeed, it is as if space is so intimately tied to the body of woman that this ungraspable founding moment is continually, and often unwittingly, reiterated. Certainly, only this kind of intimate imbrication and consistent iteration can begin to explain the numerous and diverse examples of feminized space with which this essay began.

Making apparent the corporeal basis for the production and reproduction of sexualized space may seem to simply disclose yet another instance of the utilization of woman for the ends of man, the effect of which could be argued to be the pacification, domestication and containment of both woman and space. However if the body-matter of woman is conceived as an essential and 'active' ingredient in the production of space, as Irigaray's refiguring of metaphor suggests, then the containment of woman and space within the realm of masculine ideas becomes much more problematic.

First, ideas are not given primacy, they do not simply imprint passive matter but rather are entailed or entwined with body-matter. Since ideas are crucially entailed with *female* body-matter, the idea of space can no longer be conceived of as entirely 'masculine'. Second, this body-matter is always already a writing – a corporeal text. As Derrida notes 'the contemporary biologist speaks of writing and *pro-gram* in relation to the most elementary processes of information within the living cell' (1974: 9). Body-matter is thus an active signifying substance, it is not simply the passive recipient of social constructions. And hence the passivity of space is by no means guaranteed

by its 'association' with female body-matter. Finally, this production, rather than containing and delimiting woman and/or space, actually opens the boundaries of both by intertwining them from the very beginning. So the body-model does not secure a clear boundary for notions of 'human' space; on the contrary, this 'comparison' of the female body and space profoundly complicates the identity of both terms. Such a confounding of discrete, containable identities indicates that revealing the sexualized nature of space does indeed have profound implications for how we view woman.

ACKNOWLEDGEMENTS

For their critical comments and invaluable suggestions for revision, I am indebted to Elizabeth Grosz and Vicki Kirby.

NOTES

1 Los Angeles has featured prominently in a number of writers' accounts of postmodernity: Edward Soja (1989), Jean Baudrillard (1983), Frederic Jameson (1984), to name just a few. However, the claim that Los Angeles is the capital-to-be of the twenty-first century is made by Anne Friedberg (1993: xi).
2 Stephen Hawking has argued that spacetime is finite but without a boundary (1988: 144).
3 For a more detailed discussion of the complexities of *chôra* see Elizabeth Grosz (1994).
4 Stephen Hawking states that: 'Space and time are now dynamic quantities: when a body moves, or a force acts, it affects the curvature of space and time – and in turn the structure of space-time affects the way in which bodies move and forces act' (1988: 36). This seems to correlate with what Lawrence Sklar presents as the 'substantival' theory of spacetime, as opposed to the 'relationist' theory of spacetime. He argues that the general theory of relativity, with its notion of '"dynamic" variable curved spacetime' (1977: 166), supports the 'super-substantivalist program' (1977: 214) rather than the relational theory of space. It should be emphasized that this theory of spacetime does not escape the Platonic framework. Sklar traces the lineage of the substantival theory of spacetime back to Plato:

> The view is not brand new . . . Plato perhaps, in the *Timaeus*, took *chora* or space as the 'matter' of the world, and there are some features of Descartes's 'plenum' view of space which again suggest the idea of space as the total 'stuff' of the world.
>
> (1977: 166)

5 See Terence Hawkes (1972: 1). He notes that 'the word *metaphor* comes from the Greek word *metaphora* derived from *meta* meaning "over", and *pherein*, "to carry"'.
6 On the comparative aspect of metaphor see G.E.R. Lloyd's discussion of analogy and metaphor (1987).
7 See Ricoeur's chapter, 'The Work of Resemblance' (1987: 173–215).
8 Marx's notion of 'equivalent value' is extremely useful for understanding how only one term of a binary opposition is given value (see 'The Value-Form, or Exchange-Value' (1976: 138–63)).

9 In Pierre Fontanier's taxonomy of figures, *Les figures du discours* (1830), this is defined as: 'presenting one idea under the sign of another that is more striking or better known' (Fontanier; cited in Ricoeur 1987: 59).

10 For example, Michèle Le Doeuff states that 'The sphere of influence of the gender-dichotomies created by philosophy is actually very limited' (1989: 114). Woman, or the metaphor of woman, is described as 'an available signifier, seized upon by philosophical discourse to pinpoint a difference' – man/woman becomes, for philosophy, 'validated/excluded' (Le Doeuff 1989: 115). However, she argues that 'women (real women) have no reason to be concerned by that femininity; we are constantly being confronted with that image, but we do not have to recognise ourselves in it' (Le Doeuff 1989: 116). So, unlike Irigaray, Le Doeuff does not see the metaphor of woman as constitutive of woman – it is an image external to woman. She is confronted by it but she can choose to reject it. Indeed these images seem to be conceived by Le Doeuff as mere 'ideology'. Le Doeuff states

> As soon as we regard this femininity as a fantasy-product of conflicts within a field of reason that has been assimilated to masculinity, we can no longer set any store by liberating its voice. We will not speak pidgin to please the colonialists.
>
> (1989: 116)

11 Irigaray states, in reference to Freud, that 'Woman herself is never at issue in these statements: the feminine is defined as the necessary complement to the operation of male sexuality, and, more often, as the negative image that provides male sexuality with an unfailing phallic self-representation' (1985b: 70). However, she goes on to state that

> Now Freud is describing an actual state of affairs. He does not invent female sexuality, nor male sexuality either for that matter. As a 'man of science', he merely accounts for them. The problem is that he fails to investigate the historical factors governing the data with which he is dealing.
>
> (1985b: 70)

12 Vicki Kirby (1991) has pointed out how this bracketing out of materiality, or the 'real body', operates in Jane Gallop's defence of Irigaray. This can also be seen in Margaret Whitford's defence of Irigaray. She argues:

> Although the terms 'male' and 'female' are sometimes used to refer to biological males and females, it is much more common to find the pair being used as a kind of basic and fundamental symbolism . . . [Irigaray makes] a connection between the morphology of the body and the morphology of different kinds of thought processes. It must not be assumed here that the body is the empirical body; symbolism (or representation) is selective; and it is clear from *Speculum* that Irigaray is talking about an 'ideal morphology', in which the relationship to anatomy is metaphorical, somewhat schematic, a 'symbolic interpretation of . . . anatomy'.
>
> (Whitford 1991: 58–9)

BIBLIOGRAPHY

Bachelard, G. (1969) *The Poetics of Space*, translated by M. Jolas. Boston, Mass.: Beacon Press.

Bal, M. (1988) *Death and Dissymmetry: The Politics of Coherence in the Book of Judges*. Chicago, Ill.: University of Chicago Press.

Baudrillard, J. (1983) 'The Precession of Simulacra', in *Simulations*, translated by P. Foss, P. Patton and P. Beitchman, New York: Semiotext(e): 1–79.

Bergren, A. (1992) 'Architecture Gender Philosophy', in J. Whiteman, J. Kipnis and R. Burdett (eds) *Strategies in Architectural Thinking*. Cambridge, Mass.: MIT Press.

Derrida, J. (1974) *Of Grammatology*, translated by G.C. Spivak. Baltimore, Md. and London: Johns Hopkins University Press.

Douglas, M. (1991) *Purity and Danger: An Analysis of the Concepts of Pollution and Taboo*. London: Routledge.

Fitzgerald, S.F. (1971) 'My Lost City', in A. Trachtenberg, P. Neill and P.C. Bunnell (eds) *The City: American Experience*. New York: Oxford University Press.

Friedberg, A. (1993) *Window Shopping: Cinema and the Postmodern*. Berkeley, Calif.: University of California Press.

Grosz, E. (1994) 'Woman, Chora, Dwelling', *New York Architecture*, January–February: 22–7.

Hawkes, T. (1972) *Metaphor*. London: Methuen.

Hawking, S.W. (1988) *A Brief History of Time*. London: Bantam.

Hegel, G.W.F. (1975) *Aesthetics: Lectures on Fine Art*, vol. 1, translated by T.M. Knox. Oxford: Oxford University Press.

Irigaray, L. (1985a) *Speculum of the Other Woman*, translated by G.C. Gill. Ithaca, NY: Cornell University Press.

—— (1985b) *This Sex Which Is Not One*, translated by C. Porter. Ithaca, NY: Cornell University Press.

—— (1987) 'Sexual Difference', in T. Moi (ed.) *French Feminist Thought: A Reader*. Oxford: Basil Blackwell.

—— (1988) 'Interview with Luce Irigaray: Paris, Summer 1980', in E. Hoffman Baruch and L.J. Serrano (eds) *Women Analyze Women: In France, England and the United States*. New York: New York University Press.

Jameson, F. (1984) 'Postmodernism, or the Cultural Logic of Late Capitalism', *New Left Review*, July–August: 53–91.

—— (1988) 'Cognitive Mapping', in C. Nelson and L. Grossberg (eds) *Marxism and the Interpretation of Culture*. London: Macmillan.

Jammer, M. (1968) 'The Concept of Space in Antiquity', in J.J.C. Smart (ed.) *Problems of Space and Time*. New York: Macmillan.

Kirby, V. (1991) '*Corpus delicti*: The Body at the Scene of Writing', in R. Diprose and R. Ferrell (eds) *Cartographies: Poststructuralism and the Mapping of Bodies and Spaces*. Sydney: Allen & Unwin.

Kofman, S. (1989) 'Ça cloche', translated by C. Kaplan, in H. Silverman (ed.) *Derrida and Deconstruction*. New York: Routledge.

Koolhaas, R. (1978) *Delirious New York: A Retroactive Manifesto for Manhattan*. London: Thames & Hudson.

Kristeva, J. (1984) *Revolution in Poetic Language*, translated by M. Waller. New York: Columbia University Press.

—— (1986) 'Women's Time', in T. Moi (ed.) *The Kristeva Reader*. Oxford: Basil Blackwell.

Le Doeuff, M. (1989) *The Philosophical Imaginary*, translated by C. Gordon. London: Athlone Press.

Lefebvre, H. (1991) *The Production of Space*, translated by D. Nicholson-Smith. Oxford: Basil Blackwell.

Lloyd, G. (1984) *The Man of Reason: 'Male' and 'Female' in Western Philosophy*. London: Methuen.

Lloyd, G.E.R. (1987) *Polarity and Analogy; Two Types of Argumentation in Early Greek Thought*. Bristol: Bristol Classical Press.

Lyotard, J.-F. (1989) 'Passages from *Le Mur du Pacifique*', translated by P.

Brochet, N. Royle and K. Woodward, in A. Benjamin (ed.) *The Lyotard Reader*. Oxford: Basil Blackwell.

Marx, K. (1976) *Capital: A Critique of Political Economy*, vol. 1, translated by B. Fowkes. Harmondsworth: Penguin.

Merchant, C. (1990) *The Death of Nature: Women, Ecology and the Scientific Revolution*. San Francisco, Calif.: Harper & Row.

Morris, M. (1988) 'Banality in Cultural Studies', *Block*, 14: 15–26.

Plato (1965) *Timaeus and Critias*, translated by D. Lee. Harmondsworth: Penguin.

Ricoeur, P. (1987) *The Rule of Metaphor: Multi-Disciplinary Studies in the Creation of Meaning*. London: Routledge & Kegan Paul.

Sklar, L. (1977) *Space, Time, and Spacetime*. Berkeley, Calif.: University of California Press.

Soja, E. (1989) *Postmodern Geographies: The Reassertion of Space in Critical Social Theory*. London: Verso.

Spivak, G.C. (1987) 'Displacement and the Discourse of Woman', in M. Krupnick (ed.) *Displacement: Derrida and After*. Bloomington, Ind.: Indiana University Press.

Warner, M. (1985) *Monuments and Maidens: The Allegory of the Female Form*. London: Picador.

Whitford, M. (1991) *Luce Irigaray: Philosophy in the Feminine*. London: Routledge.

11

THE JEWELS IN THE CROTCH
The imperial erotic in *The Raj Quartet*

Sabina Sawhney

In 100 years' time when men [*sic*] are wondering what India in the 1940s was like, they should read Mr Scott's quartet. It will not only describe events but, far more important, will give . . . a portrait of the real India in a way no formal history could.

<div align="right">(Daily Telegraph, 8 May 1977)</div>

For some of us working in the field of post-colonial studies, it is difficult (despite personal desires) to dismiss Paul Scott's *The Raj Quartet* (1976).[1] The reason for the difficulty does not lie in any claims that the *Quartet* may make on literary greatness. Rushdie's evaluation of the *Quartet* may err by being a tad too harsh, but it is, nevertheless, just:

In point of fact, I am not sure that Scott is so much finer an artist [than M.M. Kaye]. Like Kaye, he has an instinct for the cliché. Sadistic, bottom-flogging policeman Merrick turns out to be (surprise!) a closet homosexual. His grammar-school origins give him (what else?) a chip on the shoulder. And all around him is a galaxy of chinless wonders, regimental *grandes dames*, lushes, empty-headed blondes, silly asses, plucky young things, good sorts, bad eggs and Russian counts with eyepatches. The overall effect is rather like a literary version of Mulligatawny soup. It tries to taste Indian, but ends up being ultra-parochially British, only with too much pepper.

<div align="right">(Rushdie 1984: 124)</div>

So if *The Raj Quartet* is merely another version of the Blandings Castle, without the pig, the Earl and the humour, why should we sacrifice time and energy, not to mention the trees, in discussing it? After all, when Victoria Holt published *The India Fan* (1988) none of us felt any compulsion to report that it was merely a pot-boiler with very little to recommend it. Well for one thing, *The Raj Quartet* has not languished on the supermarket shelves; in fact, Rushdie's judgement seems to be totally at odds with the way the work has been received in Britain and in the United States. Unlike the film version of M.M. Kaye's *The Far Pavilions* which was televised in the United States on

one of the cable channels, *The Raj Quartet* (as *The Jewel in the Crown*, the title of the first novel in the quartet) made it to the Public Broadcasting System which, despite some detractors, is still widely accepted as an arbiter of good taste and literary values.

The *Daily Telegraph* was not alone in extolling its virtues. Francine Weinbaum, in her book on Paul Scott, refers approvingly to the *New York Times* article which declares that *The Jewel in the Crown* 'may be one of the finest novels about India . . . and will certainly be one of the finest novels of any kind' (1992: ix). The blurb on the jacket of *The Raj Quartet* (Scott 1976) has the eloquent testimony of the historian Max Beloff:

> Of those writers who have attempted to distill the last years of the British in India in fictional form, the most ambitious and the most successful is undoubtedly Mr Paul Scott. One cannot read Paul Scott's quartet of novels without being moved; and what is the sense of studying history if it is not to move one and to widen one's moral sensibilities? His achievement is on any count a major one.

While these influential tributes and the widespread public acclaim may be overlooked as belonging merely within the raj nostalgia mode, I believe it is necessary to understand and question the manner in which this nostalgia is orchestrated.[2] Praise for the *Quartet* originates from two basic considerations. One, that the novels transcend the category of fiction by providing us with a truthful account of history; and, two, that this history is very well balanced since the *Quartet* deals with the empire through the lens of anti-imperialism.

Let us consider the two points in order. While *The Raj Quartet* may cater to the nostalgia for lost empires, what disturbs me more is the easy acceptance of Scott's work as fictionalized history. And on this issue one has to tread carefully. One does not require the big guns in order to shoot down the newspaper reviewers and their vapid understanding of history. Scott's version of India in the 1940s (which the reviewers adopt uncritically) seems to be populated almost exclusively by the British, with the Indians existing merely as unsubstantial wraiths. While it is true that this monocular vision reinforces the Western European and North American prejudices of the relative import-ance of various peoples, it is also true that knowledge of this prejudice does not come as a startling revelation. So what else is new?

I think it is important to consider why a work of fiction is praised for being historically accurate. That is to say when literature blurs the lines between history and fiction, the result is not merely in one direction: better fiction. The impact on our understanding of history must also be evaluated. The aesthetic appreciation which informs the response to *The Raj Quartet* does not occur in a vacuum; it engages in an active redefinition of the past. However, most literary texts with historical themes engage in this process of redefining the past. What I want to emphasize is that the reception of Paul Scott's work forces the scholars in post-coloniality to confront history as an

open-ended enterprise, to see, as Homi Bhabha puts it, 'the process of history engaged, rather like art, in a negotiation of the framing and naming of social reality' (Bhabha 1992: 144). In other words, what are the attractions in Scott's framing of reality and his redefinition of the imperial past, such that his work has been embraced so wholeheartedly?

And this leads me to the second point: if the version of history that Scott proposes is anti-imperialist, why must we – the workers in the field of post-coloniality – cavil at it? In order to attempt a response to both questions one must first comprehend the basis of anti-imperialism in *The Raj Quartet*. The first novel in the quartet, *The Jewel in the Crown*, announces the theme in the opening pages:

> This is the story of a rape, of the events that led up to it and followed it and of the place in which it happened. There are the action, the people, and the place; all of which are interrelated but in their totality in-communicable in isolation from the moral continuum of human affairs.
>
> (Scott 1966:1)

Set in north-west India, and spanning the period from the Quit India Resolution (1942) to independence (1947), the four novels then proceed to elaborate on this theme, delineate the interrelationships and spell out the moral continuum.

Daphne Manners, niece of a former Governor-General, is gang-raped by six hoodlums in the Bibighar Gardens, just after she has consummated her affair with Hari Kumar. The district superintendent of police, Ronald Merrick, arrests Kumar on the charge of masterminding the gang-rape, and despite the lack of evidence (Daphne refuses to testify, fearing that any testimony will inevitably be misunderstood and may be used to accuse her lover) incarcerates Hari Kumar on a trumped-up political charge for an indefinite period. During Hari Kumar's interrogation, Merrick forges a sado-masochistic relationship with his prisoner through physical and psychological torture. These two events – the assault on Daphne Manners by six hoodlums and Hari Kumar's violation by Merrick – are the referents to the 'rape' with which the story begins. And the two events also form an insuperable obstacle to the union of Daphne and Hari Kumar; Daphne dies later in childbirth and Kumar is released after a number of years to a life of poverty and obscurity.

The significance of these events, however, resonates beyond the literal. In one of his diary entries, Scott outlines the motif of the quartet: 'Loosely the theme is to do with what I call the Indian/English love affair' (cited in Hannah 1992: 158). Daphne Manners and Hari Kumar are more than just a British woman and an Indian man; they stand for Britain and India respectively. And the colonial experience is, thus, depicted in Scott's work as a love affair between the two, rudely disrupted by Indian hoodlums and the British police. Or as Scott explains in the opening page, India and Britain were 'locked in an imperial embrace of such long standing and subtlety it was no longer

possible for them to know whether they hated or loved one another (1966: 1). Paul Scott attempts a revision of the colonial experience by figuring it in terms of an ambivalent embrace – a finessing of history that proves to be very popular among the imperial and the post-imperial nations and rather galling to the post-colonial countries. The different responses are not merely a result of different cultures misunderstanding and misinterpreting each other, but instead suggest the opposing objectives of the ex-colonizers and the ex-colonized. Both need to reinterpret the past in a manner that is most conducive to their future goals. For the colonizers, it is important to cloak the worst excesses of colonialism in a haze of romance, while for the colonized it is just as necessary to discount any evidence of their past complicity in the colonial adventure. *The Raj Quartet* caters extensively to the needs of the ex-colonizers and hence establishes its position as a distinguished piece of work with ease.

The stage is peopled mostly by the British who take their colonial mission very solemnly. The 'good sorts' and the 'plucky young things' as well as the Russian count with an eyepatch have all manfully shouldered the 'white man's burden'. They seem at times to manifest a certain scrubby-faced earnestness about their duty to civilize and educate the heathens. Paternal or maternal benevolence, depending on their gender, oozes out of their very pores. When Miss Crane, a missionary, is disturbed by twinges of self-doubt about the impact of her efforts, she realizes 'that the only excuse she or anyone of her kind had to be there . . . was if they sat there conscious of a duty to promote the cause of human dignity and happiness' (Scott 1966: 16). Both Miss Crane and her superior, Mr Cleghorn, an ordained member of the church, recognize and obey the missionary imperative: 'To teach English and at the same time love of the English' (ibid.: 19). Tutoring Indians in ways to love the English may sound rather risible; it was, however, a strategy that was essential for the success of the colonial mission.[3] On the one hand, the missionary seduction enabled contact with a large group of people whose love for the English transformed them into willing consumers of British goods, thus accomplishing one of the main economic goals of colonialism. And on the other hand, this training-in-love happily contributed to the practices of subjection – implicit in the colonial enterprise – through a minimal use of the coercive apparatus of the imperial state.

Reflecting on the character of Mr Cleghorn, Miss Crane muses: 'he was a good man: tireless, inquisitive, charitable. Mohammedanism and Hinduism, which still frightened her in their outward manifestations, merely amused him: as a grown man might be amused by the grim, colourful but harmless games of children' (ibid.: 20). This infantilization of the Indians and the Indian culture is reinforced by the deadly seriousness with which the British accepted their role as 'ma-bap' (mother-father) to the Indians who were subordinate to them. It is, in fact, one of the Indians, who expresses his admiration for the way in which the British discharged their obligations. In one of the many flash-

forwards, in 1964 Mr Srinivasan is reminiscing about the British raj and the Deputy Commissioner of Mayapore, Robin White:

> It was not until I came into the club with Desai and the Minister and Mr. White that I really understood what it was that men like Robin White stood for, stood for against all narrow opposition. . . . I saw then how well he *fitted* the club. How well the club fitted him. Like him, it had no expression that you could easily analyse. It was shabby and comfortable. But rather awe-inspiring In the club, in the smoking-room to be exact, for the first time I saw the face behind the face of Robin White. It seemed to go awfully well with the shabby leather chairs that looked forbidding but turned out to be amazingly comfortable to sit on. And Robin, you know, *looked* at the servants when he spoke to them. . . . He did not feel superior to them, only more responsible for them. It was his sense of responsibility that enabled him to accept his privileged position with dignity. That is always the kind of attitude that makes for confidence.
>
> <div align="right">(Scott 1966: 185)</div>

Of course, those of us who quibble that this 'privilege' and 'responsibility' were used to dominate a whole country, exploit its resources and deny it freedom, have just been unable to see the real face, the face behind the forbidding exterior. I wonder if this had something to do with the fact that the club was not open to Indians, unless they were accompanied and vouched for by a Deputy Commissioner?

Mr Srinivasan's recollections, however, attest to the success with which the civil branch of the imperial British state supplemented the efforts of the missionaries. He has certainly 'learned the love of the English' such that his infatuation compels him to forget the segregated situation, the condition of Indians in constant servitude to the British, and lets him dwell fondly on Robin White's look of responsible paternalism at the club attendants. The scandal of this servitude, whereby all the nationals of one country are made to serve the interests of another, is explained away by this display of the Deputy Commissioner's rectitude. As Memmi explains in *The Colonizer and the Colonized*,

> [T]he colonized could be only grateful to him [the colonialist] for softening what is coming to him. It is here that the astonishing mental attitude called 'paternalistic' comes into play. A paternalist is one who wants to stretch racism and inequality farther – once admitted. It is, if you like, a charitable racism – which is not thereby less skilful nor less profitable.
>
> <div align="right">(1967: 76)</div>

Another Indian character in the quartet, Sir Ahmed Akbar, who belongs to the Congress Party and hence is politically opposed to the British rule,

determines that the only crime that the British may be accused of is one of 'sincerity'. He reaches this conclusion while he is imprisoned for his support of the leaders of the Congress Party and explains his analysis of the different characters of the British and the Indians thus: 'we are the hypocrites because we have lived too long as a subject people to remember what sincerity means, or to know from one day to the next what we believe in' (Scott 1968: 62). Through the character and utterances of Sir Ahmed and Mr Srinivasan, Paul Scott seems to be suggesting that the blame for the failure of the colonial adventure lies with the Indians who were somehow unable to appreciate the raj. If only the Indian masses had understood the underlying purpose of colonialism! Then they would not have rebelled against this rule, would not, in Scott's version, have expressed their hatred by attacking English woman-hood. And if only there were no 'bad eggs' such as Ronald Merrick who represent the worst sorts of Englishmen – the ones who get their jollies by oppressing and torturing the darkies, and thus bring the whole institution of imperialism into disrepute. It was not the fault of the experience itself or of the 'sincere' British who were engaged in the colonial adventure that the Indians, by deciding to fight for their independence, insisted that the earth did not move for them.

> The expansion of Europe was not only a matter of 'Christianity and commerce', it was also a matter of copulation and concubinage.
>
> (Hyam 1990)

While the representation of colonialism as a romance is neither new nor particularly inventive, Scott does manage to add some interesting twists to the situation. The traditional view which conceived the colony in terms of an exotic femininity had been used to great effect in the nineteenth century to fire the imagination of the lusty Britons. Rider Haggard, for instance, in *King Solomon's Mines*, renders his narrator speechless at the sight of 'Sheba's breasts', two enormous mountains

> shaped exactly like a woman's breasts. Their bases swelled gently up from the plain, looking . . . perfectly round and smooth; and on the top of each was a vast, round hillock covered with snow, exactly corresponding to the nipple on the female breast.
>
> (1989: 85)

Portraying the landscape as virgin territory waiting to be conquered and exploited is a fairly old trick; it incites men to display their potent virility. But this old trick gets a new lease of life within the paradigms that retell the stories of colonial intimacies. The colonizers are inevitably represented as male and the colonized territories as female in a manner which encourages the viewing of the colonial adventure as an intriguing liaison. Conflating femininity and mystery, the colonized space began to take on the features of

an exotic woman. Equating the geography of the female body with the landscape of the colony provided a facile metaphorical access that enabled both penetration and control. As Said explains, the 'cultural, temporal and geographic distance was expressed in metaphors of depth, secrecy, and sexual promise: phrases like "the veils of an Eastern bride" . . . passed into the common language' (1978: 222). In short, the Orientalist tradition transmuted the colony into a 'sexy body'.[4]

In her discussion of the painting, *The Jewel in Her Crown* – which lends its title to the first novel of the quartet, and which depicts Queen Victoria being handed a large jewel (representing India) by Prime Minister Disraeli – Jenny Sharpe points out that the 'picture draws on Renaissance personifications of Asia as an exotic woman possessing the rare perfumes, precious stones, fine silks, and spices that Europe desired' (1993: 149). The image of India as an exotic, dusky maiden, richly laden with treasures, waiting to be bagged as part of the spoils, may, in part, explain the innumerable sexual adventures of the British in India. Captain Edward Sellon, for instance, in India during the mid-nineteenth century, writes:

> I now commenced a regular course of fucking with native women. They understand in perfection all the arts and wiles of love, are capable of gratifying any tastes, and in face and figure they are unsurpassed by any women in the world. . . . It is impossible to describe the enjoyment I experienced in the arms of these syrens. . . these salacious, succulent houris of the far [*sic*] East.
>
> (cited in Hyam 1990: 42)

Said refers to the latent Orientalism apparent in the writings of travellers and novelists in which 'women are usually the creatures of a male power-fantasy. They express unlimited sensuality, they are more or less stupid, and above all they are willing' (1978: 207). In fact, as Hyam indicates, the administrators, in the early days of the Indian empire, encouraged the possession of 'sleeping dictionaries', or native mistresses (1990: 115).[5] Whether this led to any appreciable improvement in their linguistic abilities is certainly open to question; the fact that many of the British fornicated their way across India has now been well established.

The sexualization of Britain's encounter with the colonies – and Scott's later romanticization of the same – may be due to a desire to keep the violence under covers. *The Raj Quartet* attempts to represent what was an inherently unequal and exploitative relationship as one that was primarily motivated by dictates of the heart. In this formulation romance figures as a justificatory gimmick: it legitimizes the rule of power and domination, and contrives to camouflage the abhorrent aspects of that rule. One of the enduring myths about the origins of colonial conquest in India may help in understanding some aspects of this romance. According to this account, in the sixteenth century the dress of a princess, Jahanara Begum, caught fire. A very proper

sense of modesty kept her from crying aloud for help, and so she suffered terrible burns. (Probably the knowledge that she would be spending the rest of her life in purdah influenced her decision. The burn marks would not show, after all.) The same sense of modesty proved to be an obstacle for either a proper diagnosis or prescriptions for her inflamed condition. When the poor girl seemed to be in danger of dying of her burns, the emperor sent to the British merchant adventurers of the East India Company to ask if western medicine might prove to be more useful. The English doctor, a veritable miracle-maker, was able to effect a cure immediately, thus placing the emperor in his debt. Upon being asked to name his price, the doctor (in time-honoured medical tradition) asked for the country. Well, he actually asked for permission to trade and for the East India Company to set up a trading settlement in the Mughal empire, which eventually grew to be the British raj.

The basis of the British Empire, thus, grew out of the most admirable motivations: to save the native, Indian woman. This element of romance was kept determinedly alive in the many Empire Day and Christmas Day broadcasts of the British Broadcasting System in the early twentieth century. (In the late twentieth century, this responsibility seems to be shared equally between the BBC and the PBS.) The Empire Youth Movement, for instance, founded by Major Frederick Ney in the 1930s, stressed the symbolism of chivalry in all its activities and publications. In fact, Ney suggested that 'youth would always be romantic and Empire appealed to the innate romanticism and love of adventure of the young' (cited in MacKenzie 1986: 174). The Empire Day Movement organized annual Festivals of Empire, which were faithfully broadcast by the BBC. One of the programmes, entitled 'The Vigil', was described as follows:

> [i]n which the Soul of the Empire dedicates itself anew to the Service of God and Mankind and prepares for the Great Crusade against the forces of Evil. A knight in shining armour is seen kneeling before an altar – sword uplifted – eyes directed to the Great Beyond. While he kneels and prays men and women from every walk of life gather behind him expectantly awaiting a signal. After some moments the knight rises and proceeds to move down the hall signalling to others to follow. Later he again signals and they come on faster and faster, finally passing on with him to the great adventure.
>
> (cited in ibid.: 176)

I suppose one could point out that this marvellous chivalric adventure was meant to attract the younger sons and other superfluities in England. One could also point out that the chivalry somehow transformed itself into its opposite on the passage from England to the colonies. And to carry this exercise further, one could refer to the relationship between a British colonialist and his Indian mistress. Her servitude included her perpetual availability as a sexual object; her masters participated in the sex trade in

order to gain ownership of her body. One could also refer to the care with which the military authorities provided facilities for the sexual satisfaction of the British soldiers in India – the regulation of the lock-hospitals, adequate provision of brothels, the rise in sex trade and prostitution and so on. And we do have recorded instances of the 'knights' occasionally beating their 'sleeping dictionaries'.[6] But enough – shooting fish in a barrel has never been a particular sport of mine.

The Raj Quartet gestures towards some of these issues, but in a manner that undercuts their purport. For instance, in one of the journal entries addressed eventually to her aunt, Daphne Manners conflates the figure of India with the character of Lili Chatterjee, a regal Rajput woman, and compares them both with herself. Trying to make sense of her own horrific experience, Manners extends the meaning of 'rape' in order to include the British/Indian relationship within its ambit:

> There is that old, disreputable saying, isn't there? 'When rape is inevitable, lie back and enjoy it.' *Well there has been more than one rape.* I can't say, Auntie, that I lay back and enjoyed mine. But Lili was trying to lie back and enjoy what we have done to her country. I don't mean done in malice. Perhaps there was love. Oh, somewhere in the past, and now, and in the future, love as there was between me and Hari. But the spoilers are always there, aren't they?
>
> <div align="right">(Scott 1966: 434; emphasis in original)</div>

In her discussion of this passage, Jenny Sharpe directs our attention to the fact that despite the initial attempt to draw a parallel between herself and India, Manners finally emphasizes the differences by pointing out the dissimilarity in the responses. That is, what Lili, as India, could try and enjoy, Daphne, as an Englishwoman, never could, thus 'negat[ing] the possibility of a similar violation' (Sharpe 1993: 155). The fact of the matter is that Lili Chatterjee, as a representative of the native elites, the small but significant group that benefited most through collaboration with British imperialists, would probably describe her experiences very differently from those Indians who were not members of this class. In other words, Lili Chatterjee's role in *The Raj Quartet* as the sole representative for the vast majority of Indian women seems highly problematic.

For my argument, however, the most significant aspect of this passage is the compare and contrast exercise performed by Paul Scott's work. On the one hand, within the British/Indian relationship, in which the British figure as emblems of masculinity and Indians connote femininity, the dividing line between rape and romance seems so fuzzy that occasionally it may be erased with impunity. On the other hand, however, within the Indian/British relationship in which Daphne Manners symbolizes British womanhood and the band of raping peasants stand in for India, the rape admits of no ambiguity. If we accept the premise on which the *Quartet* is based and to

which Daphne Manners gives concrete expression – that between India and England 'there was love. Oh, somewhere in the past, and now, and in the future' – then we must grant the Indian gang-rapers a similar justification. Maybe it was desire and love for the British woman that motivated their assault! The moronic idiocy of this argument which attempts to excuse a flagrant assault is obvious to all of us.[7]

Furthermore, this passage merely reinforces the major thematic concerns of revisionist imperialism. Faced with the detritus of the colonial experience, the blame is laid on the 'spoilers' who ruined a perfectly good romance. Additional proof about this romance is presented through further letter/ journal entries in The Raj Quartet. I wonder how B.R. Ambedkar – the architect of the Indian Constitution – would have responded to the following description of this document:

> Won't that constitution be a sort of love-letter to the English – the kind an abandoned lover writes when the affair has ended in what passes at the time as civilized and dignified mutual recognition of incompatibility? In a world grown suddenly dull because the beloved, thank god, has gone, . . . you attempt to recapture, don't you, the moments of significant pleasure – which may not have been mutual at all, but anyway existed.

(Scott 1966: 447)

This is in a letter written by Ethel Manners, Daphne's aunt and a Governor General's widow, to Lili Chatterjee in 1948. It is a truly amazing statement in that it refigures independence and freedom from foreign rule as abandonment and betrayal by a lover. The representation of British/Indian relationship in these terms augments the powerlessness of the Indians: captivated by the British, they are now forsaken by them, leaving them no recourse but to follow the traditional course of women who have lost their innocence to perfidious Don Juans. Hence the Constitution is a coded love-letter referring to moments of pleasure, a dwelling upon the past that simultaneously exacerbates and soothes the wound.[8]

Ethel Manners' letter is also particularly noteworthy because it encapsulates the strategic mode of The Raj Quartet. The novels in the quartet, like most of the nineteenth- and early twentieth-century novels of colonialism, are based on a reaffirmation of the positive aspects of imperialism.[9] Paul Scott, however, is more ingenious for his work demonstrates a brilliant ventriloquism: in The Raj Quartet it is the colonized natives, judging according to the western value systems, who acknowledge the motives underlying imperialism as praiseworthy. The ethos of imperialism is thus given adequate expression and is eventually endorsed by those who were its primary victims. Manners' letter which interprets the Indian Constitution as a last-ditch courtship attempt repeats the ventriloquism. Her rhetorical strategy, 'you attempt to recapture, don't you, the moments of significant

pleasure', transparently shifts the burden of her inferences on to her reader. The colonial Other thus echoes the sentiments that would enable the ex-colonizers to sanction the project of colonization.

This sanctioning of the imperial adventure as a misguided exercise in excessive sentimentality is further reinforced in *The Raj Quartet*. The so-called romance between England and India apparently proceeded with full observance paid to all the customary rituals and norms. It was an illicit love-affair, filled with stolen moments of pleasure, along with the guilty letters masquerading as documents of governance. But where Ethel Manners sees the Constitution as a forlorn attempt by the bereft Indians to seek just one more opportunity to connect with the British, Lili Chatterjee sees it as a special licence for an eloping couple:

> I have a feeling that when it was written into our constitution that we should be a secular state we finally put the lid on our Indianness, and admitted the *legality* of our long years of living in sin with the English. Our so-called independence was rather like a shot-gun wedding.
>
> (Scott 1966: 68)

According to this assertion, the structure of colonialism follows the structure of the majority of popular romances in modern India: religion presents the only barrier to a true union of hearts. Where the Christian missionaries were only able to seduce, the Utilitarians, however, with their message of secularism, ratified the affair and countered the necessity for a flight to Gretna Green. It is difficult not to marvel at such admirable native informants.

Accepting this metaphorical conceit, one would have thought that independence was, if anything, a divorce, with the abused woman finally asserting her right to autonomy and to existence without foreign, male oppression. Be that as it may, *The Raj Quartet* further confuses the issue. Alongside the romance in which India figures as the hapless female, Paul Scott authorizes another, similar romance, except that in this case the gendered relationships are inverted. In the second version it is the Indian man, Hari Kumar, and the British woman, Daphne Manners, who enact the romantic story of colonialism. Well, maybe that's not quite true, for Hari Kumar is not quite an Indian. Taken as a child to England, brought up there exclusively, educated in the best public schools, Kumar identifies completely with the British. It is only his colour that marks him out; he perfectly embodies Macaulay's vision to form a 'class of persons, Indian in blood and colour, but English in taste, in opinions, in morals, and in intellect' (1972: 242). Hari Kumar is even further up the evolutionary scale than Lili Chatterjee! And it is to the credit of Paul Scott's humanism that this 'blood and colour' do not pose any insuperable obstacle to the union between Hari Kumar and Daphne Manners. In fact it is the people who focus only on the colour who are the villains in this melodrama. Ronald Merrick, for instance, declares: 'That's the oldest trick

in the game, to say that colour doesn't matter. It does matter. It's basic. It matters like hell' (Scott 1966: 391).

In fact, there really isn't anything very strange about the union of Daphne and Hari. His position, his character, his inability to pronounce his own name,[10] provide the best alibi for the British conquest of India. One could have pointed to him with pride and declared, à la Galatea, that Hari Kumar represented the end result of all British efforts. The British endeavour to fashion and carve the 'natives' in accordance with their own self-image was rewarded beyond their expectations in the figure of Hari Kumar. And it is only those people – too narrow-minded to appreciate the noble mission of imperialism – who are upset by the attraction of a Pygmalion for a Galatea and who violate this naturalized British subject. This violation, in which Hari Kumar figures as the sexual object for Merrick's sadism, aligns the 'Indian' male with the female raped victim. Naked and bound to a trestle table, whipped and caned by Merrick and his subordinates, Kumar finally reveals: 'He [Merrick] had his hands between my legs at the time' (Scott 1968: 291).

Both Daphne Manners and Hari Kumar suffer sexual violations; according to the perspective provided by the *The Raj Quartet* the real victims of colonialism are the British and the British at heart. Casting Ronald Merrick – a sadistic homosexual – as a spoiler enables Paul Scott to reaffirm the heterosexual masculine ethos of imperialism. The Victorian ideals of manliness – proved by the intensely virile heterosexuality of the colonizers – are thus given a further lease of life in the novels of the quartet.

Ronald Merrick's villainy, however, is not simply due to an imagined relationship between a 'deviant' sexual preference and general wickedness, but is significantly influenced by his homosexuality. It is precisely because of his homosexuality that Ronald Merrick is unable to appreciate the worth of a Hari Kumar within the larger structure of imperialism. Colonization, as Leroy-Beaulieu explains,

> is the expansive force of a people; it is its power of reproduction; it is its enlargement and multiplication through space; it is the subjection of the universe or a vast part of it to that people's language, customs, ideas, and laws.

(cited in Said 1978: 219)

Hari Kumar, thus, is the embodiment of this self-procreation of a virile society – reproduced by the British in their own image. He owes his existence, as a black Englishman, to the expansive force of the British society which penetrates and inseminates the colonies with its 'language, customs, ideas, and laws'. Merrick's problem, within this schema, is his inability to distinguish the 'true sons of the empire' from all the rest. He tars the unredeemed gang-raping peasants and the lovable Hari Kumar with the same brush, unfit perhaps to appreciate the paternal aspect of the British raj. Merrick, in fact, believes that 'the English admiration for the martial and faithful servant [was]

a mixture of perverted sexuality and feudal arrogance' (Scott 1968: 299). Hence, Merrick, both literally and symbolically, is incompetent to perform the role of 'ma-bap' to colonized Indians.

> Hindu women seem depressed to the outsider, but a closer gaze reveals that they have their compensations.
>
> (Lowell, 1930)

Thus, Scott's double narrative presents two types of villains: the Indian peasants who assaulted Daphne Manners and Ronald Merrick who violates Hari Kumar. This group represents the majority of Indian men and the odd British homosexual, people who might have reasons to object to the love affair between India and Britain. The ingenuity of inverting the genders in the literal love story terminates, in advance, any necessity to deal with the subaltern Indian woman, who was, more often than the Indian man, the literal object of British sexuality. Remote from the worlds of the Lili Chatterjees and the emasculated Hari Kumars, this woman haunts the discourse of the four novels – not so much by her absence as by her tantalizingly meagre presence.

Despite the fact that she emerges only occasionally as an unnamed, bit player in this panoramic version of 'Indian History', her appearance never-theless raises complications which Scott prefers to ignore. The prologue to *The Day of the Scorpion*, the second novel of the quartet, is one of the few places where the narrator appears in the persona of the writer himself, and he describes his encounter with an unknown Indian woman:

> The writer encountered a Muslim woman once in a narrow street. . . . The feeling he had was that she was coming in search of a loan. She wore the *burkha*, that unhygienic head-to-toe covering that turns a woman into a walking symbol of inefficient civic refuse collection and leaves you without even an impression of her eyes behind the slits she watches the gay world through, tempted but not tempting; a garment in all probability inflaming to her passions but chilling to her expectations of having them satisfied. Pity her for the titillation she must suffer.
>
> After she passed there was a smell of Chanel No.5, which suggested that she needed money because she liked expensive things . . . drench-ing herself with a scent she did not realize was also one of public invitation.
>
> (Scott 1968: 1)

Speculation about her goal provides the narrative strategy to acquaint the reader with the map of the town. In effect that woman becomes our silent, suffering guide through the novel, as the initial story of *The Jewel in the Crown* is further elaborated. The narrator, of course, cannot help but be profoundly sorry for this woman who is dressed in what seems to him to be a garbage bag, and who, presumably, has to exercise a strong measure of

self-control not to give in to the temptations represented – I guess – by the narrator! It does not quite seem cricket, more like hitting a man when he is down, to point out that any 'titillations' in this encounter must be suffered by the narrator, and that he is exhibiting the classic symptoms of projection.

This encounter performs, in terms of neocolonial structures, what the adventure novel of the empire has already enacted. In other words, it is still the woman's fault. Just as the British imperialists of yesteryears were impelled towards colonial domination, helplessly seduced by the hot-blooded Indian women suffering the pangs of forbidden love, so too are their present-day counterparts. The writers of the empire whose work reinscribes the colonial forms of knowledge, justifying and continuing imperialism in the arena of ideas, are also the victims of native women. Juiced up on a potent brew of sexual arousal and pity, the narrator of *The Raj Quartet* proceeds to explain again the need and advantages of a good imperialism.

Robin White, the 'good imperialist', understands his duty through a somewhat similar set of circumstances. He credits his virtue to the following experience:

> [o]ne day, I remember it clearly, I was touring the district with the land settlement officer, going from village to village. On horseback, old style. I was fed to the teeth with village accountants who cringed and tahsildars who presumed and cringed all in the same breath, and I was critical of the settlement officer. . . . We were bogged down in some god-forsaken village and had to spend the night in a mud-hut. I was ready to cry from frustration and from my own sense of inadequacy. . . . My bowels were in a terrible state and I couldn't face anything. I was lying on a charpoy, without a mosquito net and suddenly saw this middle-aged Indian woman standing in the doorway watching me. . . . [S]he came to the bedside and spooned out a helping of curds and held it out and made me eat. . . . She said nothing and I couldn't even look at her. . . . I felt that I had been given back my humanity, by a nondescript, middle-aged Indian woman. I felt that the curds and flowers were for affection, not tribute, . . . [and] the suggestion that my indisposition could be overcome easily enough once I'd learned I'd no real enemies. . . . I felt it coming from them [the Indian villagers] – the good wish, the challenge to do well by them and by myself.
>
> (Scott 1966: 323–4)

Apparently Paul Scott himself underwent a similar experience while he was touring India in order to gather material for his novels. Considering Scott's acknowledgement that this experience significantly modulated his approach to *The Raj Quartet* (in Weinbaum 1981: 87), I do think that Indian woman with the curds has a lot to answer for. The import of this adventure is, I trust, not lost on anybody – it dovetails very neatly with the strategy of the *Quartet* and places the onus of responsibility on the unknown Indian woman. If it is

not her sexual charms, then it is the siren call of her affections that has lured the British male to hazard the perilous conditions in India in order to do well by her. Both Robin White and Paul Scott happily interpret this adventure to enhance their sense of self and pat themselves on the back. There seems to be no room for doubt in their minds that the offering of the food may be due to causes other than the ones they have assumed. The silence of the woman poses no constraints to their imaginations. Both of these passages, delineating the narrator's encounter in *The Day of the Scorpion*, and Robin White's meeting with an Indian woman, demonstrate the manner in which neocolonial forms of knowledge appropriate the Other.

The success of *The Raj Quartet* is, hence, perhaps not very surprising. Colonial modes of discourse have displayed an amazing persistence and tenacity, especially when they are allied to a notion of the imperial erotic. Paul Scott's representation of romance and rape under the aegis of the British raj attempts to manage the discomfort and guilt at the heart of the colonial adventure, but it does so by faithfully following the paradigms of imperialism. The anxieties of the empire are obscured through a facile conflation of race and body, which merely asserts the old truths regarding the worth of an imperial, heterosexual masculinity.

NOTES

1 *The Jewel in the Crown* (1966), *The Day of the Scorpion* (1968), *The Towers of Silence* (1971) and *A Division of the Spoils* (1975) are the four novels of the quartet.
2 A number of critics have pointed out the deleterious effects of the Raj nostalgia which encouraged support for the Falklands War and the bombing of Libya.
3 One of the methods employed in order to facilitate this 'love of the English' was the British policy of retiring its colonial administrators at the age of 55. This ensured that the 'natives' would not be presented with the image of the ageing and wrinkled British men – which might have led to serious obstacles in the facilitation of the colonial romance.
4 This tradition had its inevitable effect on the Indian nationalists as well. In one of his speeches, Nehru described Indian colonialism through the, by now, familiar metaphors of sexuality and rape:

> They seized her body and possessed her, but it was a possession of violence. They did not know her or try to know her. They never looked into her eyes, for theirs were averted and hers cast down through shame and humiliation.
>
> (cited in Suleri 1992: 17)

5 Of course Hyam also admits that: 'The world as a whole cannot be said to be worse off for the sexual activity of the British in their empire'(1990: 215). I guess that conclusion depends on your point of view, based on your national and gender identity.
6 Kenneth Ballhatchet (1980) details the centres in which 'State-Licensed Harlotry' were established by the British government in the Indian empire. In his chapter on 'Upper-Class Morals and Racial Prestige', Ballhatchet refers to the incidents of mistress-beating by British civil and medical officers (see especially pp. 144–5).

7 At this point I would like to clarify that I am not arguing against the existence of such desire, merely against its use as a justification for abuse.

8 I am not denying the influence of the British parliamentary system on the Indian Constitution. The signing of independence at a particular moment in time does not, miraculously, do away with centuries of subjugation; a complete break is neither possible, nor even desirable. One does not come to terms with the past by wiping the slate clean and pretending that the ghosts of the once-vanquished past will never return to haunt us. But that is different from what Ethel Manners seems to be suggesting, that the very writing of the Constitution is a futile attempt to communicate with the British, thus casting a haze of romantic yearning over the whole enterprise.

9 In this connection the novels and tales of Kipling, Haggard, Flora Annie Steele, G.A. Henty and John Buchan come to mind. These writings, along with those by a host of other minor writers such as Henry Newbolt and A.E.W. Mason, played their part with enthusiasm in energizing and validating the myth of the empire.

10 Hari Kumar refers to himself as Harry Coomer – the Anglicized pronunciation of his name.

BIBLIOGRAPHY

Ballhatchet, Kenneth (1980) *Race, Sex and Class Under the Raj*. New York: St Martin's Press.

Bhabha, Homi (1992) 'The World and the Home', *Social Text*, 31–2.

Haggard, H. Rider (1989) *King Solomon's Mines*. Oxford: Oxford University Press.

Hannah, Donald (1992) '"Dirty Transcripts and Very Dirty Transcripts"', *Journal of Commonwealth Literatures*, XXVII, 2.

Holt, Victoria (1988) *The India Fan*. New York: Ballantine Books.

Hyam, Ronald (1990) *Empire and Sexuality*. Manchester: Manchester University Press.

Lowell, Thomas (1930) *India, Land of the Black Pagoda*. New York: Century Company.

Macaulay, Thomas Babington (1972) 'Minute on Indian Education', in J. Clive (ed.) *Selected Writings*. Chicago, Ill.: University of Chicago Press.

MacKenzie, John (1986) '"In Touch With the Infinite": The BBC and The Empire', in J. MacKenzie (ed.) *Imperialism and Popular Culture*. Manchester: Manchester University Press.

Memmi, Albert (1967) *The Colonizer and the Colonized*. Boston, Mass.: Beacon Press.

Rushdie, Salman (1984) 'Outside the Whale', *Granta*, 11.

Said, Edward (1978) *Orientalism*. New York: Vintage Books.

Scott, Paul (1966) *The Jewel in the Crown*. New York: William Morrow.

—— (1968) *The Day of the Scorpion*. New York: William Morrow.

—— (1971) *The Towers of Silence*. New York: William Morrow.

—— (1975) *A Division of the Spoils*. New York: William Morrow.

—— (1976) *The Raj Quartet*. New York: William Morrow.

Sharpe, Jenny (1993) *Allegories of Empire*. Minneapolis, Minn.: University of Minnesota Press.

Suleri, Sara (1992) *The Rhetoric of English India*. Chicago, Ill.: Chicago University Press.

Weinbaum, Francine (1981) 'Psychological Defenses and Thwarted Union in *The Raj Quartet*', *Literature and Psychology*, 31.

—— (1992) *Paul Scott: A Critical Study*. Austin, Tex.: University of Texas Press.

12

GIRLS ON A WIRED SCREEN
Cavani's cinema and lesbian s/m

Chantal Nadeau

While I was preparing this essay, it struck me that some films become memorable because they are released at a bad time, in the wrong place. Liliana Cavani's *The Berlin Affair* is the perfect example of a movie that hit the screen eight years too soon. If *The Berlin Affair* had been shown now rather than in 1986, it would have benefited from the sapphic attractiveness that has spread through TV series, cinema and magazines during the last two years . . . for better or for worse. For example, looking at the most accessible film for a lesbian reading directed by Cavani, *The Berlin Affair*, one is surprised by the very 1990s chicness of its lesbian representation. In many aspects, the film addresses what now creates a real frenzy in popular culture: the lesbian erotic scene integrated within, or as, popular consumption.[1]

So eight years after its release and confident that the notorious invisibility that the film enjoyed might provide a sense of novelty, I want to offer an in-depth analysis of Cavani's cinema from a lesbian perspective. Often depicted as totally amoral, even outrageous, Cavani's cinema used to be considered either as a feminine version of the masculine libido or a masculine fantasy of female masochism, but not as a productive site from which to question the social construction of sexualities. Attracted by Cavani's representation of female sexuality in a s/m context, I want to question how the relation between politics and sex in her films is framed by her desire to establish that sex cannot take place outside of regulated spaces where each partner has to agree to a set of rules, laws and roles. While I remain critical of Gilles Deleuze's rigid interpretation of s/m in *Coldness and Cruelty* (1989) as two different and autonomous sexual practices, I nevertheless believe that his work allows us to rethink the relation between sex and power. Specifically, I want to use the Deleuzian interpretation of masochism as a springboard to examine how Cavani's representation of female sexuality challenges not only the hetero-sexual imaginary of lesbians' sex on screen, but also proposes ways in which women could explore their desire through power, consensus and bodily ritual. S/m sex in Cavani's films is constructed less as a titillating trick to reify sapphic fantasies than as a provocative context through which gender roles

211

are less important than power positions. At the same time as Cavani authorizes a separation between s/m, she reinscribes this categorization from a woman's position. In this sense, her construction of female s/m sex flirts with the potential to transgress the traditional position of women in cinema, both as spectator and performer.

In the conjuncture of the 1990s, while we claim that identities are not fixed, we also recognize that this identificatory fluidity is not just determined by the voices which call for new sites/positions, but is also rendered possible through a complex process of legitimation which intertwines politics, cultural values and new forms of discourses and representations. Notions such as subversion, perversion, transgression as defined by sexual practices also belong to the political scene in the measure that they confront the limits and boundaries of what constitutes the representable. While s/m popular discourses evoke a perpetual paradox for lesbian and gay identities, they also allow us to question sexuality in relation to the systems of consensus and contract which regulate the society.

Let me, then, offer some general assumptions concerning the kind of analysis that I will develop in reading Cavani's cinema. The representation of lesbian and gay cultures in her cinema is less indebted to popular imagery than to a construction of intertwining elements from highly stylized conventions specific to art film,[2] as well as some strategies developed through women's feature cinema. And because her films constantly overlap the boundaries between filmic 'genres', the address to the spectator plays on the ambivalence between fascination and critical distance. From *Beyond Good and Evil*, to *The Berlin Affair*, to *Behind the Door*, Cavani plays with the taboos of sex and refuses to locate the screen at the core of a sexual morality. In her films, sex occurs through power relations, and pleasure is subordinated to the very strict negotiations between lovers.

Simply put, Cavani locates sexuality squarely within the realm of politics. The institution, as a claustrophobic system, is a site of excess in which fantasy is aestheticized in order to emphasize the coldness of personal involvement. Desire is then a state of mind as well as a performance meticulously designed to position each of the performers. In articulating pleasure and masochism, Cavani returns the site of eroticism to the same place from which it was banished: the public space. Because she designs sex as a political game, Cavani disturbs the representation of sex as an imaginary and private realm, playing instead with references to popular memory. *Night Porter* was attacked in Italy, the United States and Britain because of this disturbing and irreverent overlap between politics – the fascist regime – and the private – the s/m relationships.[3] The world of lust depicted in Cavani's cinema remains invariably linked to the violence and the rigidity of the political scene. Laws, codes and rules are at stake in sexual practices; and it is only on the basis that everyone respects the rules of the game that desire exists.

By interrogating Cavani's cinema, I also want to address the way in which

power in s/m sex is represented and made accessible for a lesbian reading. The question here is not to say that s/m relations are based on power – which would be tautological – but, rather, I will investigate Cavani's construction of sex from popular s/m representations. While these are based on interchangeable but gendered positions between the partners (meaning that there is no fluidity in sexual roles, one playing the domina and the other the bottom), Cavani's depiction of the s/m scene does not discount the heterosexual fantasy of woman as dominatrix. What are at stake in her representation of s/m sex are the ways that sex engages the traditional understanding of perversion as politically subversive. Gay male sex and lesbianism are depicted in order to emphasize s/m practices as the means to transgress the social order and the moral codes of the 'good society'. The focus is thus not on the subjects, but on the ambiguity raised by specific sexual practices in the construction of identities.

Strangely enough, reviews of Cavani's cinema rarely raise this central aspect of her work. If some reviews point out that her films eschew sentimentality and romanticization, others denounce her predilection to depict female sexuality in an atmosphere overcoded by a context of repression, submission . . . even alienation. Cavani's reputation as a radical lesbian also contributes to the ambivalent reception of her films, both among lesbian and feminist critics[4] and within mainstream film circles.[5] A woman dealing with the realm of sex and power is suspicious to say the least.[6] This is not because Cavani plays the game of porn sex – her films, on the contrary, are very prudish – but because she boldly subverts a gendered construction of s/m sex, notably by allowing constant shifting between lovers.

Feminist critics apparently are not the only ones to have some problems with Cavani's works. In the summer 1993, for its great retrospective of contemporary Italian cinema, the Italian Cultural Center in New York chose to ignore her contribution to national production.[7] This official silence says more than anything else about a culture ready to marginalize female fantasies and celebrate masculine libido as national art.[8] The choice to silence Cavani clearly shows how it is always more acceptable to talk about male sexual obsessions than about female sexual/social fantasies concerning sexual power. Specifically inscribed in a cultural context interrogating the links between politics and sexual identities (national and historical), Cavani's cinema challenges lesbian and feminist criticism in its constant interplay between sexual intimacy and social decadence. Films such as *Beyond Good and Evil* (1977), *The Berlin Affair* (1986)[9] and *Night Porter* (1974), can then be interpreted as a critique of the pathologization of deviance and perversion. Constantly playing on the wire of the psychoanalytic pervert and the triumph of the dominant–dominated model in sexual relationships, these films compel an analysis of the articulations between politics, sexuality and sex. In emphasizing the pernicious linkages between sex, power and politics, her representation of woman's sexuality frames sex as part of the social order.

213

Historically, societies and cultures have generated various mechanisms of control to protect their social order, specifically in the domain of sexual practices. By regulating the scene of perversion through rules, laws and moral codes, societies institute a political control over what constitutes the space of representation for sexual identities. The regulation of subversion constitutes a fundamental aspect of the construction of sex as culturally visible.[10] What the regulation of subversion authorizes is the circulation of gay and lesbian representation of sex, for example, within and through the limits prescribed by the public consensus. Hence, films like *Beyond Good and Evil* and *The Berlin Affair* need to be read as the exacerbated expression of liberalism and its obsession for contracts and rules. In this pampered space, homosexuality and s/m sex paradoxically cannot exist within the social order without a consensual association which protects the partners involved.

Taking Deleuze's critique of s/m perversion in *Coldness and Cruelty* (1989) as a starting point, I propose to look at the articulations between contract (social), consensus and sexual politics in Cavani's cinema. In fact, Deleuze's revision of Sacher-Masoch's *Venus in Furs* (1989) – the classic novel which gave masochism its name – constitutes a 'treatise of politics' in which masochistic sexual practices are revealed as deeply dependent on contract. And because s/m sex is strongly dependent on expectations, consensus and reciprocal pleasure, the desire manifested by the masochist does not express a lack but a very physical and contractual involvement through postponement and delay.[11] This distinction is central to understanding the representation of power that Cavani authorizes in her films. Beyond a psychoanalytic argument, Cavani's films explore desire as politically constituted and consumed through sexual sites which are not necessarily the body.

THE PERVERT SPIRIT: CAVANI'S SUPERWOMAN

In 1977, Cavani directed *Beyond Good and Evil*, a non-biographical portrait of the intimate relationships between Friedrich Nietzsche (Erland Josephson), Lou-Andreas Salomé (Dominique Sanda) and Paul Rée (Robert Powell) in the repressive society of late nineteenth-century Germany. Trying to experience sexual and spiritual freedom – the idealistic and eternal love triangle – the three of them are very soon confronted with the dissolution of their bodily masquerade. Nietzsche, dying of syphilis, confines himself to a platonic love; Rée as he finally experiences his homosexual fantasies to be savagely raped and murdered; only Salomé, like Louise in *The Berlin Affair*, will survive, embodying the hope and the spirit of the new century for women. From the blow-jobs casually delivered by courtesans to a hallucinating Nietzsche obsessed by images of Christ, to Paul's hard-core dreams of homosexual encounters, to Salomé's voyeuristic pilgrimage in homosexual public spaces, the film celebrates the various triumphs of Eros over Reason.

The film was coldly received and practically ignored by the critics, and was not distributed in America. Most of the criticisms were directed at the under-exposure of Nietzsche the thinker[12] (the title, which was inspired directly by Nietzsche, generated great expectations). The critics especially hated the film's focus on the perverted sensationalism of a decadent and bisexual *ménage à trois* (Nietzsche's idealized superman is ironically fetishized in the figures of the masculinized Salomé and the feminized Paul Rée).[13] Denounced either as a grotesque and pretentious treatment of bourgeois society or as embracing institutions of power, *Beyond Good and Evil* has nevertheless unanimously raised a polemic debate concerning Cavani's linking of sex and sexuality to power and masochism. And the critics are quite right: Cavani's cinema is always filled with sado-masochistic intentions. But what the critics seem to forget is how much *Beyond Good and Evil* is committed to a quest for a negotiated eroticism outside the law and traditional norms. And one of the central figures in the film who leads, and even dominates, this quest for sensual pleasure is Salomé. In her own work on sexuality – strongly influenced by Freud among others – Salomé was a fierce advocate of the distinction between sentiment and body (Salomé 1984), and the rights of the body over the sentiment.[14] In *Beyond Good and Evil*, to separate the body and the spirit means to sympathize with the possibilities of transgressing the moral, proposing an ethical code analogous to the *mise en scène* of s/m relationships.

However, Cavani's film marks a rupture with popular representations of s/m sex by challenging the traditional gendered positions within the s/m relations. Cavani refuses in fact to set fixed sexual positions, as well as to hierarchize sex positions – no top, no bottom. On the contrary, *Beyond Good and Evil* demonstrates how far her representation of sex and sexual identities coalesces contract, trust and social consensus, rejecting biological determinisms. Insofar as characters negotiate sex, they expose themselves – as socially sexualized – to possible revision. Thus in bringing the notion of contract as a game where players overtly consent to explore momentarily a specific position within both the private and the public, Cavani questions also the construction of social and sexual identities. *Beyond Good and Evil* is in fact less about the sexual reversibility and negation of difference, as Silverman argues, than about the politics of sexual exchanges.[15]

The film is deeply engaged in exploring the sexual power and control that Salomé reclaims for her own pleasure. Salomé is the one who allows the trio to be involved in a gentlemen's agreement, where sex between the partners plays a marginal role, though it is definitely central for each of them outside the *ménage à trois*. She is the personification of Nietzsche's theory, she is Rée's queer *alter ego*. Salomé is not asexual; she embodies the tragic figure of a sexual wanderer eager to believe that trust and mutual consensus are the very basis of sex. Her curiosity for homosexual encounters and the sexual rules to which men seem to agree, expresses her fascination for constructing

intimacy as a regulated space. Salomé's sexuality is then filled by the desire to locate her fantasies in spaces usually inaccessible to women, mainly 'gay male scenes'.[16] Her sexual taste for 'playing' with homosexual desire and enjoying public pissing and peeping manifest in many ways her will to ridicule the social rules which refuse women such public exposure of their fantasies. Advocating the social deviancy of sexualities and sexual taboos, Salomé frees, in this sense, her mind from moral struggles.

In fact, *Beyond Good and Evil* emphasizes the complexity of power and its specific manifestations by ceaselessly teasing the established norms of domesticity and sexual exchange between consenting partners. Cavani's attempts to represent sexuality as constantly challenging traditional sexual positions defy the traditional construction of s/m. Her strategy to explore the ways in which power and trust are at the very basis of sexual practices exacerbates the clichés which circulate in popular imagery and which most of the time illustrate s/m as kinky sex involving a master and a slave.

The trust between Nietzsche, Salomé and Rée is based upon the possibility of renegotiating the margins outside the privacy of their intimacy. This is one of the very basic statements of masochism: the contract which is founded upon trust. Only the contract makes possible the postponement – the consent to postpone the satisfaction of pleasure – or in the case of *Beyond Good and Evil* the substitution of 'real sex' for the satisfaction of verbal and voyeuristic fantasies. Given this specific dimension of consensus, notions such as 'rights' and sex are constantly challenged by the possibility of being transgressed and subverted. The individual quest for pleasure is predominant over any institution.

According to Deleuze, this opposition between individual and institution is one of the statements that distinguishes sadism and masochism as two different organizations and structural (narrative) contexts. Indeed, both imply power and relations of control, but the representations and the practical realizations specific to each system cannot be settled in the same space.[17] Sadism is strongly connoted by the institutional aspect, as masochism appeals to the notion of contract. The former directly refers to the political aspect of control (in the sense of policies on sexual behaviour), the latter to the individual dimension of the sexual games. Sadism is then sketched as a conspiracy – often a group against an individual – as masochism is seen as the perfect expression of personal fantasy – one individual abandoning himself/herself to the will of the other, a will totally delimited by the limits of the abandoned. One then could be read as the sexualization of control, and the other as the liberation of sexual imagination. One evokes the repressed, the other the free spirit. According to these differences, both sadism and masochism are strongly designed by the dress codes and inflect the specific rules which characterize the two organizations. Sadistic dress codes are depicted as gross, rigid, a caricature of the institution (paramilitary), while masochistic dress codes reflect the aestheticization of fantasies and consent

of the partners. Sadistic dress codes emphasize the collective reference to a group – hence the belief that uniforms are exclusive to sadistic practices – while the masochistic dress codes distinguish the individual, and personalize, even domesticize the pain and the punishment.

While I am aware of the danger in generalizing two different organizations and structural contexts where sadism evokes the public and the masochism the private, Cavani's representation of sex and sexual identity precisely addresses this separation of sadism–masochism. In fact, Cavani's films disrupt the articulation between sadism and masochism by proposing masochistic relations within a social and historical context depicted in a sadistic fashion. Cavani is indeed committed to linking sadism and masochism, but not in the same space. Thus sadism is represented metaphorically in her films as a political context which abusively controls, and masochism is constructed as a site of fantasy where individuals experience the possibility of ridding the body of the rational. For example, one of the most stunning scenes of the film is the gang-rape of Paul Rée. Hanging around by himself on the docks in a highly macho environment directly inspired by Genet's *Querelle de Brest*, Paul stops by a bar, where he flirts with a group of men. As he becomes drunk, the sexual allusions between Paul and the men are shown as half come-on, half threatening. Paul is manifestly scared, and, despite his dizziness, seems fully aware of the latent violence of the proposal. Leaving the bar, surrounded by his 'suitors', the group heads for a deserted space where Paul is tied up to a wooden structure, vaguely recalling the Cross. One after another, the rapists climb a little scale to reach the platform – a metaphoric altar – where Paul stands and then is sodomized with dicks, bottles, sticks, fists. This hard-core bondage scene is coldly depicted in an arty style suggesting in many ways the iconographic analogy between the representation of homosexuality and Christ's agonistic scenes.[18] In this scene, Cavani exacerbates the homosexual iconography of the crucified body in ecstatic pleasure.[19] Raped by working-class men, Paul is then fucked to death through the affirmation, the 'exposure' of his true desire. In a rude *mise en scène* of homosexual s/m sex, the gang-rape scene reinscribes the attraction to 'dirty fetishism' as it was associated with class transgression in the nineteenth century.[20] Moreover, the discomfort of the scene is mainly part of the ambiguity of showing the rape in a homophobic context, opening the interpretation of public homosexual sex as a deserved punishment. In the film, Paul Rée is the one who 'initiates' the sacrificial scene, the one who picks up and subsequently buys the services of his eventual rapists. But at the same that this bar sequence asserts the no-return of Paul Rée's secret desire, it confirms clichés concerning homosexual culture, mainly those casting the instigator as the pervert, and the followers as the buddy boys having entertainment. The tragic context of homophobia is eluded; the judgemental aesthetic dispatches a moral of the right punishment for the pervert. The religious character of this social amendment is then sanctioned by the masochistic iconography of Paul dying as the sacrificial queer.

The gang-rape scene in *Beyond Good and Evil* illustrates one of the difficulties in representing transgression through sexual power relationships. And I do believe that it would be pretentious to assert that the *mise en scène* of Paul's desire is a strong demonstration of the cultural and political transgressions of s/m homosexuality. In choosing to address explicit s/m homosexuality through the archetype of Christ's martyr kingdom, Cavani disrupts the fragile balance that structures sexual power games. If the film attempts to link s/m sex to subculture more than to a dominant genre, at the same time it refers to gay-bashing as an intrinsic dimension of homosexual lust. *Beyond Good and Evil* thus plays on the ambiguity and polemics of a sexual organization that suggests that masochism is a 'theatre of social risk' (McClintock 1993: 224). Paul, so far confined in the film in the position of voyeur of homosexual activities, becomes, in the rape sequence, the instigator of his own fantasy. He allows himself to trick faith by flirting with the danger of sex with men, men that he knows to be hostile and homophobic. This presumption of 'I knew but I went for it anyway', is later confirmed when, during a spirit session, Paul appears to Lou Salomé laughing and saying that he did enjoy it – that it was quite worth it. In this scene, Cavani manifestly parodies the threat that the homosexual represents for heterosexual values. But by allowing the power of death to be in the hands of Paul, she refuses to let the power of judging the queer lie in the hands of his torturers. In other words, according to Cavani, Paul is the one who fucked them because he is the one who set the rules of the game and the limits of sexual pleasure, and was beyond the control of the German workers.

In 'The Feminist Ethics of Lesbian S/M' (1993), Mandy Merck criticizes the Deleuzian interpretation of masochism. Speaking strictly upon the basis of role models, Merck notes that Deleuze's argument does not challenge the engendering of masochism as 'the realm of female dominion' (1993: 257). What Merck denounces is the fact that for Deleuze there is only one subject, the masochist defined as a masculine position: 'Hence, the masochist is said to encounter the woman torturer not as his sadistic counterpart, *another subject*, but as the mere incarnation of "inflicting pain"' (ibid.: 257; emphasis added). The female torturer is in fact shadowed in the male masochistic subject. Merck prefers to look to Sade's work – *The Philosophy in the Bedroom* (1795) – to find an appropriate interpretation for lesbian s/m practices. By adopting an inverted model, where women are the dominata, Merck's Sadian scenario recognizes only one subject: the top one. If such critique can contribute to understanding the realm of lesbian s/m fantasies as invested by positions of power, it maintains also a scenario that catches women up in one position.

Without denying the fact that the Deleuzian interpretation of Sacher-Masoch's *Venus in Furs* can reproduce the gendered construction of masochism, I am not convinced that, by referring to Sade and his top girl model, sadism brings to lesbian sex a real site of power. Merck, in fact, identifies

Sade's sexual role positioning as offering the possibility of challenging the usual Freudian interpretation of daughter–mother identification.[21] The main issue in recognizing the positive power that sadism (against masochism) can propose for lesbians appears then as an ultimate strategy to go beyond some heterosexual statement that s/m lesbians disturb the romanticization of equality between women.[22]

I am fully aware that subcultural lesbian representation of s/m sex strongly expresses a fantasy about sadistic position, or at least the recognition of a speaking position for the sadist in lesbian sexual discourses.[23] It might then be a way to signify a dominant female position in sexual practices, a way to revise the cultural construction of women as sexually passive. But at the same time, if the introduction of power and hard sex in lesbian practices could signify a transgression of heterosexual presumptions about female sexuality, we have to question whether or not representations of lesbian sex can be integrated with depictions of social knowledge that centre the lesbian as the pervert and the sexual deviant.

Cavani's provocative way to address sexual issues and sex practices constitutes a real challenge for a critique of strategies of representation of female sexuality. Her refusal to denounce s/m sex as a perversion on the basis of moral values, and her persistent practice of casting women as sexual deviants, constitutes a very political response to a regulated sexuality. The tension between deviancy and transgression is exacerbated by Salomé's obsession with homosexual public scenes and the pleasure she shows in urging Rée to witness them. Therefore, Salomé and Paul are bound by the public homosexual body; Salomé appearing in this sense as the queer countess of homosexual peeping, provoking her lover Paul Rée eventually to come out as a homosexual.

Cavani's films are less engaged in explaining than in destabilizing the social values of sexuality. This is why, against all odds, her work explores the contradictions of pleasure in a controlled context. By locating personal stories in a context of extremist political regimes, Cavani emphasizes the discomfort of looking at sex as distinct from the social. Insisting on the coldness of the sexual contract and the tacit consensus between partners, films like *Night Porter*, *The Berlin Affair* and *La Pelle* deny any natural selection as well as any 'essentialism' in power. While critics persist in finding in her cinema a voice for male characters, and a dominant (for example, heterosexual) representation of sexuality, I propose that her complex and ambiguous construction of sexuality allows for a reconsideration of female eroticism. Cavani's films not only constitute women as subject of their own desire, they also demystify an apolitical representation of female eroticism. Women define and experience the very limits of their own fantasies. As sex is a matter of contract through which desire is ritualized and regulated by a series of specific rules, Cavani refuses any kind of romanticization of sexual practices. For her, if sex can be aesthetic it is certainly not allegorical. Her

representation of sexual practices is tortuous but never underexposed. And if sex deals so often with violence, it is to suggest how intimacy is too often a site of social constraint for women which has to be transgressed. While in *Beyond Good and Evil*, *Night Porter* and *Behind the Door*, she focuses on the heterosexualized model of transgression, with *The Berlin Affair*, she explores the fluidity of women's positions within a masochistic relation.

LESBIAN S/M IN *THE BERLIN AFFAIR*: TATTOO, PORCELAIN AND SWEET MADAMES

In an essay on eroticism published at the end of the 1970s, Cavani explains how close eroticism is to aristocracy.[24] In fact, her approach echoes critical works on sexuality relating the social and political control of sexual practices to the emergence of the bourgeoisie.[25] And from a lesbian perspective, the fact that Cavani depicts aristocratic lesbians is quite unique in the actual context of constructing lesbian history through middle-class white women or working-class Black and white American communities.

In choosing to set aristocracy in opposition to capitalism – the latter bringing the notion of censorship based upon a question of aesthetics[26] – Cavani confronts the moral judgement of the individual to the obsession of regulating the perverted in the state societies. Both *The Berlin Affair* and *Beyond Good and Evil* ambiguously denounce and celebrate Eros in aristocratic culture; though *La Pelle* ('The Skin,') for example, set in post-war Italy occupied by the Americans, gives a rude image of sexuality (a commodity sexuality where child prostitution is the only sex to be materialized). However, if *The Berlin Affair* is committed to the eroticization of aristocracy, it condemns the same class for passiveness against the homophobic politics of the Nazi regime. More than *Night Porter*, where the Nazi officers are depicted as heirs of Roman decadence, in *The Berlin Affair* the attention is directed at Berlin's administration and its regulation of sexuality. As in her other films, there is no room in *The Berlin Affair* for a moral judgement about sexual practices and social chaos. The film avoids targeting queer behaviours as the origin of social perversion and political decadence. In other words, Cavani never uses the queer to pathologize the excesses of the SS.[27]

The film is divided in two distinct parts: in the first, the plot develops around the erotic attraction that Louise Van Hollendorf (Gudrun Landgrebe), an upper-class wife of a Nazi party diplomat and heir to an aristocratic German family, has for a painting classmate, the oh-so 'oriental' Mitsuko Matsugae (Mio Takaki), the daughter of the Japanese ambassador in Berlin. An ode to the beauty of Asian exoticism, the relationship between the two women intensifies and soon is publicly gossiped about. Heinz, Louise's husband, informed about the possible 'lesbian affair' involving his wife through a propaganda print press and warned by members of the party, urges her to stop seeing Mitsuko. Louise denies any sexual encounter and keeps on

with the relationship, finally confessing to her husband as the Nazis intensify the homosexual witch-hunting among their ranks. Louise then promises to stop seeing Mitsuko. The real reason of Louise's decision though seems to be prompted by her discovery that Mitsuko is the one who is spreading the rumours in order to be able to see her other lover: Benno, the painting teacher (Andrea Prodan). Not able to keep her promise and after accidentally initiating the gay blacklisting of a close friend in the party, Louise goes back to Mitsuko. She then signs a contract with Benno allowing both of them to see Mitsuko under specific conditions.

In the second part, the story revolves around the fact that now Heinz (Kevin McNally) is part of the sexual/power game led by Mitsuko. Louise and Mitsuko try to commit suicide together, but are saved by Heinz. While Louise is still drugged and lying half-conscious in bed, Heinz has sex with Mitsuko just next to Louise. While this is the only three-way scene, it is definitely the beginning of a *ménage à trois* under the supervision of Mitsuko. Mitsuko requests the exclusive right to have sex with the two others. Thus the two Van Hollendorfs freely consent to have no sexual relations with anyone other than Mitsuko. Jealousy, suspicions, mistrust intertwine within an increasing climate of control and postponement between the three lovers.

Interestingly, the more suspicious the two spouses are of each other, the more they consent to follow the rules established gradually by an equally distrustful Mitsuko. While it seems that Mitsuko exercises all the control on and in the relationship, the film also suggests that it is the pact between the two spouses that is the very basis of the relationship. It is only because the two spouses decide that they will not have sexual intercourse that the relationship continues. In one of the most stunning scenes of the film, there is a sleeping-pill ceremony that comes to 'officialize' the ritual of the regulation of sexuality among and between the *three* of them. Each night, Mitsuko distributes sleeping-pills to the Van Hollendorfs before they go to bed, but only one is loaded. Mitsuko then decides who will be selected that night for a sexual encounter.

Even if the spouses sometimes play with chance by swapping their pills, giving them a sense of equity, they never go against the meaning of the ceremony. Both believe and hope to be chosen, each even keeps the event secret when it occurs. It is obvious that the affair with Mitsuko will end the minute they break their engagement. The film ends with a suicide pact orchestrated by Mitsuko. Hiding themselves from the Gestapo, Heinz and Louise agree to the last sleeping-pill ceremony. But Mitsuko does not drug Louise. At this point, the film returns to Louise who in flashback is telling her amazing story to her literature professor just before he is arrested for writing immoral (read pornographic) novels.[28]

The Berlin Affair was read both as a torrid lesbian affair and a bisexual narrative. And for the first time for a film directed by Cavani, reviews of the film focused on the homosexual/lesbian plot, although neglecting to define

the sex between lovers as s/m. Interestingly enough, the previous films directed by Cavani, in which the s/m issue was extensively commented upon, involved women in heterosexual contexts, enforcing the popular imagery that s/m sex is gendered and male – which includes gay sex (*Beyond Good and Evil*). Given the fact that *The Berlin Affair* perniciously mingles eroticism, exoticism and masochistic fantasy as part of female–female sex, Cavani challenges the social assumptions that female sexuality is necessarily filled by caring, sameness and self-abnegation. *The Berlin Affair* is not the only film in which Cavani explores female fantasies, but in it Cavani shows for the first time a sexuality *exclusively* imagined and controlled by women and the very possibilities that sexual contracts open for women. For Cavani, if female sexuality in the modern culture is so often de-eroticized it is because there is no explicit contract; there are only implicit rules, which for her means repression. In this sense, Cavani is less interested in intergender sexual relations – she doesn't sexualize the three-way relationship – than in positioning female sexuality through lesbian s/m desire.

And maybe more than in her other films, *The Berlin Affair* can be a disturbing film for a lesbian audience, as long as the narrative surfs on the exotic vision of two women in bed, at the same time that her female characters are not inhibited sexually. Ironically, sex between the two women, both cast as the idealized Femme, is explicit and determined by a series of rules set according to the worst clichés of the perfect encounter between the perfect race (the Aryan woman) and the perfect ideal of female servitude (the Oriental escort). But at the same time, if one can be annoyed by the lesbian chicness of Louise and Mitsuko, one should recognize that the public aspect and political dimension of their affair reorientates quite differently the privacy of lesbian sex of mainstream films. Their lesbian affair is public – the sapphic friendship makes the front page of official German papers – and circulates ironically as innocent entertainment in the circle of diplomatic life. The underpoliticization of lesbian sex by the party is counterbalanced in the film by the political gay-bashing that spreads among the German officers' ranks and that directly attacks one of the best friends of the Van Hollendorfs.

And because the lesbian story is so public and so available to popular awareness, their sexual encounters are not represented as romantic and fantasized, but subjected to a meticulous organization where control, self-control and psychological bondage are valorized. The two women are engaged in the masochistic seduction struggle, where women, beyond men, are the only subjects to perform. In this sense, the film defies the assertion that masochism always positions women as the shadow. If Mitsuko seems to be the dominata, the one who provokes the sexual encounters, Louise asserts her own position in the relationship by being the one who notifies by contract their status as lovers. Louise's commitment in negotiating Mitsuko's body as a sexual commodity (Louise calls her the 'porcelain doll') gives her the opportunity to validate her own investment in the consensus.

In fact, the narrative construction of the film refers to many aspects of Sacher-Masoch's *Venus in Furs* (1989). By constantly intertwining lesbian sexual scenes and *tableaux vivants*, the film clearly refers to the idealized and pathologized masochism of the Severin character in *Venus in Furs*. The voice-over intervening in the narrative is also a wink to the auto-critique and self-conscious masochist Severin. Again, Louise, as did Severin in *Venus*, consents to regulate the sexual dimension of her relationship with Mitsuko. The private is then constantly exposed to the public acknowledgement of their situation brought about by the contract. The fact that the contractual dimension never directly involves the two women might constitute a disturbing factor for a lesbian s/m representation in *The Berlin Affair*. But one can also read this patronized and contractual exclusion of Mitsuko as a way to regulate and keep away the heterosexual prescription, enabling a space beyond the control of the authority of the Law to open for Louise and Mitsuko.

Actually, Louise agrees to two different contracts in order to have the privilege to have sex with Mitsuko. In one contract, the written one, she agrees to the marriage between Mitsuko and Benno, and, in return, she will be allowed to see Mitsuko as often as she wishes. In the second contract, the Van Hollendorfs verbally consent to abandon any sexual intimacy, restraining their sexual libido for the Japanese lover. The two women, then, build up a series of non-official rules based upon the gradual exclusiveness of Louise's love for Mitsuko. In exchange, Mitsuko performs with meticulous excess the Japanese woman: kimono, geisha, low voice, porcelain skin . . . and kamikaze impulses (the final bed scene in which Mitsuko plans the suicide of the three of them is an allegorical telling of the rationale of death and honour sacrified that is traditionally and easily associated in western cultures with the kamikazes).

The dress code also constitutes a fascinating dimension of their lesbian relationship. For Louise, the sexual attraction of the quaint Japanese culture is consumed with the pleasure that Mitsuko shows to accentuate her exotic appeal. The contrast in the clothing between the so-occidental (read modern) Louise and the so-oriental (read exotic) Mitsuko echoes the fetishism of the Other – represented as racial difference – as a central fantasy in a masochistic scenario. However, because this fascination for the exotic other is doubly connoted by the racial and lesbian identities, the film avoids the so-predictable mimetism that usually connotes female same-sex relations on screen. The image of the double so often exploited in popular lesbian representation – and generally involving white female characters[29] – is paradoxically challenged by another apparent cliché: the exotic one. But instead of positioning the exotic in the role of the slave, according to the representation of 'love affair' between occidental and oriental,[30] the film ambiguously suggests that Mitsuko is the dominata. Desire is possible only via the imaginary nourished by the physical cultural boundaries that the two women themselves maintain. With Heinz, there is no such exotic attraction. It is only between the two women

223

that the Japanese fetishism is constantly remodelled, repeated, by the presumed Japanese women's *savoir faire* to educate their occidental seductor (ironically, the seductor is hardly racialized).

The very first sex scene between the two women is totally marked by cross-sexual, cross-cultural fantasies. Urging Louise to paint her in a private painting seance, because 'As I am your model, you don't need the class', Mitsuko dresses up Louise in a convenient kimono. This ritualizes a dress code and stages the exchange of cultural values between the two women. It also imposes the rules of s/m sex. This private seance is the one that initiates the implicit contractual sex between the two women. Using the fetish of the rope, Mitsuko uses the silk kimono belt as a sexual play toy to tie Louise to her in a very fancy, aesthetic and suggestive bondage scene. As furs are a condition *sine qua non* to sexual satisfaction in *Venus in Furs*, in *The Berlin Affair*, Japanese clothing, sophisticated tattoos and make-up glitter with the magnificence of forbidden sex. Besides, Cavani fully channels the different elements into the aesthetic and plastic dimensions of the masochistic scenarios. For instance, each scene of intimacy between the two women is shot in stills, emphasizing masochistic postponement and delay (the factor of suspense). What it unfolds is the attractiveness in elaborating fancy scenarios that suggest physical as well as emotional sensations.

So far, I have some reservations about defining lesbian masochism as necessarily sado-masochistic. But *The Berlin Affair* offers a very interesting site to interrogate such associations between the two structures of representation and self-representation. In *The Berlin Affair*, the position of the masochistic characters is constantly threatened by their inability to really endorse a position. In fact, Mitsuko is not the only one who moves through different positions. As I suggested previously, Louise is not confined to the bottom position, to employ the usual categorization of s/m sex performers. On the contrary, very often she is cast in the voyeur position, the spectator of Mitsuko's various bodily performances: the geisha's tea-time or the geisha drag performance, the midnight bath scene when Mitsuko proudly and provocatively exhibits the very sophisticated tattoo that covers her back.

Like Severin in *Venus in Furs*, Louise will survive her masochistic adventure, though she never states that she cures herself – as does Sacher-Masoch's Severin – of her own passion for the Japanese woman. If Severin through his testimony manifests his concern for his pathologized state, Louise never addresses her passion as a sickness. Rather, she insists on telling her mentor (the professor to whom she confesses) how far the consensual agreement was overtly acknowledged. Here, Cavani clearly argues for a contractual lesbian s/m representation against any interpretation of a pathologized masochist. The film then marks clearly, as Parveen Adams puts it, that 'There are important differences between lesbian sadomasochist and the clinical masochist. These differences suggest that although we are dealing with perversion we are not dealing with pathology' (1989: 261).

The Berlin Affair also interrogates important assumptions about the visibility of lesbian s/m sex on screen. One of the things that the film allows is the reconfiguration of the visible by insisting on the physical and material dimensions of fantasy and desire. By privileging fantasy, postponement and suspension as part of women's sexuality, the film addresses lesbian s/m sexuality as a site of control for women. If, for example, as Adams suggests, s/m fantasy and the factor of suspense allow lesbian sado-masochists to enjoy mobility in their desires (Adams 1989: 252), then one can see lesbian s/m sexuality as a challenge to an engendered *jouissance*, freeing lesbians to choose between a feminine or a masculine *jouissance*. To be powerfully sexual for the lesbian subject it is not a question of being on the top, but to question whether sexuality might really defy the gendered predicament that power in sex is necessarily defined by 'visible' positionalities/positions. In this sense, *The Berlin Affair* does constitute a provocative critique to the rigidity of roles in s/m (the bottom–top model) by exploring the possibilities to spread desire in the ambiguity of racial and sexual heterosexual models. And because the film positions the same sexual subject in the double position, it also contributes to a better understanding of the issue concerning lesbian s/m representation. In this way, what Mandy Merck (1993) criticizes in the Deleuzian construction of masochism – one subject who subalterns the other to the Self-shadow[31] – becomes an asset for the lesbian sado-masochist.

When I decided to look at Cavani's cinema, I had two aims in my mind: first, to question the social categorization of perversion and subversion; and then to question sexual performance in its political dimension and as a site to analyse the fragile boundaries between identities. I was then challenged by the idea of thinking of the representation of s/m sex as a political contract: in other words, of thinking of fantasy as a rational and negotiable act, rather than one submitted to the real of the unconscious desire. One of the central arguments was to examine how desire could be represented as a regulated practice. Astonishingly, for what is considered as the very first masochistic half-fictional testimony, *Venus in Furs* is truly an exploration of the capacity to regulate sexual desire, in order to fulfil the fantasized pleasure over the limits of the rational. What belongs then to the rational is not part of a moral judgement, but part of the construction of sex as consumptional value. In this sense, desire-fetishism and postponement proceed from the same regulation of sex as social contract.

The interest of Deleuze's opposition sadism/masochism lies in his ability to have formulated what in essence was always recognized and criticized as such. Feminist criticism as well as Marxist analyses have very well defined the contractual and unegalitarian aspect of sexual intercourses. Even if they address different issues and pursue contradictory purposes, the three approaches inscribed sexuality as an *exchange* which has to do with para-doxes of legitimated and unlegitimated representations of subjects. This is why it appears to me so important to look at the ways that s/m performances

can be read as directly addressing the issues of the regulation of subversion for identity politics. This is even more important when one account seems to consider the necessarily subversive aspect of every sexual position except the missionary one. As McClintock asserts, 'S/M *performs* social power as both contingent and constitutive, as sanctioned neither by fate nor by God, but by social convention and invention, and thus open to historical change' (1993: 210; emphasis in original).

I do believe that, as Adams argues (1989), masochism is not homogeneous, which means that it can proceed from either perversion or regulated subversion. By inscribing masochism as a political performance, I have tried to consider those extreme positionalities that sado-(masochist) lesbian discourses can echo. If on the one hand, lesbian s/m representation as a perverted subversion does position the lesbian subject outside a heterosexual representation of kinky sex, on the other hand, because of its liberal commitment to mutual pleasure,[32] it raises important debates concerning the very regulation of what Biddy Martin (1992) addresses as 'the newly militant politics of identities'. Therefore, what is at stake for s/m lesbian representational discourses is not just the politics of pleasure, but also the historical and social spaces intertwining sex, sexuality and gender in the reappropriation of 'configurations [that] necessarily exist' (ibid.: 107).

If, as Salomé pleads, Eros can be only achieved by allowing the body to be freed from the tyranny of the Spirit,[33] it does not mean that the erotic imaginary – so fundamental for the masochist – is disconnected from the context that generates the realm of fantasies. On the contrary, in recognizing that 'in the field of representation, there is no disclosure without concomitant closures, erasures and silences' (Martin 1992), lesbian sexual and cultural practices place the debate over female desire exactly where subversion has to be located: in the social scene.

ACKNOWLEDGEMENTS

My sincere thanks to Eric Clarke, Joy Van Fuqua and Elspeth Probyn who read this essay at various stages and offered me their tremendous support and inestimable suggestions. Also, because I am a good girl, I would like to thank the Social Sciences and Humanities Research Council of Canada (SSHRC) for their funding.

NOTES

1 See Alexis Jetter (1993: 86–92).
2 Andreas Weiss, for example, locates *The Berlin Affair* in the category of art cinema: see *Vampires and Violets: Lesbians in the Cinema* (1992: 107).
3 *The Berlin Affair* and *La Pelle* were critiqued for similar reasons.
4 See Sue Stewart (1984); and Teresa de Lauretis (1976–7).

5 See Iannis Katsahnias (1986: 87); and Thérèse Rocher (1986: 61).
6 See Pascal Bonitzer (1976).
7 Of course, a lot of Rossellinis, a lot of Fellinis and *one* Wertmuller (the other well-known Italian woman director).
8 Ironically, her last film *Dove Siete? Sono Qui!* (Italy–France, 1993) which was programmed as a world première at the Montréal World Film Festival in September 1993, is one of the most stunning reversals of fortune that a director's trajectory can reach. Putting sexual fantasies away and abandoning any allusion to provocation, Cavani achieves a film that celebrates class reconciliation and a hopefully happy end. Forget about s/m, incest, homosexualities, Nazism: the mother is back, rich and powerful, and Oedipus is quite alive. Of course, the film received enthusiastic reviews. Personally, I see this love story between two young deaf adults as a kind of social response to those who accused Cavani of being so 'perverted' that she forgot about the *human* aspect of life. So she does, so she is boring: the clichés not absent from her previous works, here find a pathetic and aseptic dimension. Controversy is no longer something that is at the core of her work (provocative clichés can be better than candy ones). Rather, a sentimental narrative develops the triumph of the will in the most predictable way. Post-neorealism is the best description of *Dove Siete? Sono Qui!*
9 In this essay, I keep this British translation of *Interno Berlinese*. In USA, the distributors adopted *Beyond Obsession*. In fact, it looks like everything with Cavani is beyond something.
10 Elsewhere I argue that the legitimation of what can be named as a subversive cultural manifestation often conducts to a depoliticization of difference. See Nadeau (1993).
11 McClintock refers to Pietz' works on fetishism (see Pietz 1985). She explains that

> the western discourse on the fetish was at least four centuries old before the phallus was singled out as its central principle. As Pietz shows, the earliest European discourse on fetishism concerned witchcraft and the clerical denunciation of illicit popular rites and wayward female sexuality.
>
> (McClintock 1993: 5)

12 See Robert Benayoun (1977: 133); and Jacques Grant (1977: 74–7).
13 See Robert Benayoun (1977) and Jacques Grant (1977); also Jean-Loup Passek (1977: 73–4).
14 Cavani herself says that it is not Nietzsche alone who encouraged her to do *Beyond Good and Evil*, but rather this period of life when Nietzsche and Salomé were together. The idea of the *relationship* was then the main project that led to the film. See the interview with Alexander Stuart (1975: 14).
15 Silverman, who was one of the few to have paid attention to Cavani's work, argues that *Beyond Good and Evil* as with the other Cavani's films, is a story about sexual reversibility and the negation of difference. Silverman maintains that 'the negation of difference is made possible only through the willingness of a male character – Paul Rée in *Beyond Good and Evil* – to divest himself of the phallus' (1988: 224).
16 Gene Youngblood in 'Shame and Exaltation' (1977: 36–8), compares Cavani's Salomé (Dominique Sanda) in *Beyond Good and Evil* to Richard Brooks' Louise (Diane Keaton) in *Looking for Mr. Goodbar* (1977) in these terms: 'Dominique Sanda generates more erotic energy by peeing in a spittoon than Diane Keaton does in all of her full repertoire as a sexual Barbie Doll cruising the Crisco Discos.'
17 As Deleuze argues about the conventional heterosexual s/m scenario:

> The woman torturer of masochism cannot be sadistic precisely because she is *in* the masochistic situation, she is an integral part of it, a realization of

227

the masochistic fantasy. She belongs in the masochistic world, not in the sense that she has the same tastes as her victim, but because her 'sadism' is of a kind never found in the sadist; it is as it were the double or the reflection of masochism. The same is true of sadism.

(Deleuze 1989: 41)

And Deleuze gives the following example:

A popular joke tells of the meeting between a sadist and a masochist; the masochist says: 'Hurt me.' The sadist replies: 'No.' This is a particularly stupid joke, not only because it foolishly claims competence to pass judgment on the world of perversions. It is unrealistic because a genuine sadist could never tolerate a masochistic victim. . . . Neither would the masochist tolerate a truly sadistic torturer.

(ibid.: 40)

18 Gene Youngblood (1977), among others, has depicted these scenes as similar to Hans-Jurgen Syberbeeg's tableaux in *Ludwig: Requiem For A Virgin King* (1972).

19 Historically, examples of the collusion between the Christ projection and gay sexual fantasies abound. From the Sistine Chapel's doom to Caravaggio to Evergon's stunning Polaroids, from the classic *Spartacus* (Stanley Kubrick, 1960) to the avant-garde *Poison* (Todd Haynes, 1991), Christ is still widely exploited. S/m iconography, exclusive male rivalry and strong body emphasis are part of the attraction that Christian culture brings to gay culture; see also McClintock (1993).

20 McClintock argues that: 'During the nineteenth century, the iconography of "dirt" became deeply integrated in the policing and transgression of social boundary. In Victorian culture, the bodily relation to "dirt" expressed a social relation to labour' (1993: 216).

21 Merck is referring to the Julia Creet article 'Daughters of the Movement: The Psychodynamics of Lesbian S/M Fantasy', *Differences*, 3, 2 (summer 1991): 135–56.

22 Merck addresses here Tania Modleski's *Feminism Without Women* (1991).

23 See Pat Califia (1992).

24 Liliana Cavani (1977).

25 See Michel Foucault (1978); and John D'Emilio (1992).

26 It is a matter of fact that one of the strongest arguments in the debate over pornography is related to the conception of aesthetic – misguided though too often in its plastic sense, denying its *ethical* generic basis. Cavani says:

There is a demarcation line beween pornography and eroticism. This line is drawn by the moralistic judgment which appears to be constitutive of pornography itself. The distinction between what is pornography and what is eroticism is based on an aesthetic choice, and any aesthetic choice always involves a political matter.

(1977: 267–8)

27 This is where Cavani is interesting compared to a film such as Luchino Visconti's *The Damned* (Italy–Germany, 1969). *The Damned* pinpoints the signs of deviancy, decadence and sadism of the Nazi regime with the character of Martin (Helmut Berger), the closeted queer and also transvestite, paedophile and incestuous son. For a comparative analysis of *Night Porter* and *The Damned*, see Annette Insdorf (1983).

28 This confession reminds me of the scene in *Henry and June* (Philip Kaufman, USA, 1990) in which Nin herself reveals some kinky details of her sexual life to her publisher.

29 I have more precisely in mind these heterosexual fantasies of lesbian girls on the

screen, i.e., *Persona* (1966), *Les abysses*, *Les biches* (1968), *Mortelle randonnée* (1983), *Single White Female* (1992), etc. Interestingly, the image of the double is most of the time shadowed by the threat of death.

30 I will not develop this topic further, because so much had been said so far and so much remains to be said about it, but in a more appropriate theoretical context. However, I cannot silence the last David Cronenberg, *M. Butterfly* (1993), which I do think reaches a height in the fantasy of the Japanese woman as the perfect symbol of eroticism. The difference with *The Berlin Affair* is slightly challenging though, because yes, this one is a really nasty one.

31 The Self-shadow subaltern as positioned by Gayatri Spivak (see Spivak 1988).

32 'S/M plays social power backwards, visibly staging hierarchy, difference and power, the irrational, ecstasy, and the alienation of the body as at the centre of Western reason, thus revealing the imperial *logic* of individualism, but also irreverently refusing it as a *fate*. S/M manipulates the signs of power in order to refuse their legitimacy as *nature*' (McClintock 1993: 211).

33 See Lou-Andreas Salomé (1984).

BIBLIOGRAPHY

Adams, Parveen (1989) 'Of Female Bondage', in Brennan Teresa (ed.) *Between Feminism and Psychoanalysis*. London and New York: Routledge.

Benayoun, Robert (1977) 'Nietzsche obsédé', *Le Point*, 263 (October).

Bonitzer, Pascal (1976) 'Le Bourreau derrière la porte: à propos de *Portier de Nuit*', *Le regard et la voix*. Paris: UGF, coll. 10/18: 98–117.

Califia, Pat (1992) 'The Limits of S/M Relationships or Mr. Benson Doesn't Live Here Anymore', *Out/Look*, 4, 3 (winter): 16–21.

Cavani, Liliana (1977) 'Cinéma et érotisme', in Michèle Causse and Maryvonne Lapouge (eds) *Ecrits, voix d'Italie*. Paris: Edition des Femmes.

de Lauretis, Teresa (1976–7) 'Cavani's *Night Porter*, a Woman's Film?', *Film Quarterly*, XXX, 2 (winter): 35–8.

Deleuze, Gilles (1989) *Coldness and Cruelty*, in Gilles Deleuze *Masochism*. New York: Zone Books.

D'Emilio, John (1992) 'Capitalism and Gay Identity', in John D'Emilio *Making Trouble: Essays on Gay History, Politics, and the University*. London: Routledge.

Foucault, Michel (1978) *The History of Sexuality: Volume I*, translated by R. Hurley. New York: Pantheon.

Grant, Jacques (1977) 'Au-delà du bien et du mal: une grande justesse', *Cinéma 77*, 277 (November): 74–7.

Insdorf, Annette (1983) 'The Condemned and the Doomed', in Annette Insdorf *Indelible Shadows: Film and the Holocaust*. New York: Vantage.

Jetter, Alexis (1993) 'Goodbye to the Last Taboo', *Vogue*, July: 86–92.

Katsahnias, Iannis (1986) 'La croix et la bannière', *Cahiers du cinéma*, 383–4 (May).

Martin, Biddy (1992) 'Sexual Practice and Changing Lesbian Identities', in Michèle Barrett and Anne Phillips (eds) *Destabilizing Theory: Contemporary Feminist Debates*. Stanford, Calif.: Stanford University Press.

McClintock, Anne (1993) 'Maid To Order: Commercial S/M and Gender Power', in Pamela Church Gibson and Roma Gibson (eds) *Dirty Looks: Women, Pornography, Power*. London: BFI.

Merck, Mandy (1993) 'The Feminist Ethics of Lesbian S/M', in Mandy Merck *Perversions*. London: Virago Press.

Modleski, Tania (1991) *Feminism Without Women*. London: Routledge.

Nadeau, Chantal (1993) 'Frosting the Lesbian Representation in the Movies, or Can

the Nasty Girl Beat the Exotic Tourist?', unpublished paper given at Screen Studies Conference, Glasgow.

Passek, Jean-Loup (1977) 'Au-delà du bien et du mal: le sublime et le sordide', *Cinéma 77*, 227 (November): 73–4.

Pietz, William (1985) 'The Problem of the Fetish', *Res*, I: 9.

Rocher, Thérèse (1986) 'Berlin Affair', *Cinématographe*, 118.

Sacher-Masoch, Leopold Von (1989) *Venus in Furs*, in Gilles Deleuze *Masochism*. New York: Zone Books.

Salomé, Lou-Andreas (1984) *Eros*. Paris: Les Editions de Minuit.

Silverman, Kaja (1988) *The Acoustic Mirror: The Female Voice in Psychoanalysis and Cinema*. Bloomington and Indianapolis, Ind.: Indiana University Press.

Spivak, Gayatri (1988) 'Can the Subaltern Speak?', in Cary Nelson and Lawrence Grossberg (eds) *Marxism and the Interpretation of Culture*. Urbana, Ill.: University of Illinois Press.

Stewart, Sue (1984) 'Is Liliana Cavani Really a Woman?', paper given at Film Forbidden: the Filmmaker and Human Rights in Aid Amnesty International, Toronto, 18–28 October.

Stuart, Alexander (1975) 'Consciousness and Conscience' (interview with Liliana Cavani), *Film and Filming*, 21, 5.

Weiss, Andreas (1992) *Vampires and Violets: Lesbians in the Cinema*. London: Jonathan Cape.

Youngblood, Gene (1977) 'Shame and Exaltation', *Take One*, 6, 1: 36–8.

13

I USED TO BE YOUR SWEET MAMA

Ideology, sexuality and domesticity in the Blues of Gertrude 'Ma' Rainey and Bessie Smith*

Angela Y. Davis

> You had your chance and proved unfaithful
> So now I'm gonna be real mean and hateful
> I used to be your sweet mama, sweet papa
> But now I'm just as sour as can be
> (Bessie Smith, 'I Used To Be Your Sweet Mama')

Like most forms of popular music, African American blues lyrics reveal a preponderance of themes associated with love. However, what is distinctive about the blues, particularly in relation to other American popular music forms of the 1920s and 1930s, is the relative ideological independence of its representations of love.[1] One of the most obvious ways in which blues lyrics deviated from that era's established popular music culture was their provocative and pervasive sexual (and not always heterosexual) imagery. According to Hazel Carby,

> What has been called the 'Classic Blues', the women's blues of the twenties and early thirties, is a discourse that articulates a cultural and political struggle over sexual relations: a struggle that is directed against the objectification of female sexuality within a patriarchal order but which also tries to reclaim women's bodies as the sexual and sensuous objects of song.

> (1986: 12)

By contrast, the popular song formulas of the period called for romantic, idealized and non-sexual depictions of heterosexual love relationships.[2] Those aspects of lived love relationships that were not compatible with the ideology of love – such as extramarital relationships, domestic violence and the often inevitable ephemerality of sexual partnerships – were largely banished from the established popular musical culture. But they pervade the blues. What is even more striking is the fact that the professional performers

231

of this music – the most widely heard individual purveyors of the blues – initially were women. One of the ways Bessie Smith earned the title 'Empress of the Blues' was through the sale of three-quarters of a million copies of her first record.[3]

The central place of the blues in the elaboration of a post-slavery Black cultural consciousness has been examined widely in works like LeRoi Jones' pioneering *Blues People: Negro Music in White America* (1971) and Lawrence Levine's engaging study, *Black Culture and Black Consciousness* (1975). While both suggest important approaches to the understanding of racial dimensions of African American culture, scant attention is accorded gender consciousness. Daphne Duval Harrison's trail-blazing study, *Black Pearls* (1988), reveals, in fact, how rich women's blues can be as a terrain for explorations of the place gender occupies in Black cultural consciousness. This essay will examine some of the ways love and sexuality figure in the blues performances of Gertrude 'Ma' Rainey and Bessie Smith.

The historical context within which the blues developed a tradition of openly addressing both male and female sexuality reveals an ideological framework that was specifically African American. Emerging during the decades following the abolition of slavery, the blues gave musical expression to the new social/sexual realities encountered by African Americans as free women and men. While the former slaves' economic status had not undergone a radical transformation – they were no less impoverished than they had been during slavery[4] – what was revolutionized was the status of their personal relationships. For the first time in the history of the African presence in North America, masses of women and men were in a position to make autonomous decisions regarding the sexual partnerships into which they entered.[5] Sexual freedom was thus one of the most tangible ways in which the meaning of emancipation was expressed. Sovereignty in sexual matters marked an important difference between life during slavery and life after emancipation.

Themes revolving around individual sexual love rarely were addressed in the musical forms produced during slavery. The sparsity of love themes in slave music may have had something to do with the slave system's economic management of procreation, which did not generally tolerate – and often severely punished – the public exhibition of self-initiated sexual relationships. However, for purposes of this analysis, I am interested primarily in the dissonance between the intensely individual nature of sexuality and the intensely collective way music was produced and performed during slavery. In other words, sexuality could not be so easily expressed through the major music forms of slavery. As the spirituals and the worksongs confirm, the individual concerns of Black people which achieved musical expression revolved around their collective desire for an end to the system declaring them unconditional slaves to their white masters.[6] This is not to argue that there was an absence of sexual meanings in the music produced by African slaves.[7] It is simply to say that slave music – both religious and secular – was

quintessentially collective music. It was collectively performed and it gave expression to the community's yearning for freedom. The blues, on the other hand, as the predominant post-slavery African American music form, articulated a new valuation of individual emotional needs and desires. The birth of the blues was aesthetic evidence of new psychosocial realities within the Black population. Since this music was presented by individuals singing alone, accompanying themselves with an instrument like the banjo or guitar, the blues also marked the advent of a new performance culture, the borders between performer and audience becoming increasingly distinct.[8] With the rise of the Black entertainment industry and the emergence of the professional blues singer (who was, for the most part, female), accompanied by small and large instrumental ensembles, this individualized mode of presenting popular music crystallized into a performance culture that would have a lasting influence on African American music.

The spirituals, as they survived and were transformed during the post-slavery era, were both intensely religious and the aesthetic bearers of the slaves' collective aspirations for worldly freedom.[9] Under the impact of changed historical circumstances, which brought former slaves in closer contact with the religious practices and ideologies of the dominant culture, sacred music began to be increasingly enclosed within institutionalized religious spaces. If slave religious practices were inseparable from other aspects of everyday life – work, family, sabotage, escape – post-slavery religion gradually lost some of this fluidity and came to be dependent on the church. As sacred music evolved from spirituals to gospel, it increasingly concentrated on the hereafter. According to Lawrence Levine,

> the overriding thrust of the gospel songs was otherworldly. Emphasis was almost wholly upon God with whom Man's relationship was one of total dependence . . . Jesus rather than the Hebrew children dominated the gospel songs. And it was not the warrior Jesus of the spirituals but a benevolent spirit who promised His children rest and peace and justice in the hereafter.
>
> (1975: 175)

The rise of the blues as the most prominent secular genre in early twentieth-century African American music, and its tendency to displace sacred music in the everyday lives of Black people, both reflected and helped to construct a new Black consciousness. This consciousness interpreted God as the opposite of the Devil, religion as the not secular and the secular as largely sexual. There was 'God's music'and the 'Devil's music'; the former was performed in church (although it could also accompany work),[10] while the latter was performed in jook joints, circuses and travelling shows. Yet, even as this binary opposition defined the relationship between the old music and the new music which had old roots, the old music reflected a new ideological grounding of Black religion and

233

the new music was deeply rooted in the same history and culture that had produced the old music. God and the Devil had cohabited the same universe during slavery, not as polar opposites, but rather as complex characters who had different powers and entered into relatively intimate relationships with human beings (and even sometimes with each other).

As many scholars have pointed out, the Devil was often associated with the trickster god Legba or Elegua in Yoruba religions. Some of the folktales Zora Neale Hurston collected in *Mules and Men* (1970) portray the Devil not as evil incarnate, but as a character with whom it was possible to identify in humorous situations. The contemporary blueswoman, Ida Goodson, in describing the religious household in which she was reared, characterizes it as one in which the blues were banned. However, she and her playmates often played and sang the blues when her parents were out. On those occasions when the parents showed up unexpectedly, they easily made the transition to gospel music without missing a beat:

> My mother and father were religious persons. And they liked music, but they liked church music. They didn't like jazz like we do. And of course we could not even play jazz in our home while they were there. But just the moment they would turn their back, go to their society or church somewhere or another, we'd get our neighborhood children to come in there and we'd get to playing the blues and having a good time. But still we'd have one girl on the door watching to see when Mr. Goodson's coming back home or Mrs. Goodson. Because I knew if they came and caught us what we would get. . . . Whenever we'd see my father or my mother coming back home, the girl be saying, 'There come Mr. Goodson 'nem.' And they'd be so close up on us, we'd change the blues, singing 'Jesus keep me near the cross.' After that my mother and father would join us and we'd all get to singing church songs.
>
> <div align="right">(cited in Dall 1989)</div>

Goodson explained later that 'The Devil got his work and God got his work' (cited in ibid.).

During slavery, the sacred universe was relatively all-embracing. Spirituals helped to construct a sense of community among the slaves that was infused with the hope for a better life. In retelling Old Testament narratives about the Hebrew people's struggle against the Pharaoh's oppression, the spirituals evoked a community of African people enslaved in North America which both transcended the slave system and encouraged its abolition. When applied to the religious contours and content of slave-initiated cultural community, the infamous observation by the young Karl Marx that religion is the 'opium' of the people elucidates the utopian potential of slave religion. However, Marx simultaneously goes too far and does not go far enough:

> *Religious* suffering is at the same time an *expression* of real suffering and a protest against real suffering. Religion is the sigh of the oppressed

creature, the sentiment of a heartless world, and the soul of soulless conditions. It is the *opium* of the people. . . . Religion is only the illusory sun about which man revolves so long as he does not revolve about himself.

<div align="right">(1964: 43–4; emphasis in original)</div>

Marx goes too far in the sense that he assumes a necessarily and exclusively ideological relationship between religious consciousness and material conditions, i.e., that religion is fundamentally false consciousness and that the 'self' or community it articulates is necessarily an illusion. Such an all-embracing conception of religion cannot account for its extra-religious dimensions. In the context of slavery, the sacred – and especially sacred music – was one way of preserving African cultural memory. On the other hand, Marx does not go far enough in his assumption that religious consciousness cannot itself play a transformative role. Considering the sacred articulation of freedom battles, as waged by Sojourner Truth and other abolitionists, by insurrectionary leaders like Nat Turner and Denmark Vesey and Underground Railroad conductors like the inimitable Harriet Tubman, religion was far more than an 'illusory sun'. However, the cultural history of African American sacred songs does give new meaning to Marx's critique of the philosophy of religion. As John Lovell Jr has argued so persuasively, the spiritual was embedded in and gave expression to a powerful yearning for freedom.[11] It was indeed the 'soul' of 'soulless conditions'.

While the spirituals articulated the hopes of Black slaves in religious terms, the vast sense of disappointment that followed abolition – when economic and political liberation seemed more unattainable than ever – helped to create a blues discourse[12] that represented freedom in more immediate and accessible terms. If the material conditions for the freedom about which the slaves had sung in their spirituals seemed no closer after slavery than they had seemed before, there were distinct differences between the slaves' personal status under slavery and that during the post-war period. In three major respects, the abolition of slavery had radically transformed their personal status: first, there was no longer a proscription on freely chosen individual travel; second, education was now a realizable goal for individual men and women; third, sexuality could be explored freely by individuals who now could enter into autonomously chosen personal relationships. The new blues consciousness was shaped by and gave expression to at least two of these three transformations: travel and sexuality. In male and female blues, travel and sexuality are pervasive themes, both by themselves and in intermingled ways.

James Cone has defined the blues, borrowing C. Eric Lincoln's phrase, as 'secular spirituals':

They are *secular* in the same sense that they confine their attention solely to the immediate and affirm the bodily expression of black soul,

<div align="center">235</div>

including its sexual manifestations. They are *spirituals* because they are impelled by the same search for the truth of black experience.

(1972: 112; emphasis in original)

Cone's essentialism aside, his interpretation of the blues as drawing upon the sacred consciousness incorporated in the spirituals points to what may very well be the key to understanding the religious attitudes condemning the blues as the Devil's music. Levine also emphasizes the 'blurring of the sacred and the secular' that is evident both in gospel music and in the blues. In fact, as Levine argues, it may not have been the secularity of the blues that produced such castigation by the church, but rather precisely their sacred nature:

The blues was threatening not primarily because it was secular; other forms of secular music were objected to less strenuously and often not at all. Blues was threatening because its spokesmen and its ritual too frequently provided the expressive communal channels of relief that had been largely the province of religion in the past.

(1975: 237)

Although both Cone and Levine make references to Mamie Smith, Ma Rainey, Bessie Smith and other women who composed and performed blues songs, they, like most scholars who have written about the blues, tend to view women as marginal to the production of the blues. In the passage from Levine's study quoted above, he very specifically refers to the 'spokesmen' of the blues. However, with the simple substitution of 'spokeswomen', the argument he suggests might become even more compelling and perhaps more deeply revealing of the new religious consciousness about which he writes. If blues practices, as Levine asserts, tended to appropriate previously religious channels of expression, this appropriation was associated with women's voices: women who summoned sacred responses to their messages about sexuality. As religious consciousness came increasingly under the control of institutionalized churches, so male dominance over the religious process came to be taken for granted. Of the blues singers who performed as professional artists and commanded large-scale audiences in revival-like gatherings (at the same time as male ministers were becoming a professional caste), Gertrude 'Ma' Rainey and Bessie Smith were the most widely known. When they preached about sexual love, they were articulating a collective experience of freedom, which, for many Black people, was the most powerful evidence that slavery no longer existed.

The expression of socially unfulfilled dreams in terms of individual sexual love is, of course, not peculiar to the African American experience. But it had quite different ideological implications as a phenomenon associated with the capitalist schism between the public and the private realms. With the

consolidation of industrial capitalism and its attendant alienation, the sphere of personal love and domestic life came to be increasingly idealized as the arena in which happiness was to be sought. This held a special significance for women, since love and domesticity were supposed to constitute the outermost limits of their lives, while men were allowed more extensive membership in the public community. The images of women and social constructions of happiness found in the themes of European American popular songs are ideologically rooted in this process.

While the blues did not entirely escape the influences that shaped the role of romantic love in the popular songs of the dominant culture, I am arguing that the incorporation of personal relationships into the blues has its own historical specificity. Love was not represented as an idealized realm where unfulfilled dreams of happiness were posited. The historical African American vision of individual sexual love linked it inextricably with possibilities of social freedom in the economic and political realms as well. Unfreedom during slavery involved, among other things, a prohibition on freely chosen, enduring family relationships. Because slaves were legally defined as commodities, women of childbearing age were valued in accordance with their breeding potential and were often forced to copulate with the men – viewed as bucks – chosen by their owners for the sole purpose of producing valuable progeny. Moreover, direct sexual exploitation of African women by their white masters was a constant feature of slavery.[13] What permanence in familial relationships the slaves did manage to construct was always subject to the whim of their masters and the potential profits to be reaped. The suffering caused by the forced break-ups of slave families has been abundantly documented in slave narratives[14] as well as in such scholarly studies as *Black Family in Slavery and Freedom* by Herbert Gutman (1977). Since the economic and political ingredients of freedom were largely denied to Black people in the aftermath of slavery, it is understandable that the personal and sexual dimensions of freedom acquired an expanded importance. The focus on sexual love in blues music was thus quite different from the prevailing idealization of romantic love in the dominant culture, i.e., a superficial surrogate for unrealized social aspirations. For recently emancipated slaves, freely chosen sexual love became a mediator between historical disappointment and the new social realities of an evolving African American community. This may be what Ralph Ellison is alluding to in what he calls 'the mysteriousness of the blues': 'their ability to imply far more than they state outright and their capacity to make the details of sex convey meanings which touch on the metaphysical' (1972: 245).

During the earliest phases of their history, blues were essentially a male phenomenon. The archetypal blues singer was a solitary wandering man accompanied by his banjo or guitar, and, in the words of Giles Oakley, his principal theme 'is the sexual relationship. Almost all other themes, leaving town, train rides, work trouble, general dissatisfaction sooner or later revert

to the central concern' (1976: 59). In women's blues, which, as one might expect, were an integral ingredient of the rising Black entertainment industry, there was an even more pronounced emphasis on love and sexuality. The representations of love and sexuality in women's blues often blatantly contradicted the prevailing ideological assumptions regarding women and/in love. They also challenged the notion that women's 'place' was in the domestic sphere. Based on the social realities of middle-class white women's lives, the ideological confinement of women to the domestic or 'personal' sphere was incongruously applied to all women, regardless of race or class.[15] This led to inevitable contradictions between social expectations and Black women's social realities. Women of that era were expected to seek fulfilment within the confines of marriage, with the husband functioning as provider and the children as evidence of their worth as human beings. It is therefore significant that within the body of women's blues songs there exists a sparsity of allusions to marriage and domesticity.

In Bessie Smith's rendition of 'Sam Jones Blues'[16] – which contains one of the few comments on the subject of marriage to be found in the body of her work – marriage is acknowledged only in relation to its dissolution. Her performance of this song satirically accentuates the contrast between the dominant cultural construction of marriage and the stance of economic independence Black women were compelled to assume by the sheer requirements of survival:

> Sam Jones left his lovely wife just to step around
> Came back home 'bout a year, looking for his high brown
> Went to his accustomed door and knocked his knuckles sore
> His wife she came, but to his shame, she knew his face
> no more
> Sam said I'm your husband, dear
> But she said dear, that's strange to hear
> You ain't talking to Mrs. Jones, you speakin' to Miss
> Wilson now
> I used to be your lofty mate
> But the judge done changed my fate
> Was a time you could have walked right in and called this place your
> home sweet home
> But now it's all mine for all time, I'm free and livin'
> all alone
> . . .
> Say, hand me the key that unlocks my front door
> Because that bell don't read 'Sam Jones' no more, no
> You ain't talkin' to Mrs. Jones, you speakin' to Miss Wilson
> now

Although the written lyrics reveal a conversation between 'proper' English

238

and Black working-class English, only by listening to the song do we experience the full impact of the way Smith plays with language in her recording. References to marriage as perceived by the dominant white culture are couched in irony. She mocks the notion of eternal matrimony – 'I used to be your lofty mate' – using words and a teasing intonation evoking white cultural conceptions. On the other hand, when she indicates the perspective of the Black woman, Miss Wilson – who 'used to be Mrs. Jones' – she sings in a comfortable, bluesy Black English. This song is remarkable for the way in which the clash between two cultures' perceptions of marriage – and particularly women's place within the institution – is translated into musical contrast and contradiction. It is easy to imagine the testifying responses that Bessie Smith no doubt evoked in her female audiences, responses that affirmed working-class Black women's sense of themselves as relatively emancipated if not from marriage itself, then at least from some of the most confining ideological straits of the institution.

The protagonists in women's blues are seldom wives and virtually never mothers. A possible explanation for the absence of allusions to institutionalized marriage might lie in the semantic differences between mainstream words designating 'male spouse' and the African American working class argot which refers to both husbands and male lovers (and even in some cases female lovers) as 'my man' or 'my daddy'. But while most Black married couples, especially during the era of Bessie Smith, had children, blueswomen rarely sang about them.[17] The absence of the mother figure in the blues does not imply a rejection of motherhood per se, but rather suggests that blueswomen found the cult of motherhood irrelevant to their realities. In contrast to the prevailing representations of womanhood, the female figures evoked in women's blues are independent women not subject to the domestic orthodoxy that constructed female subjects of the era.

In the songs recorded by Bessie Smith and Ma Rainey, there are only four – all by Bessie Smith – that refer to marriage within a relatively neutral context or in a way that takes the marital relationship for granted. In 'Poor Man's Blues',[18] mention is made of the gross disparities between the economic conditions of the working man's wife and the rich man's wife: 'Poor working man's wife is starvin', your wife's living like a queen.' In 'Pinchbacks – Take 'Em Away',[19] advice is offered to other women with respect to the most desirable quality to be sought in a husband – he should be a working man. Bessie Smith sings the following phrases in a way that demands she be taken seriously.

> Girls, take this tip from me
> Get a working man when you marry
> And let all these sweet men be
>
> . . .

239

> There's one thing about this married life
> That these girls have got to know
> If a sweet man enter your front gate
> Turn off your lights and lock your door

Even though this song assumes that most women probably will get married, it does not evoke the romantic expectations usually associated with marriage. Rather it warns women not to fall into marriage relationships in which they will end up supporting an exploitative man – a 'sweet man' or a 'pinchback'.

'Take Me For A Buggy Ride',[20] a popular song filled with sexual innuendo and recorded in 1933 during the very last session of Bessie Smith's career, contains a passing uncritical reference to marriage:

> Daddy, you're as sweet as you can be when you take me for a
> buggy ride
> When you set me down upon your knee and ask me to be your bride

According to Chris Albertson, Smith herself decided to record no blues during what would be her final recording session. She wanted to sing only popular songs, all of which were composed, interestingly enough, by the husband and wife team of Leola B. Wilson and Wesley 'Socks' Wilson (1972: 188).[21] Her producer, John Hammond, may have had something to do with this decision to exclude blues songs. For, after a hiatus in her recording career – occasioned both by the apparently approaching obsolescence of the blues and the 1929 Stock Market Crash that had left the recording industry in shambles – there were obvious economic reasons for wanting to appeal to as broad an audience as possible.

The sexual allusions in these songs, along with others recorded previously during the 1930s, have caused them to be labelled quasi-pornographic. While sexual metaphors abound in these songs, the female characters are clearly in control of their sexuality, articulating it in a way that is exploitative neither of their partners nor of themselves. It is misleading, I think, to refer to such songs as 'Need A Little Sugar in My Bowl'[22] as pornographic. Nonetheless, Hammond is probably correct in his contention that 'they do not compare with Bessie's own material of the twenties' (cited in Albertson 1972: 188). The reference to marriage in 'Take Me For a Buggy Ride' may very well be a result of Bessie Smith's work crossing over into a cultural space that required her to position herself in greater ideological proximity to white audiences as well as Black. Having put together a swing accompaniment for this last session consisting of Black and white musicians – Buck Washington, Jack Teagarden, Chu Berry, Frankie Newton, Billy Taylor and Bobby Johnson, with Benny Goodman playing on one number – John Hammond certainly was expecting to see these records distributed outside the 'race records' market (Brooks 1982: 224–5).

Gertrude 'Ma' Rainey, a pioneer on the Black entertainment circuit whose

title, 'Mother of the Blues', predated her recording career, was responsible for shaping themes of women's blues that would influence many generations of blueswomen. In the songs she composed and/or recorded, the institution of monogamous marriage was often cavalierly repudiated with the kind of attitude that is usually gendered as male. 'Blame It On The Blues',[23] for example, implicitly rejects the sexual exclusivity of marriage. Reflecting on the sources of her distress, the protagonist finds that she can blame them neither on her 'husband', nor her 'man', nor her 'lover'. The lyrics of this song – and the tragi-comic way Rainey sings them – refuse to privilege marriage over non- or extra-marital sexual partnerships:

> Can't blame my mother, can't blame my dad
> Can't blame my brother for the trouble I've had
> Can't blame my lover that held my hand
> Can't blame my husband, can't blame my man

In 'Shave 'Em Dry',[24] a song which employs an abundance of provocative sexual metaphors, Rainey sings about a woman involved with a married man. 'When your wife comes', she sings with unflappable seriousness, 'tell her I don't mean no harm.' And in her spoken introduction to 'Gone Daddy Blues',[25] the woman who has left her husband for another man seems to be playing with the notion of convincing him to take her back:

Man: Who's that knocking on that door?
Ma: It's me, baby.
Man: Me who?
Ma: Don't you know I'm your wife?
Man: What? wife?
Ma: Yeah.
Man: Ain't that awful? I don't let no woman quit me but one time.
Ma: But I just quit one li'l ole time, just one time!
Man: You left here with that other man, why didn't you stay?

'Misery Blues'[26] is the only one of Rainey's songs in which the woman appears truly oppressed by the expectations associated with the institution of marriage. She is singing the 'misery blues' because she has allowed herself to be deceived by a man who promised to marry her, i.e., to support her in the traditional patriarchal way. She expected marriage to relieve her of the daily toil she performed. The husband-to-be in this song not only does not make good on his promise of marriage, he absconds with all her money:

> I love my brownskin, indeed I do
> Folks I know used to me being a fool
> I'm going to tell you what I went and done
> I give him all my money just to have some fun

He told me that he loved me, loved me so
If I would marry him, I needn't to work no mo'
Now I'm grieving all the time
Just because I didn't know that he was lyin'

Rainey sings this song mournfully, emphasizing the woman's grief; yet it can be construed as an 'advice' song, warning women who might be similarly deceived by romantic expectations associated with the bourgeois and patriarchal institution of marriage.

Bessie Smith's work poses more explicit challenges to the male dominance that ideologically inheres in this institution. In 'Money Blues',[27] for example, it is the wife who makes life unbearable for her husband by her incessant demands for money and high living. The husband, Samuel Brown, has 'beer money', but the wife demands champagne. (As is often the case, the 'blues' in the title notwithstanding, this is a popular song, not a twelve bar blues.) In 'Young Woman's Blues',[28] one of Smith's own compositions, the protagonist is simply not interested in marriage. Smith's performance of the following verse exudes a self-confident sense of female independence and unabashed embracing of sexual pleasure:

No time to marry, no time to settle down
I'm a young woman and ain't done runnin' 'round

The same sentiment is definitively restated in the closing lines of the song.

I ain't no high yella, I'm a deep killer brown
I ain't gonna marry, ain't gonna settle down
I'm gonna drink good moonshine and rub these browns down
See that long lonesome road, lord, you know it's gotta end
And I'm a good woman and I can get plenty of men

In what is undoubtedly the most disturbing reference to marriage in Bessie Smith's work, the narrator of 'Hateful Blues'[29] threatens to use the butcher knife she received as a wedding present to carve up her fickle husband.

If early women's blues contain few innocent references to marriage, evocations of traditional female domesticity, whether associated with marriage or not, are rare as well. When women are portrayed as having fulfilled the domestic requirements socially expected of women in relationships with men, it is often to make the point that they have nonetheless been abused or abandoned. In Bessie Smith's 'Weeping Willow Blues',[30] the narrator proclaims:

Folks, I love my man, I kiss him morning, noon, and night
I wash his clothes and keep him clean and try to treat
 him right
Now he's gone and left me after all I've tried to do.

242

Smith sings these lines with convincing sincerity, thus demystifying the notion that the fulfilment of putative female domestic responsibilities is the basis for happiness in marriage. On the other hand, 'Yes Indeed He Do'[31] is full of irony in its references to domesticity, implicitly criticizing the stultifying household work women are compelled to do for their men:

> I don't have to do no work
> Except to wash his clothes and darn his socks and press
> his pants and scrub the kitchen floor

Another composition by Bessie Smith, the sardonic 'Safety Mama',[32] is a humorous critique of the sexual division of labour that confines women to the household. In this song, there is an inverted image of domesticity, in which the man is compelled by the woman to take on what are assumed to be female household chores as punishment for his male supremacist behaviour in the relationship:

> So wait a while, I'll show you child
> Just how to treat a no good man
> Make him stay at home, wash and iron
> Tell all the neighbors he done lost his mind

The manner in which Bessie Smith creates this musical caricature of domesticity reveals the beginnings of an oppositional attitude towards the ideology of male supremacy.

There are solid historical reasons why romanticized images of marriage are generally banished from women's blues, along with the permanency in personal relationships implied by the bonds of matrimony. The vision of marriage as the ultimate goal of women's lives – encouraged by the dominant culture – contradicted the realities of Black people's lives during the half century or so following the abolition of slavery. Desertion and rejection by male lovers, on the other hand, were situations objectively conditioned by the historical circumstances of the era. In search of work – and, indeed, in search of the eternally elusive guarantees of security and happiness – men jumped freight trains and wandered from town to town, from state to state, from south to north. Certainly, there were objective, economic reasons for undertaking journeys away from home. Yet even when the jobs were not to be found and when the available employment was back-breaking and poorly compensated, the very process of travelling tended to generate a feeling of exhilaration and freedom in those who had been chained for centuries to geographical sites designated by slave-masters. That this impulse to travel would come to infect great numbers of Black men as a socio-historically initiated compulsion would later be affirmed by Robert Johnson when he sang 'Hellhound On My Trail':[33]

I got to keep moving, I got to keep moving
Blues falling down like hail, blues falling down like hail
I can't keep no money, hellhound on my trail
Hellhound on my trail, hellhound on my trail

Many of the absconding and unfaithful lovers memorialized by blues-
women may have been in pursuit of that fleeting glimpse of freedom offered
by the new historical possibility of self-initiated travel. Most women, on the
other hand, were denied the option of taking to the roads. Peetie Wheatstraw
offered in his 'C. & A. Blues' one of the many blues versions of this contrast
between the male and female condition, portraying the man as assuaging his
pain through travel and the woman assuaging hers with tears:

When a woman gets the blues, she hangs her head and cries
When a man gets the blues, he flags a freight train and rides.
(cited in Oliver 1960: 85)

Bessie Smith recorded a few songs – such as 'Chicago Bound Blues'[34] –
which would seem to confirm this vision of men and women's divergent
responses to the blues. But in general, blueswomen did not acquiesce in the
idea – which occurs in so many variations in male country blues – that men
travel and women cry. The women who sang the blues did not typically affirm
female resignation and powerlessness nor did they consistently encourage
reliance on tears as an expression of femininity. While women certainly did
not possess the right to travel on such a grand scale as men, they found ways
to express themselves that were often at variance with the prevailing
standards of femininity. Even as they shed their tears, they found the courage
to lift their heads and fight back, asserting their right to be respected not as
appendages or victims of men but as truly independent human beings with
vividly articulated sexual desires. Blues queens thus provided emphatic
examples of Black female independence.

A substantial number of songs in Gertrude 'Ma' Rainey's recorded legacy
suggest some of the structures of gender politics in the Black community that
diverged from those of the dominant culture. Taken as a body, the songs she
recorded that revolved around love relationships often either mirror or
provide responses to songs associated with the male country blues tradition.
While male blues deal with a wider range of experiences, accumulated during
men's travels, those that revolve around sexuality or include observations on
love relationships are not always radically different from their female
counterparts in the behaviour they describe and the images they evoke. As
Sandra Lieb has observed, contrary to what one might expect, there are not
many songs in the body of Ma Rainey's recorded music about women who
feel so immobilized by their lover's infidelity, desertion or mistreatment that
they are incapable of action or feel pushed to the brink of self-destruction.
'Only thirteen of her songs [she recorded ninety-two] describe a woman in

abject sorrow, lying in bed and weeping for her absent man' (Lieb 1981: 83). There are, indeed, pieces in which women celebrate their right to conduct themselves as expansively and even as undesirably as men. In Ma Rainey's blues, the women often abandon their men and consider it quite normal to threaten them even to the point of violence.

While the overwhelming majority of Bessie Smith's 159 available recorded songs allude to rejection, abuse, desertion and unfaithful lovers, the preponderant response, as is the case with Ma Rainey, is not resignation and despair. On the contrary, the most frequent stance assumed by the women in these songs is one of independence and assertiveness, indeed defiance, which often borders on and sometimes erupts into violence. The first song recorded by Bessie Smith, a cover of Alberta Hunter's popular 'Down Hearted Blues',[35] portrays a heartbroken woman whose love for a man was answered with mistreatment and rejection. But her bout with the blues does not result in her dejectedly 'hanging her head and crying'. Bessie Smith represents this woman as proud and even contemptuous of the man who has mistreated her, singing the following lines in a way that affirms this woman's self-respect:

> It may be a week, it may be a month or two
> It may be a week, it may be a month or two
> But the day you quit me, honey, it's comin' home to you.

It may be true, as Paul Garon has observed, that '[T]he blues is . . . a self-centered music, highly personalized, wherein the effects of everyday life are recounted in terms of the singers' reactions' (1978: 35). At the same time, however, the blues give expression to larger world-view considerations associated with the working-class Black population. Thus 'Down Hearted Blues' does not conclude with the warning issued to the man who has mistreated, then deserted the female protagonist in the song. Instead it ends with an address to men in general, a bold, perhaps implicitly feminist response to the reign of male supremacy:

> I got the world in a jug, the stopper's in my hand
> I got the world in a jug, the stopper's in my hand
> I'm gonna hold it until you men come under my command.

An equally bold challenge can be found in Ma Rainey's marvellously humorous 'Barrel House Blues',[36] which affirms women's right to partake of alcohol and good times and to engage in acts of infidelity in a way that suggests equality with men:

> Papa likes his sherry, Mama likes her port
> Papa likes to shimmy, Mama likes to sport
> Papa likes his bourbon, Mama likes her gin
> Papa likes his outside women, Mama likes her outside men

This signifying blues, in drawing parallels between men's and women's

proclivities for drink and sex, launches a brazen challenge to the dominant notions of woman's inferior social status. This portrait of a good-time woman who is at ease with her body and her sexuality and is able to confront men as sexual equals is one that frequently recurs in the work of the classic blues singers. Indeed, it probably depicts some of the realities of the Black women who travelled the professional entertainment circuits. It was widely known that Ma Rainey could compete with any man when it came to acknowledging and seeking to satisfy sexual desires, and that Bessie Smith could show up any man who challenged her to a drinking duel.

Women's blues of Ma Rainey's and Bessie Smith's era bear witness to the contradictory historical demands made of African American women. On the one hand, they were expected to confine their lives within the parameters of marriage and love relationships simply because they were the female half of the African American community. On the other hand, the cumulative effect of their experiences both during and after slavery rendered the traditional female posture incongruous in response to the social realities they encountered. In the blues, therefore, male–female relationships are stretched to their outermost limits and beyond. A typical example is one of Bessie Smith's early songs, 'Mistreating Daddy',[37] which opens with an acknowledgement of a woman's dismal emotional state brought on by an abusive and insensitive lover:

> Daddy, mama's got the blues, the kind of blues that's
> > hard to lose.
> 'Cause you mistreated me and drove me from your door.

Smith sings these lines as if to convince us that this woman has not only attempted to make the relationship work, but is utterly despondent about having been victimized by a man she may have loved. Before too long, however, she menacingly informs him,

> If you see me setting on another daddy's knee
> Don't bother me, I'm as mean as can be
> I'm like the butcher right down the street
> I can cut you all to pieces like I would a piece of meat

Fearless, unadorned realism is a distinctive feature of the blues. Their depictions of sexual relationships are not distorted by the superficial idealizations of love characteristic of the American popular song tradition. Romantic love is seldom romanticized in the blues. No authentic blueswoman could, in good faith, sing about her conviction that a dashing prince would appear to usher her into the 'happily-ever-after'. There are only a few songs in the body of Bessie Smith's recorded performances (and none in Rainey's) that conceptualize love relationships – or the desire to participate in them – within a strictly masculinist framework. The classic blueswomen sang of female aspirations for happiness and frequently associated these with sexual

partnerships, but they rarely ignored the ambiguities and contradictions of such yearnings. In 'Honey Where You Been So Long',[38] Ma Rainey assumes the role of a woman who is overjoyed that her man is returning:

> He'll be returning and glad tidings he will bring
> Then I'll throw my arms around him, then begin to sing

But she does not attempt to pretend that this man is the paragon of perfection:

> Honey, where you been so long
> Never thought you'd treat me wrong
> Look how you have dragged me down

The fusion of a language style that mocks the dominant white culture with down home Black English, as in Bessie Smith's 'Sam Jones Blues', highlights the cultural contradictions Black women no doubt experienced in comparing their own attitudes towards love with the idealizations of the dominant culture. The woman in Rainey's 'Lawd Send Me A Man Blues'[39] harbours no illusions about the relationship she desires with a man. She is lonely and is wondering 'who gonna pay my board bill now'. Appealing for any man she can get, she pleads, singing with a bluesy zeal,

> Send me a zulu, a voodoo, any old man
> I'm not particular, boys, I'll take what I can

There is a similar message in Bessie Smith's 'Baby Doll'[40]:

> I want to be somebody's baby doll so I can get my loving
> all the time
> I want to be somebody's baby doll to ease my mind
> He can be ugly, he can be black, so long as he can eagle rock
> and ball the jack

These blueswomen have no qualms about announcing female desire to 'get their loving'. Such representations of sexual autonomy and openly expressed female sexual desire are powerful indicators of the historical possibilities of equality, as they were placed on the historical agenda via the cultural politics of the blues queens.

The realism characteristic of the blues genre does not mean that the texts demand literal interpretations. On the contrary, blues texts reveal multi-layered meanings and astounding profundity. Precisely because the blues confront reality in its rawest manifestations, they are capable of making complex statements on human circumstances that often transcend the particular historical and cultural borders of their originators and most faithful performers. There is, for example, a core of meaning in the texts of the classic blueswomen that, although pre-feminist in a historical sense, reveals the

247

extent to which Black women of that era were acknowledging issues that are at the centre of contemporary feminist discourse.

The first activist moments of the contemporary women's movement, that sought to expose the ideological separation of the public and private spheres as central to the structure of sexism, focused on the issue of misogynist violence. During the early 1970s women began to speak publicly about their experiences of rape, battering and about the violation of their reproductive rights. Hidden behind a shroud of silence, these assaults against women traditionally had been regarded as a fact of private life to be shielded at all costs from the scrutiny of the public sphere. The conceptual context of these speak-outs was the notion that 'the personal is political'. One of the few cultural spaces in which a tradition of public discourse on male violence had been previously established was created by the performances of the classic blueswomen – especially Bessie Smith, the 'Empress of the Blues'. One explanation for the fact that the blueswomen of the 1920s – and the texts they present – failed to respect the taboo on speaking publicly about domestic violence is that the blues as a genre never acknowledges the discursive and ideological boundaries categorically separating the private sphere from the public. There is no great body of historical literature on battering because white, well-to-do women, who might have been in a position to write about their own experiences in abusive relationships, have only recently been convinced that such privately executed violence is a suitable subject of public discourse.[41] But there is a body of orature about domestic abuse in the songs of blueswomen like Ma Rainey and Bessie Smith. Violence against women was always an appropriate topic for women's blues. The contemporary urge to break the silence surrounding misogynist violence and the organized political movement challenging violence against women has an aesthetic precursor in the work of the classic blues singers.

Women's blues have sometimes been accused of promoting acquiescent and therefore anti-feminist responses to misogynist abuse. It is true that some of the songs recorded by Gertrude Rainey and Bessie Smith may seem to exemplify acceptance of male violence – and sometimes even masochistic delight in being the target of lovers' beatings. Such claims are made, however, by people who do not take into account the extent to which blues meaning is manipulated and transformed – sometimes even into its opposite – by the nature of blues performance. Blues makes abundant use of humour, satire and irony, revealing their historic roots in the music of slavery, wherein indirect methods of expression were the only means by which the oppression of the slave system could be denounced. In this sense, the blues genre is a direct descendant of work songs, which often relied on indirectness and irony to highlight the inhumanity of slave-owners in such a fashion that the targets of the irony were sure to misunderstand the intended meaning.

Bessie Smith sings a number of songs whose lyrics might be interpreted as condoning emotional and physical abuse as attendant hazards for women

involved in sexual partnerships. But based on her musical presentations of these songs, it is possible to argue persuasively that there is an implicit critique of male abuse. One of the strongest examples of this is 'Yes Indeed He Do',[42] in which Bessie Smith's sarcastic presentation of the lyrics transforms their observations on an unfaithful, abusive and exploitative lover into a scathing critique of male violence:

> Is he true as stars above me? What kind of fool is you?
> He don't stay from home all night more than six times
> a week.
> No, I know that I'm his Sheba, and I know that he's
> my sheik
> And when I ask him where he's been, he grabs a rocking
> chair
> Then he knocks me down and says it's just a love lick
> dear
> . . .
> If he beats me or mistreats me, what is that to you?
> I don't have to do no work
> Except to wash his clothes and darn his socks and
> press his pants and scrub the kitchen floor
> I wouldn't take a million for my sweet, sweet daddy Jim
> And I wouldn't give a quarter for another man like him
>
> Gee, ain't it great to have a man that's crazy over
> you?
> Oh, do my sweet, sweet daddy love me? Yes indeed he do

Edward Brooks, author of *The Bessie Smith Companion*, makes the following comment about this song:

> Bessie delivers the song with growling gusto, as if it were really a panegyric to an exemplary lover; she relates his wrongs with the approval of virtues and it comes as a jolt when the exultation in her voice is compared with her actual words.
>
> (1982: 143)

Brooks' analysis assumes that Smith (although he never knew her personally, he always refers to her as 'Bessie') was unselfconscious in her performance of this song. He therefore misses its probably intentional ambiguity and complexity. Since Bessie Smith was an accomplished performer, an actor and especially a comedian, she was well acquainted with the uses of humour and irony. Her decision to sing 'Yes Indeed He Do' with mock praise and elation was, in all likelihood, a conscious attempt to highlight, in the most dramatic way, the inhumanity and misogyny of male batterers.

In any case, it would not have been the only time Bessie Smith employed

this particular approach. 'Yes Indeed He Do' was recorded in 1928, five years after she began her career as a recording artist. In the first year she recorded 'Outside of That',[43] a song about a man who was regularly abusive, but who nonetheless was a great lover. The sarcasm in 'Yes Indeed He Do' is much more obvious than in the earlier song, but 'Outside of That' also deserves a deeper examination. The woman in this song enthusiastically proclaims her love for a man who beats her, and who becomes especially violent in response to her announcing – in jest, claims the narrator – that she no longer loves him:

> I love him as true as stars above
> He beats me up but how he can love
> I never loved like that since the day I was born.
> I said for fun I don't want you no more
> And when I said that I made sweet papa sore
> He blacked my eye, I couldn't see
> Then he pawned the things he gave to me.
> But outside of that, he's all right with me.
>
> I said for fun I don't want you no more.
> And when I said that I made sweet papa sore
> When he pawned my things I said you dirty old thief
> Child, then he turned around and knocked out both
> of my teeth.
> Outside of that, he's all right with me.

At first consideration, it may appear that this song embraces and even glorifies male violence. It has been interpreted as overtly condoning sado-masochistic relationships. But when one considers the lyrics, quite apart from Bessie Smith's interpretation, there is no real evidence that the woman derives pleasure from the beatings she receives. On the contrary, she lauds her lover for his sexual expertise and proclaims that she loves him despite the brutality he inflicts upon her. The irony lurking in the lyrics warns against a literal reading. Bessie Smith's presentation is somewhat more subtle than in 'Yes Indeed He Do', but a closer listening does confirm, I think, that she uses her voice to ridicule the woman – even if she herself happened to be that woman – who would embrace with such enthusiasm a relationship so detrimental to her own physical and emotional well-being.

The historical pattern of secrecy regarding domestic violence is linked to the failure to validate it as a social problem deserving political attention. It was so effectively confined to the private sphere that until relatively recently police officers would often intervene in domestic disputes only in 'life-and-death' situations. Even in the 1990s, police intervention, when it does occur, is often accompanied by a serious reluctance to 'get involved in domestic disputes'.[44] 'Outside of That' effectively presents violence against women as a problem to be publicly reckoned with. First, the problem is named in the

voice of the woman who is the target of the battering: 'He beats me up'; 'He blacked my eye, I couldn't see'; 'he turned around and knocked out both of my teeth'. By naming domestic violence in a context that is communal, i.e., public, the song implicitly defines it as a problem worthy of public discourse, so that women who have been victims of such abuse can perceive it as a shared and thus social affliction.

Whether individual women who constituted Bessie Smith's audience took advantage of this 'speak bitterness' session as a basis for developing more critical attitudes toward the domestic violence they suffered is a matter for speculation. Certainly the political campaign to eradicate battering did not emerge in the United States until the 1970s. However, there is evidence that among Black working-class women, oppositional stances *vis-à-vis* male violence were culturally possible, at least on the level of individual experience. In fact, the lyrics indicate some measure of resistance by the victim: 'I said for fun I don't want you no more'; 'when he pawned my things, I said you dirty old thief'. Even though these comments are offered in a humorous vein, they nevertheless imply that the victim does not cower before the batterer but rather challenges his right to assault her with impunity. Moreover, in Bessie Smith's rendering of this song, the recurring phrase 'outside of that, he's all right with me' is sung with a satirical edge, implying that its significance may be precisely the opposite of its literal meaning. Ma Rainey's 'Black Eye Blues'[45] is a similarly comic presentation of the issue of domestic violence, describing a woman named Miss Nancy who not only defends herself physically but also assumes an attitude of defiance towards her man:

> Take all my money, blacken both my eyes
> Give it to another woman, come home and tell me lies
> You low down alligator, just watch me sooner or later
> Gonna catch you with your britches down

What is most significant about women's blues as they suggest emergent feminist insurgency is that they unabashedly name the problem of male violence, ushering it out of the shadows of domestic life behind which society dictated it be hidden. Even when she does not venture to offer a critical perspective, Bessie Smith names the problem as well as the ambivalence it occasions. In 'Please Help Me Get Him Off My Mind',[46] for example, the protagonist consults a gypsy about her emotional entanglement with a violent man, whose influence she wishes to exorcise from her mind. Other explicit references to physical abuse in Bessie Smith's work can be found in 'It Won't Be You',[47] 'Slow and Easy Man',[48] 'Eavesdroppers' Blues',[49] 'Love Me Daddy Blues',[50] 'Hard Driving Papa'[51] and 'T'ain't Nobody's Bizness If I Do'.[52] In the first song, the protagonist sardonically celebrates her decision to leave her man by informing him that if in fact her next partner 'beats me and breaks my heart', at least 'it won't be you'. 'Slow and Easy Man' presents a woman who presumably delights in the sexual pleasures offered her by a

partner reminiscent of the famed 'easy rider',[53] but there is a casual reference to the fact that this man 'curses and fights'. We can assume that the woman is indeed the target of verbal and physical abuse sometimes, as she is in 'Eavesdroppers' Blues' where the man turns her 'eyes all blue' if she finds no money to give him. In 'Love Me Daddy Blues', as in 'Please Help Me Get Him Off My Mind', the woman experiences the dilemma typical of battered wives who continue to love their abusers. Edward Brooks describes the last lines of 'Hard Driving Papa' as 'a celebration of masochism' (1982: 109). But when Bessie Smith sings 'Because I love him, 'cause there's no one can beat me like he do', it is clear that rather than rejoicing in the beatings she has received, she is expressing utter desperation about her predicament. The penultimate line, 'I'm goin' to the river feelin' so sad and blue', is delivered in such a melancholy manner that we are all but certain that the protagonist is considering the possibility of suicide. This is one of those rare moments of apparently unmitigated despair in Bessie Smith's work. To interpret the reference to battering as a celebration is to ignore the complexity of the song.

One of Bessie Smith's most widely known recordings – one that is also associated with Billie Holiday – is the Porter Grainger composition, 'Tain't Nobody's Bizness If I Do'. Like 'Outside of That', it has been interpreted as sanctioning female masochism. For women whose consciousness regarding domestic violence has been radically transformed by feminist activism – which has effectively challenged the ideological location of male violence against women within a private sphere where male discretion determines the fate of women – it is extremely painful to hear Bessie Smith and Billie Holiday sing the following verse so convincingly:

> Well, I'd rather my man would hit me than to jump right
> up and quit me
> 'Taint nobody's bizness if I do do do
> I swear I won't call no copper if I'm beat up by my papa
> 'Tain't nobody's bizness if I do (if I do)

Yet, the lyrics of this song touched a chord in Black women's lives that cannot be ignored. And while it does contradict other postures assumed in Bessie Smith's work that emphasize women's strength and equality, it does not annul them. Moreover, this seeming acquiescence in battering is presented within a larger affirmation of women's right as individuals to conduct themselves however they wish – however idiosyncratic their behaviour might seem and regardless of the possible consequences. The song begins:

> There ain't nothing I can do or nothing I can say
> That folks don't criticize me
> But I'm going to do just as I want anyway
> And don't care if they all despise me

What follows is a series of hypothetical and extreme situations that appear

to be presented more for their shock value than out of any desire on the female protagonist's part to actually conduct herself thus. For example:

> If I should take a notion to jump into the ocean
> 'Tain't nobody's bizness if I do do do do.

Even if she did choose to take her life, she is not thereby suggesting that such conduct should be universalized.

Violence against women remains a pandemic phenomenon. And almost equally pandemic – although fortunately less so today than during previous eras – is women's inability to break free from this web of violence. Which is to say that the conduct defended by the woman in this male-authored song is not so unconventional after all. The presentation of this posture as idiosyncratic may well have been a catalyst for introspective criticism on the part of many women in Bessie Smith's listening audience who found themselves entrapped in similar situations. In the final analysis, even 'Tain't Nobody's Business If I Do' implies a hint of criticism *vis-à-vis* the phenomenon of misogynist violence.

Ma Rainey's 'Sweet Rough Man'[54] is described by Sandra Lieb as a 'classic expression of the "hit me, I love you" tradition of masochistic women's songs' (1981: 120). In her analysis, Lieb argues that this song is an exception within the body of Ma Rainey's work in the sense that it presents 'a cruel, virile man abusing a helpless, passive woman' (ibid.). Hazel Carby calls it 'the most explicit description of sexual brutality in her repertoire' (1986: 18), emphasizing that it was composed by a man and reiterating Lieb's argument that there are differing responses to male violence in female- and male-authored blues.

> I woke up this mornin', my head was sore as a boil
> I woke up this mornin', my head was sore as a boil
> My man beat me last night with five feet of copper coil
>
> He keeps my lips split, my eyes as black as jet
> He keeps my lips split, my eyes as black as jet
> But the way he loves me makes me soon forget
>
> Every night for five years, I've got a beatin' from my
> man
> Every night for five years, I've got a beatin' from my
> man
> People says I'm crazy, I'll explain and you'll understand
>
> Lord it ain't no maybe 'bout my man bein' rough
> Lord it ain't no maybe 'bout my man bein' rough
> But when it comes to lovin', he sure can strut his stuff

Of all the songs recorded by Bessie Smith and Ma Rainey, this one is not

merely the most graphic in its evocation of domestic violence, it also goes farthest in revealing the contradictions in women's attitudes towards violent relationships. While it was composed by a man, Ma Rainey must be acknowledged as having exercised some agency in deciding to sing it – and to sing it enthusiastically. Perhaps the most important point to make is that as in Bessie Smith's songs about physical abuse, the issue is rescued from the silent realm of women's private lives and reconstructed as a public problem. The woman in the song assumes a stance which is as normal as it is pathological. It is pathological to desire to continue a relationship in which one is being systematically abused, but given the extent to which social attitudes are governed by presumptions of female acquiescence to male superiority, it is equally 'normal' for women to harbour such self-deprecatory ideas. While Ma Rainey's rendering of 'Sweet Rough Man' does not challenge male supremacist conduct in any apparent way, it does present the issue as a problem. Because the female character acknowledges that 'people says I'm crazy' for loving such a brutal man, the song very clearly states the dilemma facing women who tolerate violence for the sake of feeling loved.

The process of naming issues that pose a threat to the physical or psychological well-being of the individual is a central function of the blues. Indeed, the musical genre is called the 'blues' not only because it employs a musical scale based on 'blue notes' but also because it names, in myriad ways, the social and psychic afflictions and aspirations of African American individuals. In this sense, the blues preserve and transform the West African philosophical centrality of the naming process. In the Dogon, Yoruba and other West African cultural traditions, the process of Nommo – naming things, forces and modes – is a means of establishing magical (or, in the case of the blues, we might say aesthetic) control over the object of the naming process.Through the blues, menacing problems are ferried out of the context of the isolated individual experience and restructured as problems shared by the community. As shared problems, they are less threatening and potentially can be challenged within a socio-political context.

In Ma Rainey's and especially in Bessie Smith's blues, the problem of male violence is named, and varied patterns of implied or explicit criticism and resistance are woven around it. What is lacking, however, is a sense of the social forces responsible for Black men's propensity (and indeed the male propensity in general) to inflict violence on their female partners. One cannot expect to find developed social analyses of these problems in the blues. Their role is to name the problem in the context of an individual situation, reveal through the blues form the social dimensions of this individual problem, and offer a perspective from which it can be critically perceived. The blues accomplishes what it can within the confines of its form. The political analysis must be developed elsewhere.

On the subject of violence against women, it should be pointed out that there are no references to sexual assault in either Rainey's or Smith's music.

Certainly Black women of that era suffered the cruelty of sexual abuse – both by strangers and by acquaintances. It is therefore tempting to speculate why the blues confer no name on this particular problem. One possibility, of course, is that 'rape' is an unacknowledged and unarticulated subtext of domestic violence. But we know that during that period, middle-class African American women militantly challenged the white rapists who violated Black women in Ku Klux Klan-initiated terrorist assaults as well as in the routine context of domestic employment. Leaders like Mary Church Terrell and Ida B. Wells, who were responsible for the creation of the Black Women's Club Movement, linked the rape of Black women to the manipulation of false rape charges against Black men as a justification for the widespread lynching of the period. Black men were propagandistically represented as savage, sex-crazed rapists, bent on violating the physical and spiritual purity of white womanhood. It may well be that the discourse on rape was so thoroughly influenced by the prevailing racism that intra-racial rape seemed to pale in comparison. On the other hand, the difficult and belated emergence of the beginnings of a collective consciousness regarding sexual harassment, rape and incest within the Black community is indicative of how hard it has been to acknowledge abuse perpetrated by the abused.

Another possible explanation for the absence of allusions to rape within women's blues may be derived from the very nature of female blues discourse. The female characters memorialized in women's blues songs, even in their most despairing moods, do not fit the mould of the typical victim of sexual abuse. The independent women of blues lore are women who do not think twice about wielding weapons against men who they claim have mistreated them. They frequently brandish their razors and guns and they dare men to cross the danger lines they draw. While they do acknowledge the physical mistreatment they have received at the hands of their male lovers, they do not envision themselves as powerless in face of such violence. Indeed, more often than not they fight back passionately. These women – if we are to believe the contemporary literature on rape, which counsels women to adopt more assertive stances and to study the art of self-defence – are more likely than others to ward off sexual assault.

In a substantial number of their songs, Ma Rainey and Bessie Smith pay tribute to fearless women who attempt to avenge themselves when their lovers have been unfaithful. 'Black Mountain Blues',[55] recorded by Bessie Smith, furnishes a particularly dramatic example:

Had a man in Black Mountain, sweetest man in town
Had a man in Black Mountain, the sweetest man in town
He met a city gal, and he throwed me down.

I'm bound for Black Mountain, me and my razor and my gun
Lord, I'm bound for Black Mountain, me and my razor and my gun.
I'm gonna shoot him if he stands still, and cut him if he run.

In 'Sinful Blues',[56] there is a woman whose rage turns into violence, with a variety of different targets – her man, herself and the women she perceives as actual or potential competitors. This is the threat she utters with respect to her lover:

> I got my opinion and my man won't act right
> So I'm gonna get hard on him right from this very night
> Gonna get me a gun long as my right arm
> Shoot that man because he done me wrong
> Lord, now I've got them sinful blues

There is a similar theme in Ma Rainey's 'See See Rider Blues':[57] the woman who has discovered that her man has another woman friend, announces her intention to buy herself a pistol, and to 'kill my man and catch the cannonball'. Her concluding resolution is: 'If he don't have me, he won't have no gal at all'. In 'Rough and Tumble Blues',[58] also by Ma Rainey, the woman focuses her violent actions not on the man, but on the women who have apparently attempted to seduce him:

> I got rough and killed three women 'fore the police got the news
> 'Cause mama's on the warpath, with those rough and tumble
> blues.

In 'Sleep Talking Blues',[59] the woman threatens to kill her man if he mentions another woman's name in his sleep. The woman in Bessie Smith's 'Them's Graveyard Words'[60] responds to her lover's confession that he has acquired a new womanfriend, to whom he has already made a gift of a fur coat with the terrifying threat, 'them's graveyard words':

> I done polished up my pistol, my razor's sharpened too
> He'll think the world done fell on him when my dirty work
> is through

In some songs, the woman does actually kill her partner and is condemned to prison – or to death – for her action. Frequently, she kills out of jealousy, but at other times, as is the case in Ma Rainey's 'Cell Bound Blues',[61] she kills in self-defence, protecting herself from her man's violent blows. In two of Bessie Smith's songs on this theme –'Sing Sing Prison Blues'[62] and 'Send Me To The 'Lectric Chair'[63] – when she comes before the criminal justice system, the woman is ready and willing to pay the consequences for having killed her man. In the former song, directing her words to the judge, she says,

> You can send me up the river or send me to that mean
> old jail
> You can send me up the river or send me to that mean
> old jail
> I killed my man and I don't need no bail.

In the latter, she pleads with the judge to give her the death penalty because she is not prepared to spend the rest of her life in prison – and, indeed, because she is willing to accept the punishment she deserves for having 'cut her good man's throat'. What is striking about the posture assumed by these women is that they offer not even a hint of repentance for having taken their lovers' lives. In the last song, the woman sardonically describes the details of her crime:

> I cut him with my barlow, I kicked him in
> the side
> I stood there laughing over him while he wallowed round
> and died.

Such rowdy and hardened women might at first glance appear to be simply female inversions of the stereotypical model of male aggressiveness. When analysed within the context of the blues' community-building process, however, their role can be perceived in a more meaningful light. One of the important projects of women's blues is the moulding of an emotional community based on the affirmation of Black people's – and in particular Black women's – thoroughgoing humanity. The blueswoman thus challenges in her own way the social imposition of gender-based inferiority. When she paints blues portraits of tough women, they serve as psychic defences disallowing the routine internalization of male dominance. One such portrait is evoked in Bessie Smith's 'Hateful Blues'[64] (to which reference was made earlier on p. 242). The woman in this song is responding to a male partner who has skipped out on her. She is feeling 'low down', but she does not hesitate to inform us that 'nothin' ever worries me long'. Although she has cried and cried, she persuades herself to cease: ' ain't gonna cry no more', and, with increased determination in her words, she announces that 'if he can stand to leave me, I can stand to see him go'. It is at this point that she entertains thoughts of violent revenge:

> If I see him, I'm gon' beat him, gonna kick and bite him too
> Gonna take my wedding butcher, gonna cut him two 'n' two

This rough-and-tumble, sexually aware woman, capable of issuing intimidating threats to men who have mistreated her, and more than willing to follow them through – even to the point of knock-down, drag-out fights – might also be considered a spiritual descendant of women like Harriet Tubman, who apparently always warned her passengers on the Underground Railroad, simultaneously brandishing her pistol, that no one would be permitted to turn back. They would all attempt the trek northwards or else die at her hands – to guarantee that no information regarding their flight leaked out to the enemy. In this sense, the female portraits created by the early blueswomen served as a constant reminder that African American women had historically forged models of womanhood that dramatically challenged prevailing notions of femininity.

The lives of many of the blueswomen of the 1920s bore a certain resemblance to the fearless women created in their songs. Although, according to her biographer, Chris Albertson, Bessie Smith herself was sometimes a victim of male violence, at other times she would not hesitate to hurl threats of violence – which she sometimes carried out – at the men who she felt had betrayed her. But neither was she afraid to confront the most feared symbols of white racist terror. One evening in July of 1927, robed and hooded Ku Klux Klansmen attempted to disrupt her tent performance by pulling up the tent stakes and collapsing the entire structure. When Smith was informed of the trouble, she immediately left the tent and, according to Albertson,

> ran toward the intruders, stopped within ten feet of them, placed one hand on her hip, and shook a clenched fist at the Klansmen. 'What the fuck you think you're doin'' she shouted above the sound of the band. 'I'll get the whole damn tent out here if I have to. You just pick up them sheets and run!'
>
> The Klansmen, apparently too surprised to move, just stood there and gawked. Bessie hurled obscenities at them until they finally turned and disappeared quietly into the darkness. . . .
>
> Then she went back into the tent as if she had just settled a routine matter.
>
> (1972: 132–3)

According to Daphne Harrison, women's blues in the 1920s 'introduced a new, different model of black women – more assertive, sexy, sexually aware, independent, realistic, complex, alive' (1988: 111):

> The blues women of Ida Cox's era brought to their lyrics and performances new meaning as they interpreted and reformulated the black experience from their unique perspective in American society as black females. They saw a world that did not protect the sanctity of black womanhood, as espoused in the bourgeois ideology; only white middle- or upper-class women were protected by it. They saw and experienced injustice as jobs they held were snatched away when white women refused to work with them or white men returned from war to reclaim them. They pointed out the pain of sexual and physical abuse and abandonment.
>
> (ibid.: 64)

Blueswomen were frequently expected to deviate from the norms defining orthodox female behaviour, which is, in all probability, why they were revered by Black working-class communities, women and men alike. Ida Cox's 'Wild Women Don't Have the Blues'[65] presents the most famous portrait of the nonconforming, independent woman and the 'wild woman' has become virtually synonymous with the blues queen:

I've got a disposition and a way of my own
When my man starts kicking I let him find another home
I get full of good liquor and walk the street all night
Go home and put my man out if he don't treat me right
Wild women don't worry, wild women don't have the blues

You never get nothing by being an angel child
You'd better change your ways and get real wild
I want to tell you something I wouldn't tell you no lie
Wild women are the only kind that really get by
'Cause wild women don't worry, wild women don't have the blues

'Easy Come, Easy Go Blues'[66] allowed Bessie Smith to explore the theme of the 'wild woman', the woman who consciously rejected the mainstream values defining women's place in the society, and specifically the passive mode of relating to men. Like Ida Cox's 'Wild Women Don't Have the Blues', this Bessie Smith song is about a woman who refused to allow herself to sink into the depths of depression because of the mistreatment she suffered at the hands of a man. She never takes love so seriously that when it is lost, she feels obligated to behave as if her essence has been assaulted:

> If my sweet man trifles, or if he don't
> I'll get someone to love me anytime he won't

And, in conclusion:

> This world owe me a plenty lovin', hear what I say
> Believe me, I'll go out collectin' most any day
> I'm overflowing with those easy come easy go blues

Ma Rainey's 'Prove It On Me Blues'[67] evokes the experiences of just such a 'wild woman', who affirms her independence from the orthodox norms of womanhood by boldly flaunting her lesbianism. Ma Rainey's sexual involvement with women was no secret among her colleagues or her audiences, and, in fact, the advertisement for this release consisted of a drawing of the blueswoman sporting a man's hat, jacket and tie and obviously attempting to seduce two women on a street corner:

> They say I do it, ain't nobody caught me
> Sure got to prove it on me
> Went out last night with a crowd of my friends
> They must've been women, 'cause I don't like no men
>
> It's true I wear a collar and a tie
> Make the wind blow all the while
> They say I do it, ain't nobody caught me
> They sure got to prove it on me
>
> . . .

Wear my clothes just like a fan
Talk to the gals just like any old man
'Cause they say I do it, ain't nobody caught me
Sure got to prove it on me

Sandra Lieb has described this song as 'a powerful statement of lesbian defiance and self-worth' (1981: 125). It is certainly a cultural antecedent to the organized lesbian movement of the 1970s, which, interestingly enough, began to crystallize around the performance and recording of lesbian-affirming songs. On an album entitled *Lesbian Concentrate*, Teresa Trull recorded a cover of Ma Rainey's song. 'Prove It On Me Blues' was composed by Ma Rainey herself and, as Hazel Carby has insightfully observed, it is a song which

> vacillates between the subversive hidden activity of women loving women [and] a public declaration of lesbianism. The words express a contempt for a society that rejected lesbians. . . . But at the same time the song is a reclamation of lesbianism as long as the woman publicly names her sexual preference for herself. . . .
>
> (Carby 1986: 18)

Carby sees this song as 'engag(ing) directly in defining issues of sexual preference as a contradictory struggle of social relations' (ibid.).

'Prove It On Me Blues' suggests that the iconoclastic blueswomen of the 1920s were pioneers in many respects for later historical developments. It also suggests that the influence of homophobia within the Black community was not so powerful as to enshroud lifestyles that challenged the stereotypical notions of women's realities with the silence imposed within mainstream society. The absence of moral condemnation in Memphis Willie B. Borum's song, 'Bad Girl Blues'[68] is one example of how lesbianism was dealt with by bluesmen:

> Women loving each other, man they don't think about no
> man
> Women loving each other and they don't think about no man
> They ain't playing no secret no more, these women playing
> it a wide open hand

Ma Rainey's 'Sissy Blues'[69] likewise reveals the existence of male homosexuality in the Black community and the absence of rigorous moral disapprobation towards this particular sexual preference. As is generally the case with the blues, the issue is simply named:

> I dreamed last night I was far from harm
> Woke up and found my man in a sissy's arms
>
> . . .

My man's got a sissy, his name is Miss Kate
He shook that thing like jelly on a plate
. . .
Now all the people ask me why I'm all alone
A sissy shook that thing and took my man from home

By way of conclusion, I want to suggest that the blues songs recorded by Ma Rainey and Bessie Smith offer us a privileged glimpse, from the vantage point of African American women who helped to shape the collective consciousness of their contemporaries, of the prevailing perceptions of love and sexuality in the post-slavery Black community in the United States. The two women were certainly role models for untold thousands of their sisters to whom they delivered messages of defiance *vis-à-vis* the male dominance encouraged by mainstream culture. The blueswomen openly challenged the gender politics implicit in traditional cultural representations of marriage and of heterosexual love relationships in general. Refusing, in the blues tradition of raw realism, to romanticize romantic relationships, they exposed the stereotypes and explored the contradictions of those relationships. In the process, they redefined women's role. They forged and memorialized images of tough, resilient and independent women who were no more afraid of their own vulnerability than they were of defending their right to be respected as autonomous human beings.

NOTES

* This essay comprises the whole of the first chapter in Davis' forthcoming book, tentatively entitled *Ma Rainey, Bessie Smith and Billie Holiday: Black Women's Music and Social Consciousness*.
1 See Lawrence Levine: 'While both blues and popular music were dominated by lyrics concerning love, black consciousness of and attitudes toward this relationship differed considerably from those of the larger society' (1975: 275).
2 See Henry Pleasants' *The Great American Popular Singers* (1974), as well as Levine: 'the physical side of love which, aside from some tepid hand holding and lip pecking, was largely missing from popular music, was strongly felt in the blues' (1975: 279).
3 See Chris Albertson (1972); Levine (1975: 226).
4 See W.E.B. DuBois (1972).
5 See Herbert Gutman (1977) and others.
6 And to black ones as well.
7 Lawrence Levine cites a rowing song heard by Frances Kemble (1961: 163–4) in the late 1830s and characterized by her as nonsensical, but interpreted by Chadwick Hansen as containing hidden sexual meanings:

> Jenny shake her toe at me,
> Jenny gone away;
> Jenny shake her toe at me,
> Jenny gone away.
> Hurrah! Miss Susy, oh!
> Jenny gone away;

261

Hurrah! Miss Susy, oh!
Jenny gone away

'Chadwick Hanson [1967: 554–63] has shown that in all probability what Miss Kemble heard was not the English word "toe" but an African-derived word referring to the buttocks. The Jenny of whom the slaves were singing with such obvious pleasure was shaking something more interesting and provocative than her foot' (Levine 1975: 11).

8 Popular musical culture in the African American tradition continues to actively involve the audience in the performance of the music. The distinction, therefore, is not between the relatively active and relatively passive stances of the audience. Rather it is between a mode of musical presentation in which everyone involved is considered a 'performer' – or perhaps in which no one, the song-leader included, is considered a 'performer' – and one in which the producer of the music plays a privileged role in calling forth the responses of her/his audience.

9 See the discussion of the liberation content of the spirituals in James Cone (1972). John Lovell Jr (1972) also emphasizes the relationship between the slave community's yearning for liberation and the music it produced in the religious tradition of Christianity.

10 Religious themes are to be found in some of the prison worksongs recorded by folklorists during the 1930s, 1940s and 1950s.

11 See John Lovell Jr (1972).

12 See Houston Baker Jr (1987) for an in-depth discussion on the nature of blues discourse in relation to African American literature.

13 See my discussion of the role of sexual abuse in the structure of power relationships during slavery in *Women, Race & Class* (1983).

14 Examples of slave narratives in which family breakups are documented.

15 See Angela Y. Davis (1983).

16 Bessie Smith, 'Sam Jones Blues', 24 September 1923, Columbia 13005-D. Reissued on *Any Woman's Blues*, Columbia G. 30126.

17 The themes Daphne Duval Harrison lists in her subject index (1988: 287) are advice to other women, alcohol, betrayal or abandonment, broken or failed love affairs, death, departure, dilemma of staying with man or returning to family, disease and afflictions, erotica, hell, homosexuality, infidelity, injustice, jail and serving time, loss of lover, love, men, mistreatment, murder, other woman, poverty, promiscuity, prostitution, sadness, sex, suicide, supernatural, trains, travelling, unfaithfulness, vengeance, weariness, depression and disillusionment, weight loss. It is revealing that she has not deemed it necessary to index marriage, husband, children, domesticity, etc.

18 Bessie Smith, 'Poor Man's Blues', 24 August 1928, Columbia 14399-D. Reissued on *Empty Bed Blues*, Columbia CG 30450.

19 Bessie Smith, 'Pinchbacks – Take 'Em Away', 4 April 1924, Columbia 14025-D. Reissued on *Empty Bed Blues*, Columbia CG 30450.

20 Bessie Smith, 'Take Me For A Buggy Ride', 24 November 1933, Okeh 8945. Reissued on *The World's Greatest Blues Singer*, Columbia CG 33.

21 The four songs she recorded on 24 November 1933 were: 'Do Your Duty', 'Gimme a Pigfoot', 'Take Me For A Buggy Ride' and 'I'm Down in the Dumps'.

22 Bessie Smith, 'Need A Little Sugar in My Bowl', 20 November 1931, Columbia 14611-D. Reissued on *The World's Greatest Blues Singer*, Columbia CG 33.

23 Gertrude 'Ma' Rainey, 'Blame It On The Blues', September 1928, Paramount 12760. Reissued on *Ma Rainey*, Milestone M-47021, 1974.

24 Gertrude 'Ma' Rainey, 'Shave 'Em Dry', 1924, Paramount 12222. Reissued on *Ma Rainey's Black Bottom*, Yazoo 1071.

25 Gertrude 'Ma' Rainey, 'Gone Daddy Blues', August 1927, Paramount 12526. Reissued on *Ma Rainey*, Milestone M 47021.

26 Gertrude 'Ma' Rainey, 'Misery Blues', August 1927, Paramount 12508. Reissued on *Blues the World Forgot*, Biograph BLP 12001.

27 Bessie Smith, 'Money Blues', 4 May 1926, Columbia 14137-D. Reissued on *Nobody's Blues But Mine*, Columbia CG 31093, 1972.

28 Bessie Smith, 'Young Woman's Blues', October 1926, Columbia 14179-D. Reissued on *Nobody's Blues But Mine*, Columbia CG 31093, 1972.

29 Bessie Smith, 'Hateful Blues', 9 April 1924, Columbia 14023-D. Reissued on *Empty Bed Blues*, Columbia CG 30450.

30 Bessie Smith, 'Weeping Willow Blues', 26 September 1924, Columbia, 14042-D. Reissued on *Empty Bed Blues*, Columbia CG 30450.

31 Bessie Smith, 'Yes Indeed He Do', 24 August 1928, Columbia 14354-D. Reissued on *Empty Bed Blues*, Columbia CG 30450.

32 Bessie Smith, 'Safety Mama', 20 November 1931, Columbia 14634-D. Reissued on *The World's Greatest Blues Singer*, Columbia CG 33.

33 Robert Johnson, 'Hellhound On My Trail', Reissued on Robert Johnson, *The Complete Recordings*, Columbia compact disk C2k 46222, Ck 46234, 1990.

34 Bessie Smith, 'Chicago Bound Blues', 4 December 1923, Columbia 14000-D. Reissued on *Any Woman's Blues*, Columbia G 30126.

35 Alberta Hunter, 'Down Hearted Blues'; Bessie Smith, 'Down-Hearted Blues', 16 February 1923, Columbia A 3844. Reissued on *The World's Greatest Blues Singer*, Columbia CG 33.

36 Gertrude 'Ma' Rainey, 'Barrel House Blues', December 1923, Paramount 12082. Reissued on *Queen of the Blues*, Biograph BLP 12032.

37 Bessie Smith, 'Mistreating Daddy', 4 December 1923, Columbia 14000-D. Reissued on *Any Woman's Blues*, Columbia G 30126.

38 Gertrude 'Ma' Rainey, 'Honey Where You Been So Long', March 1924; Paramount 12200. Reissued on *Queen of the Blues*. Biograph BLP 12032.

39 Gertrude 'Ma' Rainey, 'Lawd Send Me A Man Blues', May 1924, Paramount 12227. Reissued on *Queen of the Blues*, Biograph BLP 12032.

40 Bessie Smith, 'Baby Doll', 4 May 1926, Columbia 14147-D. Reissued on *Nobody's Blues But Mine*, Columbia CG 31093, 1972.

41 Refer to contemporary literature on violence against women.

42 Bessie Smith, 'Yes Indeed He Do', 24 August 1928, Columbia 14354-D. Reissued on *Empty Bed Blues*, Columbia CG 30450.

43 Bessie Smith, 'Outside of That', 30 April 1923, Columbia A 3900. Reissued on *The World's Greatest Blues Singer*, Columbia CG 33.

44 Reference to work on domestic violence.

45 Gertrude 'Ma' Rainey, 'Black Eye Blues', September 1928, Paramount, 12963. Reissued on *Ma Rainey*, Milestone M 47021, 1974.

46 Bessie Smith, 'Please Help Me Get Him Off My Mind', 24 August 1928, Columbia 14375. Reissued on *Empty Bed Blues*, Columbia CG 30450.

47 Bessie Smith, 'It Won't Be You', 21 February 1928, Columbia 14338-D. Reissued on *Empty Bed Blues*, Columbia CG 30450.

48 Bessie Smith, 'Slow and Easy Man', 24 August 1928, Columbia 14384-D. Reissued on *Empty Bed Blues*, Columbia CG 30450.

49 Bessie Smith, 'Eavesdroppers' Blues', 9 January 1924, Columbia 14010-D. Reissued on *Any Woman's Blues*, Columbia G 30126.

50 Bessie Smith, 'Love Me Daddy Blues', 12 December 1924, Columbia 14060-D. Reissued on *The Empress*, Columbia CG 30818.

51 Bessie Smith, 'Hard Driving Papa', 4 May 1926, Columbia 14137-D. Reissued on *Nobody's Blues But Mine*, Columbia CG 31093, 1972.

52 Bessie Smith, 'Tain't Nobody's Bizness If I Do', 26 April 1923, Columbia A 3898. Reissued on *The World's Greatest Blues Singer*, Columbia CG 33.
53 Ma Rainey, sang 'See See Rider', December 1925, Paramount 12252. Reissued on *Ma Rainey*, Milestone M-47021, 1974.
54 Gertrude 'Ma' Rainey, 'Sweet Rough Man', September 1928, Paramount 12926. Reissued on *Ma Rainey*, Milestone M-47021, 1974.
55 Bessie Smith, 'Black Mountain Blues', 22 June 1930, Columbia 14554-D. Reissued on *The World's Greatest Blues Singer*, Columbia CG 33.
56 Bessie Smith, 'Sinful Blues', 11 December 1924, Columbia 114052-D. Reissued on *The Empress*, Columbia CG 30818.
57 Gertrude 'Ma' Rainey, 'See See Rider Blues', December 1925, Paramount 12252. Reissued on *Ma Rainey*, Milestone M-47021, 1974.
58 Gertrude 'Ma' Rainey, 'Rough and Tumble Blues', 1926, Paramount 12303. Reissued on *The Immortal Ma Rainey*, Milestone, MLP 2001, 1966.
59 Gertrude 'Ma' Rainey, 'Sleep Talking Blues', 1928, Paramount. Reissued on *Ma Rainey's Black Bottom*, Yazoo, 1071.
60 Bessie Smith, 'Them's Graveyard Words', 3 March 1927, Columbia 14209-D. Reissued on *The Empress*, Columbia, CG 30818.
61 Gertrude 'Ma' Rainey, 'Cell Bound Blues', 1925, Paramount 12257. Reissued on *The Immortal Ma Rainey*, Milestone MLP 2001, 1966.
62 Bessie Smith, 'Sing Sing Prison Blues', 6 December 1924, Columbia 14051-D. Reissued on *The Empress*, Columbia CG 30818.
63 Bessie Smith, 'Send Me To The 'Lectric Chair', 3 March 1927, Columbia 14209-D. Reissued on *The Empress*, Columbia CG 30818
64 Bessie Smith, 'Hateful Blues', 8 April 1924, Columbia 14023-D. Reissued on *Empty Bed Blues*, Columbia CG 30450.
65 Ida Cox, 'Wild Women Don't Have the Blues', Paramount, 1924. Reissued on Riverside RLP 9374.
66 Bessie Smith, 'Easy Come, Easy Go Blues', 10 January 1924, Columbia 14005-D. Reissued on *Any Woman's Blues*, Columbia G 30126.
67 Gertrude 'Ma' Rainey, 'Prove It On Me Blues', June 1928, Paramount 12668. Reissued on *Ma Rainey*, Milestone M-47021, 1974.
68 See text of Memphis Willie B. Borum's 'Bad Girl Blues' in Sackheim (1969: 288).
69 Gertrude 'Ma' Rainey, 'Sissy Blues', 1928, Paramount 123384.

BIBLIOGRAPHY

Albertson, Chris (1972) *Bessie*. New York: Stein & Day.
Baker Jr, Houston (1987) *Blues Ideology and Afro-American Literature*. Chicago, Ill.: University of Chicago Press.
Brooks, Edward (1982) *The Bessie Smith Companion*. New York: DaCapo Press.
Carby, Hazel (1986) 'It Jus Be's Dat Way Sometimes: The Sexual Politics of Women's Blues', *Radical Amerika* 20, no. 4 (June–July).
Cone, James (1972) *The Spirituals and the Blues: An Interpretation*. New York: Crossroad.
Dall, Christine (dir.) (1989) *Wild Women Don't Have the Blues*. Calliope Film Resources, Inc.
Davis, Angela Y. (1983) *Women, Race & Class*. New York: Random House.
DuBois, W.E.B. (1972), *Black Reconstruction: An Essay Toward a History of the Part Which Black Folk Played in the Attempt to Reconstruct Democracy in America, 1860–1880*. New York: MacMillan (reprint of 1969 edn).
Ellison, Ralph (1972) *Shadow and Act*. New York: Vintage Books.

Garon, Paul (1978) *Blues and the Poetics of Spirit*. New York: DaCapo.

Gutman, Herbert (1977) *Black Family in Slavery and Freedom*. New York: Random House.

Hanson, Chadwick (1967) 'Jenny's Toe: Negro Shaking Dances in America', *American Quarterly*, 1, 9: 554–63.

Harrison, Daphne Duval (1988) *Black Pearls: The Blues Queens of the 1920's*. New Brunswick, NJ: Rutgers University Press.

Hurston, Zora Neale (1970) *Mules and Men*. Westport, Conn.: Greenwood (reprint. of 1935 edn).

Jones, LeRoi (pseudonym of Imamu A. Baraka) (1971) *Blues People: Negro Music in White America*. New York: Morrow, William & Company.

Kemble, Frances (1961) *Journal of a Residence on a Georgian Plantation*. New York: Knopf (reprint of 1863 edn).

Levine, Lawrence (1975) *Black Culture and Black Consciousness: Afro-American Thought from Slavery to Freedom*. New York: Oxford University Press.

Lieb, Sandra (1981) *Mother of the Blues: a Study of Ma Rainey*. Boston, Mass.: University of Massachusetts Press.

Lovell Jr, John (1972) *Black Song: The Forge and the Flame; the Story of How the Afro-American Spiritual was Hammered Out*. New York: MacMillan.

Marx, Karl (1964) *Early Writings*. New York: McGraw-Hill.

Oakley, Giles (1976) *The Devil's Music: History of the Blues*. New York and London: Harcourt, Brace & Jovanovich.

Oliver, Paul (1960) *The Meaning of the Blues*. New York: Collier Books.

Pleasants, Henry (1974) *The Great American Popular Singers*. New York: Simon & Schuster.

Sackheim, Eric (ed.) (1969) *The Blues Line*. New York: Shirmer Books.

14

DESTRUCTION

Boundary erotics and refigurations of the heterosexual male body

Catherine Waldby

Towards the end of *Oranges Are Not the Only Fruit*, Jeanette Winterson's newly lesbian protagonist, musing on her desire for love, says 'I want someone who will destroy and be destroyed by me . . . I would cross seas and suffer sunstroke and give away all I have, but not for a man, because they want to be the destroyer, and never be destroyed' (1985: 170). I was struck by this phrase because it suggests a way of thinking about the different implications for women of engaging in relationships either with other women or with men; a way of thinking which runs counter to the normally rather anodyne terms in which 'lesbian love' is proffered as desirable within certain kinds of feminism. Winterson's character wants to have women as her lovers not because they offer a safe haven from the destructiveness of men, but because such relationships offer the possibility of a reciprocity of destruction. The problem, Winterson's words imply, lies not in destruction as such, rather in the ways that it is transacted. While men want only to be destroyers, women can negotiate alternations in the position of destroyer and destroyed in the intimate economy of love.

I am using the idea of destruction here as I understand Winterson's character to use it, to connote erotic destruction. By erotic destruction I mean both the temporary, ecstatic confusions wrought upon the everyday sense of self by sexual pleasure, and the more long-term consequences of this confusion when it works to constitute a relationship. Destruction seems an appropriate word for these states because it captures both the tender violence and the terrors involved in sexual practice and relationships, the kinds of violence this does to any sense of self as autonomous. Erotic pleasure arguably requires a kind of momentary annihilation or suspension of what normally counts as 'identity', the conscious, masterful, self-identical self,[1] lost in the 'little death' of orgasm. These momentary suspensions, when linked together in the context of a particular relationship, work towards a more profound kind of ego destruction. I do not mean that the ego in love relations is destroyed in an absolute sense. Rather each lover is refigured by

the other, made to bear the mark of the other upon the self. But all such transformation involves the breaking down of resistance, of violence to an existing order of the ego.

In this sense, the problem with men, for Winterson's character, is not that they are destructive, for all of us are implicated in the kinds of tender violence attendant upon sexual desire. The problem lies rather in the non-reciprocity of this destruction between men and women. Men, she implies, are so concerned with the maintenance of their sovereign selfhood that they cannot tolerate its infringement by another. They seek instead to be always the destroyer, to refigure their women in their own interests but to resist such refiguration themselves. In this case the transformational possibilities offered by the limited destructions of erotic intimacy are perverted into the very real destruction of one partner, the woman, whose sense of self is not merely refigured but systematically dissipated.

If I have interpreted Winterson's words correctly then, they open out on to a much more general critique of heterosexuality that feminism has been conducting for quite a while now. What I want to pursue here, which comes out of both Winterson's words and this more general critique, is the question of how erotic practice stands to the negotiation of subjectivity within relationships between men and women. If sex can be regarded as a kind of theatre where subjective negotiations between men and women are played out, then the choreography of sexual encounters – what counts as active and passive, whose boundaries are breached, who gives and who takes pleasure – tells us something about these negotiations. My contention with Winterson will be that while the rituals of heterosexual sex can and often do enact the non-reciprocity of destruction that she condemns, they can also play out disturbances and secret reciprocities in this erotic economy.

In what follows I will first map out the kinds of sexual and bodily choreographies of masculinity and femininity implied by Winterson's formulation, choreographies which give men exclusive rights in destruction. What I want to suggest as I go along is that not all masculinities are uniformly invested in the maintenance of such non-reciprocity. Certain opportunities for erotic complicity and exchange between men and women are available, and I will make some suggestions about where those opportunities might be presented. In pursuing this line of investigation I do not mean to suggest that sex is the origin of power relations between men and women, or that a reformation of sex equals a reformation in these relations. It seems possible though that sex provides certain resources of fantasy which might help in renegotiating such power relationships and the ways that masculine and feminine bodies live these out. Opportunities for complicity lie, I will speculate, in certain shared fantasies about the receptive erotic potentials of the male body, fantasies which find their cultural correlate in the proliferation of images of the phallic woman.

CATHERINE WALDBY

INTERCOURSE AS IDEOLOGY

Erotic practice lends itself to more general investigations of the relations between men and women because it involves such a detailed engagement between the bodily imagos of masculinity and femininity. I am using Lacan's term 'imago' rather than the weaker term 'body image' because, unlike the latter term, 'imago' does not connote a real biological body over which a cultural image is laid. Rather it places the morphology of the body, the configuration of its flesh, its boundaries and the relationship between parts, in an indissociable relationship with its psychic investment by the subject who lives that body. In other words a body cannot come into social existence, cannot take on a recognizable anatomy except in so far as it is psychically animated.[2] This animation happens in turn in a particular libidinal, historical and social context. The particular 'imaginary anatomy' of each subject is generated in relation both to its love objects, those whom it desires, and to socially generated 'imaginary anatomies', to ideas about bodies which circulate in the culture.[3] The 'imaginary anatomies' of sexual difference can be regarded as indicative of certain historically available forms of desire.

Here I will first outline what I consider to be the hegemonic bodily imagos of sexual difference. These are hegemonic imagos because they demonstrate the vertical aspects of power relations between men and women most starkly. In this sense they live out the non-reciprocity of destruction decried by Winterson's protagonist. I am working here with the proposition that these imagos do not exercise an exhaustive hold over the ways that sexual identities and practices are lived out, but that they nevertheless set the terms for their negotiation.

The culture's privileging of masculinity means that the hegemonic bodily imago of masculinity conforms with his status as sovereign ego, the destroyer, and that of women with the correlative status of the one who is made to conform to this ego, the destroyed. The male body is understood as phallic and impenetrable, as a war-body simultaneously armed and armoured, equipped for victory. The female body is its opposite, permeable and receptive, able to absorb all this violence. In other words, boundary difference is displaced outwards from (imaginary) genital difference. The fantasy of the always hard and ready penis/phallus characterizes the entire surface of the male body, while the fantasy of the soft accommodating and rather indeterminate vagina is synecdochal for the entire feminine body. In this way the genital markers of sexual difference, the penis and the vagina, seem to render the kinds of power relations attendant upon them as natural and inevitable.

The ideological function of these imagos can be seen in its starkest form when we consider the kinds of implications they carry for how sexual violence is transacted between men and women. On the one hand, the mobile and indeterminate nature of women's boundaries renders violation of women

268

difficult, in the phallic imagination at least. Sexual penetration without the woman's agreement does not count as violence in this imagination because no line is considered to be crossed. It will only count as violence, in courtrooms and forensic laboratories, for example, if it is accompanied by other kinds of violence – visible signs, bruises, cuts, etc., some empirical marks of damage. Specific instances of damage to women's bodily integrity do not count because women's bodies are considered to be already damaged, already transgressed.

On the other hand, it is very easy to do sexual violence to men's bodies because any form of penetration, or even the threat of penetration, hits up against a clearly defined and absolute boundary, crosses a property line. This understanding is evident, to return to the courtroom, in the repeated acquittals of men charged with violent assault and even murder on the basis of 'homosexual advance'. This term does not refer to rape or any kind of physical assault; it simply means that the man acquitted is considered to have been justified in using violence against another man who made a sexual overture to him.[4] This points towards an economy of sexual violence in which even the momentary possibility of penetration, the very fantasy of penetration, counts as an absolute violation. Clearly if such overtures counted as violence against women, and women felt free to retaliate, the streets would be littered with battered men.

If these imagos of sexual difference are treated as though they exercise complete control over the field of representation then they also render the choreography of 'normal' heterosexual sex, that is intercourse, politically problematic. In one sense at least, straight sex can be read as yet another implementation of these imagos, albeit a domestic one. Intercourse appears as just another example of the monotonous insistence on the male body as naturally penetrative, and on women's bodies as naturally penetrable. In other words on this model no real distinction can be maintained between sex and sexual violence. They simply collapse into each other.

This reading of sexual practice, which I will call an ideological reading, renders sex between men and women as both synecdoche for and means of the unilateral destruction which Winterson says is attendant upon heterosexual relationships. Insofar as the woman is refused either recognizable boundaries, or reciprocal powers to violate her partner's boundaries, to transgress his sense of integrity, then their erotic practice extends and shores up masculine privileges in the uses of violence and access to the kinds of social power which accompany bodily integrity in our culture. Intercourse simply reiterates the general process whereby his selfhood swells and hers disintegrates.

In calling this an ideological reading of sex I do not mean to suggest that such a reading never finds its correlate in actual practice. It would be virtually impossible, I suspect, to find a woman whose history of sexual relationships with men did not include some experience of systematic annihilation. Rather,

it is an ideological reading because it assumes that it is only dominant 'imaginary anatomies' which exercise any force in sexual practice or in the wider field of heterosexual relations. It thinks that it is only those bodily imagos most deeply implicated in the maintenance of power relations between men and women, in supporting masculine ownership of the phallus and correlative feminine castration, which obtain in the everyday living of masculinity and femininity. This is an ideological reading because it assumes that everyday culture works entirely in the service of relations of dominance and submission, and it does not admit the existence of other possibilities for interpretation or negotiation.

The problem with this is that in closing off other interpretive possibilities such a reading tends to work against its own best intentions. It becomes self-defeating in the sense that it shores up exactly what it sets out to problematize. Sharon Marcus identifies this effect in her discussion of feminist conceptions of rape, when she points out that in feminism which simply assumes a masculine penetrative drive on the one hand, and a feminine violability on the other, rape is inevitable. It even amounts, she writes, to an ontology: 'To take male violence or female vulnerability as the first and last instances of any explanation of rape is to make the identity of rapist and raped pre-exist the rape itself' (Marcus 1992: 391). Similarly, Moira Gatens (1995) suggests that any feminist work, notably that of Andrea Dworkin and Catherine MacKinnon, which assumes the body of woman as violable space and poses everyday intercourse as a form of rape, cedes far too much power to a phallic masculine imaginary. Rape is arguably the social practice which takes the ideological imagos of masculinity and femininity most literally, which animates these imagos most fully. But by assimilating all sexual exchange to the model of rape this feminist work helps to extend and naturalize these imagos rather than challenge them.

A more sophisticated investigation of the bodily imagos of sexual difference and their implications for subjectivity must take into account a certain instability in what they mean and how they are lived out. Bearing this in mind, it seems to me possible to problematize the ideological interpretation of heterosexual sex from at least two points of view. First of all, if we start from the assumption that the rape model of intercourse does not exhaust all possibilities of significance, then penis–vagina sex can be read quite differently. It need not be fantasized, either by feminist theory or by sexual partners, as powerful male penetration of soft womanly interior space, but rather as the vagina's embrace or grasp of the penis, for example.[5] It is important to reiterate here that this is not a case of a wrong-headed fantasy overlying real biological genitals, which are carrying on regardless. The penis does not *act* the phallus in sex unless it is lived by one or both partners *as* the phallus. If mutual erotic fantasy involved the penis' surrender or engulfment, then this counts also as a description.

Second, while an ideological reading would render sexual practice as the

most pure point of the existence of the seductive bodily imagos I described above, it is possible to counter this along the lines that sexual practice, exactly because it involves erotic pleasure, is a potential site for their subversion or reconfiguration, and for a correlative freeing up of their subjectivity implications. The point here is that there are, as Judith Butler observes, always costs associated with full identification with hegemonic imagos of masculinity and femininity:

> This 'being a man' and this 'being a woman' are internally unstable affairs. They are always beset by ambivalence precisely because there is a cost in every identification, the loss of some other set of identi-fications, the forcible approximation of a norm one level chooses, a norm that chooses us, but which we occupy, reverse, resignify to the extent that the norm fails to determine us completely.
>
> (Butler 1993: 126–7)

In what follows I want to consider how the costs of identification cash out for heterosexual masculinity with regard to sexual practice, and discuss some erotic and political possibilities offered by failures of identification.

TAKING IT

The benefits for men of identification with a phallic imago derive from the kind of social power it confers, the various attributions of mastery it solicits from others. Now while inhabiting such a position of mastery carries its own erotic thrill (and this may be the only kind of sexual pleasure that rapists want), there are also some erotic costs. Full identification with the phallic, proprietal imago of masculinity demands a kind of de-eroticization of most of the body. If his sovereign ego is to stay intact it must guard against its own destruction-in-pleasure that I referred to at the beginning. It cannot afford this kind of abandon. This involves a refusal of pleasure, or an anxiety in pleasure in order not to surrender power. To defend the sovereign ego, the rest of the body is drained of erotic potential in favour of its localization in the penis, taken to be the phallus' little representative.[6]

Not only must the penis be invested with an exclusive erotic potential, but full identification with this imago also requires a suppression of that in his body which confounds a phallic image. This suppression can be seen in the shame for men associated with 'impotence', having a soft penis or a penis which is 'too small'. It can be seen also in the various negative sexual injunctions which men often feel compelled to obey. These include the injunction against passivity, which says that the phallus gives pleasure rather than receives it (the injunction which tends to give men's approach to women's pleasure a rather missionary zeal). There is also an injunction against narcissism, an enjoyment of being looked at, which is associated with

the passive feminine. Above all there is the injunction against what Sartre called 'men's secret femininity', receptive anal eroticism.

This last is particularly problematic for the maintenance of a phallic imago, which shores up sexual difference as the complementary opposition phallic/castrated. Anal eroticism carries disturbingly feminizing connotations. Part of the significance of intercourse understood in its ideological aspect is its assertion not just of the woman's penetrability but of the man's *im*penetrability, the exclusive designation of his body by its seamless, phallic mastery. Intercourse can count as a demonstration of the idea that women's bodies lack the means to penetrate another body, and that male bodies are impenetrable. When a man puts his penis in a woman's vagina he is saying, 'look, it is she who is the permeable one, the one whose body accommodates, takes in and lets out, *not I*'.

But the possibilities of anal erotics for the masculine body amount to an abandonment of this phallic claim. The ass is soft and sensitive, and associated with pollution and shame, like the vagina. It is non-specific with regard to genital difference in that everybody has one. It allows access into the body, when after all only women are supposed to have a vulnerable interior space. All this makes anal eroticism a suasive point for the displacement or erasure of purely phallic boundaries.

In a sense then, anal eroticism is the sexual pleasure which conformation to a phallic imago most profoundly opposes. If the point of the phallic imago is to guard against confusion between the imaginary anatomies of masculine and feminine, and to shore up masculine power, then anal eroticism threatens to explode this ideological body. And if the rigid boundaries and penetrative intent of the phallic imago anatomize the non-reciprocity of subjective violence between men and women, then anal erotics in the male body amount to a surrender to the other, to a taking of pleasure in being destroyed rather than being the destroyer. But the negative injunction of the phallus against such pleasure is, like all laws, also an invitation to transgression, and it seems likely that this phallic taboo might intensify, rather than disperse, the erotic potential of the anus for heterosexual men.

To point towards this erotic potential does not however say anything about how such potential is realized, and the kind of sexual energy such potential exerts could be transmuted in a number of different ways. I have already suggested that intercourse could be considered as a way of channelling anal erotic potentials back into the penis by projecting the permeable possibilities of the male body on to women, of distracting psychic attention away from this as it were. The kinds of homophobic violence described earlier, and homophobia in general, might also be ways of adjudicating the anxiety aroused in heterosexual men by their own penetrability. If a potential for passive anal pleasure is denied, its denial can be acted out as violence against, or contempt for, those who are interpreted as wishing to either experience such pleasure themselves, or to 'impose' it upon another. In this sense the

repression or elision of anal eroticism in heterosexual men can be seen to work not only along the lines of the masculine/feminine division, but also along the homosexual/heterosexual divide.

THE PHALLIC WOMAN

Despite all these available means of adjudication, however, it seems to me that certain current developments in sexual politics and sexual culture indicate that the edges of the phallic imago have become a little blurred, and that the kind of subjective and erotic possibilities involved in a mutuality of penetrability between men and women are more available. There are no doubt a number of such developments, but the two that come to mind are present feminist struggles around women's body boundaries and the great increase in circulation of images of the phallic woman in both popular culture and a growing margin of sexual practice.

In some senses the question of women's body boundaries and rights to bodily integrity dominates present feminist struggles. This question informs, for example, the issues of rape and date rape, of sexual harassment and of safe sex practice, of the reorganization of birthing practices and certain aspects of the politics of women's health. This intense politicization of what counts as violence to women's bodies has implications for the maintenance of a phallic masculine imago. Phallic fantasy can only be maintained when it has penetrable bodies to feed on, and if women systematically refuse to bear the weight of these kinds of projection then it falters. At the same time I think that some of the more dephallicizing effects of these struggles are being pre-empted by their tendency, discussed above, to continue to frame themselves as struggles to protect women's vulnerable interior space from the attack of the ever rigid phallus.

Perversely enough, there seems to be more promise for the engendering of a receptive masculine erotics in some current developments in what might be called the pornographic imaginary – the sex clubs, magazines, brothels and sex shops – as well as certain very profitable sectors of popular culture. What I am referring to here is the recent proliferation of the image of the phallic woman, the mistress or dominatrix. This image informs certain pop culture icons like Madonna and Sandra Bernhardt, the explosion of demand for s/m prostitution services (Perkins 1991), the considerable trade in dildos and other sex toys, now marketed through suburban party selling (like Tupperwear once was), and the incursion of dominatrix imagery into mainstream pornography.

Now from a politically correct psychoanalytic position, this proliferation of the phallic woman does not represent a new possibility for erotic negotiation between men and women, because the phallic woman is a fantasy which embodies man's fear of woman's castration. He endows his object of desire with a phallus because he cannot bear to face the wound of her genitals. But I think that there are other ways to consider the significance of this image.

273

Following on from Judith Butler's recent work on the lesbian phallus (Butler 1993), the image of the phallic woman clearly contradicts any masculine claim to 'own' the phallus, with its attendant privileges. If the allegedly natural relation between the penis and the phallus can be severed, and the phallus can be demonstrated to be a transferable property, then the bodily imagos it guarantees are made available for reworking. Or as Butler puts it, it may become possible to 'delineate body surfaces that do not signify conventional heterosexual polarities' (1993: 64). In other words, the current eroticization of the phallic woman implies not just a reworking of the meaning of the feminine body but also its relation to the masculine. It could be taken to indicate a realization of the masculine erotic potential for pleasure in passivity, a desire to be fucked, to be taken.

The emergence of such a form of erotics should theoretically imply possibilities for non-exclusive reformulations of sexual difference, for serious problematizations of the ways that active/passive and phallic/castrated binaries condition hegemonic forms of sexual difference. But as Eve Sedgwick cannily points out, the existence of instabilities in the binary logic of sexual difference has no necessary effect on the politics of sexual difference. A further step must be taken if feminist or gay struggles are to benefit (Sedgwick 1990).[7] In other words, some kind of social practice must lean on these instabilities if they are to represent any kind of transformative possibility.

Sedgwick's caveat rings true in this case because it seems to me that the current forms taken by such erotics work against a realization of their full political effects. This is so because of the degree of privatization involved in their practice. This can be seen, for example, in the tendency for men to contain the subjective significance of passive sexual desire by restricting its practice to prostitution relationships.[8] This privatization has a kind of 'theme park' effect, in that it allows the client to experience the thrill of subjective danger when no real danger exists. In other words it allows the momentary infringements of mastery without these infringements accumulating into the subjective reconfigurations and vulnerabilities involved in a continuing relationship. By containing a passive sexual practice to the secretive and commodified world of prostitution, men can continue to stand in a phallic relation to their wives and girlfriends, so the active/passive distinction continues to describe the masculine/feminine distinction.

What all of this suggests to me is the desirability of feminism finding ways to deprivatize this masculine desire, and make it available as an erotic resource for both men and women. Now I am not suggesting the 'outing' of the clients of the local dungeon here. Perhaps what is needed are strategies to elaborate the erotic attractions and possibilities of a sexually receptive masculinity in the domain of public culture. While, at the moment, images of the phallic woman have quite a presence in this domain, the correlative masculine desire is only implied, never represented.

One such strategy might involve celebratory alliances between feminism

and other groups with political/erotic interests in dephallicizing the straight male body. Such an alliance might be formed in relation to queer political practice, for example, with its general project to problematize existing orders of sexual identity, and to deprivatize the repressed homosexual erotics of homosociality. I can also imagine alliances with certain aspects of the sex club and sex work scene around this question.

Another strategy might be the elaboration of such domains of desire in feminist-influenced representational practice – those of fictional and theoretical writing, of visual and performance art practice and so on. Perhaps feminism needs to develop something like a pornographic imagination in relation to masculine bodies, and bodies in general. By this I mean that it should allow itself to think through and in pleasure, in order to develop ways of fantasizing erotic surfaces and orifices, of relations between organs and parts, that depart from the monotonous imagos described earlier.

The beginning of such an imagination is already evident, it seems to me, in certain areas. It can be seen, for example, in some lesbian fiction, like that of Mary Fallon (1989) and Jane Delynn (1991), whose writing invents startling erotic choreographies and vernaculars as it goes along, exploring relational possibilities opened up by such erotics. It is also evident in some areas of visual arts practice which have aligned themselves with certain of the representational practices and obsessions of pornography. The installation work of Linda Dement is one example of such an alignment, in work that cuts up or opens up anatomical bodies and reworks them in various ways, within the virtual space of the computer. Dement's recent installation, 'Techno-Girl Monster',[9] involved the 'donation' of different participants' body parts, which were scanned into the computer and then formed into mobile assemblages that could be manipulated with a curser by the viewer. Here the curser acts like an erotic technology, which can create provisional objects of desire without regard for an orthodox anatomical or sexual order.

While this kind of adventurous erotic imagination has begun to invent itself in these representational practices, it has yet to find a locus in theoretical writing.[10] Theoretical feminism is, I suspect, rather inhibited about employing an explicitly erotic or pornographic imagination because it is still for the most part caught up in the academic aesthetics and politics of reason and sobriety, and in a liberal distaste for the violence of desire. But as I have tried to demonstrate, there are certain regrettable ways in which the absence of such an erotic imaginary leads theoretical feminism to reinscribe precisely the bodily imagos it wants to disable. If the desire to dephallicize the heterosexual male body that I have articulated here is to find further theoretical elaboration it seems crucial to draw on the resources of perversity and fantasy that can be found both in the experimental cultural work described above, and in everyday sexual practice. Maybe what theoretical feminism needs now is a strap-on.

ACKNOWLEDGEMENTS

I would like to thank Mark Berger, Moira Gatens, David McMaster and Zoe Sofoulis for their suggestions.

NOTES

1 For a discussion of this idea see Bersani (1988).
2 For a very thorough elaboration of this idea see Butler (1993).
3 For more on the idea of the 'imaginary anatomy' see Gatens (1983) and also Butler (1993).
4 See McMaster (1993) for documentation and discussion of the homophobic implications of such cases.
5 This point is made in Gatens (1983).
6 For a slightly different discussion of the costs of maintaining proprietal masculinity in the face of sexual pleasure, see Waldby, Kippax and Crawford (1991).
7 I am indebted to Penelope Deutscher's paper (1993) for bringing this to my attention.
8 Bondage and discipline and s/m prostitution services, where the sex worker plays the 'top' and the client the 'bottom', is the fastest growing and most profitable area of the sex industry (Perkins 1991). These services do not necessarily involve the man being penetrated but they certainly involve his erotic passivity.
9 Work-in-progress installation at Adelaide Artists Week, Adelaide, February 1994.
10 One exception here would be some of Jane Gallop's work, particularly the essays in *Thinking Through the Body* (1988).

BIBLIOGRAPHY

Bersani, Leo (1988) 'Is the Rectum a Grave?', in D. Crimp (ed.) *AIDS: Cultural Analysis, Cultural Activism*. Cambridge, Mass.: Massachusetts Institute of Technology Press.

Butler, Judith (1993) *Bodies That Matter. On the Discursive Limits of 'Sex'*. London and New York: Routledge.

Delynn, Jane (1991) 'Butch', in A. Scholder and I. Silverberg (eds) *High Risk: An Anthology of Forbidden Writings*. London: Serpent's Tail.

Deutscher, Penelope (1993) 'Recent Queer and Gender Theory, Operative Différance and the "Brundle-Fly Effect"', paper given to the Department of Philosophy Seminar, Macquarie University, Sydney, November.

Fallon, Mary (1989) *Working Hot*. Melbourne: Sybylla Press.

Gallop, Jane (1988) *Thinking Through the Body*. New York: Columbia University Press.

Gatens, Moira (1983) 'A Critique of the Sex/Gender Distinction', in J. Allen and P. Patton (eds) *Beyond Marxism? Interventions After Marx*. Sydney: Intervention Publications.

—— (1995) 'Contracting Sex: Essence, Geneology, Desire', in M. Gatens and M. Trapper (eds) *Reading the Social/sex Contract: Women, Contract and Politics*. Sydney: Allen and Unwin.

Marcus, Sharon (1992) 'Fighting Bodies, Fighting Words: A Theory and Politics of Rape Prevention', in J. Butler and J. Scott (eds) *Feminists Theorise the Political*. London and New York: Routledge.

McMaster, David (1993) 'Bodies That Matter: Homophobic Violence and "Homo-

sexual Advance"', unpublished paper, National Centre for HIV Social Research, Macquarie University, Sydney.

Perkins, Roberta (1991) *Working Girls: Prostitutes, Their Life and Social Control.* Canberra: Australian Institute of Criminology.

Sedgwick, Eve Kosofsky (1990) *Epistemology of the Closet.* Berkeley and Los Angeles, Calif.: University of California Press.

Waldby, Cathy, Kippax, Susan and Crawford, June (1991) 'Equality and Eroticism: AIDS and the Active/Passive Distinction', *Social Semiotics*, 1, 2 (October): 39–50.

Winterson, Jeanette (1985) *Oranges Are Not the Only Fruit.* London, Sydney and Wellington: Pandora.

277

15

ANIMAL SEX

Libido as desire and death

Elizabeth Grosz

If there's one thing that animals don't need more information on, it's sex. That's because sex holds no mystery.

(Freedman 1977: 9)

We make love only with worlds.

(Deleuze and Guattari 1977: 294)

Sex continues to obsessively fascinate human subjects, even if, as Freedman suggests, it holds little mystery for animals. That it lacks mystery, that sexual acts and desires are ruled by natural impulses, impelled by instincts, part of a natural cycle of life, reproduction and death, may not in fact be as clear-cut and uncontentious as Freedman claims, even in the natural order. But even if it is true that sex holds no mystery for the animal (a claim which is not in any case self-evident: what would 'mystery' be to an animal?), it is clearly not true that sex, in animal or human form, holds no mystery for man.[1] Animals continue to haunt man's imagination, compel him to seek out their habits, preferences and cycles, and provide models and formulae by which he comes to represent his own desires, needs and excitements. The immense popularity of nature programmes on television, of books on various animal species, beloved or feared, and the work of naturalists recording data for scientific study, all testify to a pervasive fascination with the question of animal sex: how do animals *do it*? How do elephants make love (the standard old joke: very carefully)? How do snakes copulate? What are the pleasures of the orang-utang, the gorilla, the chimpanzee?

It is ironic that in the rich plethora of animal sex that has been thus far surveyed, two examples taken from the microcosmic insect world continue to haunt the imaginations and projections of men perhaps more than any other examples taken from ethology – the black widow spider and the praying mantis. These two species have come to represent an intimate and persistent link between sex and death, between pleasure and punishment, desire and revenge which may prove significant in understanding certain key details of male sexuality and desire, and, consequently, given the differential and

oppositional structure of sexual identities and positions, in specifying elements or features of female sexuality and subjectivity.

It will be my claim in this essay that any attempt to understand female sexual pleasures and desires on the models provided by male sexuality and pleasure risks producing a model of female sexuality that is both fundamentally reliant on heterosexual norms of sexual complementarity or opposition, and that reduces female sexuality and pleasure to models, goals and orientations appropriate for men and not women – models, in short, which reduce female sexuality to versions of male sexuality. Such manoeuvres short-circuit any acknowledgement of the range, scope and implications of erotic pleasure for understanding sexual difference. This is not to say that female and male sexualities must be regarded as two entirely distinct species, separate, sharing nothing in common, set up in absolute opposition, each with their own identities and features (an essentialist commitment): this would entail the possibility of attaining a precise and positive understanding of the independent features that characterize each sex (a project that has tempted many women, and perhaps even more men, to outline what they understand to be a universal, characteristic or essential femininity). Nor do I wish to suggest the contrary claim that the two sexes must be understood only in terms of each other, as mutually defined, reciprocally influential, each conforming to the other's needs and expectations (this is the dominant fantasy that has thus far governed the contemporary West's thinking about relations between the sexes, a fantasy that has left unacknowledged the social and representational constraints mitigating against any structural possibility of reciprocity).

Originally, I had planned to write this essay on female sexuality, and particularly on female orgasm. After much hope, and considerable anguish that I would be unable to evoke the languid pleasures and intense particularities of female orgasm – hardly a project for which the discipline of philosophy, or, for that matter, psychoanalysis, could provide adequate theoretical training! – I eventually abandoned this idea, partly because it seemed to me to be a project involving great disloyalty – speaking the (philosophically) unsayable, spilling the beans on a vast historical 'secret', about which many men and women have developed prurient interests – and partly because I realized that, at the very most, what I could produce would or could be read largely as autobiography, as the 'true confessions' of my own experience and have little more than anecdotal value. I could have no guarantees that my descriptions or analyses would have relevance to other women. Instead, in an attempt both to stay obliquely with my self-chosen topic, while avoiding these dangers and points of uneasiness, I decided to look at what seems entirely other to and completely different from women's pleasure and desire – at men, at insects – in an attempt, if not to say what female pleasure is, then at the least to say what it is not, to dispel accounts which bind women too closely to representations of men's or animals' sexuality, to clear the air of certain key projections, even if what is left is not

a raw truth of women's desire but perhaps another layer in the complex overwriting of the inscriptions or representations that constitute the body or subjectivity. Thus, instead of focusing on various representations of women's sexual pleasure (in literature, poetry, painting, sculpture, pornography and so on) or on personal experience, as many feminists have tended to, I decided to explore the work of two apparently unrelated male theorists whose candour and intellectual honesty have for some time impressed me, and whose work represents a rare combination of openly expressed personal obsession and scholarly rigour, the rigorous reading and analysis of their driving personal preoccupations:[2] Roger Caillois, the French sociologist and co-founder of the College de sociologie,[3] whose life-long preoccupation with insects, with the *femme fatale* and with rocks,[4] signals early anticipations of what might be considered a 'philosophy' or perhaps even an 'anthropology' of the post-human; and Alphonso Lingis, distinguished American philosopher and translator of phenomenological theory (most notably, Merleau-Ponty and Levinas), the only professional philosopher I have read who writes openly yet philosophically, and at great length, about orgasm, bodily pleasures, lust and sexuality in its many permutations and extremes (transvestism, trans-sexualism, prostitution, pornography, pederasty, sado-masochism among them). Between them, Caillois and Lingis provide a coverage from among the most primitive and ancient of insects[5] to the most developed and enculturated of human sexual practices – a veritable panorama of sexual pleasures and practices which may help to specify what is masculine about representations of human, and non-human, sexualities.

HOLY INSECTS: LOVE AND THE PRAYING MANTIS

Caillois' pioneering contributions to ethology have long been recognized. His by now well-known analysis of the function of mimicry in the insect world[6] has proved salutary for any analysis of materiality that reduces it to instrumentality, any attempt to define form in terms of function, being in terms of *telos*. He shows, in this study and in a number of his earlier writings, that the particular characteristics defining an insect species – its colouring, its camouflage abilities, the organization of its sense organs, etc. – are always in excess of their survival value. There is a certain structural, anatomical or behavioural superabundance; perhaps it is the very excess or superfluity of life itself, at work over and above the survival needs of the organism:

> It is obvious that the utilitarian rôle of an object never completely justifies its form, or to put it another way, that the object always exceeds its instrumentality. Thus it is possible to discover in each object an irrational residue. . . .
>
> (Caillois 1990: 6)

This 'irrational residue', this going over the mark, this inherently ex-

orbitant expenditure which functions in an economy of luxury becomes a locus of fascination for him. In his work on mimicry, Caillois makes it clear that an insect's ability to camouflage itself does not have survival value – it does not protect the creature from attack or death, and in fact may leave it open to even more hideous and unimaginable forms of death: he cites cases of the caterpillar cut in half by pruning shears, or the insect devoured by a member of its own species who mistakes it for a leaf. Camouflage is excessive to survival, just as the plumage of the peacock is excessive to sexual reproduction. Instead of demonstrating the finality of instinctual determinations, an existence defined in Darwinian terms, Caillois introduces an excessive, wanton dimension to his explanations of such features of animal existence. Camouflage, the capacity to imitate one's habitat or surroundings, far from performing an adaptative function, witnesses the captivation of a creature by its representations of and as space, its displacement from the centre, from a 'consciousness' of its place (in its body, located in space) to the perspective of another. The mimicking insect lives its camouflaged existence as not quite itself, as another.[7] In comparing the phenomenon of mimicry with the psychosis of legendary psychasthenia, Caillois suggests that there is a disintegration of the bond tying consciousness to its body: the subject feels outside him- or herself, what is inside may be perceived as coming from another.

Caillois, who described himself as an 'insect collector' (1990: 62), seems to have had a life-long fixation with the *Mantis religiosa*, or praying mantis. He claims to have been attracted to this species partly through frustrated curiosity: where he had lived as an adolescent, they were not to be found. His curiosity piqued, he was determined to possess, to see, to know. His description is couched in the terms of an impassioned epistemophilia: '[t]he difficulty of getting a specimen only increased my desire to possess one. I had to wait two years, and finally during a summer vacation in Royan I was thrilled to capture a fine *Mantis religiosa*' (1990: 63).

Part of the attraction the praying mantis holds, not only for Caillois, but for very many others, which may help to explain the insect's privileged status in the myths of many cultures,[8] is its close and curious association with femininity, with female sexuality, and, above all, with the fantasy of the *vagina dentata*; with orality, digestion and incorporation; and with women's (fantasized) jealousy of and power over men. Moreover, its richly evocative power, its ability to be used as a source of projections and an object of fantasy and speculation, a site for overdetermination (in Caillois' distinctive sense), must no doubt in part be attributed to its uncanny resemblance to the human form, the isomorphism of its limbs with human ones:

of all insects it is the one whose form most reminds one of the human form, mainly because of the resemblance of its rapacious legs to human arms. As for its ordinary pose, it is not that of someone praying, as

common consensus would have us believe (one does not pray lying on
one's stomach), but that of a man making love [men on top!]. This alone
is enough to justify an obscure and constant identification. One can now
see why men have always been so interested in the mantis and its habits,
and why it is so aptly associated as much with love as with hatred,
whose ambivalent unity it condenses so admirably.

<div align="right">(1990: 63)</div>

The ambivalence is derived primarily from a narcissistic identification
facilitated by the apparent resemblance of the mantis' posture to the human
form; the closer this identification, the more horrifying are the consequences,
for the more ominous is the fate of the human/male subject identifying with
the mantis. Above all, what seems most to provoke Caillois' fascination are
its terrifying nuptial habits, the well-known inclination of the female mantis
to devour the male in the act of coitus. The female mantis is the most
ungrateful of mates, engulfing and ultimately destroying her lover in a frenzy
of self-seeking. This scene is of course rife with the possibilities of pro-
jection, and Caillois does not hesitate to suggest that the mantis may serve
as an apt representation of the predatory and devouring female lover, who
ingests and incorporates her mate, castrating or killing him in the process.
The *femme fatale* writ small.[9] This small insect is heir to, and comes to
embody, a whole series of fundamentally paranoid projections, whereby it is
not the male subject or the phallus which threatens the female lover but,
rather, the female lover who threatens the phallus. The father's castrating
position *vis-à-vis* the son is transformed into the image of the devouring
mother; the mother is no longer the potential object of rape, but the
perpetrator of a *theft*, castrating the son and keeping his phallus for herself,
in a kind of retaliation against the father's authority and law.[10]

Psychoanalytic theory is clear that this is not what the mother does to the
son, but rather what the son fears of the (fantasmatic) mother, what he
projects on to her. She, no less than the mantis, is the projective vehicle for
his worst fears. This may help explain the anthropomorphic identification of
the female mantis with the female human – a neutralization of his investment
in the father's image as a threat and a danger, the cost of which is linking
castration to the mother, producing the phallus and sexual pleasure in
connection with mutilation or death. Indeed, for Caillois, this links the mantis
to a series of other parasitic images – the bat, the vampire and the mandrake
– which, by virtue of their resemblance to the human, particularly the male,
form, renders them objects of projection and identification:

> The anthropomorphic appearance of an element seems to me an
> infallible source of its hold on the human imagination. This is the case,
> for example, with vampires and mandrakes and the legends about them.
> It is by no means coincidental, in my opinion, that the belief in blood-
> sucking specters uses a bat as a kind of natural point of reference. The

anthropomorphism of the bat runs particularly deep and goes well beyond the level of a general structural identity (the presence of true hands with a thumb opposed to the other fingers, pectoral breasts, a periodic menstrual flow, a free hanging penis).

(Caillois 1990: 73 n. 10)

But, in spite of this series of stereotypically feminine images, which focus on the role of the female mantis, the subject that is probably the object of his most intense fascination is the role and functioning of the amorously imperilled male.

The female mantis had been 'scientifically observed' since at least the sixteenth century in the act of decapitating the male, not only after or during coitus but even before! He would be devoured completely after copulation. For centuries it was believed that such acts of cannibalism could be described in terms of utility: needing protein to make the newly fertilized eggs grow, the female could find great quantities in devouring her mate. However, it seems more likely that the male's decapitation may well serve not only procreative but also specifically sexual functions for the female mantis:

Dubois's theory . . . wonders whether the mantis's goal in decapitating the male before mating is not to obtain, through the ablation of the inhibitory centers of the brain, a better and longer execution of the spasmodic movements of coitus. So that in the final analysis it would be for the female the pleasure principle that would dictate the murder of her lover, whose body, moreover, she begins to eat during the very act of making love.

(1990: 81–2)

The female decapitates the male to facilitate more vigorous coital movements! What seems to preoccupy Caillois most is the automatic nature of the male's sexual drive: headless, without a brain to take in representations or to undertake voluntary behaviour, it nonetheless doggedly persists in its automatic sexual movements, and is even able to utilize various autonomous strategies to evade danger and predators while nonetheless, in a certain sense at least, dead (but still kicking!):

[t]he fact is that there are hardly any reactions that it is not also able to perform when decapitated. . . . In this condition, it can walk, regain its balance, move one of its threatened limbs autonomously, assume the spectral position, mate, lay eggs, build an ootheca, and, quite astoundingly, fall down in a false corpse-like immobility when confronted by danger or following a peripheral stimulation. I am deliberately using this indirect means of expressing myself because our language, it seems to me, has so much difficulty expressing, and our reason understanding, the fact that when dead, the mantis can simulate death.

(1990: 82)

The automatism of this whole procedure strikes Caillois as one of the significant features of the mantis; not only can the mantis 'act dead' while decapitated, its sexual behaviour is induced reflexively, like a wind-up (sex) doll. It can perform its functions without the organizational structure of consciousness (whatever that might mean in the case of the mantis), the structurings provided by a central nervous system or an intact perceptual apparatus.

The mantis is a perfect machine; not a machine for survival, but a sexual machine, a fucking machine (much as the shark is commonly referred to as the perfect feeding or killing machine), whose reaction, under threat of imminent death, is automatically coital. Yet, if the mantis is a human-like machine, an android, it is distinctively coded as female:

> Indeed, the assimilation of the mantis to an automaton – that is, in view of its anthropomorphism, to a female android – seems to me to be a consequence of the same affective theme: the conception of an artificial, mechanical, inanimate, and unconscious machine-woman incommen-surable with man and other living creatures derives from a particular way of envisioning the relation between love and death, and, more precisely, from an ambivalent premonition of finding the one within the other, which is something I have every reason to believe.
>
> (Caillois 1990: 82)

Caillois posits a network of associations, an implicit linkage between the praying mantis, religiosity, food and orality, blood-sucking vampires, the mother who feeds the child, cannibalism, the *vagina dentata*, the devouring female, the *femme fatale*, the mechanisms of automatism and the female android. He has the insight to suggest, that this is not somehow a natural or innate set of connections, but largely a function of a constellation of concepts that have become inextricably linked, overdetermined in their mutual re-lations: by linking sexual pleasure to the concept of death and dying, by making sex something to die for, something that in itself is a kind of anticipation of death (the 'little death'), woman is thereby cast into the category of the non-human, the non-living, or a living threat of death.

LIBIDINAL INTENSITIES: THE DISARRAYS OF LOVE

Caillois' intuition about the formative character of the link between sexual pleasure, death and dying, finds clear confirmation in abundant examples in everyday life: the production of weapons on the model of the phallus, the functioning of the phallus as a weapon of war and retaliation, the very dependence of the function of the phallus on the castration complex, the operations of psychical impotence, the link between male orgasm and de-tumescence, the depletion of psychical energies after orgasm, the fantasmatic projection on to woman of phallic power during the act of intercourse,[11] the

'evolutionary' linkage of the death of the individual to the (sexual) repro-
duction of the species (the perceived link between sexuality and immortality)
prefigure or attest to the tenacity of the link between desire and death.

In turning away from Caillois' musings about the praying mantis, I will
now look in more detail at the work of Lingis on erotic sensibility, libido or
lust to see if we can glean a better understanding of the connections between
sexual pleasure and death, and, in a more challenging and difficult fashion,
to see if these two terms might be extricated so that their relations of influence
and their particular specificities and details, and thus their possibilities of
transformation and change, may be explored.

Lingis distinguishes between corporeal needs and satisfactions, and lust or
erotic desire. Corporeal gratification takes what it can get, lives in a world of
means and ends, obtaining satisfaction from what is at hand. He links
gratification or need to the functioning of the body-image or corporeal schema
– and through it to anatomy, physiology and the capacity for movement[12] –
which maps inner physiological and psychological functions on to the
exterior or 'objective' movements, comportment and posture of the body
through a mediating representational schema. Lingis makes it clear that the
body-image provides the subject with an experience, not of its own body, but
of the ways in which its body is perceived by others. The subject's experience
of the body is irreducibly bound up with both the body's social status and its
status in the eyes of others.

Libido or erotic desire involves a certain dis-quieting, troubling or unset-
tling of the body-image even while functioning in conformity with it. Rather
than resolving itself, gratifying its urges as quickly and simply as possible,
erotic craving seeks to prolong and extend itself beyond physiological need,
to intensify and protract itself, to revel in 'pleasurable torment' (Lingis
1985a: 55). It no longer functions according to an 'intentional arc', according
to the structures of signification, meaning, structure, pattern or purpose;[13]
voluptuous desire fragments and dissolves the unity and utility of the organic
body and the stabilized body-image. The limbs, erogenous zones, orifices of
the other, provoke and entice, lure and beckon, breaking up the teleological,
future-directed actions and plans of a task to perform. Sexuality, desire,
cannot be seen in terms of a function, purpose or goal, for this is to reduce
it to functionality; materiality, as I have already suggested following Caillois,
is always in excess of function or goal. This is one of the problems with the
sex-manual approach: 'how-to' books on sexuality presume a certain prin-
ciple of the performance of a chore or task, not the uncovering of desire,
which cannot be summarized, put into a formula or learned by rote. Lingis
will argue that the voluptuous sense of disquiet engendered by and as lust
disarrays and segments the resolve of a certain purposiveness, unhinging any
determination of means and ends or goals.

Moreover, if libidinal impulses are fundamentally decomposing, de-
solidifying, liquefying the coherent organization of the body as it performs

functional tasks, unhinging a certain intentionality, they are more dependent on the sphere of influence of otherness, on an other which, incidentally, need not be human but which cannot simply be classified as a passive object awaiting the impressions of an active desiring subject. The other, this otherness, solicits, beckons, implores, provokes and demands. The other lures, oscillates, presenting everything it has to offer, disclosing the whole body without in fact giving up anything, without providing 'information' as such.[14]

Carnal experience is uncertain, non-teleological, undirected. While not entirely involuntary, it lacks the capacity to willingly succumb to conscious intentions or abstract decisions. It upsets plans, intentions, resolutions; it defies a logic of expediency and the regimes of signification (one often cannot say or know what it is that entices and allures, a gesture, a movement, a posture or look, which becomes loaded with more affect and impetus than is required to explain it). It is like an ever-increasing hunger, a hunger that supplements itself, feeds itself, on hunger, and can never be content with what it ingests, that defers gratification to perpetuate itself as craving, languishing in its erotic torments rather than hastening to quench them. Its temporality is neither that of development (one experience building on the last in order to create a direction or movement) nor that of investment (a relation between means and ends). Nor is it a system of recording or memory (erotic pleasures are evanescent, they are forgotten almost as they occur); the memory of 'what happened', or movements, setting, gestures, behaviour may be open to reminiscence, but the intensity of pleasure, the sensations of voluptuousness, the ache of desire have to be revivified in order to be recalled. In this case, there is not recollection or recreation, but always creation, production:

> Carnal intimacy is not a practical space; it does not open a field for action. The erotic movements are agitation that handles and fondles without keeping anything in its place, without extending its force outward and without going anywhere. Here nothing will be accomplished; one will waste time, unprofitably. Voluptuousness has no tasks and no objectives and leaves no heritage; after all the caresses and embraces, the carnal is left intact, virgin territory. . . . It is not the locus from which would emerge the meaning of one's history.
>
> (Lingis 1985a: 67)

Erotic desire cannot be recorded or stored, cannot be the site for the production of information or knowledge. Masters and Johnson's empirical research on human sexuality can only measure and record physiological transformations, reactions, responses, bodily changes: it comes nowhere near to mapping desire. Desire's turbulent restlessness defies coding into signs, significations, meanings; it remains visceral, affective, which is not to say that it is in any way reducible to physiology. Resisting redeployment in pragmatic projects, it functions in its own ways, seeking to endlessly extend itself, to fill itself with intensity. But it is incapable of being filled up,

completed, for it contains ineliminable traces of alterity: it is an otherness in the subject, triggered by an other, something that overtakes one, induces one to abandon what one has planned, and even what one understands, in exchange for its momentary evanescence, its dazzling agitations and stirring sensations. The other erupts into the subject, and interrupts all the subject's aims and goals:

> This very flesh, exposed and palpable, no longer sighing subtle mean-
> ings, heavy and panting, no longer illuminating a field of significance,
> incandescent with ardour, afflicts the physical and natural continuity,
> afflicts me and the phenomenal field I appropriate, as other. In the
> contact of our common flesh, the spasm of disorder that demoralises my
> position is a trace of radical alterity. The approach of the other is
> dismemberment of the natural body, fragmentation of the phenomenal
> field, derangement of the physical order, breakdown in the universal
> industry.
>
> (Lingis 1985a: 72)

If the sexual drive is object-directed, and takes for itself a specific, if interchangeable, series of objects, it is significant that eros, desire, has no objectives, no privileged objects, only a series of intensities. Having outlined the elements of a phenomenology of carnal experience relying on the various writings of Sartre, Merleau-Ponty and Levinas, Lingis shifts his focus in *Libido* (1985a) away from the structures of consciousness, intentionality and givenness to look more directly at what might be understood as a materialist analysis of sexual desire using the work of Lyotard and Deleuze and Guattari. He moves away from a framework which privileges the psyche and systems of representation, which understands carnality in terms of concepts, reasons, motives, causes, intentions, fantasies, projects – that is, in terms of interiority, however conceived – to one which privileges the erotogenic surface, the body's 'outside', its locus as a site for both the perception of the erotic (as phenomenology recognized) and also for the inscription and intensification of bodily regions.

The orgasmic body cannot be identified with the organic body, but is more an interference in and displacement of the body of 'nature'.[15] This is not the intervention of a supervising consciousness, but the reorganization or the rebinding of bodily energies, passing along the body's surface. Relying on a model established by Lyotard in *Libidinal Economy* (1993), where the subject is viewed in terms of the twisting, contortions and self-rotations of the Moebius strip,[16] Lingis refigures carnal desire in terms of the lateral ('horizontal') contamination of one erotogenic zone or bodily surface by another, rather than in terms of a horizontal relation between (bodily) surface and (psychical) depth. The intensification of one bodily region or zone induces an increase in the excitation of those contiguous with it. Significantly, the two or more interacting zones or regions need not be part of the one body

but may come from different bodies and different substances. Their relations cannot be understood in terms of complementarity, the one completing the other (a pervasive model of the heterosexual relation since Aristophanes), for there can be no constitution of a totality, union or merging of the two. Each remains in its site, functioning in its own ways.

The relationship between these regions or zones cannot be understood in terms of domination, penetration, control or mastery, but rather in terms of *jealousy*, as one organ jealous of another, as the desire of organs and zones for the intensity and excitations, the agitations and tumultuousness of others. We have here another version of a Derridean notion of the violence of difference itself, its constitutive tearing or etching of a surface: in order that one bodily part (whether an orifice, a hollow, a protuberance, a swollen region, a smooth surface) intensify its energetic expenditure, it must drain intensity from surrounding regions. It seems impossible to conceive of a situation in which there is an even intensity throughout the whole of the body, a situation of pure equilibrium or stasis: any activity at all 'prefers' or privileges some bodily regions over others, and even sedentary inactivity focuses on some parts of the body at the expense of others. This creates a gridding or marking of the body in terms of sites of uneven intensity, patterns or configurations of feeling, labyrinthine maps of voluptuous pleasures and fluxes. Each organ envies the intensity of its surrounding bodily context, craves enervation, seeks incandescence, wants itself to be charged with excitations:

> Every intensity induces intensities – jealousy of the vulva for the mouth, jealousy of the nipple for the fondled testicles, jealousy of the woman over the book her lover is writing, jealousy of the sun upon the closed shutters behind which the reader reads that book.
>
> (Lingis 1985a: 77)

Lingis seeks to evoke, to bring to discourse, to try to replay in words the intensities that charge all erotic encounters, whether the amorous relations of the carpenter to wood and tools, the attachment of the sadist to the whip, the linkage between the breast and a mouth, lips and tongue. There must be some coming together of disparate surfaces; the point of conjunction of two or more surfaces produces an intensification of both. It makes a hand a sexual organ, the fingers a site, not just for the production of pleasure in another, but for their own orgasmic intensities though they cannot be classified as a orifice or genital organ on a psychoanalytic or physiological model.[17] The hand, while in a sense 'jealous' of the pleasure it induces in the body it caresses, also participates in the very intensities it ignites in a vagina or around testicles: it does not simply induce pleasure in another, for another, but also always for itself. The contiguity of hand and region instils in both a yearning for intensity and a craving for more intensity that both enlivens them, rouses their 'jealousy' of each other and propels them into a path of unpredictable and restless movement.

These sites of intensity – potentially any region of the body including various internal organs – are intensified and excited, not simply by pleasure, through caresses, but also through the force and energy of pain. Pain is as capable, perhaps more so, of inscribing bodies as pleasure. Sadism and masochism intensify particular bodily regions – the buttocks being whipped, the hand that whips, the bound regions of the body in domination practices – not using pain as a displacement of or disguise for the pleasure principle, but where pain serves as a mode of corporeal intensification. We cannot readily differentiate the processes by which pleasurable intensities are engendered from those by which painful intensity is produced. One craves repetition of these practices because the intensity is ephemeral, has no life span – it exists only in the moments of its occurrence, in the present (even if not as pure presence; rather, its status is as the evanescence of pure difference, the momentary shimmering and dazzling of a zone or orifice; it is the trace, the marking of a pathway, *frayage*). This repetition (or rather, the inherent openness of these practices to repetition ad infinitum) produces the intensity of affect, pleasure or pain, but can never repeat its initial occurrence. Each repetition engenders an experience or intensity, without any presumption of identity. Strictly speaking, exact repetition remains impossible.

Erotogenic zones do not desegment the fully functional organic body, for the organic body is itself a product of the organization and hierarchization of localized and particular libidinal zones: the organic, unified body is the provisional end-result of the alignments and coagulations of libidinal zones. These regions, moreover, continually intervene in the functioning of the organic body and its attendant body-image(s). Instead of adopting the psychoanalytic position, which takes erotogenic zones as nostalgic reminiscences of a pre-oedipal, infantile bodily organization – that is, instead of seeing the multiplicity of libidinal sites in terms of regression – these libidinal zones are continually in the process of being produced, renewed, transformed, through experimentation, practices, innovations, the accidents or contingencies of life itself, the coming together of surfaces, incisive practices, inscriptions. There is nothing particularly infantile about these regions, insofar as to be effective, to function as the sites of orgasmic intensity, they must continually be invested through activity, use.

Modes of greatest intensification of bodily zones occur, not through the operations of habitual activities, but through the unexpected, through the connection, conjunction and construction of unusual interfaces, through a kind of wild and experimental free play that re-marks, reinscribes orifices, glands, sinews, muscles differently, giving organs and bodily organization up to the intensities that threaten to overtake them, seeking the alien, otherness, the disparate in its extremes, to bring into play these intensities. The interruption and interaction of a surface with another, its disengagement from the circuit of organic functioning (where it operates within an hierarchical and systematic whole) so that it realigns itself in different networks

and linkages performs the intensification of libidinal circulation that Lingis seeks. In this way, the subject's body ceases to be *a* body, and becomes the site of provocations and reactions, the site of intensive disruptions. The subject ceases to be a subject, giving way to pulsations, gyrations, fluxes, secretions, swellings, processes over which it can exert no control and to which it only wants to succumb. Its borders blur, seep, liquefy, so that, for a while at least, it is no longer clear where one organ, body or subject stops and another begins:

> To become passionate is to become an anonymous conductor of a circulation of libidinous effects, a dismembered body over which intensifications undergo their metamorphoses. There is not *a* libido that would be behind all that, and that could be identified with the consciousness or the intentional arc of the organism – none of these are the telos of the libidinal processes.

(Lingis 1985a: 85)

Libido abdicates a certain sense of responsibility, the controlling operations of the ego and superego. It is not irrational, illogical or even non-rational; rather it exhibits a logic of its own that is governed by modes of intensification. It does not provide information or knowledge, although it probes (this may be part of the problem of the sexualized metaphor of knowledge-production as sexual conquest; conquest can only make sense where lust does not operate but something else does, the struggle for prestige, control). It breaches the innermost regions, secret parts, of the body, but does not learn anything. It learns only that it cannot hold on to what it craves. Lust cannot know itself, it does not know what it is or what it seeks. It does not discover or learn, but immerses itself, becomes. It resists pragmatics, any logic of functionality, of appropriation. Instead it insists on a certain formlessness, indeterminacy, that very excess of materiality that makes any creature resist reduction to its functions alone: it insists on an open responsiveness that can be viewed as a passivity or susceptibility to the appeals and resistances of the other. Lust throws one into the vagaries of the other's libidinal intensities.

Libidinal desire, the carnal caress, desire as corporeal intensification, then, is an interchange with an other whose surface intersects its own. It is opened up, in spite of itself, to the other, not as passive respondent but as co-animated, for the other's convulsions, spasms, joyous or painful encounters engender or contaminate bodily regions that are apparently unsusceptible. It is in this sense that we make love to worlds: the universe of an other is that which opens us up to and produces our own intensities; we are placed in a force field of intensities that we can only abandon with libidinal loss and in which we are enervated to become active and willing agents (or better, agencies). The other need not be human or even animal: the fetishist enters a universe of the animated, intensified object as rich and complex as (perhaps

more so than) any other sexual relation. The point is that both a world and a body are opened up for redistribution, dis-organization, transformation; both are metamorphosed in the encounter, both become something other, something incapable of being determined in advance, and perhaps even in retrospect, but nonetheless that has perceptibly shifted and realigned. The sexual encounter cannot be regarded as an expedition, an adventure, a goal, or an investment, for it is a directionless mobilization of excitations with no guaranteed outcomes or 'results' (not even orgasm): 'Lust is the dissolute ecstasy by which the body's ligneous, ferric, coral state casts itself into a gelatinous, curdling, dissolving, liquefying, vaporizing, radioactive, solar and nocturnal state. *Exstase matérielle*, transubstantiation' (Lingis 1991: 15).

THE MURDEROUS LOVER, OR KISS ME DEADLY

In *Beyond the Pleasure Principle* (1919) Freud raises the question of the necessary binding or linkage of the pleasure principle with the death drive. He links the accumulation of unbounded intensities or affects with unpleasure, and the relief or satisfaction of libidinal impulses with pleasure. He uses Fechner's constancy principle to suggest that the organism attempts to keep the quantity of energy or excitation as low as possible – not so low as to 'wind down', to approach death, but low enough not to 'overstimulate' the organism, causing it to seek all sorts of inappropriate outlets to vent the excessive energy which would otherwise accumulate. There is an entropic principle internally directing the organism towards simplicity and quiescence, impelling it gradually towards death. Life can be seen, on this Freudian scenario, as the limited deferment or delay of the death drive, the detour of the drive through the deferment provided by the pleasure principle. These two principles, Eros and Thanatos, life/pleasure and death/unpleasure, are both complementary and opposed: they function together, one operating through the other, and, as it were, against the interests of the other. The pleasure principle provides a way in which the death drive can express itself through the processes of gratification, in this 'unwinding' or diminution of psychical energies, and the death drive provides, as it were, the medium, the material – the accumulation of tension – through which the pleasure principle gains its satisfaction.

Paradoxically, the death drive and libido do not cancel out but reinforce each other. Libido or the life-drives produce self-preservative and pleasurable (respectively, instinctual and drive) processes which aim to protect the organism from dangers coming from without and from the unpleasant accumulation of energies from within the organism. In this sense, they allow the death drive to take its own course and its own time: they protect the organism from outside dangers, so that it can be carried towards death by its own immanent processes.

In Freud's phylogenetic perspective, sex or pleasure and death are internally linked. The pleasurable sexual activities of individuals are closely linked to the reproduction of the species, and the reproduction of the species is contingently dependent on the life, reproduction and death of individuals. Such an assumption has proved very strong in ethological studies: it is significant that the simplest of living organisms, amoeba and single-celled organisms, those which do not reproduce sexually through interchange with 'the opposite sex' but reproduce through the division of cells, are considered immortal. Sexuality introduces death into the world, or perhaps the converse: death is inevitable, and sexuality may function as a compensation for and supplement to death. Not only is the sexual act *grosso modo* linked to death and, through it, to the reproduction of the species, but more significantly for the purposes of my argument, the eroticism of orgasm – at least of male orgasm (the case of female orgasm is considerably more complicated and it is not clear to what degree it conforms to this model, if it does so at all) – is modelled by Freud on the build-up of excitation, the swelling of the sexual organ, the accumulation of energies and fluids, their release and then the organ's detumescence and state of contentment.

The immediacy and the directness of this link between death and sex is perhaps the intriguing thing about the praying mantis: it provides a tangible example of the worst possible fears surrounding the ways in which sexuality and relations between the sexes are conceived, the most horrific consequences of amorous passion (even though it is not clear that the mantis is either amorous or passionate outside of any anthropomorphic projection). Severing this link between death and sexual desire is particularly crucial at this historical conjuncture, not only because of the constricting effects it has on female (not to mention male) sexuality, but also because of its potentially lethal effects within gay men's communities.[18]

Lingis has recognized the link between horror and lust: the transformative, transubstantiating effects of erotic attachments, desire, are echoed in the seeping out beyond boundaries and the dissolution of lines of bodily organization prompted by orgasmic dissolution. There is something about the compulsive incitements of sexuality that may bring one to the brink of disgust and to the abject, not only to accept but seek out activities, objects and bodily regions that one might in other contexts disdain. The melting of corporeal boundaries, the merging of body parts, the dripping apart of all the categories and forms that bind a subject to its body and provide it with a bodily integrity – so fascinating for the surrealists, not to mention the current android and cyborg fantasies that sell movies and feminist science fiction – are at once imperilled in a way that alarms and horrifies, and, at the same time, entices to the highest possible degree. This is what lust has in common with the appeal of illicit drugs: their intensity melts a certain subjective cohesion, the 'high' more or less obliterates key boundaries between the body and its others, more or less pleasurably and more or less temporarily.

Although his perspective admits a connection between horror and desire, Lingis resists the temptation to make the link between desire and death intrinsic, as psychoanalytic theory has tended to. This may prove particularly instructive insofar as, in the last ten years, Lingis has primarily published material either directly related to sexuality (in its broadest sense) (Lingis 1983, 1985a, 1991, 1992) or on the question of death (Lingis 1989) but has not attempted to link these two projects to each other. This may be because, in my understanding of his work on Eros, he is attempting, among other things, to disconnect the two, to sever the bond between sexual pleasure and the death drive, to think libido in terms other than the hydraulics of the Freudian model of sexual discharge or cathexis. All of Freud's works can be understood as a generalization of and abstraction from the model of male orgasm to the fundamental principle of life itself: the constancy principle, and indeed the pleasure principle, the notion of psychical investment or cathexis, the movements of repression which sever an ideational representative from its energetic intensity, all accord with this hydraulics of tumescence and detumescence. The death drive is not simply a 'new discovery' made by Freud in his later writings, for the notion of a closed energetic system, an hydraulics, is already inscribed in his understanding of the pleasure principle even in his earliest psychoanalytic writings.

The fantasy of the *vagina dentata*, of the non-human status of woman as android, vampire or animal, the identification of female sexuality as voracious, insatiable, enigmatic, invisible and unknowable, cold, calculating, instrumental, castrator/decapitator of the male, dissimulatress or fake, predatory, engulfing mother, preying on male weakness, are all consequences of the ways in which male orgasm has functioned as the measure and representative of all sexualities and all modes of erotic encounter. Lingis' project is of relevance to the disentangling of masculinist and Freudian conceptions of sexuality, pleasure and desire insofar as it provides an understanding of (male) subjectivity and desire beyond and in breach of the opposition between pleasure and death.[19] He demonstrates that sexual passion is not reducible to the goal of sexual satiation, but lives and thrives on its own restless impetus. Orgasm need not be understood as the end of the sexual encounter, its final culmination and moment of conversion towards death or dissipation; instead it can be displaced to any and every region of the body, and, in addition, can be seen as a mode of transubstantiation, a conversion from solid to liquid:

> The supreme pleasure we can know, Freud said, and the model for all pleasure, orgasmic pleasure, comes when an excess tension built up, confined, compacted is abruptly released; the pleasure consists in a passage into the contentment and quiescence of death. Is not orgasm instead the passage into the uncontainment and unrest of liquidity and vapor – pleasure in exudations, secretions, exhalations? . . . Lust surges through a body in transubstantiation.
>
> (Lingis 1991: 15)

Caillois also recognizes, but goes no further in analysing or transforming the binding of the death drive to the pleasure principle in the masculine projection of woman as cold, mechanical, inanimate, machine-like. If we recall, such conceptions 'derive from a particular way of envisioning the relation between love and death, and, more precisely, from an ambivalent premonition of finding the one within the other' (Caillois 1990: 82), a particular, presumably not a universal or inevitable, relation between love and death which in principle can be disentangled. Love, or rather, erotic desire, can be reconsidered in terms that do not see it entwined with death.

The fantasy that binds sex to death so intimately, is the fantasy of a hydraulic sexuality, sexuality as a biologically regulated need or instinct, a compulsion, urge or mode of bodily release (the sneeze provides a paradigm). The apparently urgent and compulsive nature of sexual drives is implicit in the claim made by many men who rape, those who frequent prostitutes and those prostitutes who describe themselves as 'health workers', insofar as they justify their roles in terms of maintaining the 'health' of their clients. It is a model of sexuality based upon the equation of sexual desire with orgasmic release, with instrumental or functional relief of the body. It is a model that men commonly transpose from their own lived experiences on to the experiences of women, and, moreover, it reappears in another guise in the current reclamation of female ejaculation by some feminists.[20] When eroticism is considered a programme, a means to an end ('foreplay'), a mode of conquest, a proof of virility or femininity, an inner drive that periodically erupts, or an impelling attraction to an object that exerts a 'magnetic' force (i.e., as actively compelling, or as passively seduced), it is reduced to versions of this hydraulic model.

The provocations and allure of the other can have no effect on the erotic receptivity of the subject without resonances with the intensities and surfaces of the subject's body. Indeed nothing seems sillier and less erotic than someone else's unreciprocated ardour or passion. The other cannot excite without the subject already being excited or excitable. The other cannot induce erotic impulses and caresses from the outside alone. I am not suggesting a necessary reciprocity here, but rather a co-implication. There is always equivocation and ambiguity in passion; on the one hand, the erotic is self-contained and self-absorbed – lovers are closed off to the world, wrapped up in each other, disinterested in what is outside – yet on the other hand, in a contrary movement, eroticism and sensuality tend to spread out over many things, infecting all sorts of other relations.[21] Erotic desire is not simply a desire for recognition, the constitution of a message, an act of communication or exchange between subjects, a set of techniques for the transmission of intimacy; it is a mode of surface contact with things and substances, with a world, that engenders and induces transformations, intensifications, a becoming something other. Not simply a rise and fall, a waxing and waning, but movement, processes, transmutations. That is what constitutes the appeal and power of desire, its

capacity to shake up, rearrange, reorganize the body's forms and sensations, to make the subject and body as such dissolve into something else, something other than what they are habitually. Sexual relations need not presume desire – habitual orgasmic practice, the so-called '8 minute average' of sexual intercourse in married or long-term couples,[22] is not the most conducive milieu for the ignition and exploration of desire; desire need not, indeed commonly does not, culminate in sexual intercourse but in production. Not the production of a child or a relationship, but the production of sensations never felt, alignments never thought, energies never tapped, regions never known.

NOTES

1 I use the terms 'man' and 'men' advisedly here, for it is not clear to me that such a fascination is a universal *human* concern; I do not even want to suggest that most men find animal sex fascinating, but, rather, the more limited claim, that such a fascination is a masculine one, that for *some* men, animal sex and even insect sex hold immense fascination because they represent motifs, themes and fantasies that are close to what might be understood as a masculine imaginary, to a masculine mode of representation of self and other.

2 What seems rare is not the combination of scholarship and personal obsessional – this could be said to characterize much if not all theoretical and scientific discourse – but the open acknowledgement that the research is based on personal concerns.

3 For further details, and for reproductions and translations of some of his formative works on what might be understood as a sociology of the sacred, see Denis Hollier (1988).

4 See a quirkily personal book, written relatively late in his life, *The Writing of Stones* (1985).

5 The mantis species is probably among the earliest to appear on land:

> Mantidae were probably the first insects to appear on earth, given that the *Mantis protogea*, whose fossil prints were found in the oeningen Myocena, belongs to the paleodictyoptera group as defined by Scudder, and whose traces are manifest from the Carboniferous Age on.
>
> (Caillois 1990: 69)

6 See here Caillois (1984): I have discussed this analysis at some length in Grosz (1994b).

7 Lingis, in his dazzling evocative account of deep-sea diving in 'The Rapture of the Deep' (in Lingis 1983), provides something of an indirect confirmation of both the superabundance or excessiveness of camouflage and display and the irrelevance of an audience, an eye observing the spectacle:

> Before the plumage and display behaviors of the bird-of-paradise, before the coiled horns of the mountain sheep, one has to admit a specific development of the organism to capture another eye . . . there is a logic of ostentation over and beyond camouflage and semantic functions. The color-blind *octopus vulgaris* controls with twenty nervous systems the 2–3 million chromatophores, iridophores and leucophores fitted in its skin; only fifteen of these have been correlated with camouflage or emotional states. At rest in its lair, its skin invents continuous light shows. The sparked and streaked coral fish school and scatter as a surge of life dominated by a compulsion for exhibition, spectacle, parade.

The most ornate skins are on nudibranchia, blind sea slugs. In the marine abysses, five or six miles below the last blue rays of the light, the fish and the crabs, almost all of them blind, illuminate their lustrous colors with their own bioluminescence, for no witness.

(Lingis 1983: 9–10)

8 Caillois outlines a whole series of cultural associations regarding the mantis, which seem to place it in a privileged, if somewhat ambivalent social and theological position:

> sometimes the mantis is called an 'Italian girl' or a 'phantom', and less explicably a 'strawberry' or a 'madeleine'. More generally, an ambivalent attitude emerges: on the one hand the insect is regarded as sacred, whence its usual name of *prégo-Diéou* ('pray-to-God'), with its variants and corresponding expressions . . . on the other hand the insect is considered diabolic, as testified by the symmetrical name of *prégo-Diablé* ('pray-to-the-Devil').

> If we look now at the sayings used by children with respect to the mantis, we find two main themes: first, it is said to be a Prophetess who knows everything, and especially the whereabouts of the wolf, and secondly, it is assumed that it is praying because its mother died or drowned. On this last point the testimony is unanimous. . . .

> [For the Hottentots and Bushmen] the supreme deity and creator of the world is precisely the mantis, whose loves are, it seems, 'pleasing' and it is especially attached to the moon. . . . Note that its main function seems to be to obtain food for those who beg for it, and that in addition it was devoured and vomited alive by Kwaï-Hemm, the devouring god. So the accent seems definitely to be on digestion, which is hardly surprising when one knows about the incredible voracity of the insect, which is a prototype god. . . .

(1990: 69–72)

9 Caillois will cite a series of remarkable case-studies from the annals of psychoanalysis, particularly examples of oral persecution mania, to make more explicit this link between the mantis, the *vagina dentata* and the *femme fatale*:

> Bychowski analyses a case of a victim who is convinced that he will be devoured by a prostitute before he has even approached her. I would be inclined more generally to link these fantasies with the development of most castration complexes that . . . commonly originate in the terror of the toothed vagina, given the assimilation of the entire body to the male member and likewise that of the mouth to the vagina are . . . classics of psychoanalysis.

(1990: 78–9)

10 Rather ironically, Caillois' analysis at this point finds a linkage with Deleuze's early analysis of the structure of masochism in his analysis of Sacher von Masoch: he claims that masochism is not, as Freud suggests, an inverted homosexual desire for the father, who is disguised by the figure of the punishing mother, but rather, an attempt to psychically kill the father, insofar as it is the father that induces male and filial identifications in the son (see Deleuze 1989). Caillois explicitly connects the appeal of the praying mantis to the sado-masochistic complex.

11 Caillois quotes Paul Eluard, who

> admits to seeing the ideal sexual relationship in their love-making habits; the act of love, he says, diminishes the male and aggrandises the female, so it is natural that she should use her ephemeral superiority to devour him, or at least to kill him.

(Caillois 1990: 79)

Freud makes a similar claim in his analyses of love relations and the 'tendency to debasement in the sphere of love'.

12 Lingis explicitly acknowledges the debt that such a conception of the body-image owes to the pioneering efforts of Schilder, Goldstein, Merleau-Ponty and others. I discuss this notion of the body-image in reference to the work of neuro-physiologists in Grosz (1994b).

13 While remaining critical of the Sartrean analysis of sexual desire as fundamentally appropriative, sadistic, the imposition on to the other which confirms one's consciousness and sense of self, Lingis nonetheless affirms Sartre's refusal to reduce sexuality and sexual pleasure to functional or pragmatic projects or goals:

> The movements of lust are incantations rather than techniques. . . . It is not the dexterity of the hands that is most captivating but a hand trailing over the other with trembling and indecisive movements. . . . A sex organ is not a tool; it is essential that penis and clitoris in erection, the vagina lubricating, not be activated voluntarily, used by a reflective consciousness. No fine, prehensile organ assembled with striated muscles can be a sex organ, Sartre says; a sex organ can only be part of a vegetative system.
>
> (Lingis 1985a: 25)

14 It is not clear that this Levinasian conception of alterity is not implicitly dependent on a certain feminization of the other, the Other as Femininity, as Woman. This is precisely the issue addressed by Derrida in his second paper on Levinas, and by Irigaray in her two papers on Levinas, 'The Fecundity of the Caress' (in Irigaray 1993) and 'Questions to Levinas' (Irigaray 1991).

15 In Lyotard's text (1993), the organic body does function as something of a pure plenitude, a prelapsarian given (which, if it is produced, is the effect of physiology, anatomy, neurology and biochemistry) or presence which is deflected by a secondary intervention, a structure not unlike that which is the object of Derrida's continuous criticisms.

16 The Moebius strip, incidentally, also a pervasive metaphor in some of Lacan's writings on the subject, is the driving model behind my own understanding of the mind/body relation in Grosz (1994b).

17 I have discussed some of the effects of severing the notion of sexual desire from the predominance of genitality, and the corresponding expansion of conceptions of desire and sexual pleasure into areas commonly assumed to be somehow outside the erotic, functioning in the desexualized and sublimated realm of 'public life' – the quasi-fetishistic attachment of the writer to the tools of writing, the bureaucrat to numbers, statistics, rules, in Grosz (1994a).

18 It is significant that in gay community responses to the AIDS crisis and the advocacy of 'safe sex' sexual practices, there has been considerable effort devoted to publicizing the fact that 'safe sex' does not necessarily imply more boring sex; that one need not court danger and possible death in the search for an ultimate sexual high: or rather, there are many bodily ways in which sexual and erotic relations remain intense and exciting without necessarily being life-imperilling.

19 It is not clear to me to what degree Lingis is prepared to limit the relevance and scope of his analysis of libido: while certainly much of what he says about the formlessness of sexual pleasure, the indeterminacy of the objectives of desire seems to me directly relevant to women and female sexuality, nonetheless it is also likely that much of his account, as (quasi-)autobiographical, is specifically limited to masculine experience.

20 See, for example, Shannon Bell (1991), who claims that women too can, with the right information and practice, achieve ejaculatory orgasms. While I do not doubt that some women, and perhaps, under certain circumstances, all women, are

capable of orgasmic ejaculations, it is not clear why this should be regarded as an improvement on or progression from non-ejaculatory orgasms.

21 In his paper, 'Khajuraho' (1983), Lingis makes a similar point:

> It turns the most unlikely things into analogies or figures of lust so as to be able to excite itself anywhere; it even, in the case of fetishes, can displace itself entirely onto things remote from any possibility of interaction. It is as though the libidinous impulse is an exorbitant energy that tends not to satisfy itself and subside, like other desires and appetites, but to excite itself with its own function; everything gets infected with its trouble, even practical associations to work with tools, political relationships within institutions, pedagogical relationships over ideas, military alliances before the imminence of disaster and in the thirst for conquestion. Not only can the pursuit of riches or the investiture with political authority function as a means to obtain partners of flesh and blood, but cupidity and calculation themselves become lascivious.
>
> (1983: 50)

22 This statistic is cited in Marilyn Frye's analysis of the ways in which lesbian sexual relations do not count as proper or real 'sex' according to the implicit values and models of heterosexual intercourse (see Frye 1990).

BIBLIOGRAPHY

Bell, S. (1991) 'Feminist Ejaculations', in A. and M. Kroker (eds) *The Hysterical Male; New Feminist Theory*. New York: St Martin's Press.

Caillois, R. (1984) 'Mimickry and Legendary Psychasthenia', translated by J. Sheply, *October*, 31: 12–32.

—— (1985) *The Writing of Stones*, translated by B. Bray. Charlottesville, Va.: University of Virginia Press.

—— (1990) *The Necessity of Mind. An Analytic Study of Mechanisms of Overdetermination in Automatic and Lyrical Thinking and of the Development of Affective Themes in the Individual Consciousness*, translated by M. Syrotinski. Venice, Calif.: The Lapis Press.

Deleuze, G. (1989) *Coldness and Cruelty: Masochism*, translated by J. McNiel. New York: Zone Books.

Deleuze, G. and Guattari, F. (1977) *Anti-Oedipus: Capitalism and Schizophrenia*, translated by R. Hurley, M. Seem and H.R. Lane. New York: Viking.

Freedman, H. (1977) *Sex Link*. New York: NEL Paperbacks.

Freud, S. (1919) 'Beyond the Pleasure Principle', *Standard Edition of the Complete Psychological Works of Freud: Vol. 18*, translated by J. Strachey. London: Hogarth Press.

Frye, M. (1990) 'Lesbian "Sex"', in Jeffner Allen (ed.) *Lesbian Philosophies and Cultures*. Albany, NY: State University of New York Press.

Grosz, E. (1994a) 'Refiguring Lesbian Desire', in L. Doan (ed.) *The Lesbian Postmodern*. New York: Columbia University Press.

—— (1994b) *Volatile Bodies. Toward a Corporeal Feminism*. Bloomington, Ind.: Indiana University Press, and Sydney: Allen & Unwin.

Hollier, D. (1984) 'How to not take Pleasure in Talking about Sex', *enclitic* Vol VIII, Nos.1–2: 84–93.

—— (ed.)(1988) *The College of Sociology 1937–39*, translated by B. Wing. Minneapolis, Minn.: University of Minnesota Press.

Irigaray, Luce (1991) 'Questions to Levinas', in M. Whitford (ed.) *Irigaray Reader*. Oxford: Basil Blackwell.

—— (1993) *An Ethics of Sexual Difference*, translated by C. Burke and G. Gill. Ithaca, NY: Cornell University Press.

Lingis, A. (1983) *Excesses. Eros and Culture*. Albany, NY: State University of New York Press.

—— (1985a) *Libido. The French Existential Theories*. Bloomington, Ind.: Indiana University Press.

—— (1985b) 'The Libidinal Origin of Meaning and the Value of the I', *enclitic*, IX, 1–2: 80–94.

—— (1989) *Deathbound Subjectivity*. Bloomington, Ind.: Indiana University Press.

—— (1991) 'Lust', unpublished manuscript.

—— (1992) 'The Society of Dismembered Body Parts', in J. Broadhurst (ed.) *Pli. Warwick Journal of Philosophy*, special issue on 'Deleuze and the Transcendental Unconscious': 1–20.

Lyotard, J.-F. (1993) *Libidinal Economy*, translated by I. Hamilton Grant. Bloomington, Ind.: Indiana University Press.

INDEX